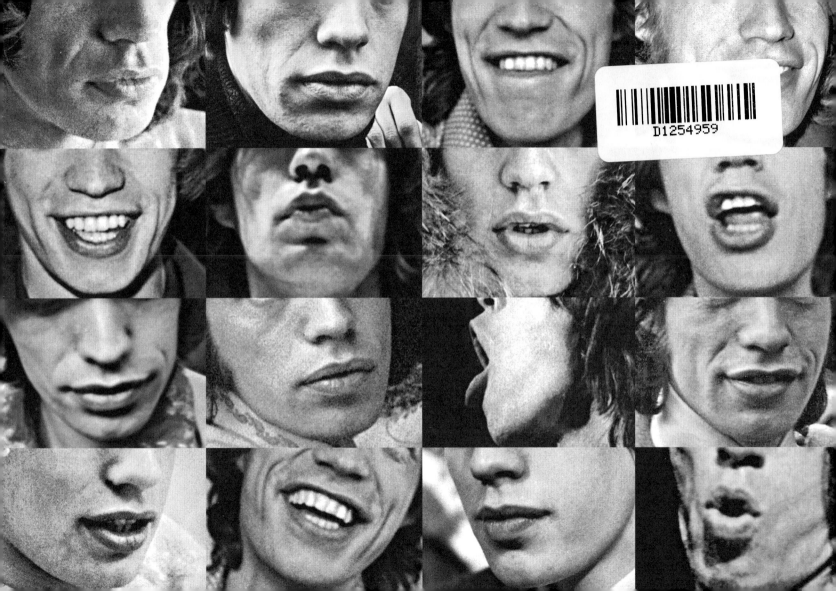

gettyimages® SIMON WELLS

THE ROLLING STONES · 365 DAYS

ABRAMS, NEW YORK

THE ROLLI

IG STONES

Introduction

Whatever one's opinion of the Rolling Stones, it is undeniable that the group has become the longest-lived rock-and-roll institution in history. As recently as 2006, the Stones beat out all the young pretenders at capturing headlines, while augmenting their past accomplishments with spectacular new triumphs.

The band's arrival on the scene in 1963 inspired acres of column space concerning their nonconformist fashions and attitudes. The perception was that, whereas the Beatles wanted to "hold your hand," the Stones wanted more than that, and weren't afraid to tell you. Musically, the group had few competitors. With a nod to the likes of John Lee Hooker, Muddy Waters, and Robert Johnson, they added a slice of youthful angst and frustration to the pot, and were rewarded with instant stardom. Relishing the pursuits that came with their celebrity status, the Stones then set about redefining excess and self-indulgence as only a rock-and-roll band can do.

All this carousing would take its toll. Unbeknownst to the Stones, the British establishment was watching their every move—and what it perceived as the band's bullish arrogance—with utter contempt. A series of drug-related arrests in the late 1960s reflected an outraged moral majority hell-bent on retribution.

Labeled instigator and protagonist was front man Mick Jagger. It's debatable whether the finger-pointing was entirely warranted: in private Jagger was a thoughtful young man whose passion for rebellion was equally matched by his desire to embrace more traditional pursuits. On the other hand, guitarist Keith Richards unapologetically embraced the lifestyle of a rock star, and he ultimately became the foremost rebel of his generation. Guitarist Brian Jones was the group's fair-haired enigma, whose troubled psyche and weak constitution would betray him in the prime of his life. Bill Wyman, Charlie Watts, and Ron Wood all had their shining moments over the years, and ultimately rounded out the group as all-important backup men.

As the era of peace and love collided with the '70s, the Stones positioned themselves at the forefront of the new "stadium rock." Despite its pretensions as antiestablishment, rock proved to be a profitable commodity. Jagger came into his own during this time, effortlessly straddling the line between rebel and society darling, while tacitly masterminding the group's finances, deftly steering them toward riches beyond their wildest dreams.

Over the years the Stones bore equal shares of criticism and praise, yet their longevity ultimately served to win over many of their critics. Undoubtedly the best gauge of their enduring appeal is the fans who pay homage at the Stones' now-legendary concerts. Following a recent show, one fifty-something summed it up perfectly: "The best thing about the Rolling Stones is, as long as those guys are on stage, I'm not old!"

Whittled down from the millions of photographs in the Getty Images collection, these pictures, many of them never seen before, offer a unique insight into the iconic rockers who continue to shape musical history today.

So, ladies and gentlemen, without further ado, we present to you the Rolling Stones!

May 1, 1964: The Rolling Stones pose, rather begrudgingly, for one of many publicity shoots they had to do to please their voracious fans.

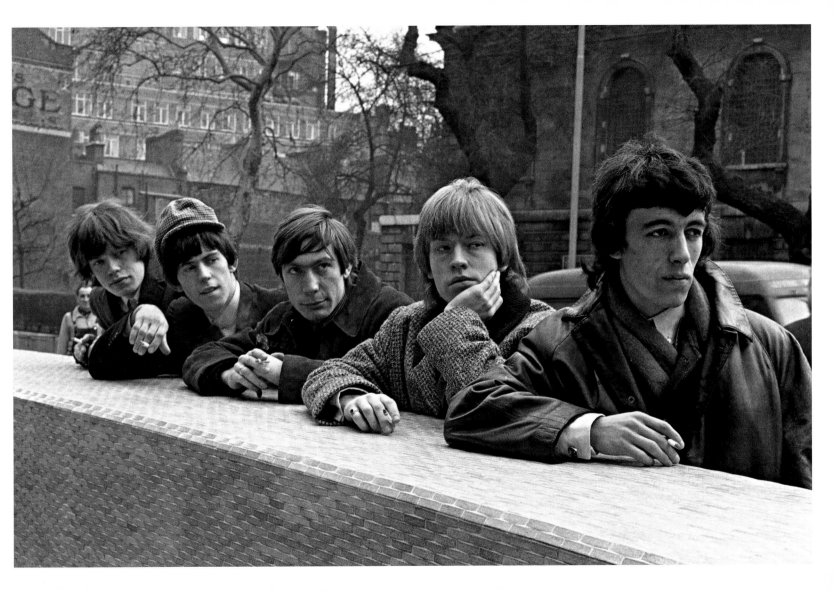

1963

Mick Jagger: "With all this attention, you become a child. It's awful to be at the center of attention. You can't talk about anything apart from your own experience, your own dopey life. I'd rather do something that can get me out of the center of attention. It's very dangerous. But there's no way, really, to avoid that."

Keith Richards: "They don't like young kids with a lot of money. But as long as you don't bother them, that's cool. But we bothered them."

Brian Jones: "Such psychic weaklings has Western civilization made of us all."

Bill Wyman: "I was a straight working-class type. I thought they were a bunch of layabouts but very dedicated to their music. That I could appreciate, but I couldn't appreciate the way they lived."

Charlie Watts: "You don't think I take this seriously, do you? It's just a rock-and-roll band."

The Seed of a Stone

Relaxing with friends in the Kent countryside, Basil Jagger (far left) keenly watches a spot of knot tying. Basil, or just plain "Joe" to those who knew him, was a PE teacher and a great exponent of basketball (predominantly perceived in the United Kingdom as being a women's sport). Jagger Senior's athletic talents were so well regarded that he was hired to train teachers to share their skills with disadvantaged communities around the globe. His wife, Eva, was an attentive Australian woman who tended with great pride to the family's modest dwelling on Denver Road in Dartford.

Dartford, notorious for its proliferation of car-manufacturing plants, would in later years have something more inspired to boast about: principally, one Michael Philip Jagger.

Mick: "My mum is very working-class, my father bourgeois, because he had a reasonably good education, so I came somewhere in between. Neither one nor the other."

1

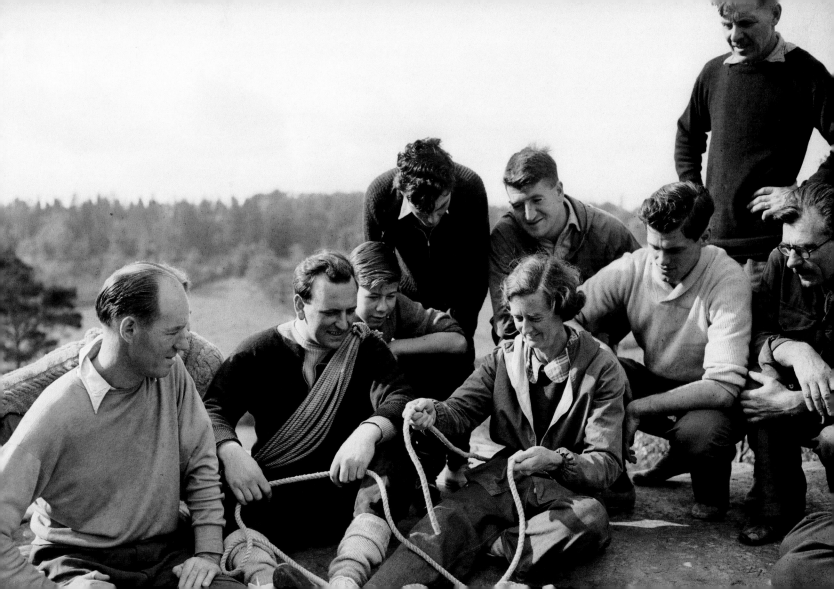

Mick Jagger: The Front Man

Say "the Rolling Stones," and you immediately think of Mick Jagger. While the question of who started the group may be under dispute, it is undoubtedly Jagger—by dint of his total commitment to his craft—who has become the life, soul, and embodiment of the band.

Born to Joe and Eva Jagger on July 26, 1943, in Dartford, Kent, Michael Jagger was distinguished in his early years by his academic prowess, and he easily passed his primary school exams for entry into grammar school. Outside of school—like many of his peers in the 1950s—Mick was intensely drawn to rock and roll, and he decided to form his first band, Little Boy Blue & the Blue Boys. Despite his early forays into the music scene, Mick kept up with his studies. Ultimately, his diligence resulted in acceptance to the London School of Economics, England's leading college for finance and social science. But being in London with a coterie of like-minded musicians meant that he was fast outgrowing the confines of his studies. Something had to give, so he decided to abandon economics for rock and roll.

Mick: "To me, I'm just an ordinary English bloke, same as everyone else."

2

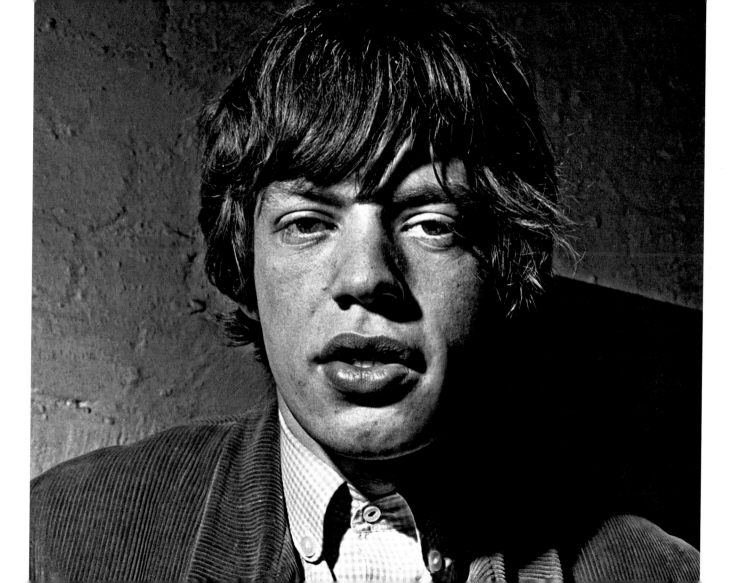

Keith Richards: Simply Keith

If ever there was a living personification of rock and roll, Keith Richards is it. Cool and hip, with a perpetual swagger, Richards set out a manifesto of anarchic intent from the Stones' inception. An only child born during wartime, Richards's working-class lineage couldn't have been more different from Mick's middle-class stock. Nonetheless, their lives converged at an early age across the sandboxes and playgrounds of Kent, and again—as if their destinies were inextricably linked—years later on a train during Jagger's tenure at the London School of Economics, when they picked up their relationship again. Richards soon moved to London, lured by the promise of fame and fortune and by the love of the blues that he and Mick shared.

Keith: "I never question myself or the Stones too closely; I've always done things on a very instinctive basis. I think brains have gotten in the way of too many things, especially something as basic as what we're doing."

3

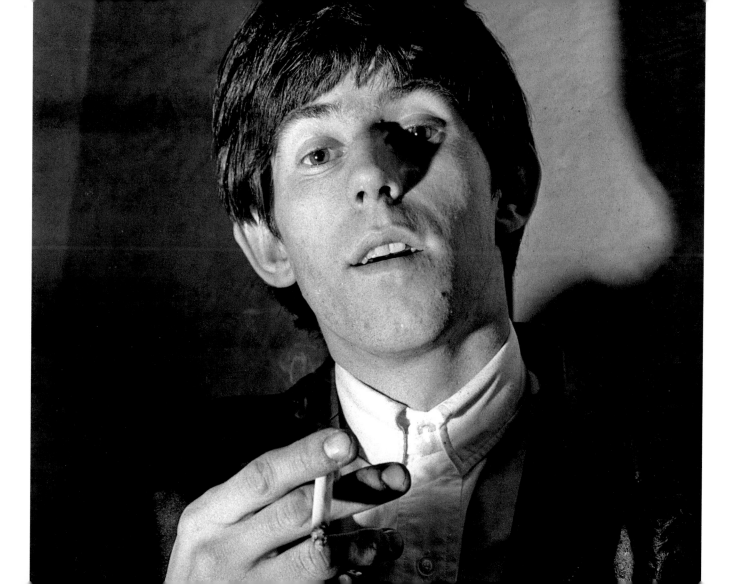

Brian Jones: The Troubled Adonis

The Rolling Stones' enigmatic chemistry was further bolstered by the presence of Brian Jones. Born Lewis Brian Hopkin-Jones in affluent Cheltenham, Gloucestershire, on February 28, 1942, Jones distinguished himself early on with his IQ of 135. At home, Brian quickly mastered the piano, none too difficult a task seeing as his mother was a music teacher. Soon he was proficient on clarinet and a range of other instruments to boot. The guitar ultimately captivated him, and he fully honed his musical prowess on the instrument.

At school, Jones was popular with his fellow pupils, and his good looks meant attention from admiring females. Jones was free with his affections as well, and after getting a couple of local girls pregnant he was singled out as a loose cannon in a district that prided itself on respectability. Jones split town and traveled throughout Europe as a street musician, living a bohemian lifestyle—something he took to with considerable ease.

Upon his return, Brian hobnobbed with local musicians and, high on the blues sounds he had been exposed to abroad, began to look for a permanent base to develop his interest in the genre. But another unwanted pregnancy in Cheltenham quickly sounded the death knell for his settling there, and he split for London, where he fell in effortlessly with the burgeoning music scene, and soon had his first meeting with Mick and Keith.

Brian: "Let's face it. Before we all got together, we were just a bunch of layabouts."

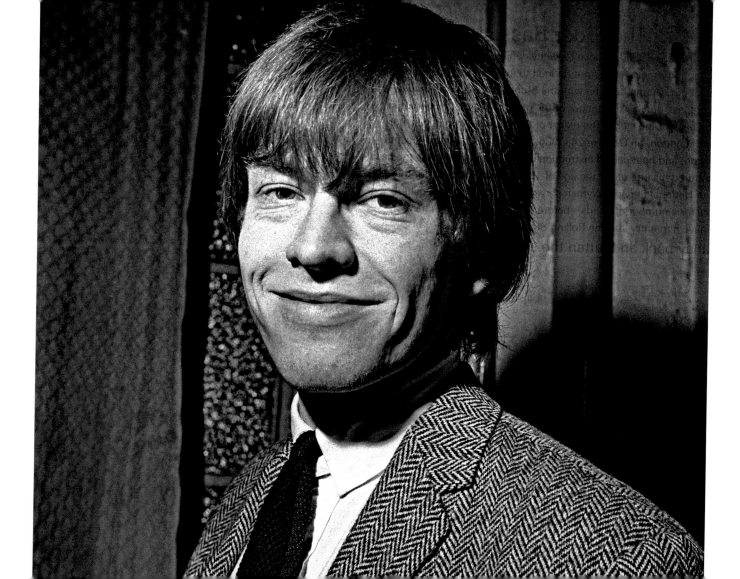

Bill Wyman: The Elder Bassist

The name William George Perks doesn't exactly conjure up images of rock-and-roll glamour and excess, so it's not difficult to imagine how the name Bill Wyman came about. During his time with the Stones, Wyman was marked by his unassuming bass duty as the anchor of the group—despite his perpetual loitering at the back of the stage. The oldest of the Stones, Wyman was born in Penge, South London, on October 24, 1936. His musical leanings became apparent early on, and he received instruction on the piano, but it was the bass guitar that captured his interest at the age of 13. After doing his bit for the last vestiges of National Service, Wyman served a musical apprenticeship—providing bass for a number of bands—before a chance meeting in a West London pub gave him entry into the Rolling Stones.

Bill: "I just lay back and fatten the sound."

5

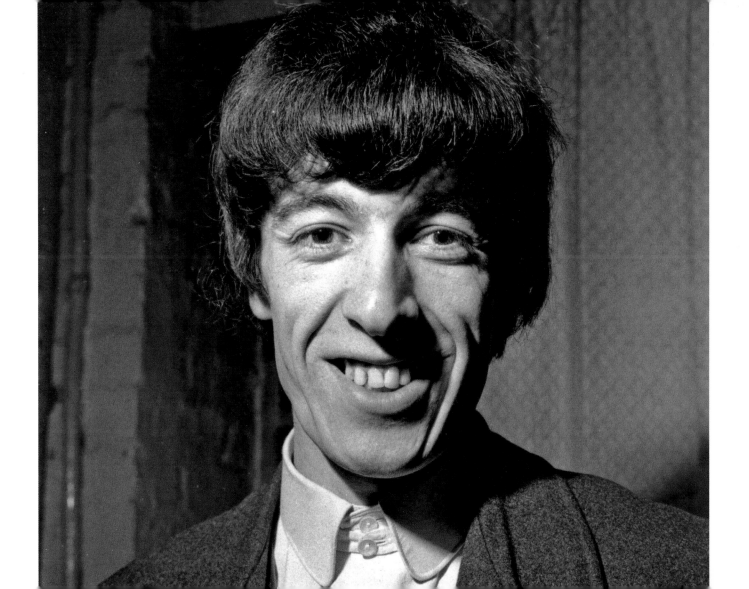

Charlie Watts: Supremely Rhythmic

If "enigma" seems an unlikely word to describe a rock-and-roll drummer, Charlie Watts nonetheless fits the bill. Shy, retiring, and not disposed to bouts of hotel room smashing or late-night carousing, Charlie Watts may not exactly be cut from the same cloth as most drummers, but that has never taken away from his reputation as a consistently strong skin pounder.

Born in the North London borough of Islington in 1941, Charlie exhibited artistic ability in his early years. In 1960, blues maestro Alexis Korner noticed Charlie while he was playing with an R & B quintet called Blues by Five. Korner immediately purloined him for his own band, Blues Incorporated. At that time, Korner's broad mix of musicians included Mick Jagger, Brian Jones, and Keith Richards; with Charlie Watts involved, things were set in place for the genesis of the Rolling Stones.

Charlie left for a brief period of time to pursue a career in graphic design, but that decision would quickly be reversed when, in 1962, he was cajoled into returning to the Stones, prompted by a long-term engagement at the Crawdaddy Club in Richmond. Despite the notoriety the group would soon acquire, Charlie would remain a quiet yet dedicated drummer, eschewing the controversy the Stones' image garnered.

Charlie: "Playing the drums was all I was ever interested in. The rest of it made me cringe."

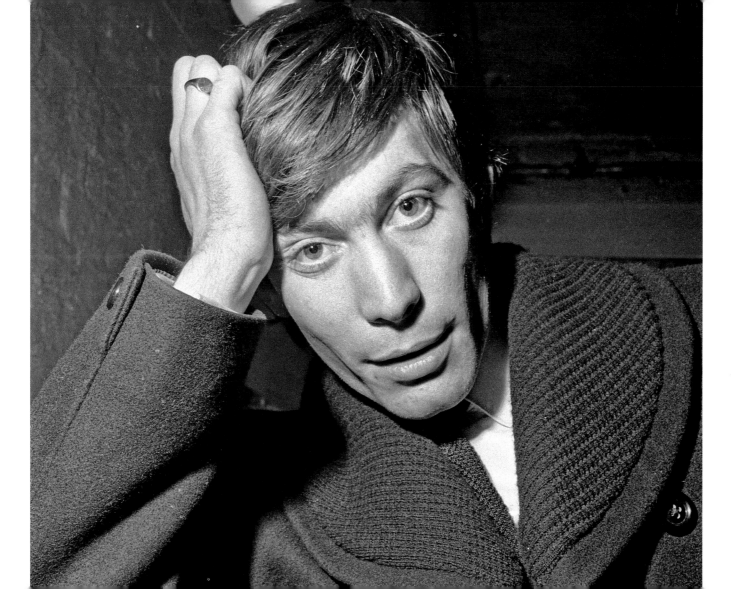

A Checkered Cast

An enthusiastic neophyte in 1963, Stones manager and mentor Andrew Loog Oldham at first cast the Stones in a variety of styles and fashions, all variations on the familiar look exhibited by other bands at the time. Despite an earlier misstep with leather waistcoats, Oldham later decked the boys out in these equally unflattering jackets, which similarly failed to ignite any interest.

Keith: "There are photographs of us in suits he [Oldham] put us in, those dogtooth checked suits with the black velvet collars.... For a month on the first tour we said, 'All right. We'll do it. You know the game. We'll try it out.' But then the Stones' thing started taking over. Charlie would leave his jacket in some dressing room and I'd pull mine out and there would be whiskey stains all over it or chocolate pudding."

7

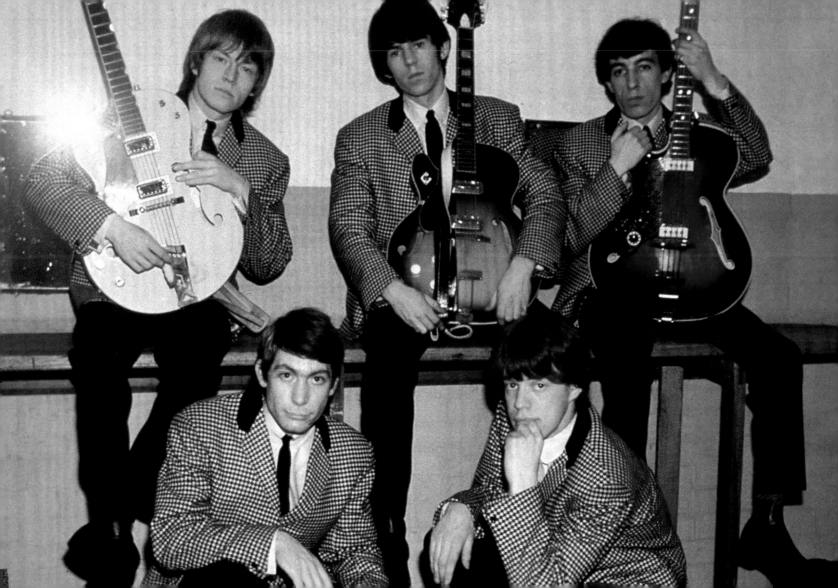

Rooftop Divas in the Making

The Beatles had set the precedent for the look of a pop group during 1963, and photos like these were typical re-creations of the Fab Four's "leap in the air" shots. The Stones happily acquiesced to this sort of promotional silliness early on in their career, but once their success was established, they resolutely avoided any such contrived photo sessions.

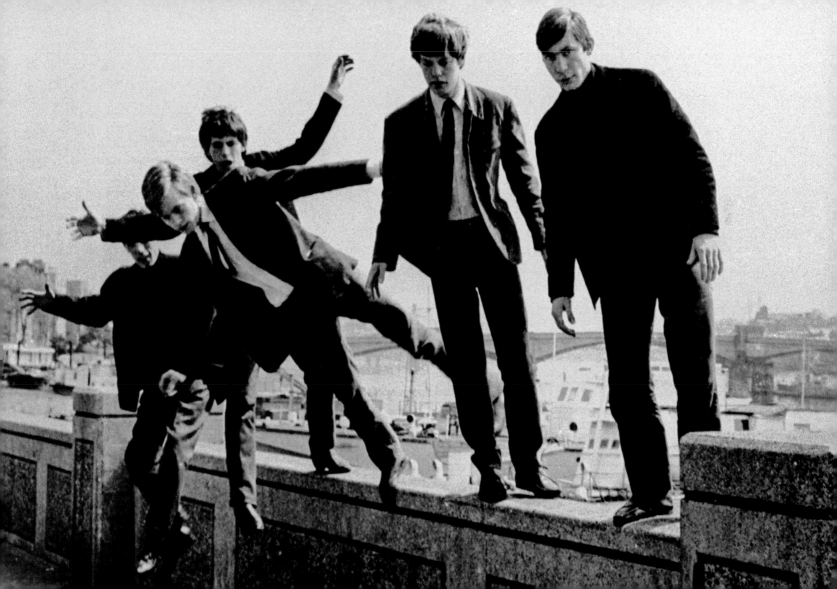

White Boys on Soul

Backstage, late 1963. Regardless of their rapidly growing status, none of the Stones, aside from Brian, was an exceptionally gifted musician—but this mattered little, as the coagulation of their various musical talents produced something quite startling, raw, and fresh. The group's twin guitarists, Brian and Keith, shared the onstage duties; Brian was more confident when it came to handling the lead breaks, and Keith seemed happy to provide the rhythm. But if the onstage chemistry among band members was cordial, elsewhere it was a different matter.

Keith: "Brian was a very weird cat. He was a little insecure. He wouldn't be able to make it with two other guys at one time and really get along well."

9

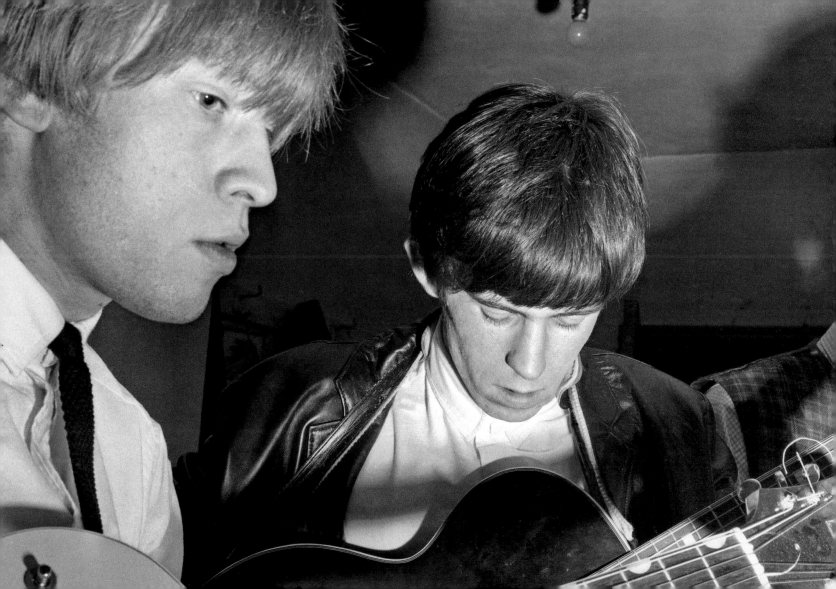

Backstage Tomfoolery

Brian, Bill, and Mick seem visibly amused at the sparse contents of their touring luggage. Along with the multitude of other problems that arose on tour, clean laundry was a constant worry for any group shuttling around on the pop touring caravan, especially when image was of paramount importance.

Keith: "There were things like having to wear the same sweaty shirts three nights running; is it two shirt sets or one long set? Or else Brian's hidden half the money from the gig under the carpet."

Getting It Together

In the early 1960s, touring defied all logic. Groups would usually have to share the bill with at least eight other acts and would find themselves crisscrossing the length and breadth of the United Kingdom, often giving two shows a night. The arrangements backstage were rudimentary at best, and dressing rooms would have to be shared by a legion of artists, all desperate for space. The Stones' rising fame had little bearing on the hospitality on offer at these shows, and the group would have to squeeze in with everyone else.

Keith: "You've gotta do it. That's the testing ground, in those ballrooms where it's really hard to play.... Being on the road every night, you can tell by the way the gigs are going, there's something enormous coming."

11

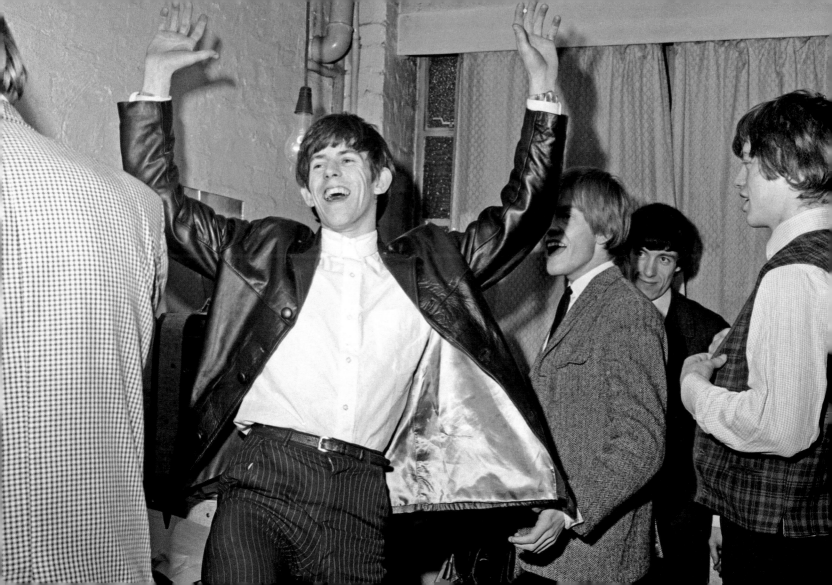

Stone Alone

It ain't all glamour at the beginning. Mick in the basement of Regent Sound Studios in December 1963. Any notion that early success would guarantee luxurious surroundings was soon dashed when the recording of the band's first album required the inglorious descent into the basements of Soho.

Keith: "We did our early records on a two-track Revox [tape machine] in a room insulated with egg cartons at Regent Sound. It was like a little demo in 'Tin Pan Alley,' as it used to be called. Denmark Street in Soho.... We used to think, 'Oh, this is a recording studio, huh? This is what they're like?' A tiny little back room. Under those primitive conditions it was easy to make the kind of sound we got on our first album and the early singles, but hard to make a much better one."

12

"You need a manager."

Andrew Loog Oldham casts a watchful eye over Keith and Brian during their first album recording sessions. Oldham was probably more influential than anyone else in the Rolling Stones' early career. Inspired by American producer supremo Phil Spector, Oldham came to the Stones' camp after working as an assistant to Beatles' Svengali, Brian Epstein.

Oldham played a multitude of roles for the Stones, but he principally directed his energies into promoting their image—something he instinctively detected had enormous mileage. Initially the arrangement worked well, but as fame gathered pace, the group's rapidly expanding egos would clash with Oldham's style of management. Nonetheless, early on there was a definite meeting of minds.

Andrew Loog Oldham: "The Stones and I gave each other confidence. A lot of it had to do with being the same age—same lack of experience and same passion for life. In many ways, I managed them less than I inspired them to become what they became."

13

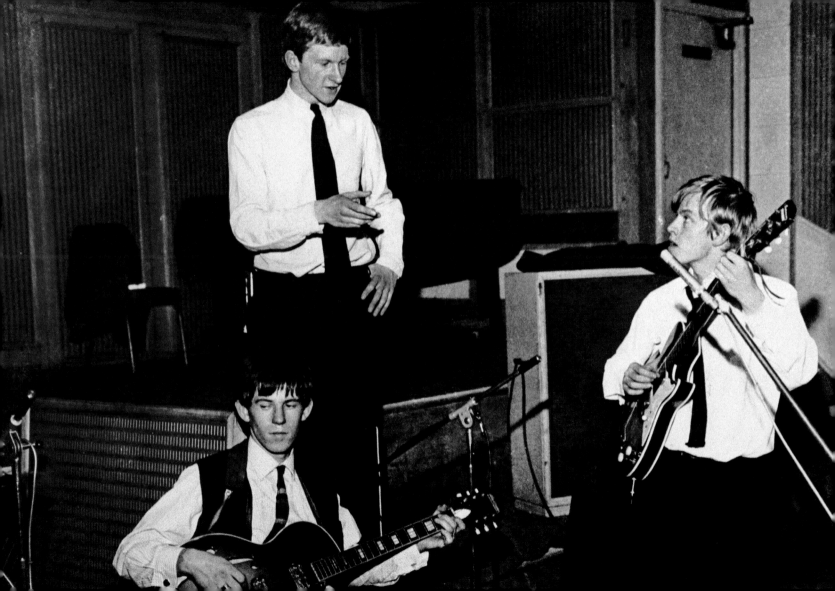

Rhythm-and-Blues Men

Brian and Keith give it their all during the Stones' first LP sessions in late 1963. Both happily acquiesced to the demands of being a Rolling Stone, and were buoyed along by the positive feedback from audiences from concert hall to ballroom. Brian perfectly complemented the ragged sound of the group, and his schooled musicianship was recognized and respected by his fellow players.

Keith: "In 1962, just when Mick and I were getting together, we read this little thing about a rhythm-and-blues club starting in Ealing. Alexis Korner really got this scene together. He'd been playing in jazz clubs for ages, and he knew all the connections for gigs. So we went up there. The first or the second time Mick and I were sitting there Alexis Korner gets up and says, 'We got a guest to play some guitar. He comes from Cheltenham. All the way up from Cheltenham just to play for ya.' And it's Brian, playing bar slide guitar.... He's really fantastic."

14

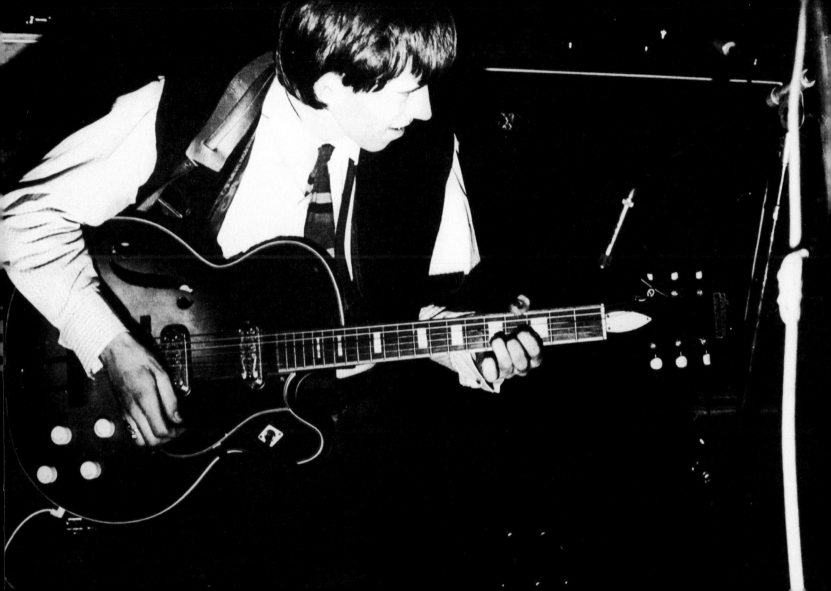

Posturing

The Stones mug for Terry O'Neill's camera outside Soho's Tin Pan Alley Club in early 1964. Any group worth their salt would make frequent trips to London's Denmark Street to visit the many shops selling musical equipment and the agents' and publishers' offices scattered along the narrow road. The Stones' first album sessions were cut at the primitive Regent Sound Studios, 4 Denmark Street—conveniently situated nearby Europe's publishing center.

Andrew Loog Oldham: "We did the first album in about ten days. We'd decide to do a tune, but Mick wouldn't know the words, so Mick would run around to Denmark Street to Carlin Music to pick up the words to something like 'Can I Get a Witness?' He'd come back 25 minutes later and we'd start."

15

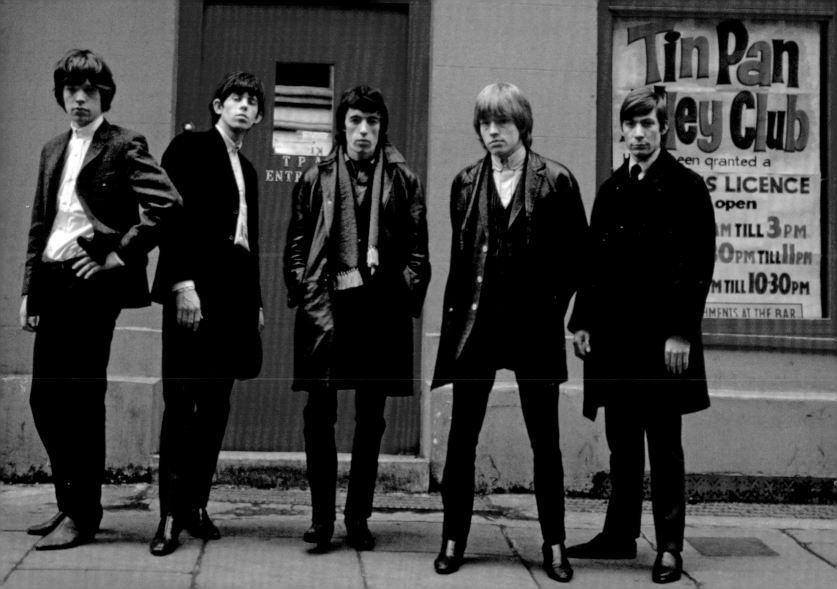

Mean, Moody, and Magnificent

In the midst of a 21-date UK tour, the Stones shuffle onto the steps outside St. George's Church in London's Hanover Square on January 17, 1964. The group found themselves in the uncomfortable position of scheduling studio time around their live commitments, which ultimately saw them recording by day and performing by night. The first album was cut in a short time span, and the crude equipment ironically helped produce a sound that was reflective of the raw energy the band was concocting onstage.

Bill: "On the first album, we cut everything in mono. The band had to record more or less live in the studio, so what was on our record was more or less our act, what we played on the ballroom and club circuits. It was really just the show you did onstage, recorded in one take—as it should be."

16

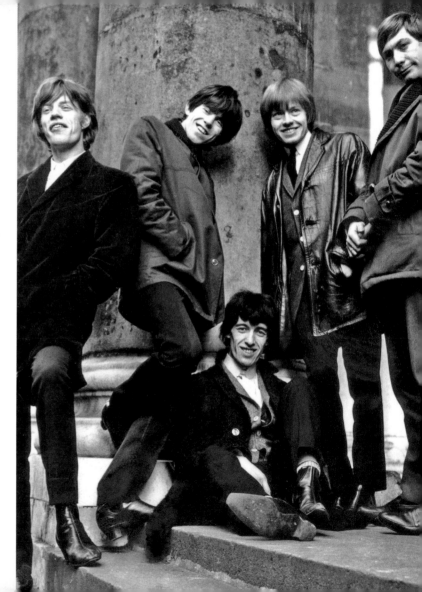

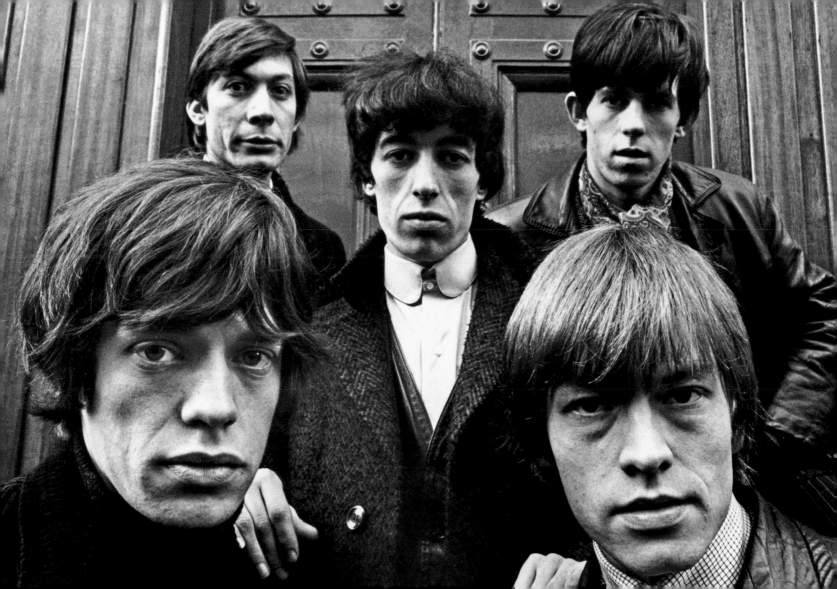

Got Live If You Want It

A classic Jagger pose, early 1964. Prior to the mass-communication explosion, the infant pop-music genre had precious few vehicles for relaying new sounds to new audiences. British radio in particular was limited to only a handful of shows specializing in the "new wave," so touring was obligatory. Onstage—without the benefit of monitor speakers, and backed only by minimal amplification—singers would literally have to scream into the microphone.

The Stones' mean and moody image, both onstage and off, reinforced their no-nonsense attitude. However, during January 1964 (and more likely at the insistence of Andrew Loog Oldham) the group momentarily relaxed their standards to provide the music for a Rice Krispies television commercial. The lyrics—including Mick singing the memorable lines, "Pour on the milk-a-licious to the crackle of that rice"—were accompanied by a pastiche of images mimicking the UK television show *Juke Box Jury.*

17

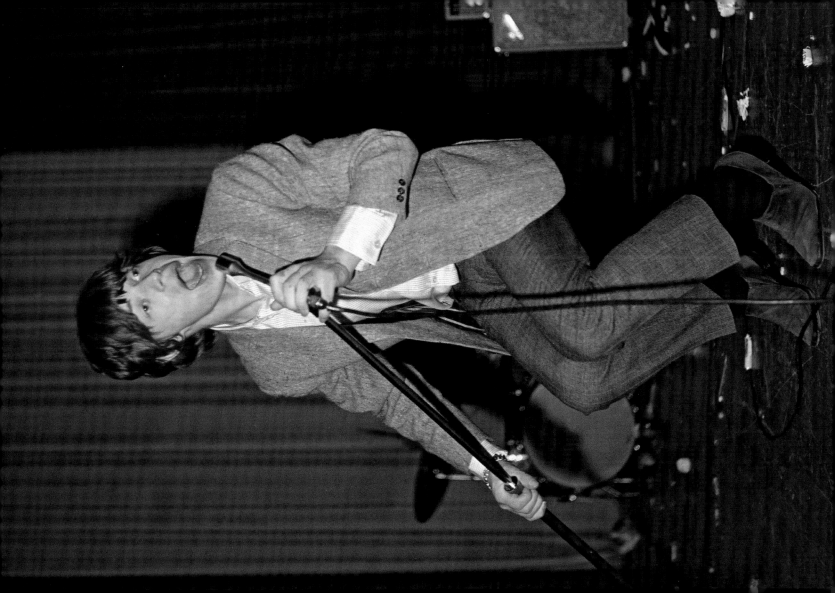

Early Signs of Glimmer

Mick and Keith sort through some fan mail backstage in 1964. The pair's unstinting loyalty to the band ensured, despite personality differences, a healthy respect for each other's talents and understanding of each other's failings. Their self-proclaimed moniker for their enduring partnership was the Glimmer Twins, a label they would sometimes use when coproducing the Stones' recordings.

Keith: "We used to see the same couple in the bar, who kept saying to us, 'Who are you? What's it all about? Come on, give us a clue. Just give us a glimmer.' That's when Mick and I started to call ourselves the Glimmer Twins."

18

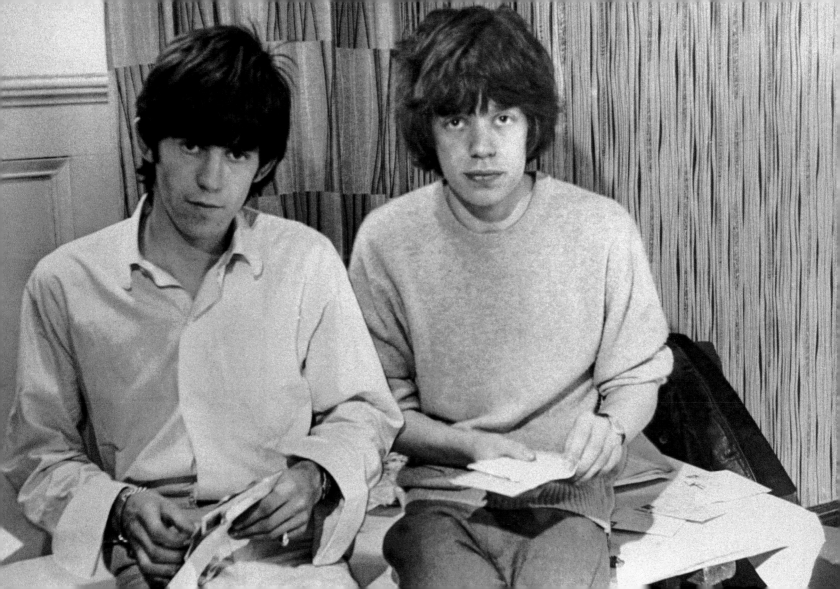

The Road to Glory Is Paved...

Given the size of the stadiums the Rolling Stones play nowadays, it is easy to forget that back in the early years many months were spent trekking up and down the length of the United Kingdom to promote their sound. This early 1964 shot from a gig somewhere in the hinterlands of Britain pays testament to that fact. Security was starting to become important, though more often than not it was to protect the venue from wreckage rather than to protect the artists from rampaging fans. At this gig, the local football team doubled as stewards.

The group maintained a hectic touring schedule, and the band members were slowly being worn down by the constant environmental and cultural changes they experienced on the road.

Mick: "I don't like touring at the best of times. I'll be glad when it's all over. I don't like the provinces. You can't eat and you can't get clean shirts."

19

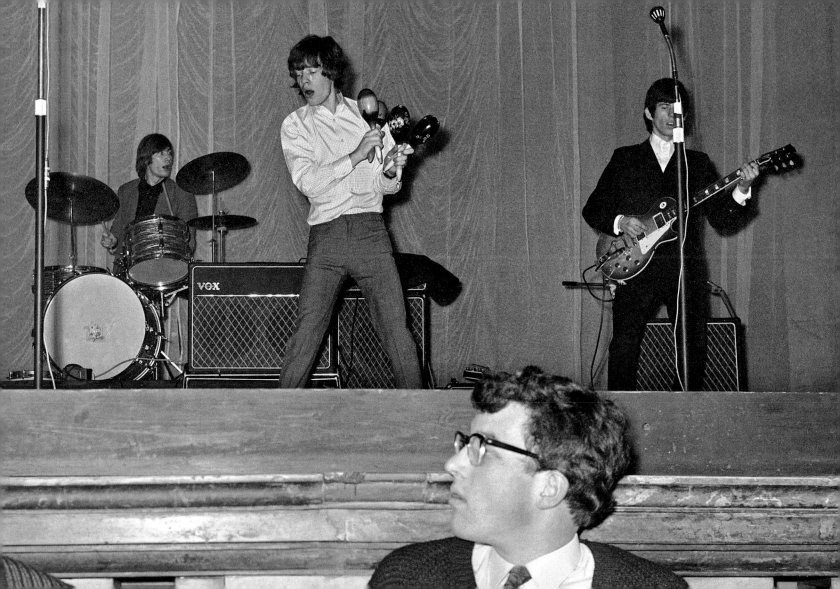

The King Keeps Watch

The presence of Andrew Loog Oldham dominates the room while an image of Elvis Presley keeps a cautionary watch over drummer Charlie Watts. One key to Oldham's initial success was that he established himself as being on the same level as the band. Whereas Brian Epstein stood aloof from the Beatles, Oldham was for all intents and purposes a true Rolling Stone and was totally in tune with the group's mind-set. With his brilliant vision he was able to perceive the appeal of the Stones as something far beyond that of the typical 1960s band.

Andrew Loog Oldham: "The Rolling Stones are more than just a group—they're a way of life."

20

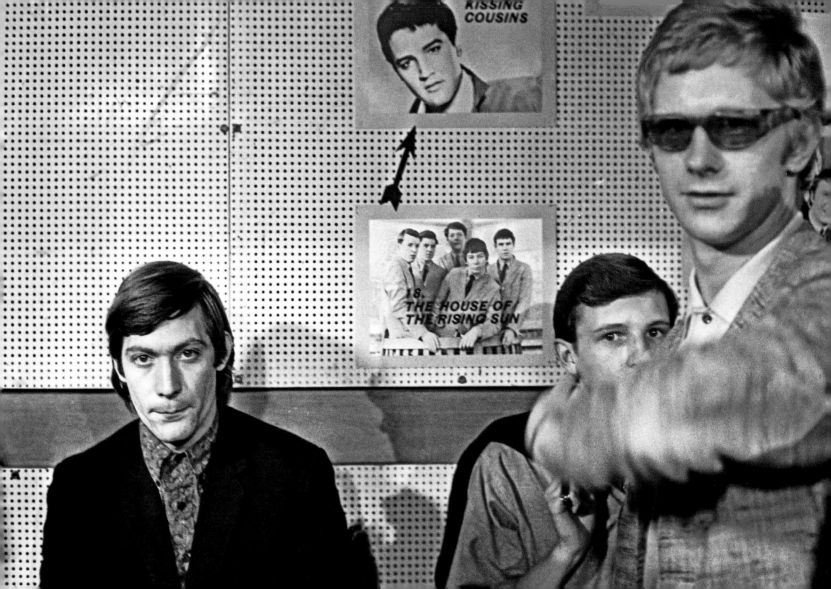

"The weekend starts here!"

A *Ready Steady Go!* appearance. Back in 1963 manager Andrew Loog Oldham had to hustle to get the Stones any cathode-ray coverage, but by 1964 demand for the group to perform on television was enormous. Keenly aware that the hippest music show on television was *Ready Steady Go!*, Oldham arranged for the group to appear on the show a staggering eight times that year. No mean feat, when the Beatles could manage only two dates. This February 14 appearance was to promote the Stones' latest single (and first album highlight) "Not Fade Away."

21

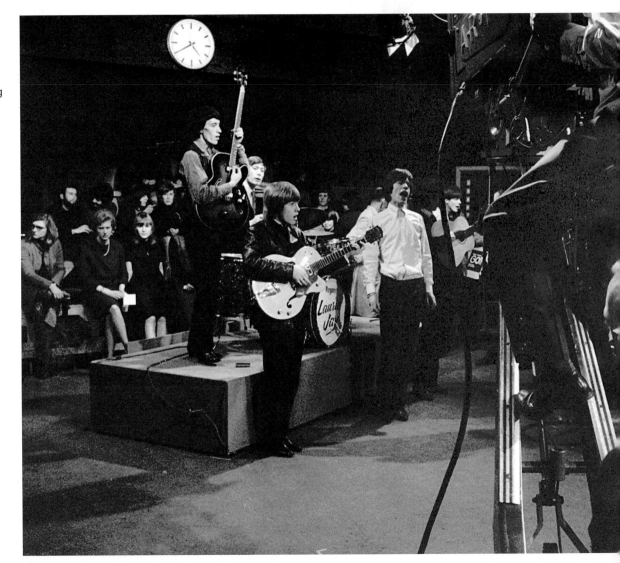

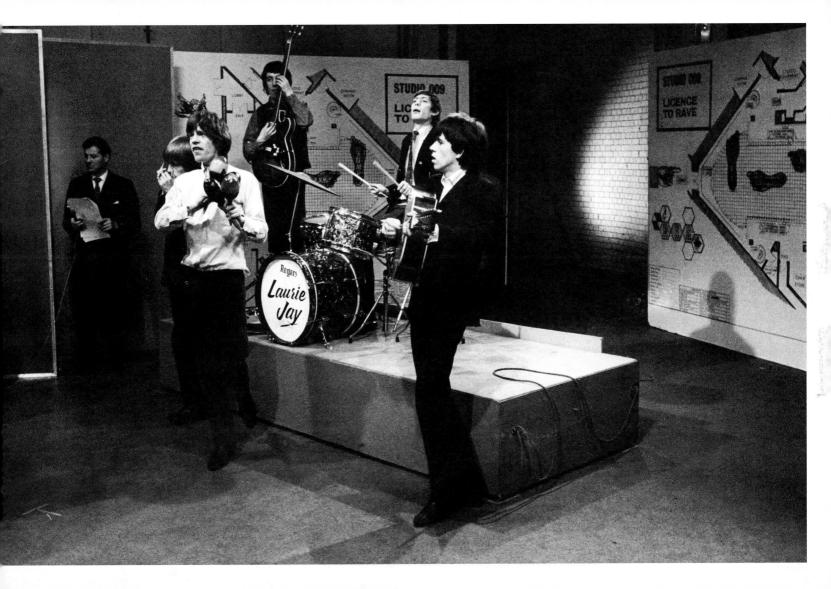

Ready Steady Mick!

Again promoting "Not Fade Away" on *Ready Steady Go!* in March 1964, Mick glances somewhat nervously at the camera. Broadcast from Kingsway, a thoroughfare just outside London's West End, the show was the most influential of all the early 1960s UK pop shows. It ran from August 1963 to December 1966, when the Beat Boom generation was giving way to psychedelia. The Stones appeared numerous times during the show's run and even headlined an exclusive live edition in 1966.

22

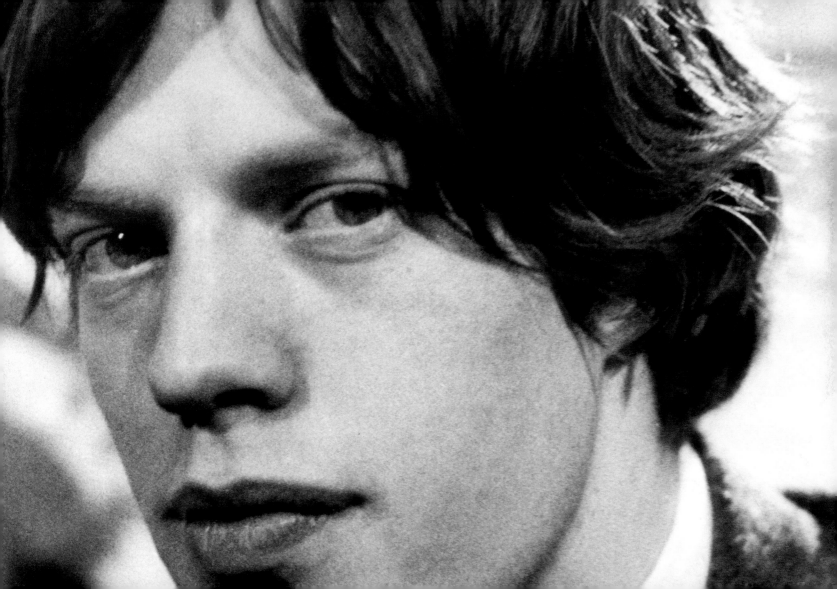

Lost in Thought

Charlie appears to be deep in thought as he ponders the intricacies of the guitar. Watts had, by 1964, quietly and diligently proved himself to be one of the most competent drummers on the scene. His inventive and imaginative delivery was in no small part due to his obsession with jazz, an interest that brought him much respect from his peers.

23

Leaving on a Jet Plane

All smiles, Charlie, Mick, and Keith face the press at London Heathrow Airport on June 1, 1964, before taking off for their first tour of the States. It should be remembered that the Beatles' invasion of America earlier that year opened the doors to all British bands. Naturally, the Stones were keen to travel across the Atlantic in search of similar fame and fortune. This first tour was more of an introductory jaunt, with a handful of concerts mixed in with a plethora of press and TV commitments. Naturally, the highlight of the visit was the band's two concerts at New York's Carnegie Hall. The hall's guardians had harbored some doubts about the Beatles' appearance there in February 1964, but that had passed off well. The Stones' appearance was to be a different kettle of fish.

Sid Bernstein (promoter): "The Rolling Stones' crowd was different. They had never had a rock-and-roll concert at Carnegie Hall prior to the Beatles, and that went very well, but the Stones' crowd got them nervous. The kids didn't do any damage, but they were older and more excited, so the people at Carnegie Hall asked me not to come back."

24

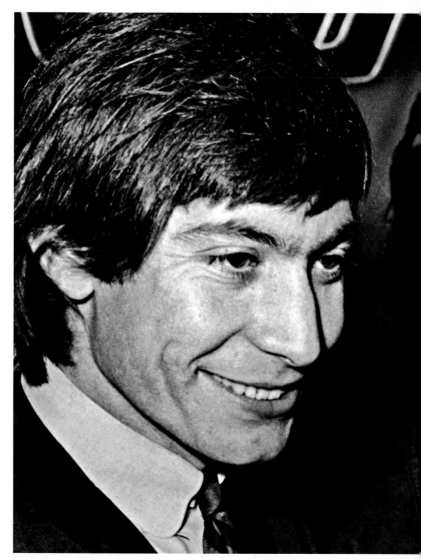

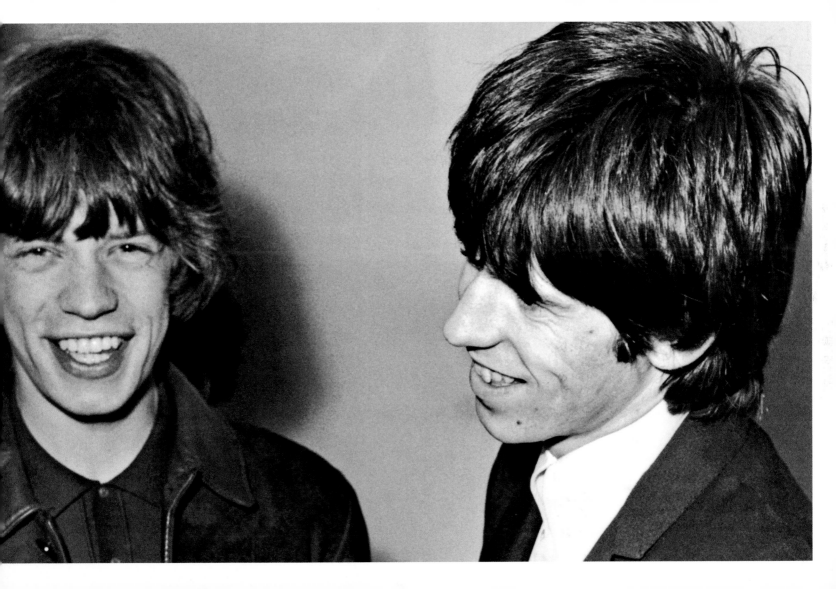

Press Call

June 2, 1964. The Stones mount the dais in the press reception room on arrival at JFK for the start of their first U.S. tour. Seeing as Charlie's birthday coincided with their arrival, the welcoming gifts poured in and included a birthday cake. The savvy New York press was eager to quiz these new pretenders to the Beatles' throne, especially given that the Stones' first album had unseated the Beatles from the top spot in the UK charts. The Stones had yet to make any great musical impact in America, although their image definitely preceded them.

New York Times: "Another British singing group, this one a rock-and-roll quintet called the Rolling Stones, arrived in New York by plane yesterday. The young men with shoulder-length haircuts were greeted at Kennedy International Airport by about five hundred teenage girls. About fifty Port Authority and New York City policemen were on hand to maintain order."

25

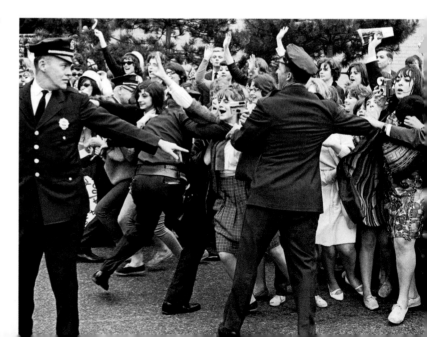

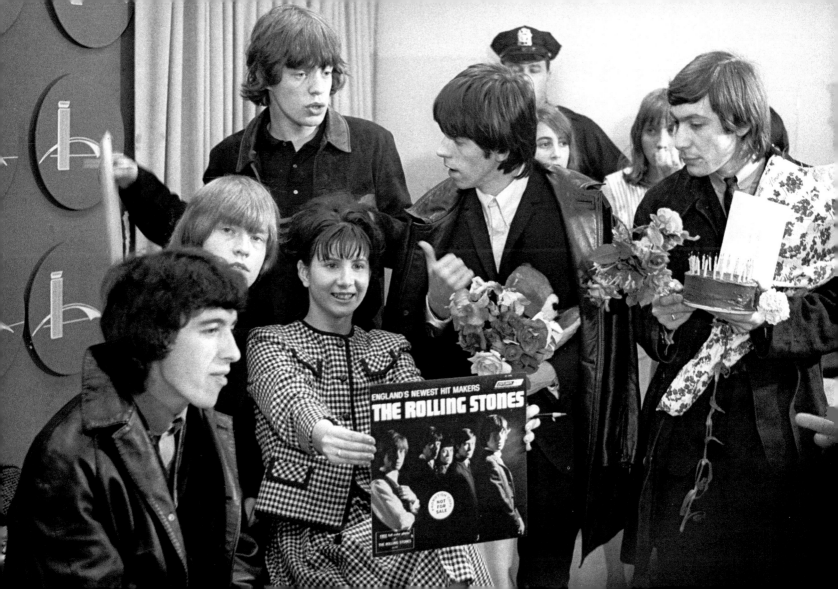

Arrival!

The Stones' arrival in New York brought the predictable scenes of chaos New Yorkers had come to expect from British groups landing at JFK. The press had whipped teenagers into an uncontrollable frenzy prior to the Stones' June visit, and the accompanying press releases contributed to the hysteria on the streets.

Associated Press: "In the tracks of the Beatles, a second wave of sheepdog-looking, angry-acting, guitar-playing Britons is on the way. They call themselves the Rolling Stones and they're due in New York Tuesday. Of the Rolling Stones, one detractor has said: 'They are dirtier and are streakier and more dishevelled than the Beatles, and in some places, they're more popular than the Beatles.'"

26

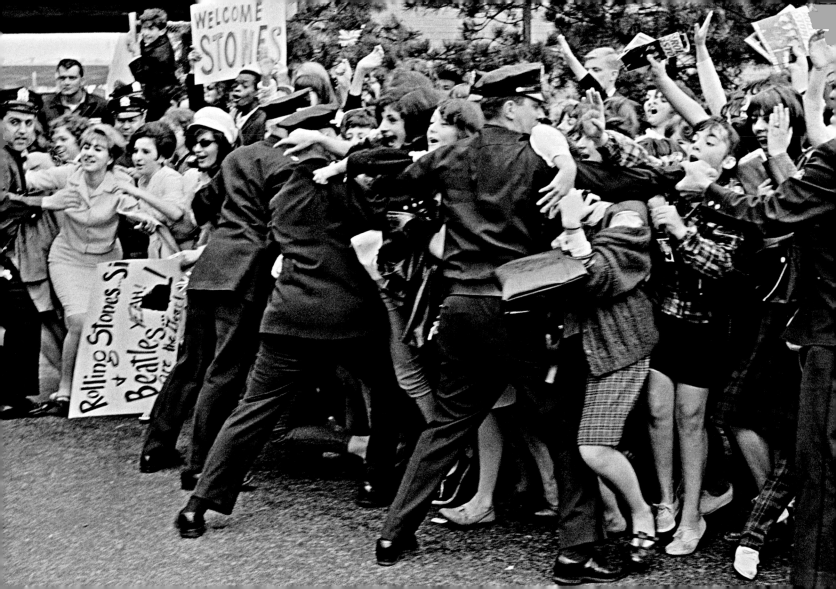

Run for Your Life

With the aid of the NYPD, Brian and the other Stones are forced to run the gauntlet of rabid New York fans as they exit JFK airport after their press reception on June 2, 1964.

Whereas the media reports in the United Kingdom were balanced equally between the group's musical ability and their reputation, the press in the States preceding the group's first U.S. visit was hardly flattering and was designed mainly to stir up controversy lest the music didn't score a hit.

Vogue: "For the British, the Stones have a perverse, unsettling sex appeal, with Jagger out in front.... To women, Jagger looks fascinating, to men, a scare."

27

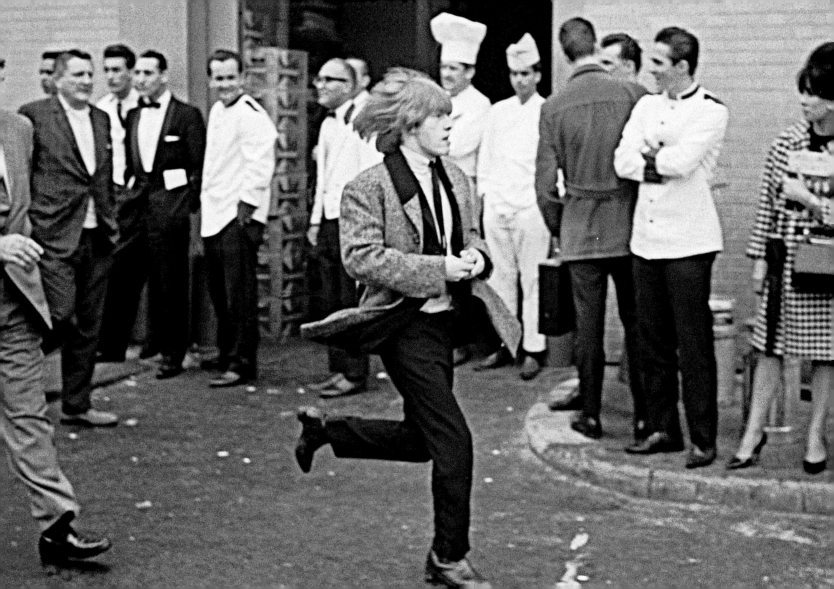

Waiting to Take on the World

The Stones take a breather between concert and TV appearances, June 17, 1964. Whereas the tabloids had made up their minds about the bad-boy Stones, the music press was somewhat more generous in their appraisal. As would become the norm in the decades to come, a build up of anticipation preceded the release of any new musical offering from the group.

Record Mirror: "Yes, it's the Rolling Stones, the London lads with the long hair and the pounding R & B music. Good news is that an LP is currently being cut by the boys. Some of the titles on the LP are, provisionally, *Carol*, the old Chuck Berry number; *Mona*, a Bo Diddley number; and another big 'live' favourite, *Route 66*. Two of the boys, Mick Jagger and Keith Richards, are also having a close look at the U.S. charts. The reason? Gene Pitney's *That Girl Belongs to Yesterday* was penned by them, and the good news is that it enters the Cashbox Top 100 this week."

28

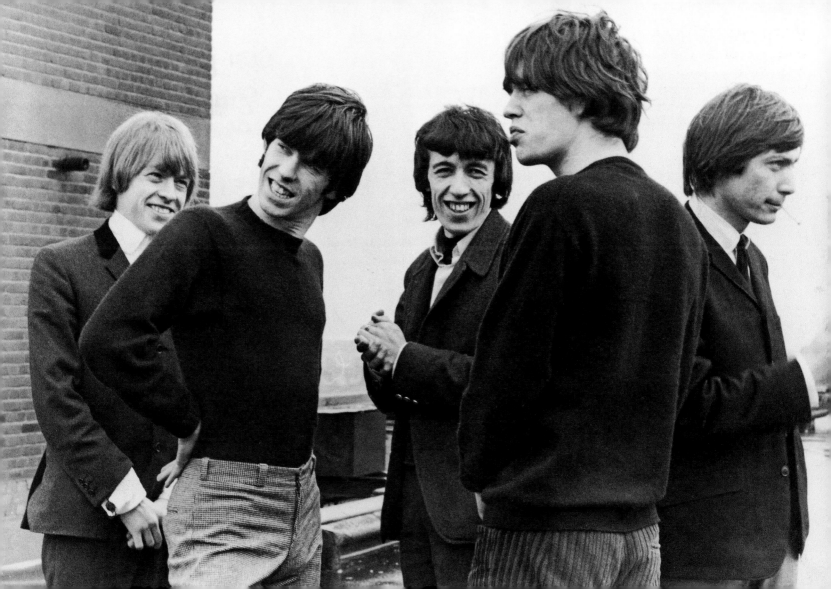

In Conversation

Back in New York for a couple of shows at Carnegie Hall, June 20, 1964. The Stones' first tour of the United States allowed for shows mixed in with promotional television and radio work. The high point for the band was the chance to record at the legendary Chess studios in Chicago. They also met with some of their inspirations: Chuck Berry, Buddy Guy, and their all-time hero, Muddy Waters—who had, on that occasion, been relegated to an unexpected position in the studio hierarchy.

Keith: "I have several memories of Muddy Waters. The weirdest one is when we first went into Chess studios in '64. As we walked by into the studio, somebody said, 'Oh, by the way, this is Muddy Waters, and he's painting the ceiling.' He wasn't selling records at the time, and this is the way he got treated.... I'm dying, right? I get to meet the Man—he's my fucking god, right?—and he's painting the ceiling! And I'm gonna work in his studios. Ouch! Oh, this is the record business, right?... Bless him."

29

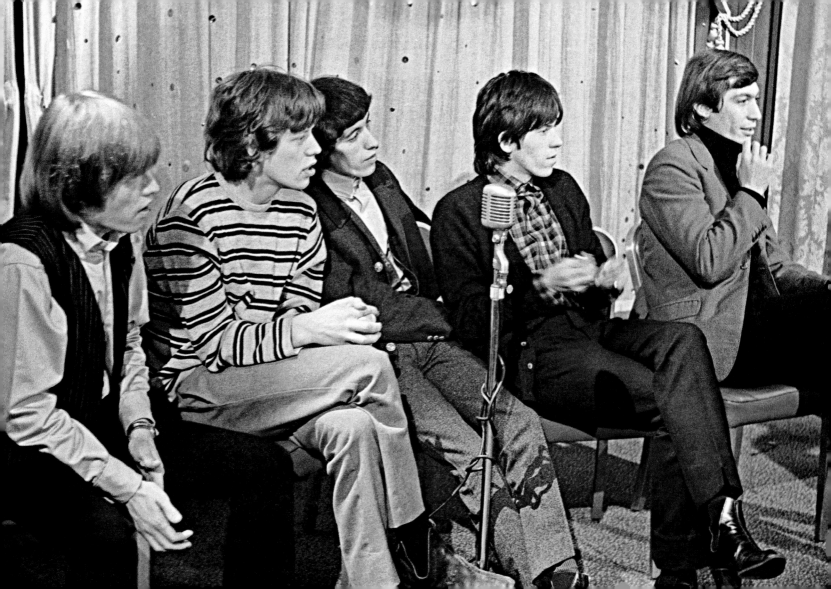

Let Loose on Times Square

At the end of the first U.S. tour, the group returned to New York for two sell-out concerts at Carnegie Hall. Between showtimes on June 20, 1964, the Stones ventured out near Times Square to meet photographers and a gaggle of fans. The mood around West 45th Street was cordial enough, and the grins seem to reveal a contented group of musicians.

Keith: "America was still very much into Frankie Avalon. There wasn't any thought of long-haired kids; we were just entertainment-business freaks with long hair, just like a circus show."

30

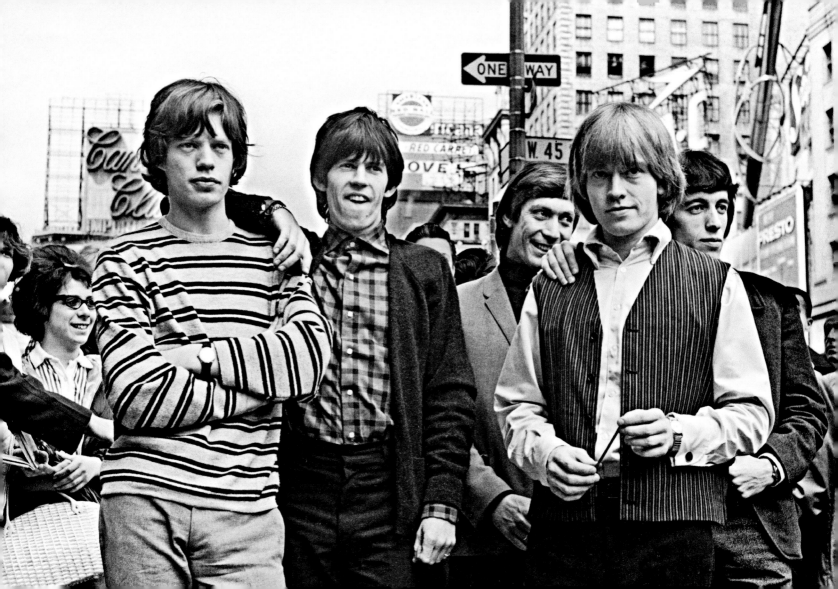

Signing Session

The fans around West 45th Street on June 20 were able to penetrate the modest security to secure some prized autographs from the Stones prior to their Carnegie Hall concerts. Here, Keith signs a fan's Pop Profile magazine. For most of 1964, the American music scene had to give way and reinvent itself in the face of the British Invasion.

31

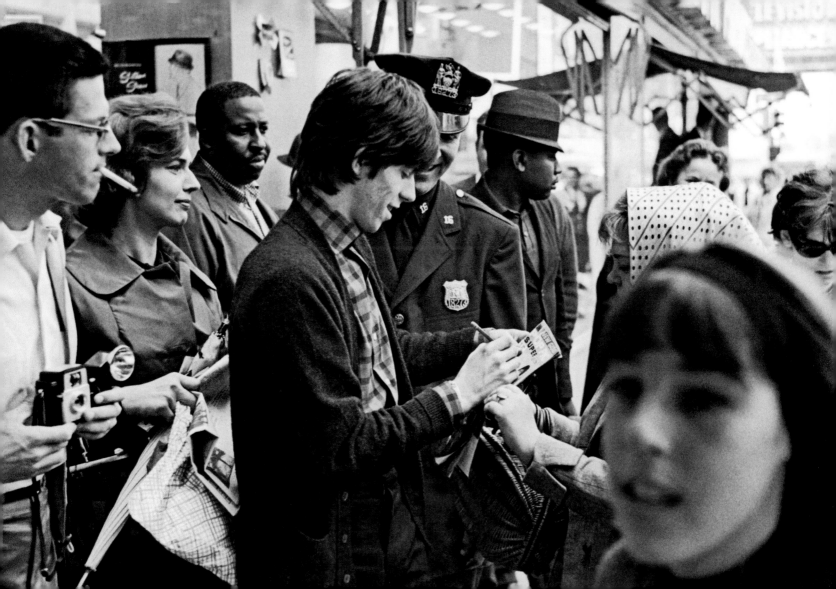

Innocence at Home

Marianne Faithfull, age 16, along with a coterie of friends, looking through some records in her mother's small terraced house in Reading. The demure and waiflike princess was drawn like a moth to the flame of celebrity. Marianne's world first collided with the Stones when she encountered Mick Jagger at a party in London in March 1964.

Born Marianne Evelyn Gabriel Faithfull on December 29, 1946, she was rooted by birth in the higher echelons of Britain's middle class. Her father, Glynn, was a major in Britain's intelligence service, M16, and her mother, Eva, was a dancer who hailed from Austro-Hungarian nobility. Eva's family's name, von Sacher-Masochs, carried with it some notoriety, as Eva's great uncle had written *Venus um Pelz*, a book that coined the term "masochism." Although in hindsight it seems rather ironic, Faithfull's school days were indeed served in a Roman Catholic convent. Marianne was still at school studying for her A levels when fame knocked at her door. Needless to say, her transition from St. John's Convent School to the pop world totally disrupted her family life, even prompting her brother Chris, then a student at Brighton Art College, to give a speech denouncing pop music.

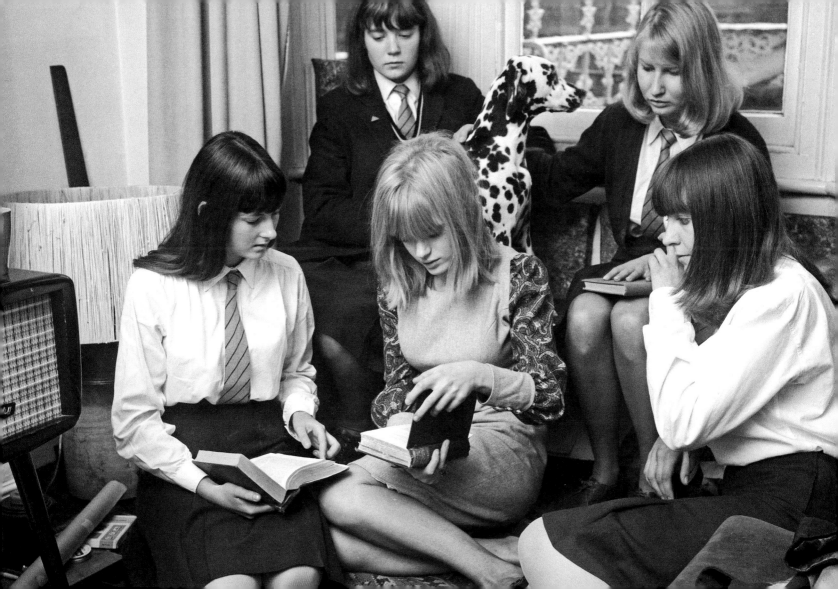

I Sit and Watch

Marianne Faithfull's first foray into the world that would enthrall and ultimately overwhelm her came in 1964 when Andrew Loog Oldham encountered her subtle charms in a London coffee bar. She was soon contracted to Oldham's ever-growing roster of London-based blues and soul musicians, and began recording for Decca—the Rolling Stones' label. After recording the Stones' song "As Tears Go By," her career took off. Originally, "As Tears Go By" was pitched as the B-side to Marianne's first single. Mick and Keith had written the song in answer to Andrew Loog Oldham's pleas to write a song that had a commercial sound, as opposed to their usual R & B fare. Contrary to popular belief, the song was not written with Marianne in mind, but it was she who made it a hit. At right she's posing at home in Reading underneath an old portrait with her Dalmatian, Sarah.

Andrew Loog Oldham: "At a time when most chicks were shaking ass and coming on strong, here was this pale, blond, retiring, chaste teenager looking like the Mona Lisa, except with a great body."

33

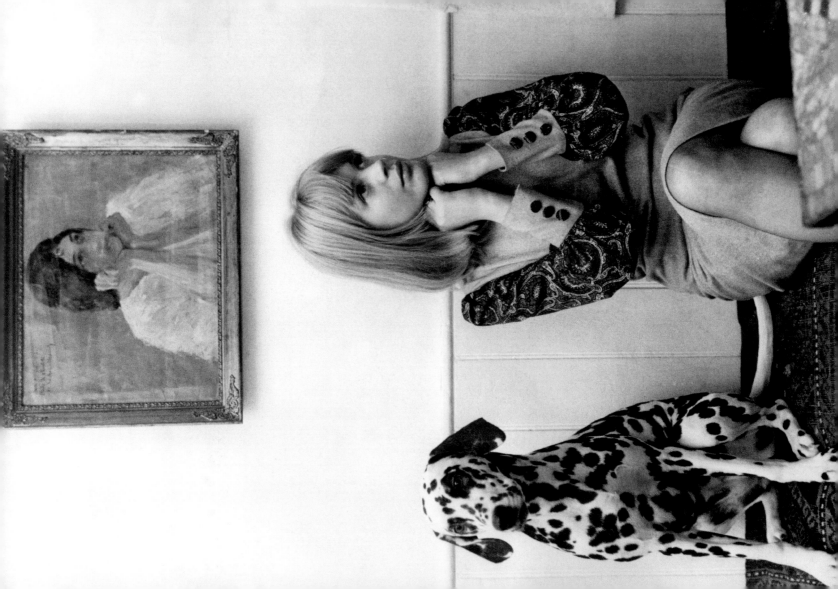

Ballroom Blitz

During another ballroom date in July 1964, Brian lets rip on the harmonica as Mick keeps time with his trademark maracas. With the room's heavy drapes deadening the sound, the Stones were fighting a losing battle to hear themselves. By now the group's reputation had spread far and wide, and fans were coming to expect more than just music: they wanted some action. It ended up being an eventful night.

Keith: "We'd walk into some of those places and it was like they had the Battle of Crimea going on: people gasping, tits hanging out, chicks choking, nurses running round with ambulances.... There was one ballroom number in Blackpool during Scots week when all the Scots came down and got really drunk and let it rip. A whole gang of them came to this ballroom, and they didn't like us and they punched their way to the front, right through the whole 7,000 people, straight to the stage, and started spitting at us. In those days, I had a temper, and—'You spit on me?'—I kicked his face in."

34

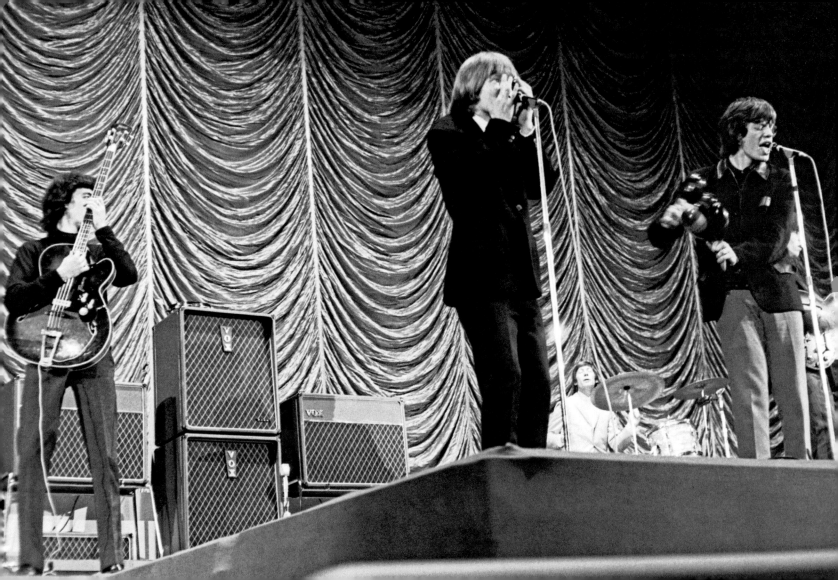

The Spiral Staircase

One of the features of the top-rated *Ready Steady Go!* was the spiral staircase that allowed divas to descend (or ascend, for that matter) while crooning their latest hit. The Stones' choreography precluded any such pretensions. All that was needed was a dais for drummer Charlie and enough space for Mick to strut his stuff. The July 23 show offered the Stones the chance to promote their new single "It's All Over Now"; Marianne Faithfull also turned up on the bill with her single "As Tears Go By."

Mick: "I wrote the lyrics [for "As Tears Go By"], and Keith wrote the melody. It's a very melancholy song for a 21-year-old to write.... you know, it's like a metaphor for being old: You're watching children playing and realizing you're not a child."

35

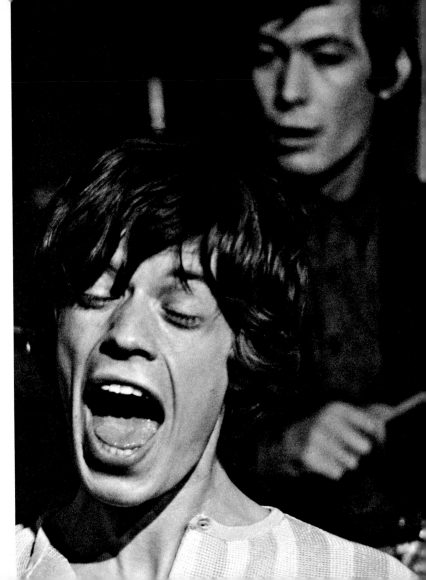

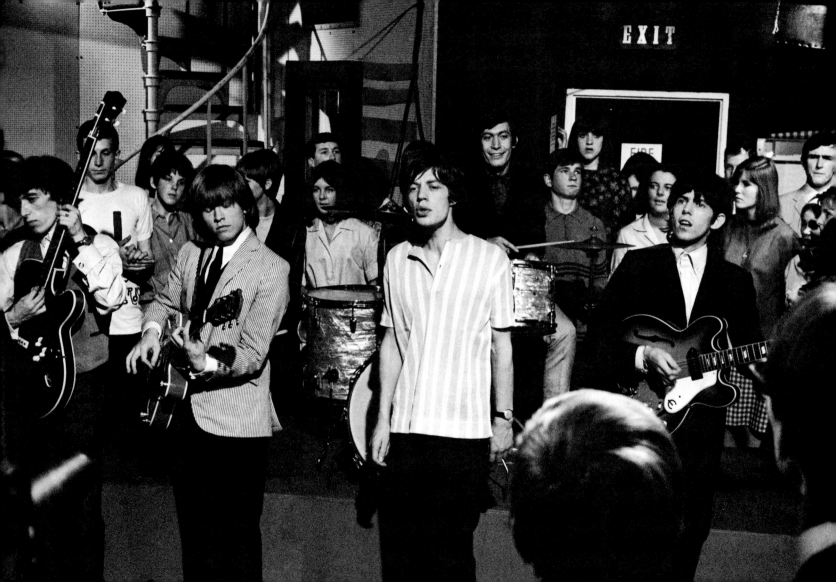

From a Window

Mick poses for cameraman Terry O'Neill as fans try to catch a glimpse of him through the frosted panes at the studio where *Ready Steady Go!* was being filmed.

It was always Mick who grabbed the lion's share of attention from photographers, partly because he was the charismatic front man, partly because the camera couldn't get enough of his intriguing features. And with Mick's involvement in all aspects of the Stones' publicity machine, it wasn't surprising that his visage led the majority of features about the group.

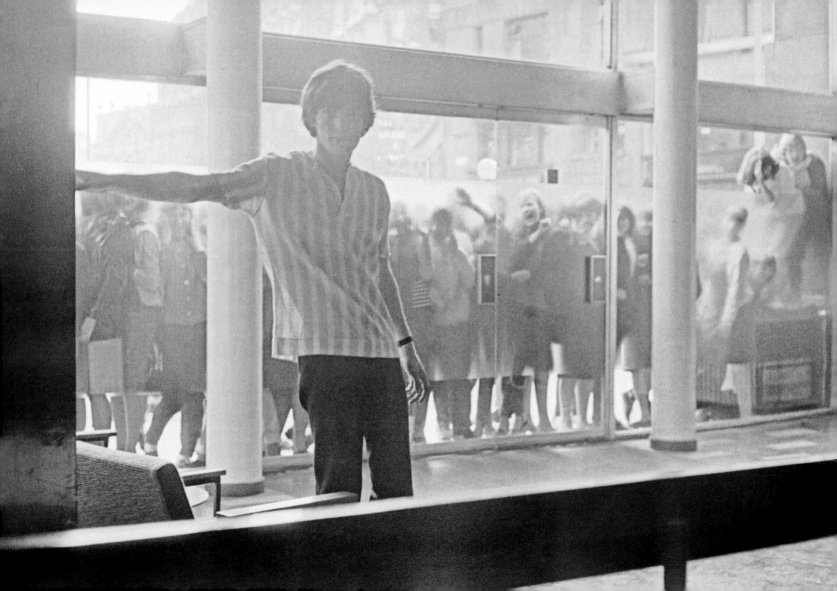

Out of the In Crowd

Brian Jones caught between dancers on *Ready Steady Go!* on July 23, 1964. With the immense amount of coverage Jagger was receiving, Jones was experiencing some difficulty defining his own role in the group. Granted, his musical prowess was respected and his angelic good looks had won him a great deal of attention from both sexes—but behind the fringe and sweet smile lay intense conflict.

Bill: "Brian was one of those people that is a bit of a hypochondriac and also a bit of a worrier. He was highly intelligent, very articulate. But he was sort of on the edge all the time. He could be the sweetest, softest, most considerate man in the world and the nastiest piece of work you've ever met. Opposites all the time. He'd flit from one to the other. He wouldn't give a shit for anything and then he'd worry about the slightest detail."

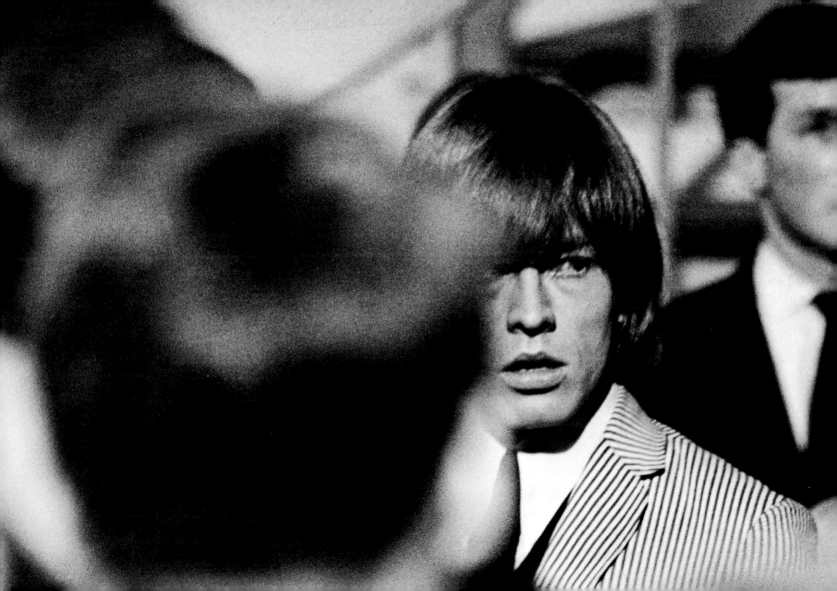

Wimbledon Palais Welcomes
the Rolling Stones!

It's all too much! A commissioner and security guard assist as a young girl finds the Stones' presence too hot to handle. The Stones' appearance at the Palais on January 24, 1964, was a typically rowdy affair, and the guardians of the club were taking no chances with their precious ballroom floor—they had it covered over well before the legions of Stones' fans made their way into the building. The venue most famously hosted the Beatles the year before during a fan club convention where fans were effectively caged in for the concert. (These days the former ballroom is serving its time as a carpet showroom.)

38

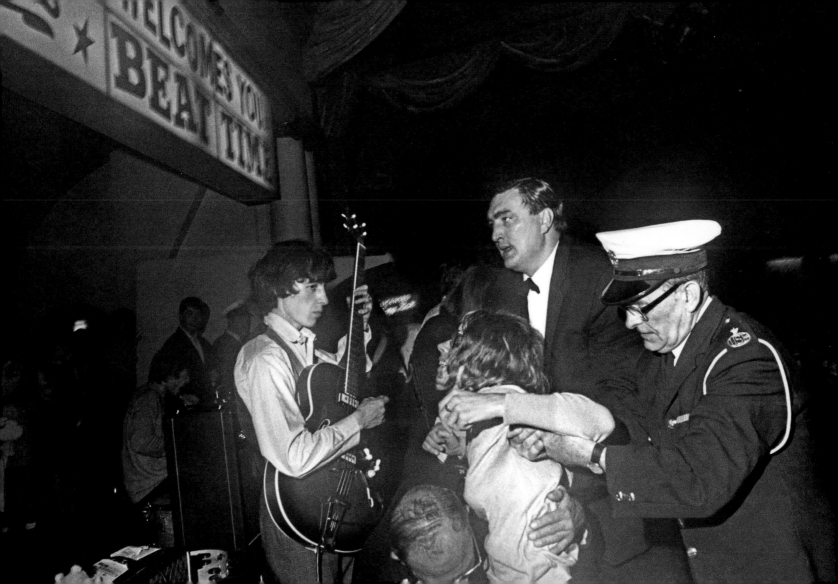

Beating the Beatles

Top of the Polls at the Savoy Hotel, September 11, 1964. Although *New Musical Express* boasted the preeminent annual celebration of pop-scene VIPs, the publication's chief rival, *Melody Maker*, had its own, slightly muted festivities honoring the best of the current pop crop. Collecting their awards at the ritzy Savoy in London's West End, the Stones appeared relatively jolly, despite coming off the back of a grueling 32-date UK tour. *Melody Maker*'s readers had broken with what seemed a forgone conclusion and had voted the Stones the top UK group—above the Beatles. The Fab Four, who didn't attend the shindig, did have the consolation of being voted Top International Group.

39

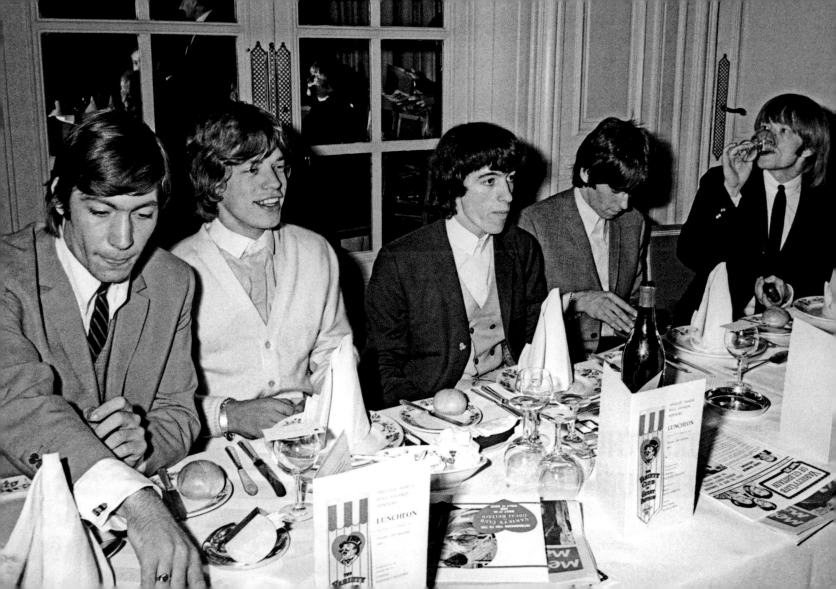

Between Two Roses

More autographs. Bill Wyman performs what was rapidly becoming a formality on arrival at London Heathrow Airport on October 23,1964, for the band's up-and-coming tour of America. The group's two 1964 U.S. tours would capitalize on their steadily growing audience in the States and, somewhat predictably, would court both triumph and controversy. Devoted fans, already smitten, awaited the group's arrival at New York's JFK airport.

Q: "Why do you like the Rolling Stones?"
Fan: "Because Keith is so beautiful, and because... [pause] they're so ugly, they're attractive."

40

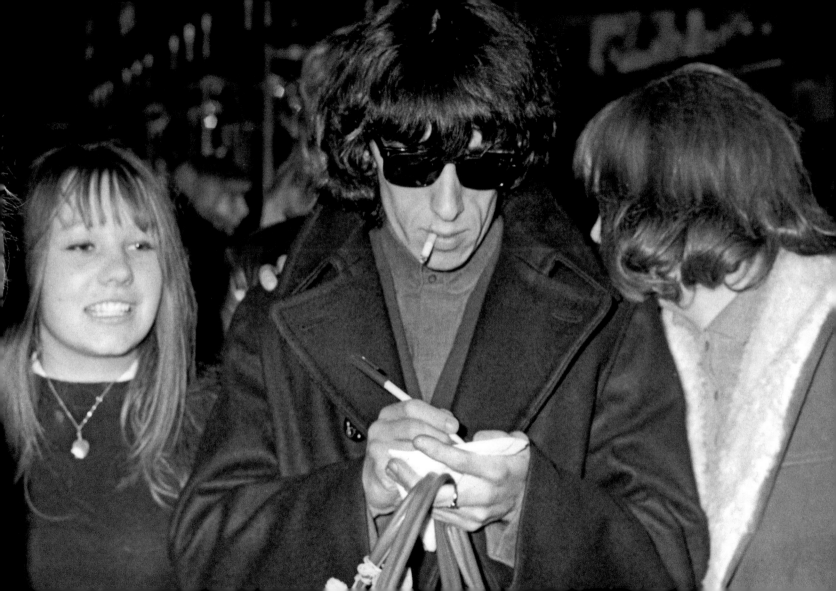

Squatters' Rights

Mick strikes a pose in late 1964. The lead singer was a mass of contradictions, and whereas he could fit into any gathering with consummate ease, there was often an overriding uncertainty about where his true loyalties lay. Even the society columnist of the "William Hickey Diary" for the *Daily Express* was able to discern the dichotomy.

Daily Express: "There's no harm these days in knowing a Rolling Stone. Some of their best friends, in fact, are fledglings from the upper classes."

Glamourless

Mick sidles up to an unsuspecting canteen worker for a photo mid-tour in late 1964. One aspect of the group's attraction was their connection to working-class culture. Whereas the Beatles were seen in some quarters as having sold out to the trappings of high society, the Stones were widely viewed as having stayed in touch with the people.

Fan letter to *Tiger Beat* magazine, 1964: "I met Mick Jagger only once. He was as interested in me as I was him. He took the time to not only sign my autograph book, but also he asked me questions about myself and what I was like as a person. At all times he was polite and a gentleman. His clothes were off-beat, but very nice and clean."

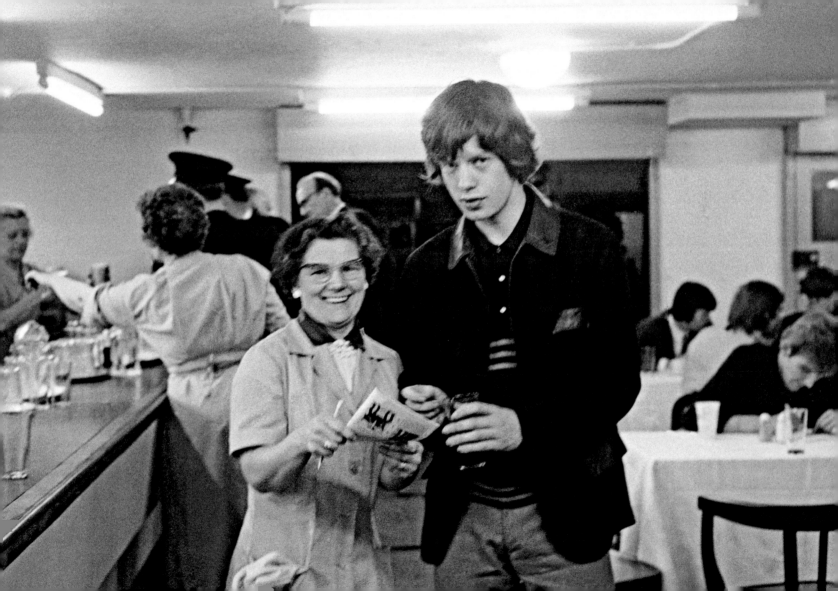

A Quick Conference

While Mick was having his photo taken with the awestruck tea lady, the rest of the band was having an impromptu chat around the table with manager Oldham and his future business partner, Tony Calder. Calder was another young gun in the music business, who'd handled the press for a plethora of early 1960s bands hailing from Manchester. It was only natural that his and Oldham's paths would cross; the pair would later go on to found the specialized record label, Immediate.

43

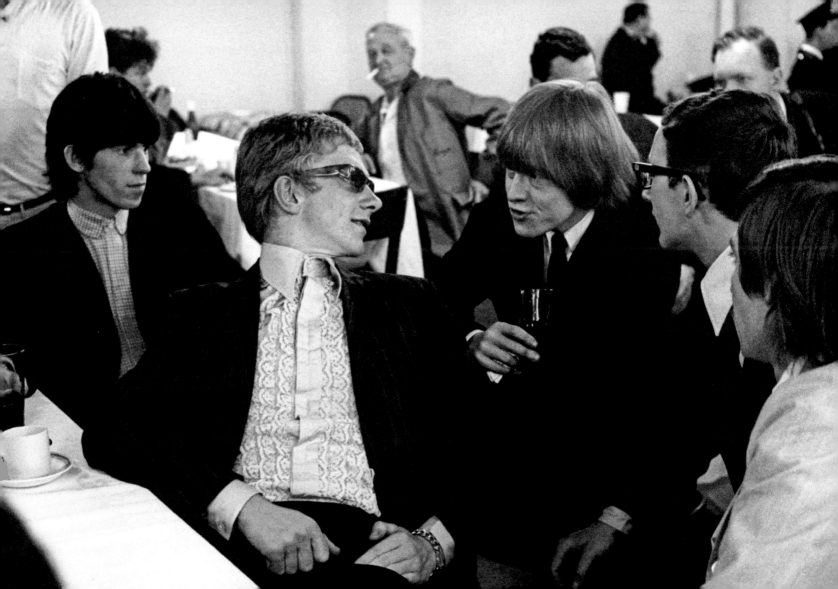

The Same as Everyone

Brian and Mick join the queue at the cafe for some much-needed nourishment. Although the Stones' status as a class act was gradually gaining momentum, hospitality for pop stars was still in its infancy (despite the Beat Boom of 1964). No matter, as the Stones were very much in touch with their roots, which was revealed in a questionnaire four of the band members (sans Brian—his responses were all unprintable) answered for the teen journal *16 Magazine* in 1964.

Q: "What, for you, is the height of misery?"
Charlie: "No paper in the lavatory."
Q: "What is your idea of happiness?"
Mick: "Grovelling in the weeds."
Q: "What is your most admirable virtue?"
Bill: "Kindness."
Q: "What quality do you like most in a woman?"
Keith: "Understanding."

One Lump or Two?

Charlie brings up the rear of the queue to score a welcome cup of tea from the canteen ladies. Watts's single-minded, no-nonsense approach to his duties as a representative of the band both on- and offstage kept the group anchored in some semblance of reality. Whereas Bill was disposed to offstage carousing and womanizing, Watts was content to steer away from the partying seemingly inherent in the band's lifestyle. The drummer has maintained a steady relationship with his partner, Shirley, to whom he was married in 1964.

Charlie: "I give the impression of being bored, but I'm not really. I've just got an incredibly boring face."

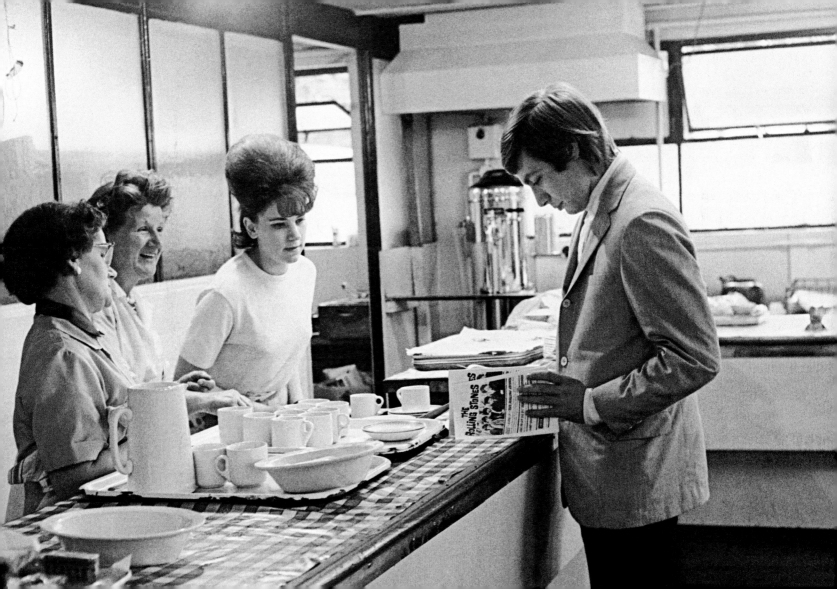

Vox Pop Photos

Keith, Charlie, Mick, and Brian tug heavily on their cigarettes as Terry O'Neill snaps away. Brian's choirboy persona was never more evident than it was in 1964, and even off duty, the most sartorially conscious of the group would be neatly coiffured and smart. But behind the look lay a complex and damaged young man, whose arrogance was more a reflection of his troubled youth than of his elevated status as a pop star. Brian had few genuine friends within the music world, but his close relationship with Beatle George Harrison (who himself felt somewhat in the shadows of John Lennon and Paul McCartney) was a notable exception.

George Harrison: "There was nothing the matter with him that a little extra love wouldn't have cured. I don't think he had enough love or understanding. He was very nice and sincere and sensitive, and we must remember that's what he was."

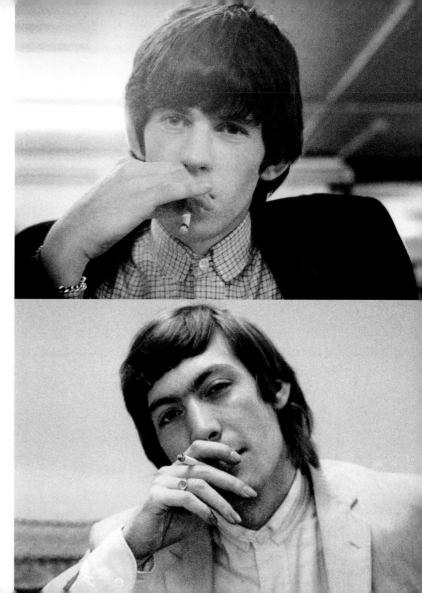

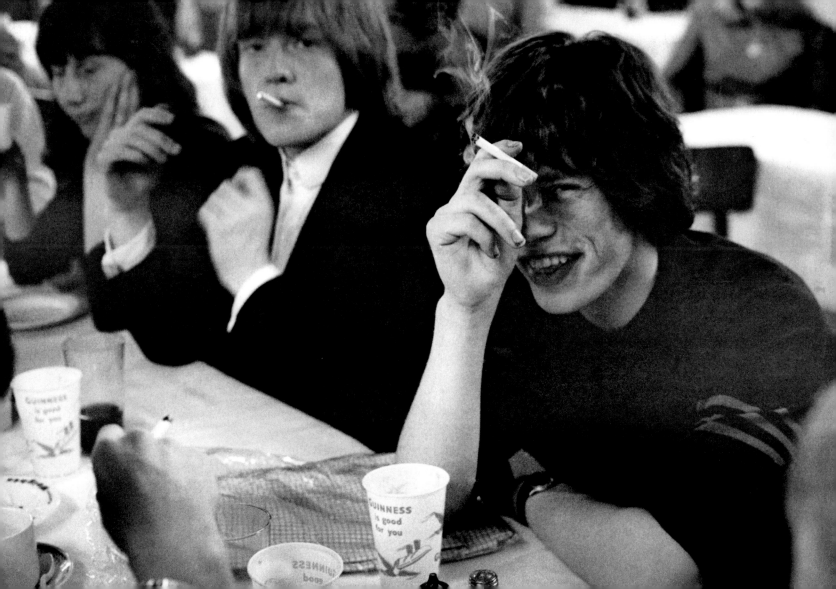

Got a Light?

Charlie gets close to a blond fan, and later he and Keith light up backstage in late 1964. The Beatles had broken the mold when it came to smoking and drinking—they did both on or off duty, regardless of whether or not cameras were present. The Stones were equally disposed to drink and light up, and they did so without fear of their image being tainted. The Stones' fan base wasn't in the slightest bit perturbed by the group's penchant for unruly behavior; indeed, some fans were convinced of the band's inherent divinity.

Fan letter to *Tiger Beat* magazine, 1964: "This isn't something that the Stones brag about, but I happen to know that the last time they were in town, Keith personally phoned an invalid girl who had been sick for years. After she heard his voice, the girl began to improve. Now she's almost well. Don't tell me the Stones are godless boys."

47

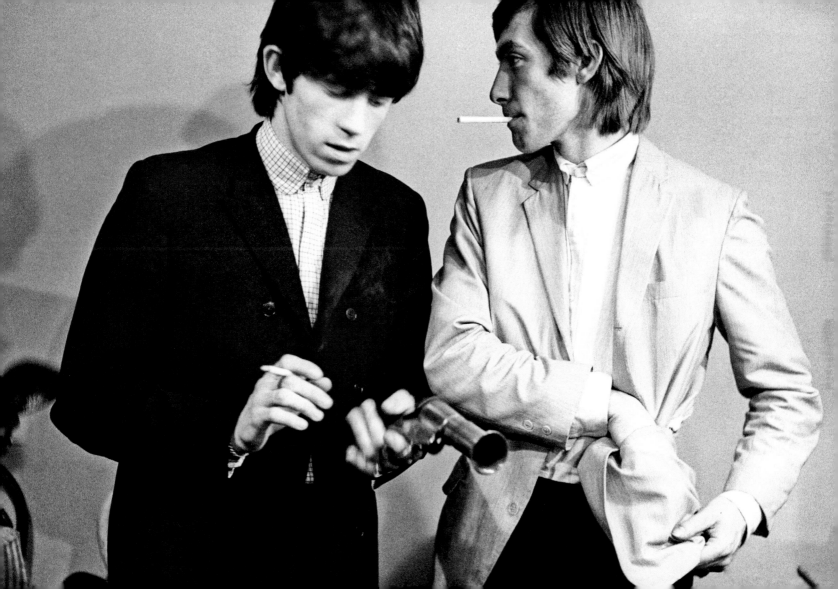

Blond Ambition

Backstage, mid-1964, Brian offers his innocent look to the camera. Although Brian fell behind Mick and Keith in the popularity stakes in the UK, abroad Brian's enigmatic persona was more warmly received. Seminal folk-rockers the Byrds were fervent acolytes, and Michael Clarke and Chris Hillman even mimicked Jones's look. Europe, too, was smitten with him. For Jones, this adulation was all the confirmation he needed to confirm that the path he'd chosen was the right one. He was keen to prove his naysayers wrong.

Brian: "I've finally proved to those people who said I was always doing the wrong thing that I've been right all along. I've got somewhere by doing things my own way."

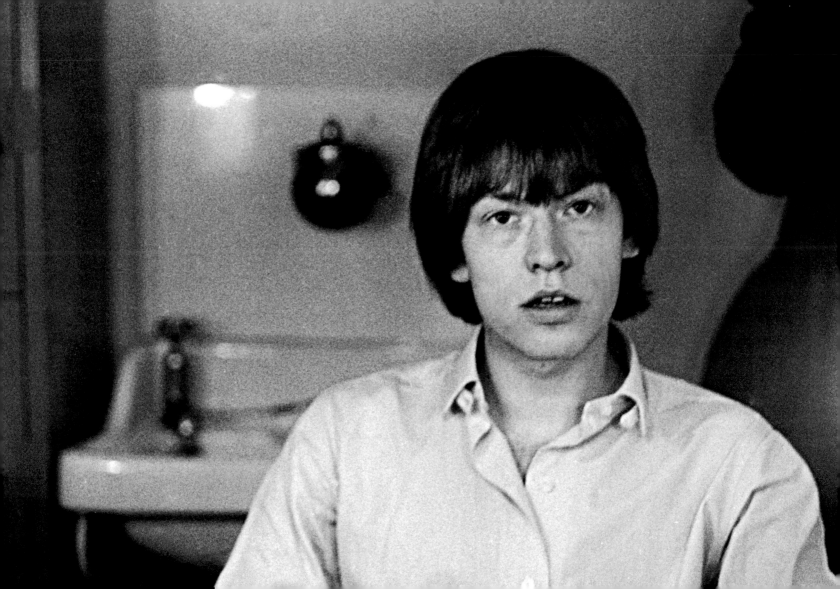

Hair Matters

In a rare display of mutual hair care, Keith attends to Brian's locks backstage in late 1964. Jagger and Richards tolerated Jones's aloof demeanor and conniving antics, and although they were more than aware of the sizable fan base Jones attracted, ultimately there was no way a Stones holy trinity was ever going to come about.

Keith: "There was always something between Brian, Mick, and myself that didn't quite make it somewhere. Always something. I've often thought, tried to figure it out. It was in Brian, somewhere; there was something… He still felt alone somewhere… He was either completely into Mick at the expense of me, like nicking my bread to go and have a drink. He'd do something like that. Or he'd be completely in with me trying to work something against Mick. He was a little insecure."

49

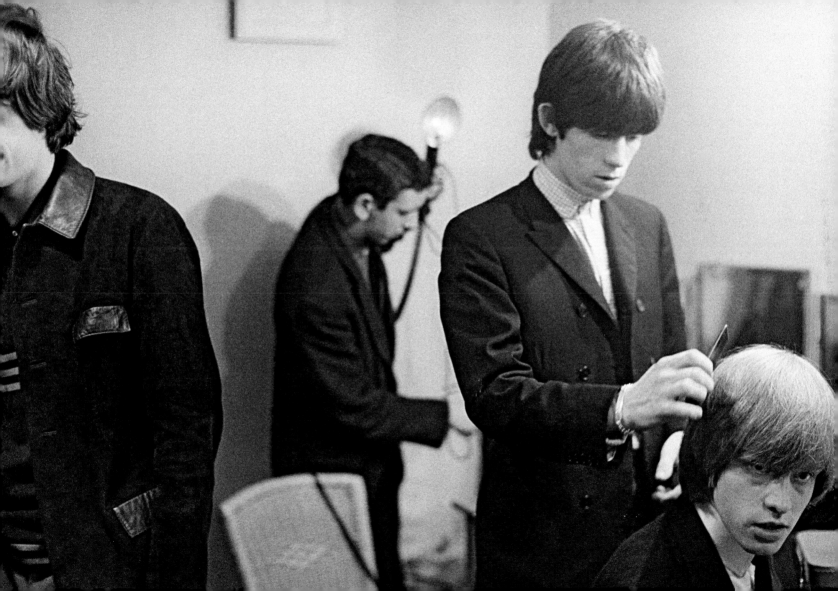

Another Gig, Another City, Another Dressing Room

Brian caught backstage in various stages of preparation in late 1964. Like any group from the era, the Rolling Stones shuttled back and forth on the plethora of pop package tours, which focused more on quantity than quality. The Stones quickly rose through the ranks and were soon starting to headline their own tours, and by 1964 they were second only to the Beatles in the United Kingdom. Demand to see the group live was rising, though British venues—often cinemas or ballrooms—were limited in their capacity. Nonetheless, the Stones' live act was always exciting, and warmly received by both critics and fans.

New Musical Express: "Lead singer Mick Jagger whips out a harmonica occasionally and brews up more excitement, while the three guitars and drums throb away in the back."

50

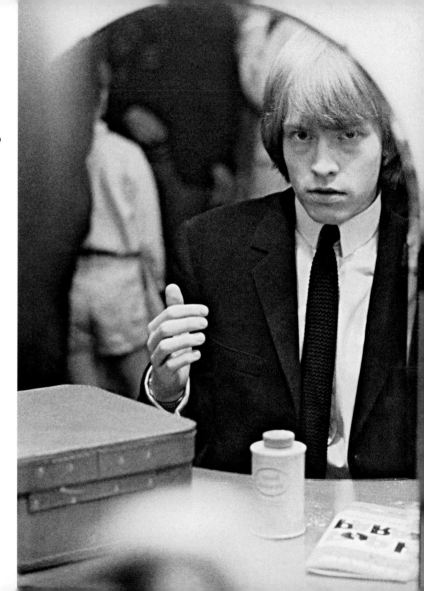

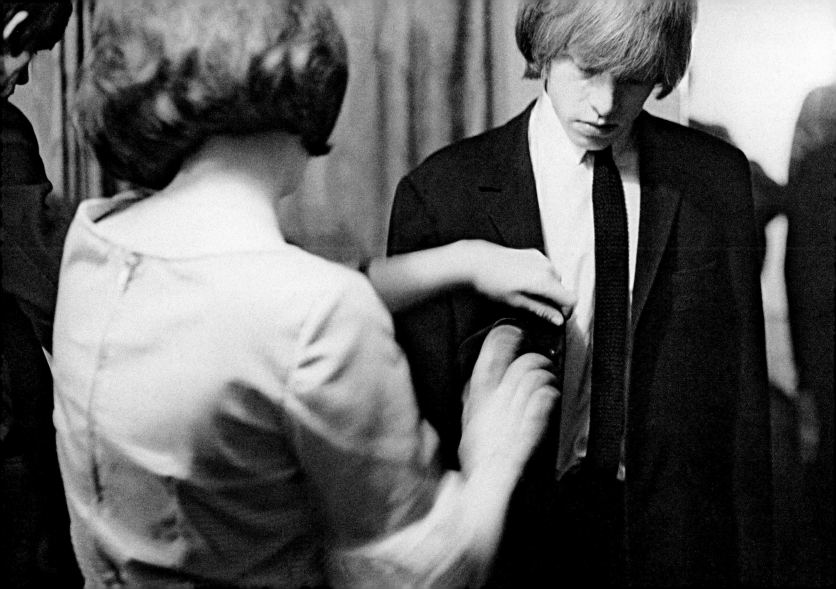

Signature Theme

Brian signs an autograph for a fan backstage in late 1964. Brian's tacit but overwhelming desire to succeed was his principle dynamic, and carving out a special niche for himself was his way of side-stepping competition with Mick.

Brian: "I know I earn too much, but I'm still young and there's something spiteful inside of me which makes me want to hold on to what I've got."

51

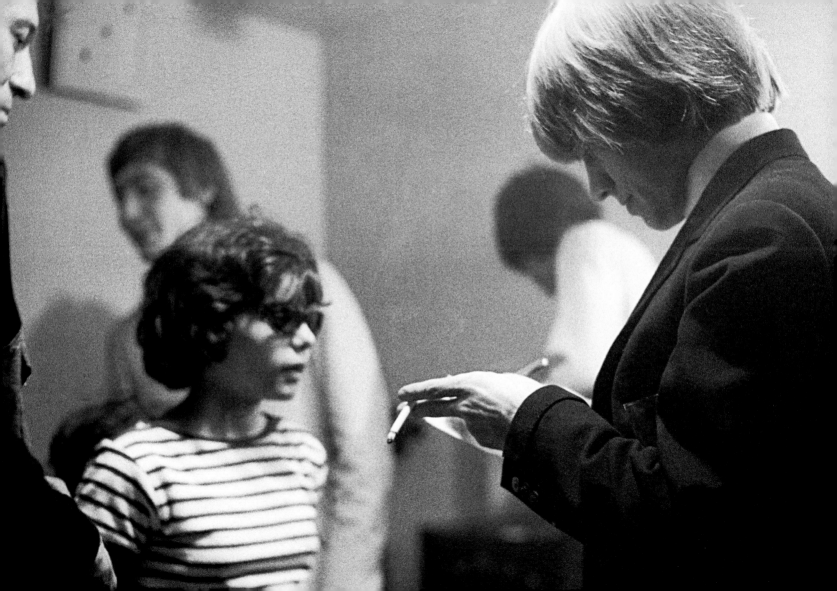

Thank Your Lucky Stars

Ready to entertain, on November 29, 1964. During the 1960s in the United Kingdom there were three major pop shows on television that could literally make or break a group. The BBC had the enormously influential *Top of the Pops*, with viewing figures well into the twenty millions, and the commercial station ITV had two retaliatory shows: the weekly pop sensation *Ready Steady Go!* and the slightly less frenetic *Thank Your Lucky Stars*. *Lucky Stars* was broadcast from Birmingham, which meant that the legions of groups from Liverpool and Manchester could make a quick dash to the studios. The Stones, however, had to make a 120-mile trip up from London—but such was the show's influence that an appearance could guarantee enormous coverage for a new single release.

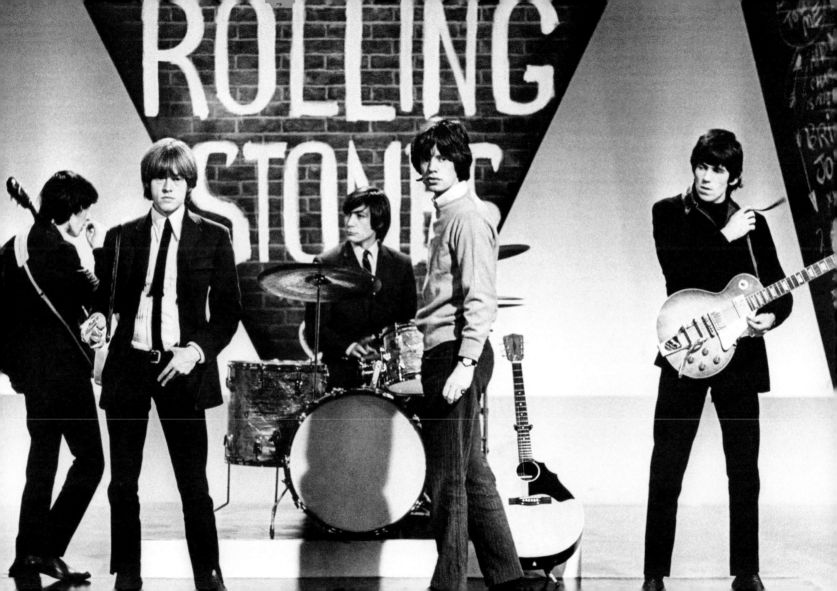

Little Red Roosters

The Stones' commitment to promoting themselves on television led them to appear on *Thank Your Lucky Stars* five times in 1964. This particular appearance gave the group a chance to preview their up-and-coming single "Little Red Rooster." Buoyed by their time in the States among their blues heroes, and by the huge cache of blues and soul records they had purchased during their trip, the group produced the single as a tribute to their major influences.

Mick: "This time, I didn't want to do a fast beat number. If the fans don't like it, then they don't like it. I like it. It's a straight blues and nobody's ever done that. Except on albums. We thought just for a change we'd do a nice, straight blues on a single. What's wrong with that?"

53

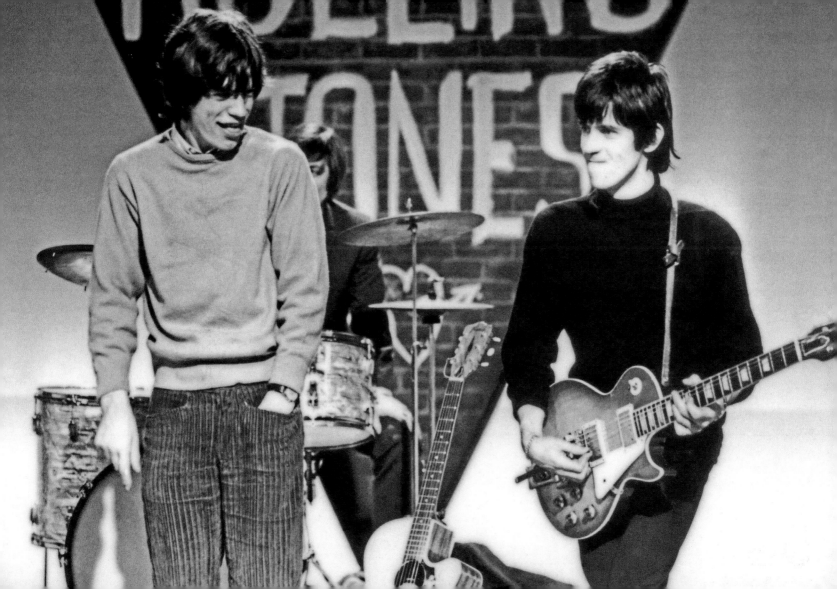

Mug Shot

Brian pulls a face for the camera while recording the November 29 *Thank Your Lucky Stars*. Jones's broad musical knowledge often led him to experiment with innovative instruments; his trademark guitar during the Stones' early days was this iconic and unusually shaped Vox Teardrop.

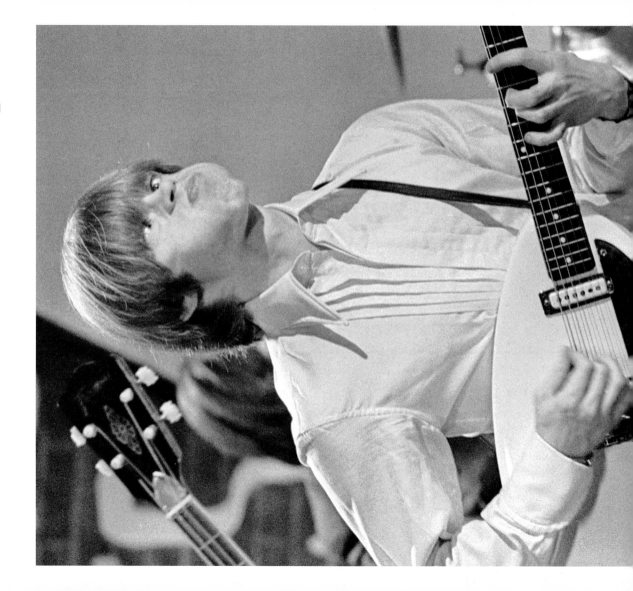

Setting Up

The Stones crack up between miming duties on *Thank Your Lucky Stars*. The band's manager, Andrew Loog Oldham, was fully cognizant of TV's promotional advantages over other mediums, and between publicity, recording, and concert duties, the Stones' itinerary for 1964 was intensely hectic. Nonetheless, the group's boundless energy, fueled by their perfunctory bouts with drugs and a never-ending supply of love-struck groupies, ensured life on the road was always eventful.

Mick: "Basically the thing at that period was that you used to just try and find girls that would fuck.... In those days it was a big deal. You were just discovering yourself and your own body... kinda weird."

55

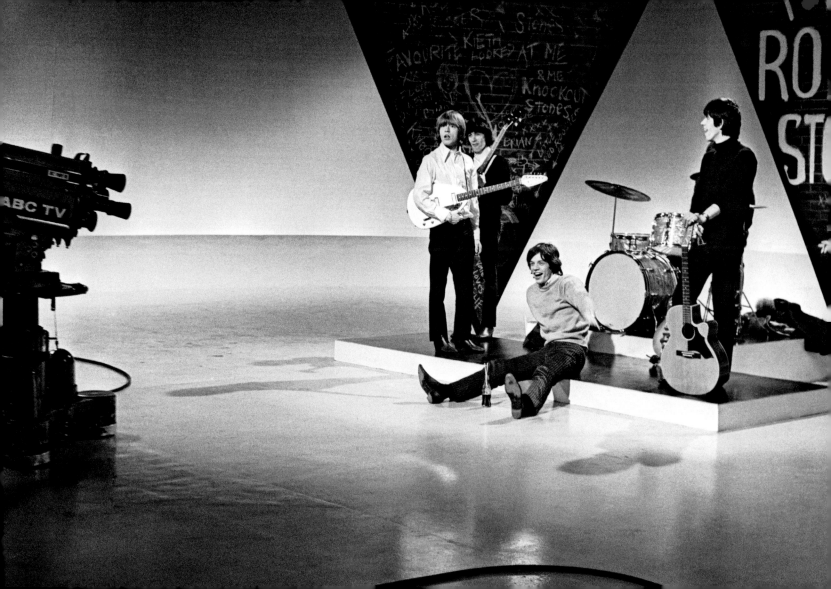

Beat Combo

With a guitar braced high up against his chest, Keith mocks a familiar Beat-group stance, while Mick looks on with obvious appreciation. The music landscape of the early 1960s was schizophrenic to say the least. The Beatles had quite literally blown the lid off the music industry, but the scene was still dominated by groups like Freddie and the Dreamers, the Searchers, Gerry and the Pacemakers, and Herman's Hermits. Conformity was still the name of the game. So when the Stones arrived on this conservative scene, the impact they made was quite dramatic. Although critics tried to pigeonhole the group's sound, the Stones were adamant that they were a highly unique outfit.

New Musical Express: "Their own opinion is simply that they are unique! Spokesman Brian Jones, who sings and plays harmonica, says, 'We believe that we sound like ourselves and no one else.' "

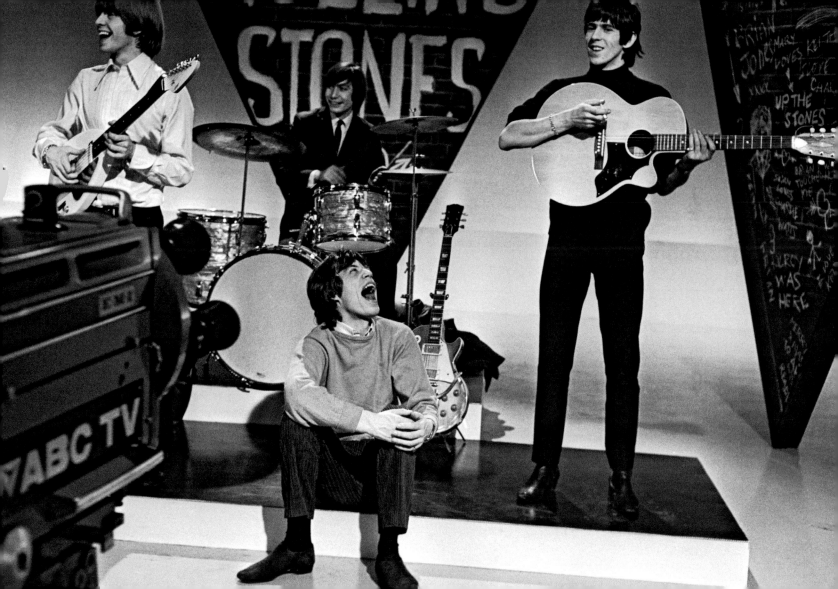

Laughing It Up

Stifling a giggle, Mick is confronted by an ABC sound engineer on set in Birmingham in November 1964. Given that the Stones were now fully established as Britain's number two act, they were afforded an ample amount of creative control on their TV appearances. Things hadn't gone so smoothly in mid-1963, prior to their first appearance on *Thank Your Lucky Stars*, when the group had clashed with the presenter—the affable yet crusty Brian Matthew—who had strongly objected to their unkempt appearance and Jagger's primitive stage gyrations.

57

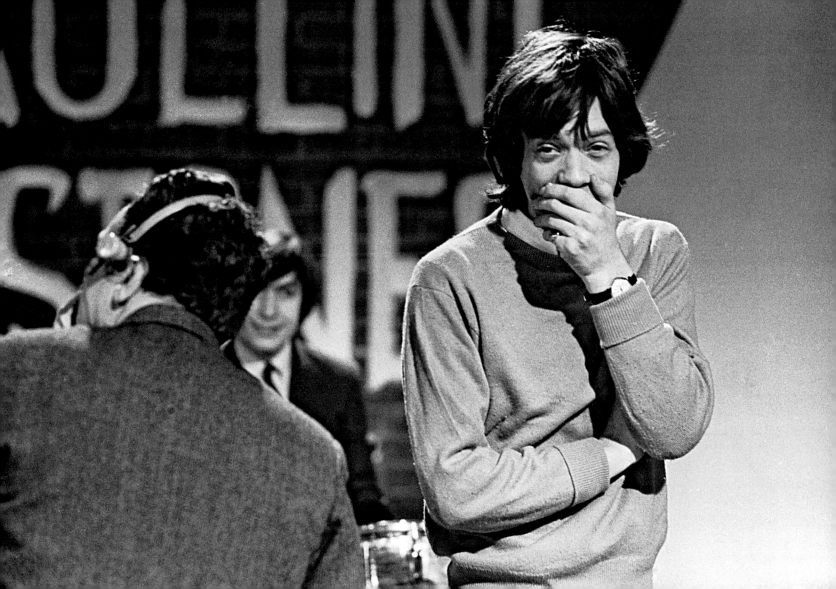

The Joint Is Rocking

Still between takes, Mick hams it up for Terry O'Neill at ABC studios in Birmingham, November 1964. During the Beatlemania-dominated days of 1964, the Stones provided an excellent counterweight to the Beatles' lovable mop-top image. One notable story at the time concerned eleven male pupils at a school in Coventry who'd been suspended for wearing hairstyles similar to the Stones'. When quizzed by the press, the head of the school reiterated the point he had made to the students: they wouldn't be welcome back at the school until their hair was "cut neatly, like the Beatles."

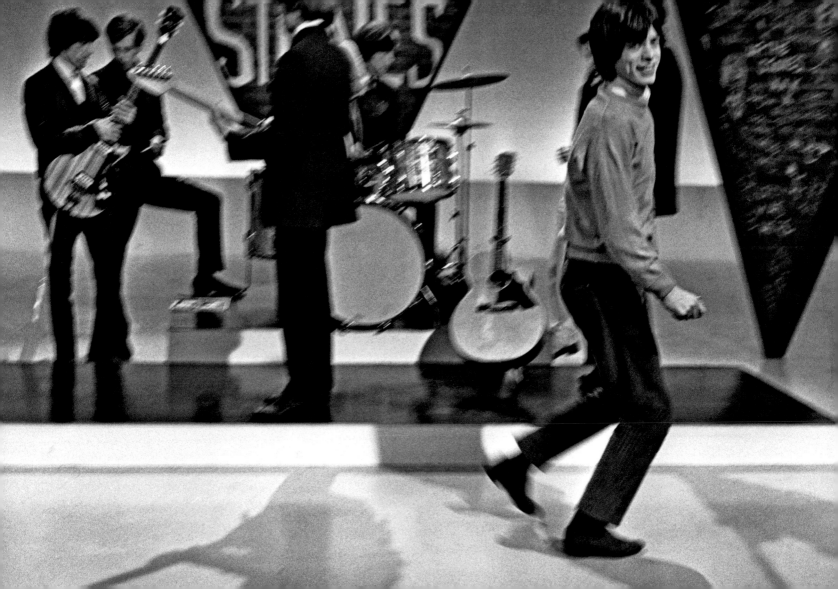

Neither One Nor the Other

It had been a hectic day for the Stones, what with filming *Thank Your Lucky Stars* and making sure they'd been making all the right poses for Terry O'Neill's lens. In need of some well-deserved sustenance, Mick donned his natty parka and headed for the ABC studio's canteen. Neither mods nor rockers, the Stones were intent on maintaining their own highly idiosyncratic style in the face of critics.

Mick: "We're non-conformists. We dress as we please. We're not dirty. We're not going to cut our hair or wear conventional clothes because parents object to our casual style."

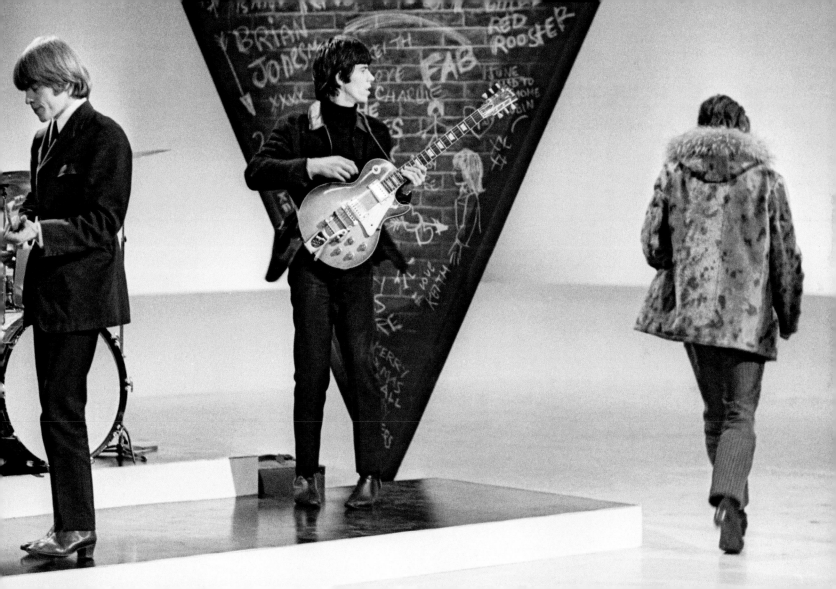

Knights of the Sound Table

The Stones share some quality time around the Formica. Any personal differences the group had in those early days had no bearing on the direction the band was taking, on which point the group was evidently unified. Even Jagger's and Jones's prima-donna antics were tacitly accepted as being secondary to the group's ultimate goals.

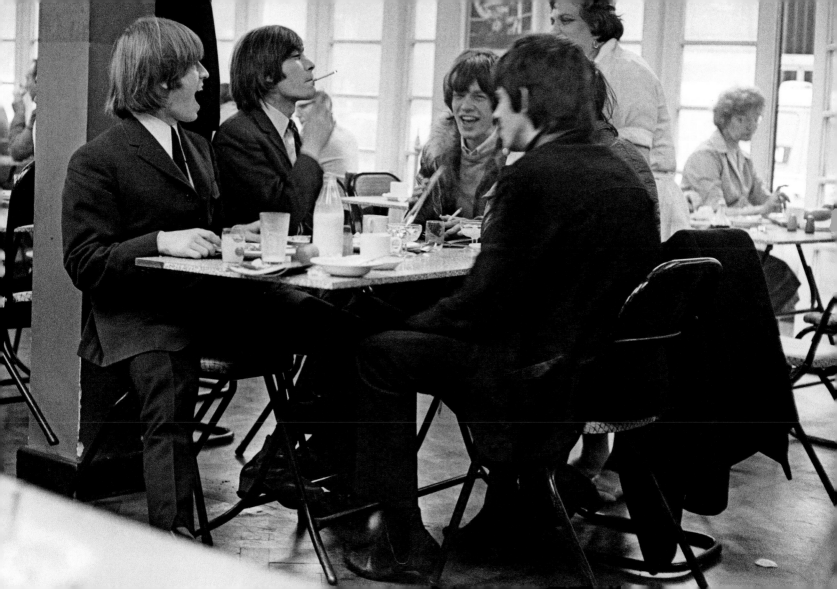

Sheep in Wolf's Clothing

Of all the Stones, it was Mick Jagger who received the most attention from photographers. This classic series by Terry O'Neill features Mick wrapped in a fur-trimmed parka—an essential accoutrement of the mod era. Jagger's classically androgynous features, lodged somewhere between choirboy and fallen angel, principally accounted for the broad appeal the band had with both sexes.

61

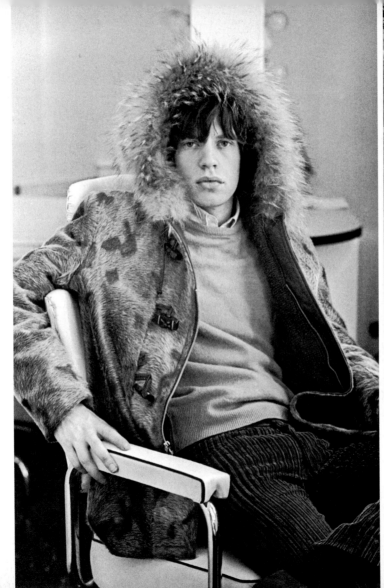
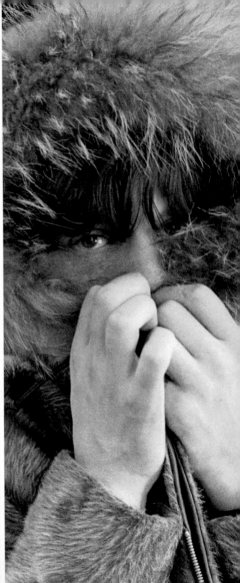

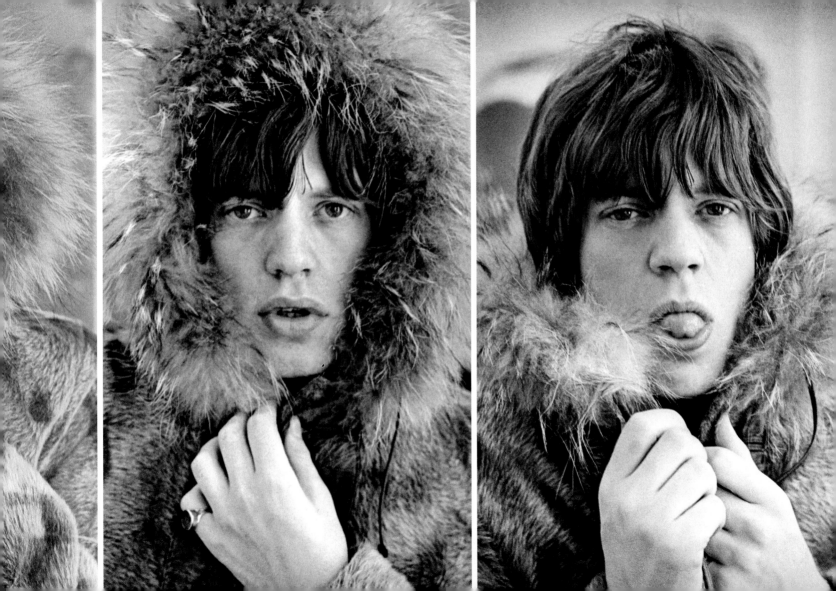

Across the Aisle

Bill and Mick stir it up while Brian cools things down with milk at the canteen of Shepperton Studios, December 1964. The group was at the studio to film some promotional spots for television, which ultimately would save them several treks across the UK. The Stones' 1964 itinerary had been especially grueling, but they were young, full of boundless energy, and blessed with powerful constitutions.

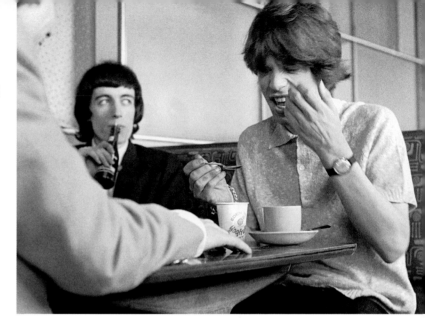

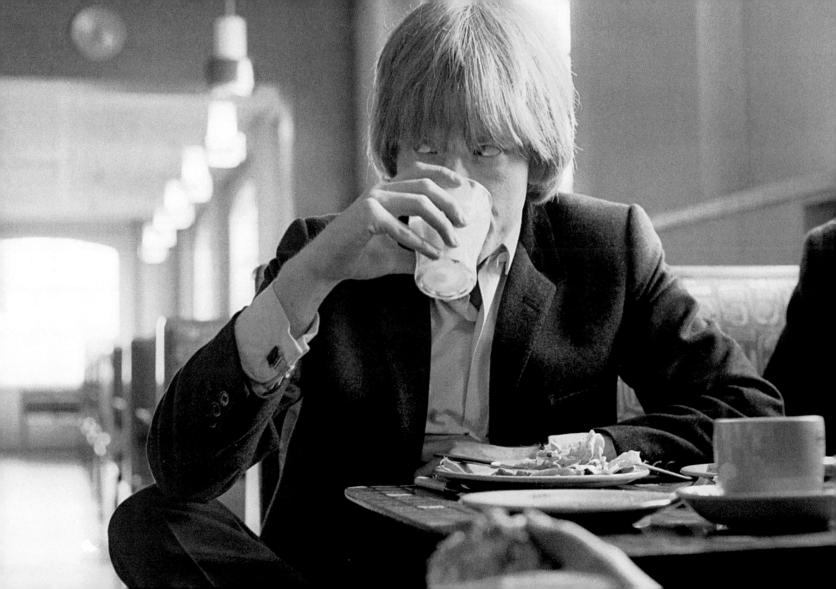

Out the Back

Coaxed outside the confines of their dressing room, the Stones are posed with a bevy of beauties during another 1964 tour. For a posse of young men possessed of some of the most rampant testosterone on the planet, the rock-and-roll lifestyle guaranteed a never-ending supply of willing females, who were more than happy to satisfy the group's enormous libido. Given the band's voracious appetite for sex, looks mattered little.

Q: "What kind of groupies did the Stones used to attract?"
Mick: "Great ugly ones! Dreadful Northern ones with long black hair, plastic boots, and macs. Ugh. It used to be terribly sordid—still is really. Thankfully the girls are much prettier now than they were then."

63

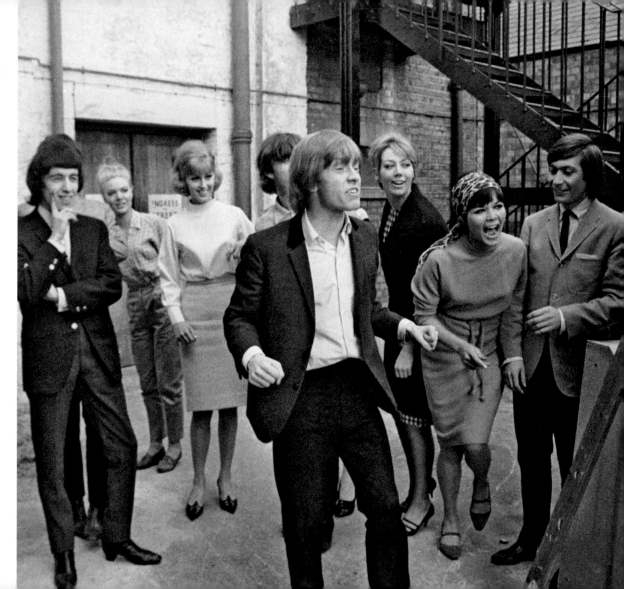

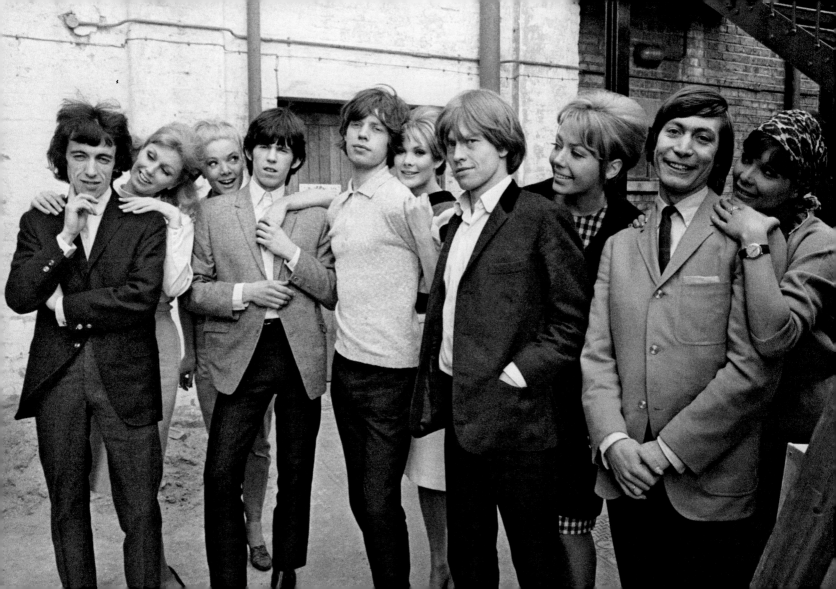

Larking Around

The multitalented singer/songwriter/comedian Kenny Lynch playfully grabs
Keith's cherished Epiphone Casino during a filming session in late 1964.
The group had convened at Shepperton Studio to film some promotional
footage, as was usually the case, collided with other artists backstage.
Lynch had established himself as a good friend of the group and their
manager. He was seemingly omnipresent during the Beat Boom of the early
1960s; virtually every chart and variety show featured an appearance by the
popular Afro-Caribbean entertainer.

64

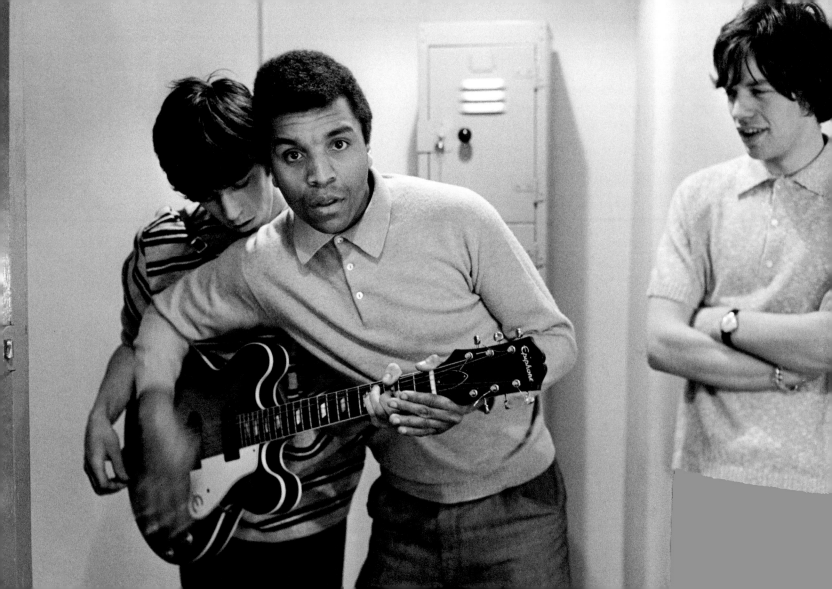

Making Up

In the dressing room prior to their filming session in late 1964, the Stones are given the full treatment by the studio's makeup department. Despite the media's portrayal of the band as wayward scruffs who couldn't care less about their appearance, this was misleading since they were actually quite savvy about their public image. Mick and Brian in particular were fastidious about their appearances.

Rolling Stones monthly magazine: "When I last saw Mick Jagger he was standing stripped to the waist, bending over a wash basin with shower in hand, washing his hair in one of the BBC's makeup rooms. In between an eyeful of soap, he managed to say to the makeup girl that he could handle it himself."

65

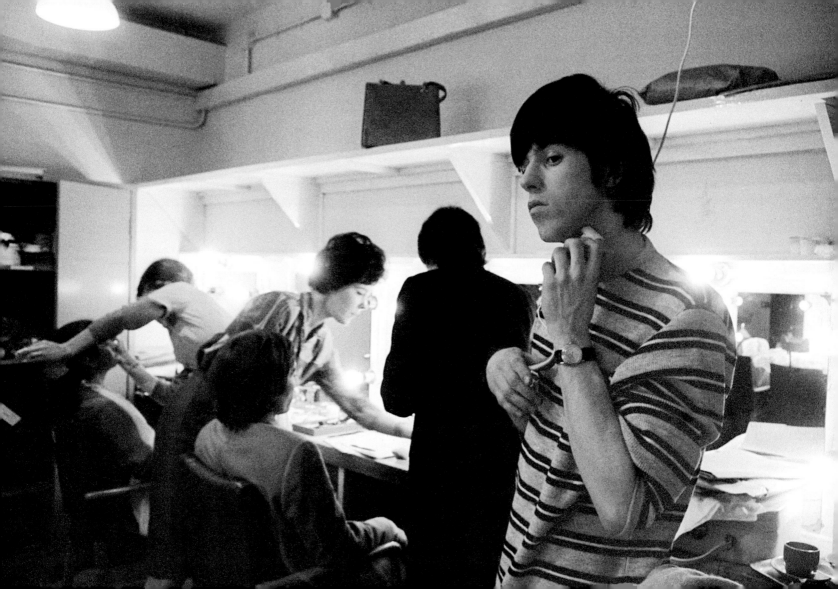

Oh, You Pretty Things

Despite being controversial in the eyes of some, Jagger's pose for trusted
lensman Terry O'Neill (and Brian Jones) probably wasn't too earth-shattering
for the Stones' management. Andrew Loog Oldham knew instinctively that
any publicity was good publicity, and that a large part of the group's attraction
was shock factor—something the Stones certainly weren't shy about.

66

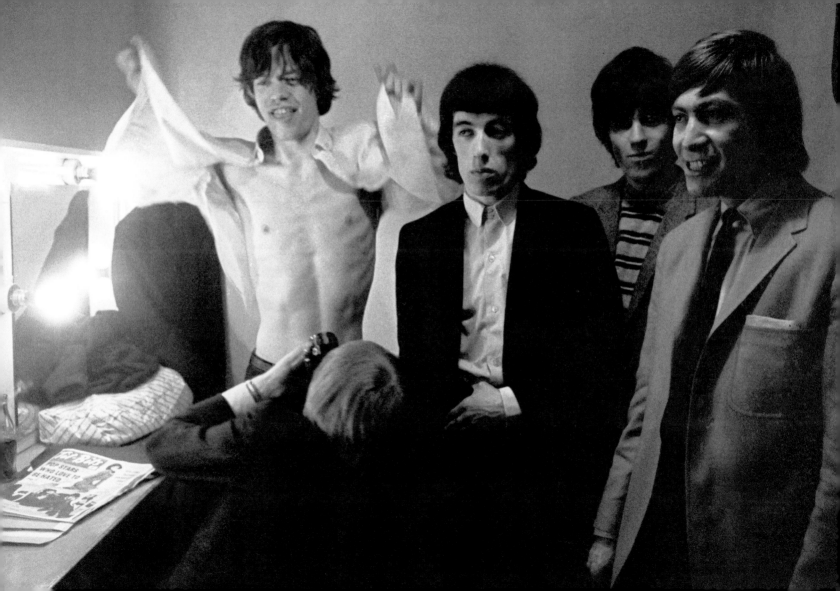

Charlie Is My Darling

Despite his being in the public eye for more than forty years, Charlie Watts remains as enigmatic a character today as he was when he first rolled in with the Stones in 1963. Watts's commitment to the twin loves of his life—music and art—led many to label him a dark, sardonic figure. Yet he was simply ruled by his passions, and could even be loquacious under certain circumstances.

Charlie: "The only time I am not bored is when I'm drawing, playing the drums, or talking. I talk a lot, about nothing usually, and all contradictory. Shirley always accuses me of having no beliefs. Maybe that's why I can talk to anyone."

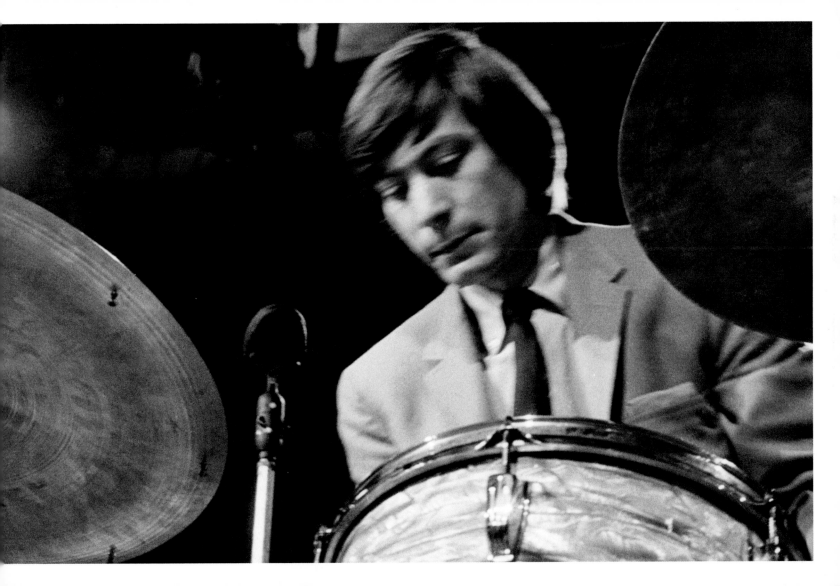

Ready Steady Go!

The classic Stones lineup. The main protagonists, Jagger, Jones, and Richards, provide the three-pronged assault, while the rhythm twins of enigma, Wyman and Watts, anchor the sound at the rear of the stage. It was this classic stance that balanced the Stones' live image perfectly. Other pretenders to the Stones' crown, most notably the Pretty Things and the Yardbirds, never had the natural choreography the Stones had, and as a result their concerts never had the same dynamics. Despite the illusion that the Stones just shambled up onstage and plugged in, behind the scenes there was some serious consideration given to their stage presence.

Bill: "People don't realize how much effort is involved. If they don't see you doing a Little Richard on top of the piano they think either you're not into it, or you're being lazy. But some people aren't onstage movers. Yet another example of the band's uncanny ability to realize group and individual limitations and not to exceed them."

68

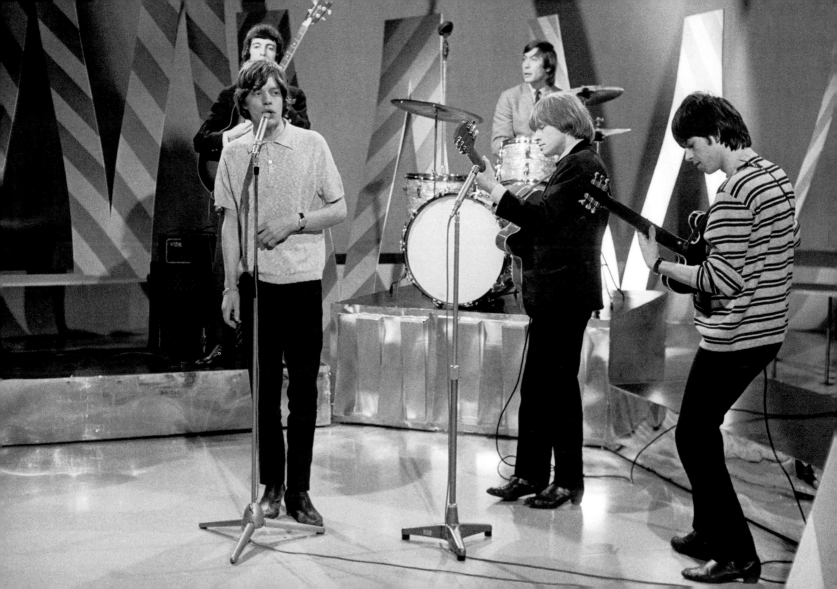

Testing the Light

A lighting engineer checks the exposure level on Keith during the band's December 1964 promotional filming. On hand to capture the action was Terry O'Neill. The London-based photographer was one of a coterie of similarly gifted young artists, including David Bailey, who were all attracted to the smoldering magnetism of the Rolling Stones.

69

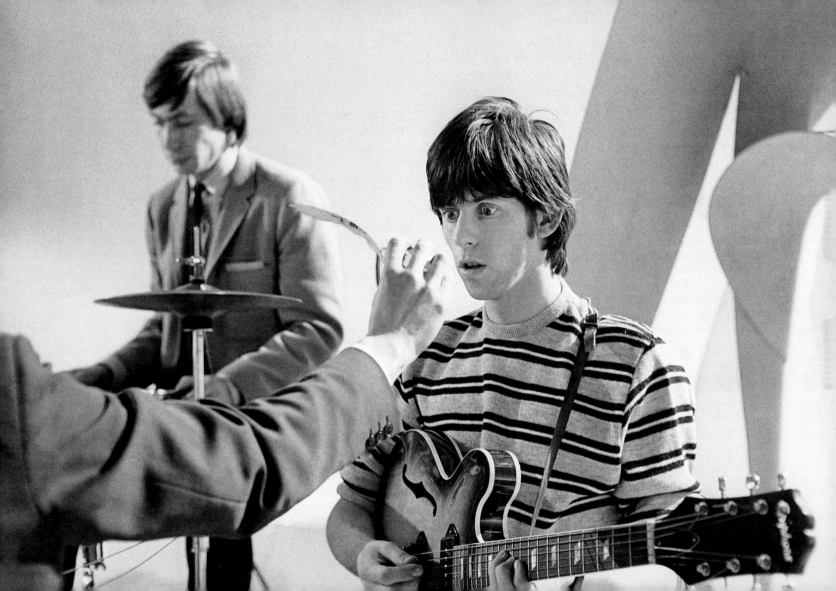

Slide Guitar

The highlight of the Stones' single "Little Red Rooster" was Brian's adept handling of the slide guitar. In 1964, the use of the slide technique was an innovative addition to the narrow confines of pop music. Any doubts that critics had over the single's esoteric sound were soon quashed when the song rocketed straight to number one on the UK single's chart.

Mick: "I don't see why we should have to conform to any pattern. After all, wasn't 'Not Fade Away' different from 'It's All Over Now'? We try to make all our singles different, and so far every one has been in a different tempo."

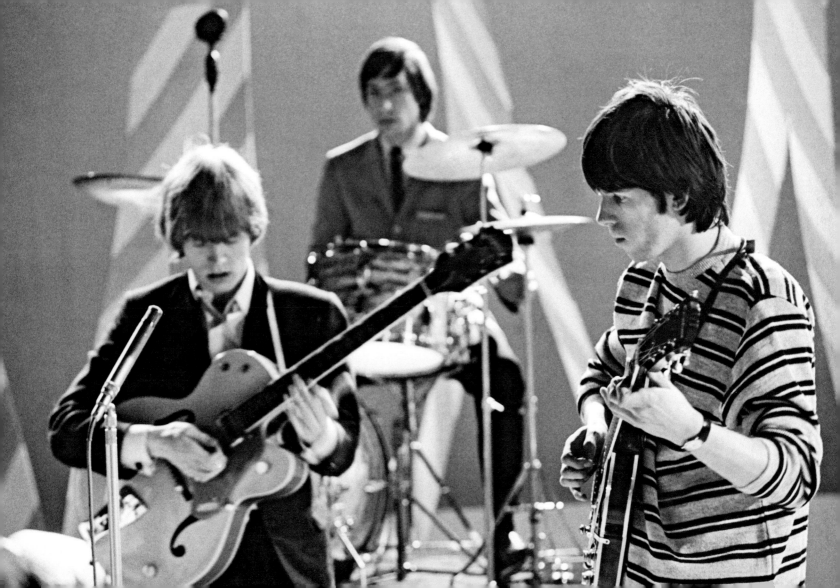

Break for a Chat

Kenny Lynch (far left) draws near for a chat about Brian's guitar technique, while Bill loses himself in his bass, December 1964. Lynch was an early associate of Andrew Loog Oldham's; while his own career was on the rise, an opportunity to co-manage the band with Oldham was quickly made a moot point.

Kenny Lynch: "One day Andrew said to me, 'Come and see this group; we'll manage them.' I said, 'I'm an artist, I don't want to go managing groups, I don't know anything about managing groups.' But to help them out, I took him to the Delfont Agency [the most prestigious theatrical agency of the time]. Mick and Brian were in their usual gear, and when Bernard Delfont saw them he said, 'Get them out of here!'"

71

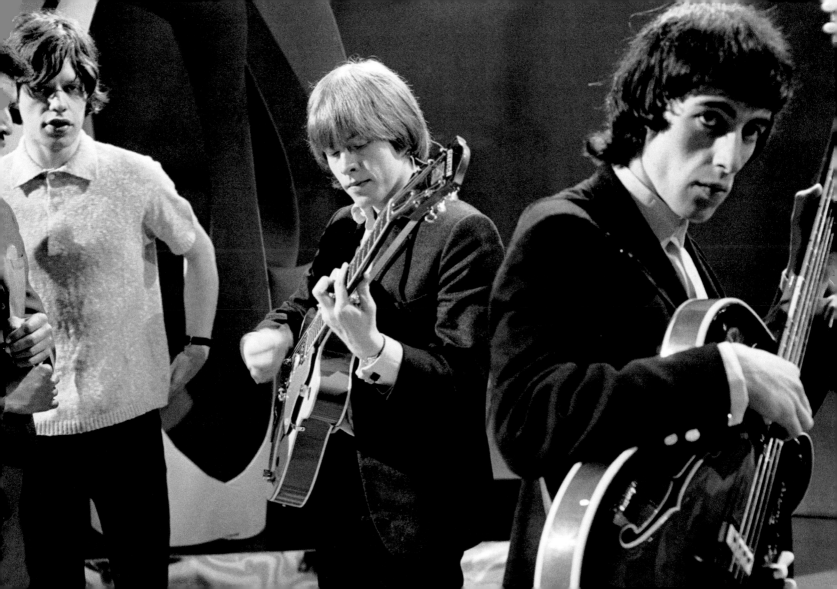

Carrying On

Patently worse for wear, Mick surveys the scene while Keith jumps onto Charlie's vacant drum stool during the promotional-film shoot. Previewing new material live on television was a gamble for a TV company—more so in this case, given the controversy the Stones had garnered over the year. Nevertheless, the Stones were keen to play live whenever possible; their dislike of lip sync emanated from some less-than-convincing performances from their peers, the Beatles included.

Mick: "I thought the Beatles were awfully nice on television the other night… John's hair was lovely and fluffy. But they weren't live! I mean, were they?"

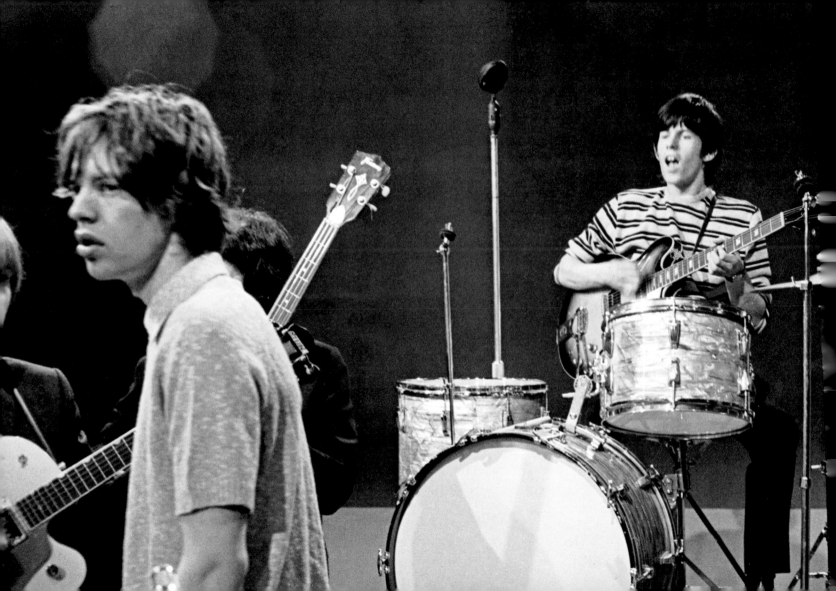

Photo Op

During a break in TV rehearsals, Britain's paparazzi take their shots. Toward the end of 1964 the Rolling Stones were national news, and any appearance, on television or live, would draw legions of press in search of a story or an interesting photo opportunity. The media was characteristically gung-ho when it came to whipping up some controversy, especially when setting the Stones against the Beatles.

News of the World: "There are few mothers who wouldn't welcome a Beatle into the family. The Beatles bubble with laughter. They make jokes, wear neat clothes, get along with royalty. Even their long hair becomes acceptable after a time. But it's different with the Stones. They leer rather than smile. They don't wear natty clothes. They glower. Nobody would accuse them of radiating charm. And the extraordinary thing is that more and more youngsters are turning towards the Stones. The Beatles have become too respectable... The Stones give one the feeling that they really enjoy wallowing in a swill-tub of their own repulsiveness."

73

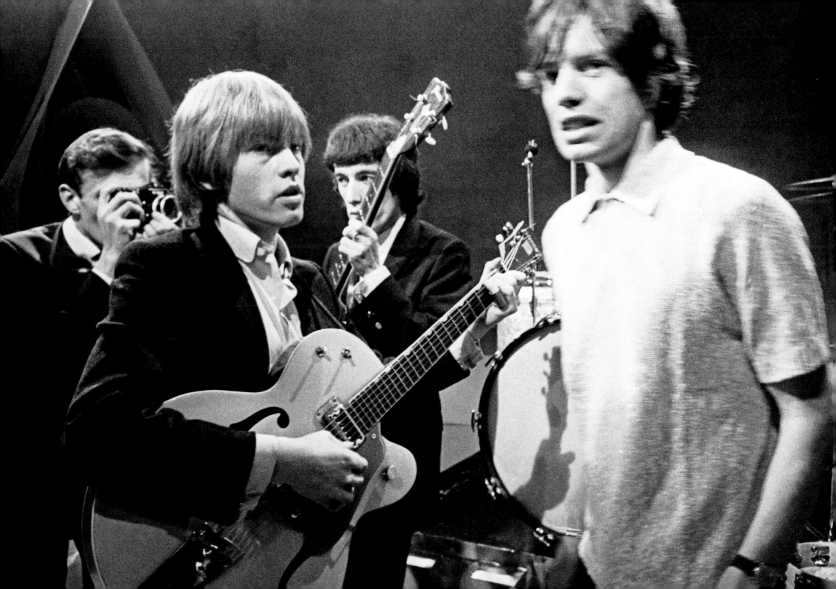

Program Giggles

Keith, Brian, and Bill check out the details of their tour program backstage at the Commodore Theatre in Hammersmith, West London. The Stones had just come off the back of a successful tour in Ireland, and were able that night to preview tracks from their second LP, entitled—somewhat unimaginatively—*Rolling Stones No. 2*. As was the norm, two evening shows were scheduled, to accommodate as many fans as possible. Another notable on the bill that night was fellow Andrew Loog Oldham discovery Marianne Faithfull.

74

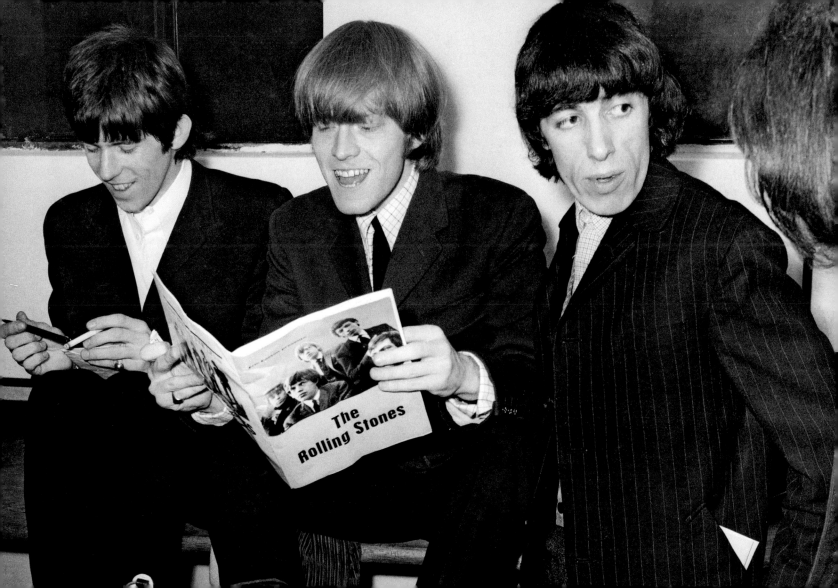

Break on Through

Upon the Stones' arrival in Sydney, Australia, on January 21, 1965, a fence is brought down by the sheer weight of thousands of ecstatic fans on hand to welcome the band. The scene Down Under was a typical one; Stones fans everywhere were intent on securing their own piece of the group.

Daily Mirror: "Three thousand fans, most of them girls, rioted as the five Rolling Stones flew into Sydney airport at the start of their Australian tour. About three hundred of them tore through a chain wire fence and then smashed into a quarantine area, ripping a Customs Hall rail."

75

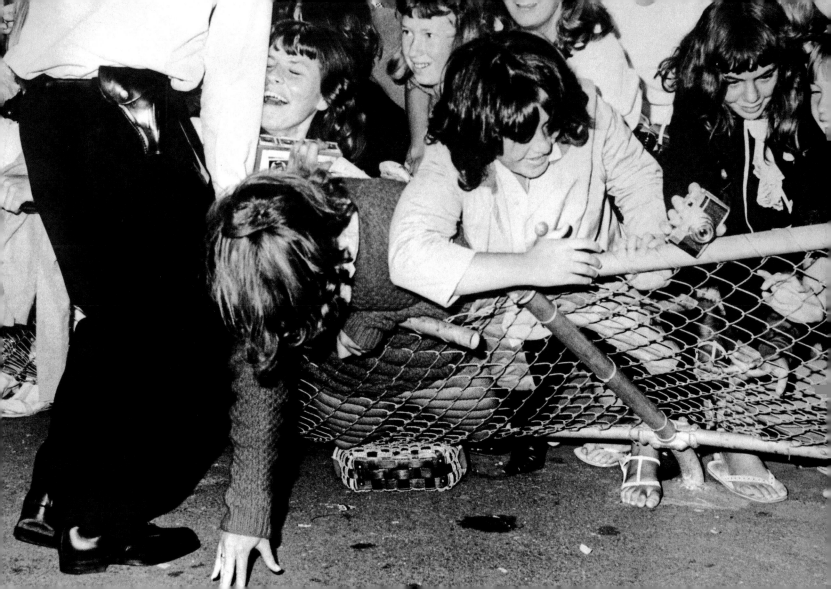

The Beach Boys

With the Sydney Harbour Bridge in the background, the group enjoys the golden sand and a welcome respite from the swarms of rabid fans. Their sell-out concert later that January 22, 1965, the first of their Australian tour, would prove to be a manic reiteration of the band's worldwide popularity. But the Stones were by now acclimated to the frenzy, and their thoughts on it were bordering on philosophical.

Keith: "Once you've survived a Liverpool or London crowd you can take care of yourself anywhere in the world."

76

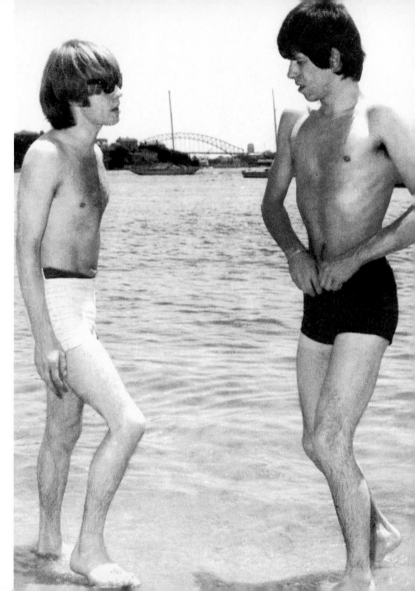

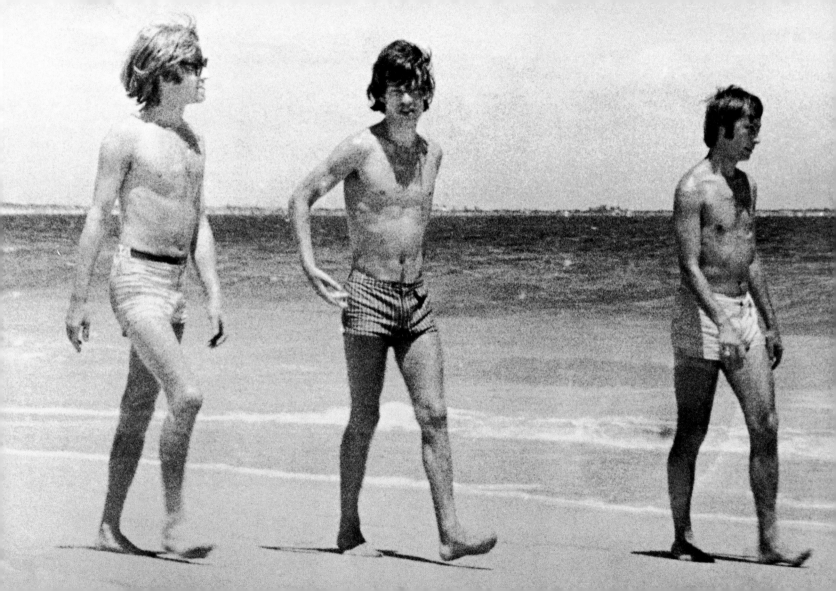

Sand Dune Rocker

While the other Stones check out the beach, Mick, rarely without a music system of some description, gets down in the dunes. The Stones' arrival caused the usual consternation, with headlines proclaiming "Ugly Manners" and "Ugly Looks" among the hyperbole. Andrew Loog Oldham cheekily upstaged the chaos with his mock colonial diatribe to reporters at Kingsford Smith Airport in Sydney.

Andrew Loog Oldham: "The boys and I were moved as we stood on the steps of the airliner, which had brought us here to this distant land, receiving a tremendous welcome from these warmhearted and wonderful colonials."

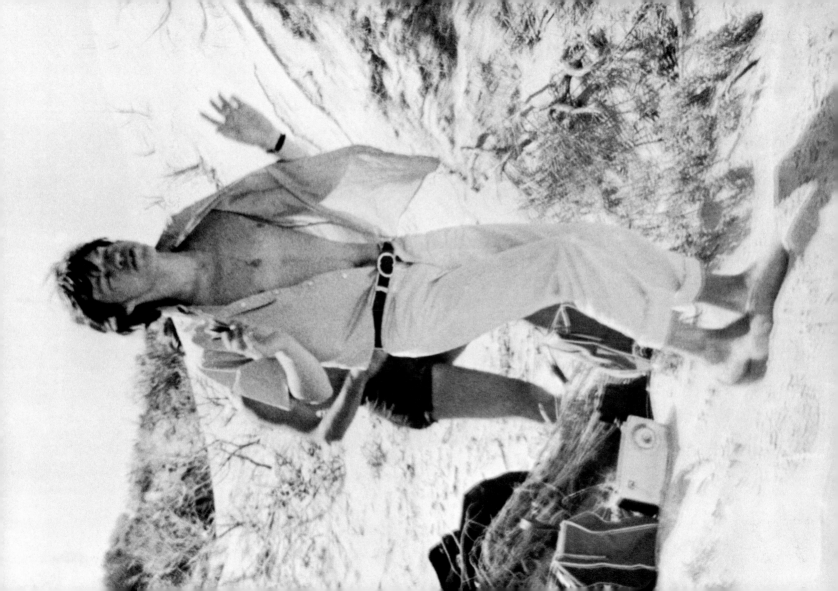

Three Men in a Boat

During an afternoon sojourn around Sydney's Double Bay, Keith, Brian, and Andrew Loog Oldham take to the water in a dinghy. At the incongruous sight of three pale British VIPs trying, rather unsuccessfully, to maneuver a tiny vessel, students from nearby Cranbrook College (labeled by the press as being "for children of wealthy families") closed in with the aim of overturning the boat. The students got more than they bargained for when Andrew set about them with the oars.

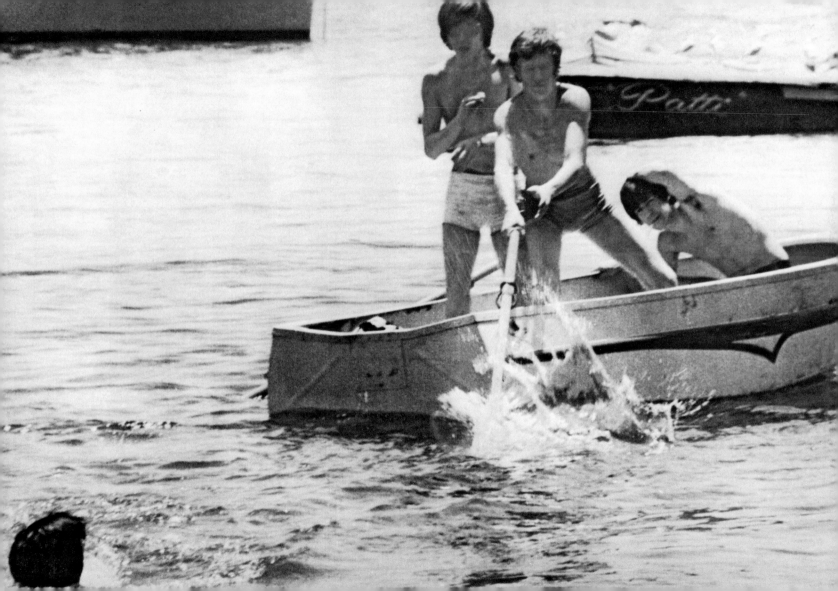

Soft-shoe Shuffler

Tripping the light fantastic, Mick strikes a classic pose mid-song. Jagger's presence in Australia with his fellow troubadours was an outstanding success; the ten thousand fans who crammed into the band's first Sydney concert held testament to the gospel according to the Stones—and screamed their way through the entire concert.

Associated Press: "During one number, in which he [Jagger] shook off his coat, they nearly went wild and several girls tried to storm the stage."

79

I Told You Once...

The Stones go all out, promoting "The Last Time" on UK television, early 1965. Musically and lyrically, that year saw the group emerge from the shadows of their former blues influences to concentrate fully on their own talents as songwriters and musicians. "The Last Time" was worlds apart from their previous single "Little Red Rooster" and helped to define the Stones' unique sound—but not without a few nods to their influences.

Keith: "I guess we were just getting about good enough to be able to resort to write for ourselves, you know, and to believe we could do it. I think 'The Last Time' was the first one we actually managed to write with a beat, the first non-puerile song. It had a strong Staple Singers influence in that it came out of an old gospel song that we revamped and reworked."

80

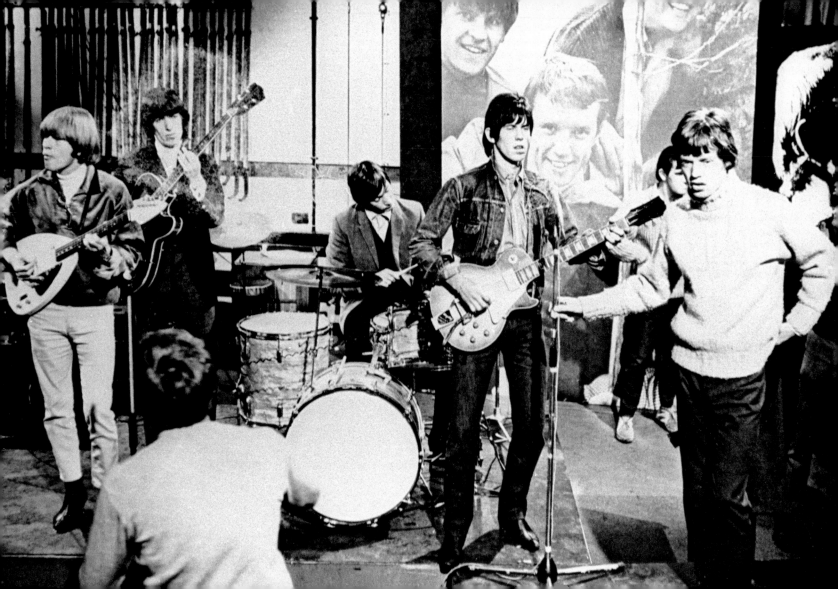

Continental Stones

En route to their first series of concerts in Scandinavia, the Stones make their way to their SAS plane in March 1965. The band hadn't yet cut their teeth working around the clubs and bars of Western Europe, a popular touring destination for bands in the early 1960s. Their first jaunt onto the Continent included six dates in Denmark that would lead to further shows in Sweden—in Gothenburg and Stockholm.

81

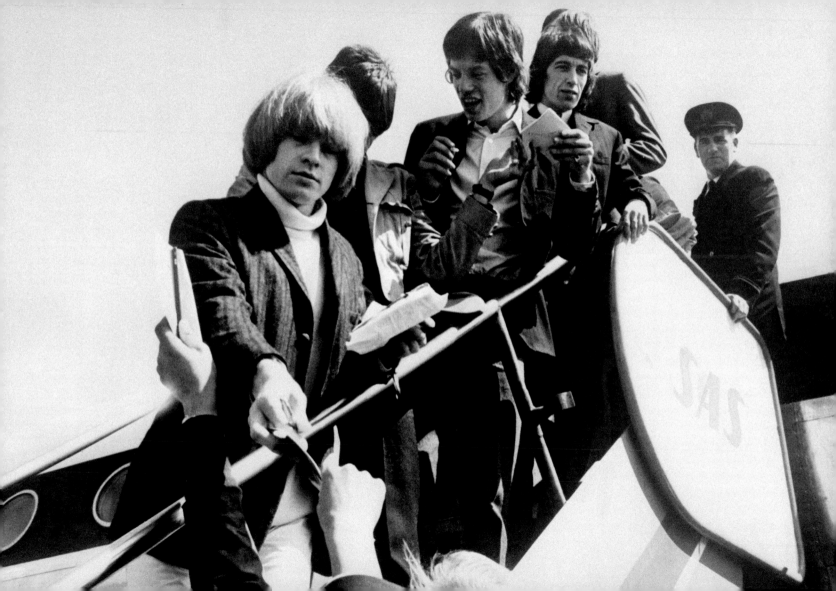

Shocking Welcome

The Stones arrive in Denmark to kick off their Scandinavian tour in March 1965. In a mishap far more inauspicious than the usual storm of controversy, three band members received powerful electric shocks while rehearsing for their concert in the Danish city Odense.

Daily Mirror: "During a sound-check before their concert in Odense, Denmark, last Friday, the Rolling Stones received a shock (of the electrical kind) when lead singer Mick Jagger came into contact with two live microphones at once. They short-circuited, throwing him against Brian Jones who collided with Bill Wyman who was knocked unconscious by the 220-kilo volt shock. The show's promoter, Knud Thorbjoerson, said, 'Bill Wyman came to after a few minutes. The thing that saved them was that an electric plug was pulled out by Mick Jagger's fall.'"

82

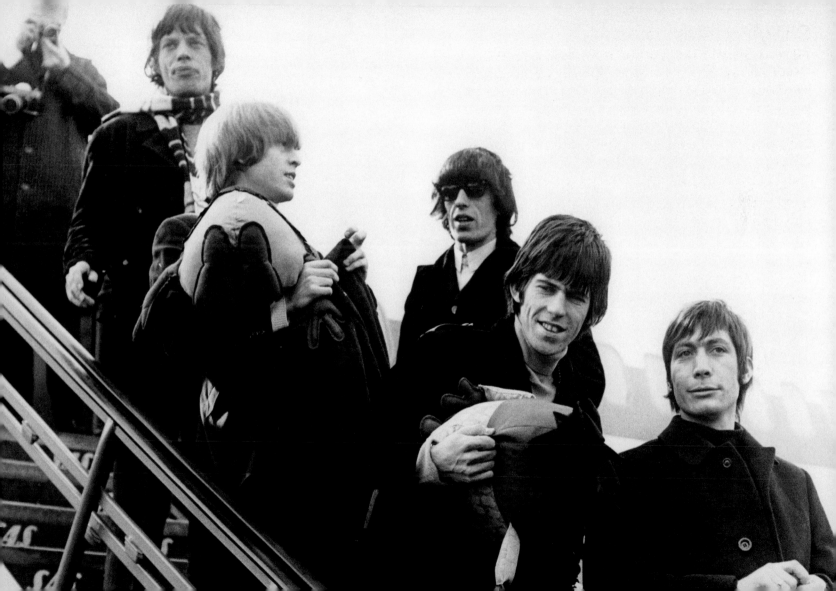

Poll Winners!

The Rolling Stones clasp their silverware at the *New Musical Express* awards show on April 11, 1965. Held at the cavernous Wembley Empire Pool, the shindig offered all the major groups the chance to celebrate the previous year's achievements. The Stones easily walked away with the award for Best Rhythm and Blues Act of 1964, and also played a short set to an ecstatic audience of ten thousand. On hand to give out the awards was American crooner Tony Bennett. The Beatles walked away with the majority of the silverware that day, but the Stones were on their tail. There had been a spirited discussion backstage led by John Lennon—perhaps feeling the heat—as to whether the Stones or the Beatles should close the show. Lennon's rage won the Beatles their spot, and little love was lost in the process.

83

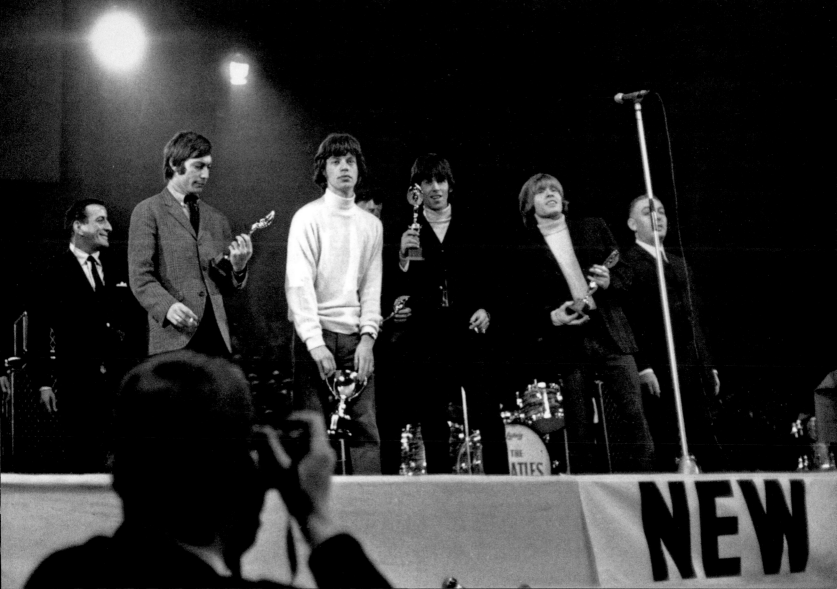

All Together Now

In among the *New Musical Express* poll winners, Brian and Mick represent the Stones at London's Wembley Arena, April 11, 1965. With their star-studded rosters, *NME* poll-winner concerts were easily the top annual celebrations of British talent. Backstage at Wembley Arena, the leading bands socialized with one another in the cramped dressing-room area; it was more like an end-of-term social event than a concert. The 1965 lineup was exceptional, including among its ranks the Kinks, the Searchers, the Animals, and the Beatles. That year saw a shift away from the domination of the Mersey Beat contingent, with southern England's corner being represented, quite naturally, by the Rolling Stones.

The noise emitted from the sound system during the Stones' ten-minute slot was primitive in the extreme—not surprisingly, since they had only been allotted two minutes to adjust their amplifiers and check tuning. Nevertheless, the crowd went characteristically potty for the Stones' set.

84

Pleasing Mr. Sullivan

"A word in your ear, Mr. Jagger." Rehearsing for the *Ed Sullivan Show,* May 2, 1965. The Stones' relationship with the doyen of American variety was somewhat rocky. Sullivan had been put off by the band's conduct and their general appearance when they had first appeared in 1964, and had vowed never to give the group airtime again. However, given the Stones' massive popularity in America, demand for their return to the country's principal variety show was something even Mr. Sullivan couldn't ignore. But there was a catch: Sullivan sent an edict to Andrew Loog Oldham demanding that the group smarten themselves up for the show. The Stones acquiesced, and spent the afternoon before recording out shopping for some snazzy new gear. Sullivan was evidently impressed, and so seemingly were the set designers, who positioned the band under dozens of chandeliers. The resulting show was a tremendous success, prompting the celebrated host to wire a carefully worded telegram congratulating them.

Telegram from Ed Sullivan: "I received hundreds of letters from parents complaining about you, but received thousands of letters from teenagers praising you. Best of luck with your current tour. Kindest regards. Ed Sullivan."

85

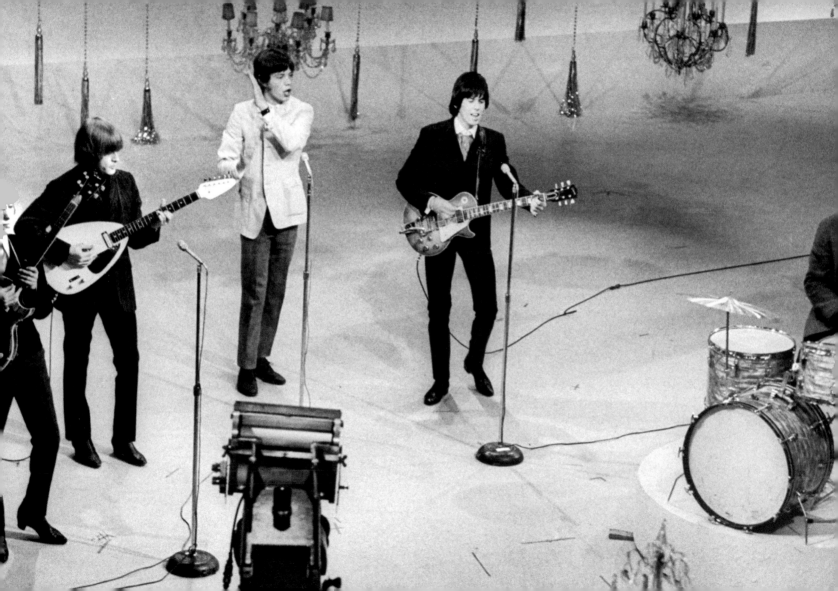

Hitting Their Marks

A view from the high seats on the set of the *Ed Sullivan Show* on May 2, 1965. Although their reputation preceded them, the Stones were savvy enough to realize that Sullivan's show would give them unprecedented exposure and had the potential to send record and concert sales into the stratosphere. Manager Andrew Loog Oldham, well aware that the coverage they would receive would be far greater than any they could conceive of in Europe, ensured that every U.S. media outlet knew about the appearance.

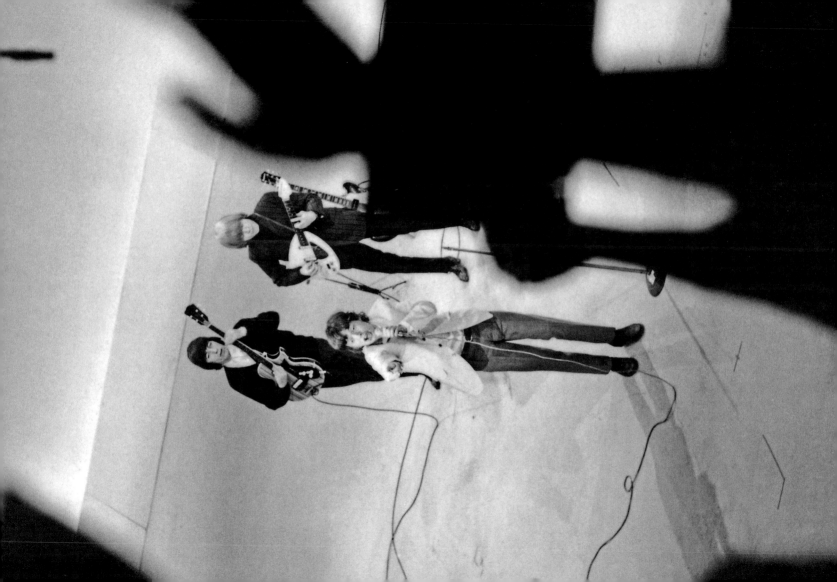

As Tears Go By

While Mick and the Stones were enjoying some time off from their third American tour, chanteuse Marianne Faithfull was locked into the predictable tour/television/promotion routine. Touring was grueling and never a joy for Faithfull; she had pulled out of a feverish UK tour in late 1964 due to exhaustion, and in February 1965 she—with Roy Orbison—endured a grueling thirty-day tour.

With Faithfull's single releases maintaining healthy positions in the charts, her broad appeal was maximized with the simultaneous release of two albums. The folksy collection *Come My Way* and an eponymous LP that included two hit singles did well in the charts and received critical acclaim. Despite her popularity, however, she was obliged to attend such events as the British Pop Song Contest in Brighton on May 26, 1965—standard fodder for any artist hoping to stay in the limelight.

Marianne Faithfull: "The dolly girls all jiggled and jumped up and down and shook their moneymakers, doing little go-go steps in their thigh-length white boots. I didn't want to compete with that, so I decided to go as far as I could in the other direction. I simply stood there in front of the microphone, very still, my hands dangling by my side and sang from someplace deep inside me…"

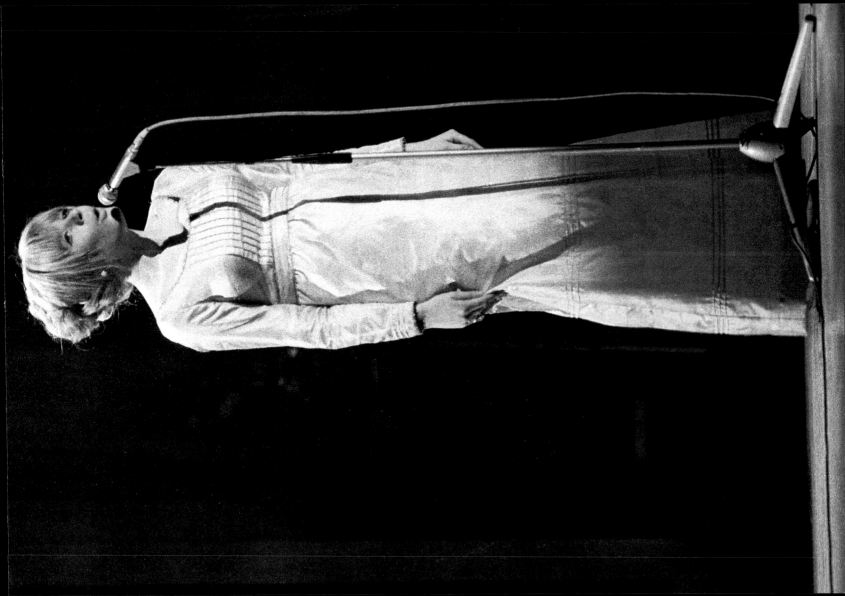

Insulting Behavior

After a night of carousing in East London on March 18, 1965, the Stones stopped off at an all-night filling station in Stratford, East London, so that a liquor-filled Bill Wyman could relieve himself. The station owner, Mr. Charles Keeley—a former monk—wasn't that keen on Bill Wyman (or, in his words, the "shaggy-haired monster") using his facilities at such a late hour, so he denied entry. Upon refusal, "eight or nine youths" including Jagger and Jones, leaped out of the car chanting, "We'll piss anywhere, man." Jagger, Jones, and Wyman then allegedly relieved themselves against the garage wall. The resulting hearing on July 22 found the three Stones convicted on the charge of "insulting behavior," and they were each fined £3 plus costs. The court appearance brought brotherly support from character witnesses Charlie and Keith.

Keith: "Suddenly this guy steps out. And a cop flashes his torch on Bill's cock and says, 'All right. What you up to then?' And that was it. The next day it was all in the papers. Bill was accused and Brian was accused of insulting language. The thing with Bill is, and this is one of the best-kept secrets in the Rolling Stones, that he has probably got one of the biggest bladders in human existence. When that guy gets out of a car to take a pee you know you aren't going to move for 15 minutes. I mean it's not the first time it happened to him. To my knowledge, Bill has never done 'one' in under five minutes."

88

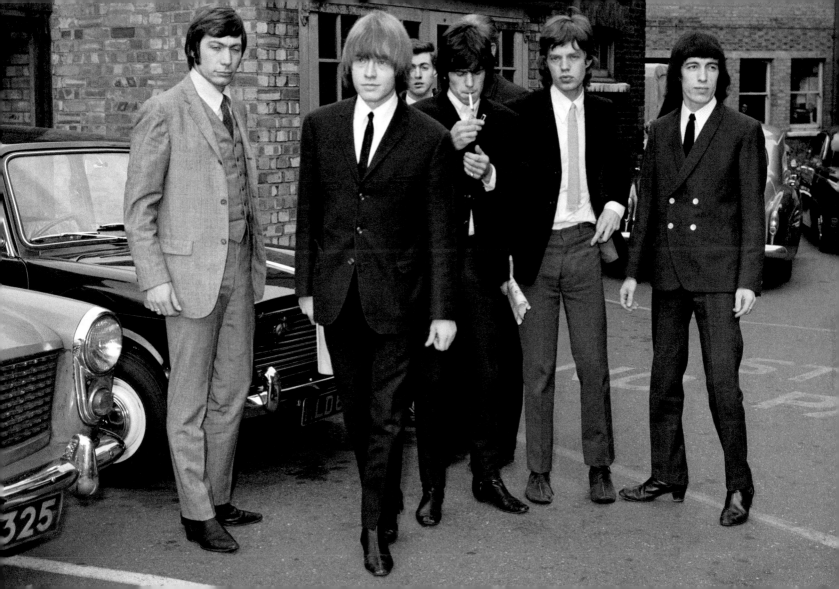

Loyal Support

Character witnesses Keith and Charlie share a quick cup of tea prior to their compatriots' July 1965 court hearing for the charge of "insulting behavior." More than three hundred curious onlookers gathered around the magistrates' building in West Ham, East London, to await the Stones' emergence from court.

Magistrate: "Because you have reached exalted heights in your profession it does not mean you have to act like this. On the contrary, you should set a standard of behavior which should be a moral pattern for your large numbers of supporters."

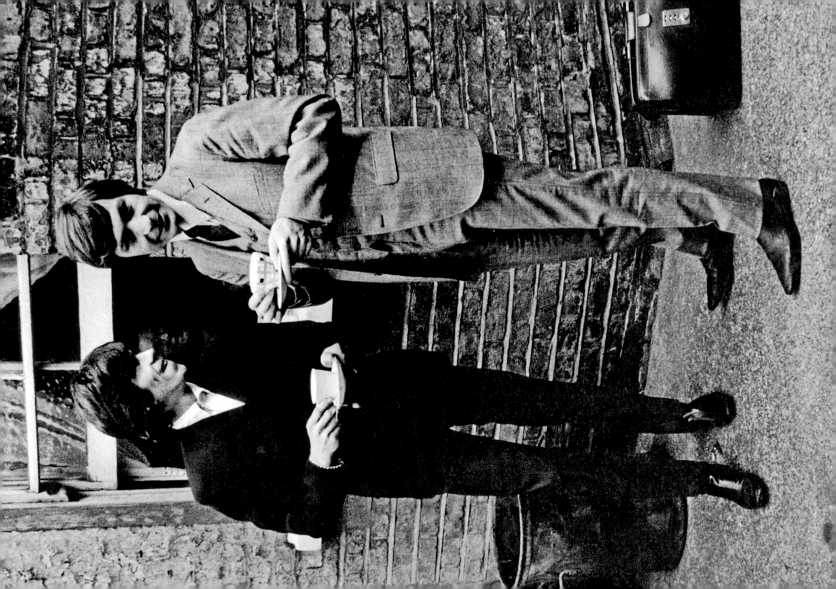

Shrimpton and Jagger

Evidently the link between photographer David Bailey and Mick Jagger was enormously strong. As two of London's prime movers in the new aristocracy comprised of pop stars and artists, they could move around the swinging social scene with ease. Of all the young photographers exploding on the scene, it was Bailey who best personified the "young, brash artist." His stark monochromatic style was in keeping with the current mood, and he gained enormous respect among the ranks of young British celebrities who were seemingly taking over the world. Bailey married the 21-year-old French actress Catherine Deneuve on August 18, 1965, and as if to publicly endorse his friendship with Jagger, he invited the Stone to be his best man. Mick arrived at the ceremony at St. Pancras Registry Office in London's West End with his sweetheart Chrissie Shrimpton—sister to the queen of British fashion Jean Shrimpton (and ironically, an old flame of Bailey's). He then spent a few quiet moments with Chrissie in the anteroom of the registry office before leaving with Bailey and Deneuve to meet the world's press, who'd formed a throng at the entrance.

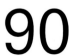
90

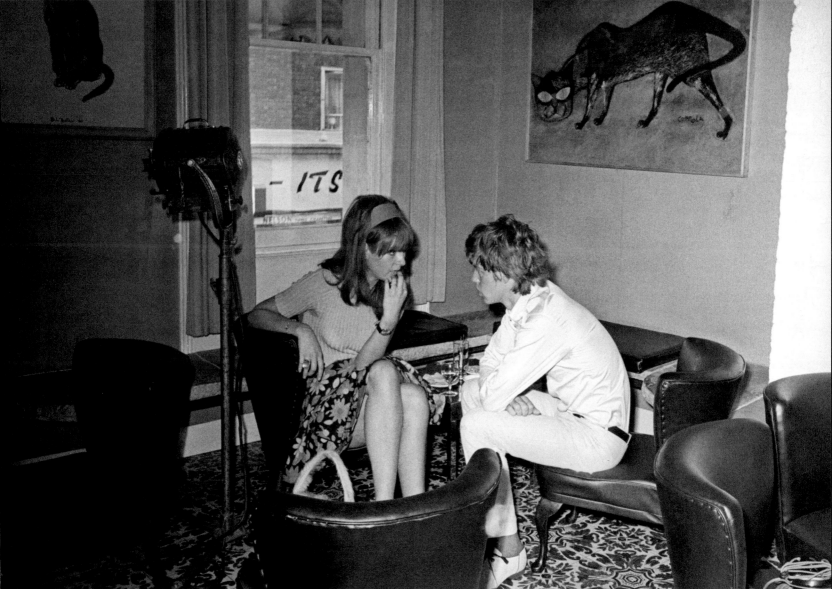

Rodeo Show

Recording again in California, the Rolling Stones held a brief press conference at LA's swanky Beverly Rodeo Hotel on July 10, 1965. The group enjoyed recording in the States, and found the freedom of the sessions worlds away from the formal constraints of UK recording duties. It was during this trip that Andrew Loog Oldham secured the services of business manager Allen Klein. The appointment of the savvy 32-year-old entrepreneur was timely as the group's paltry contract with Decca Records was due to expire later that month. With Oldham keen to explore more creative pursuits, Klein was the ideal person to negotiate on the behalf of the Stones and to secure Oldham's financial dreams.

91

Forward into Chaos

With Andrew Loog Oldham at far right, the Stones prepare to leave London Heathrow Airport to begin another tour abroad. Often mayhem awaited them.

Daily Mirror: "Düsseldorf: Police used fire hoses on several thousand screaming teenagers here yesterday as the mob broke through security cordons when the group's plane touched down. Police called a press conference after 15 minutes to say that they couldn't guarantee the safety of the British group."

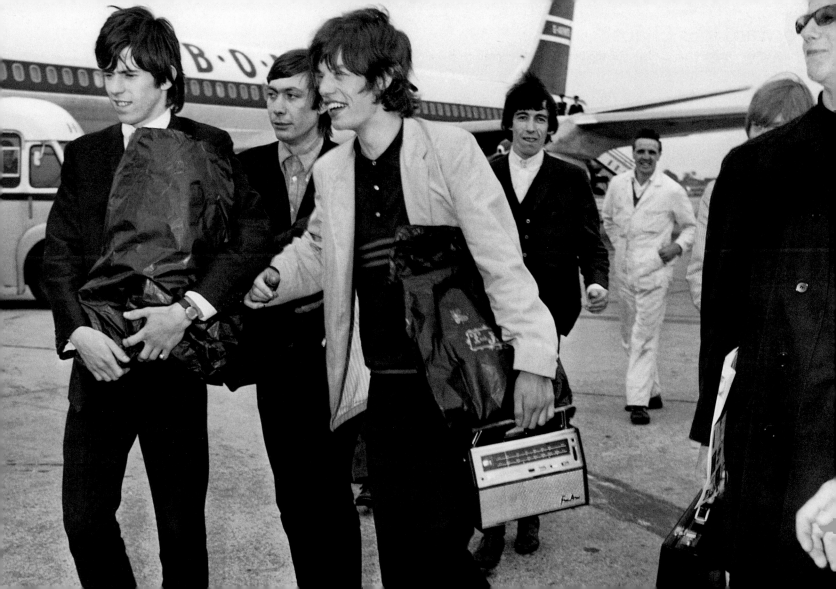

Surrounded

During their September 1965 tour of West Germany, the Stones put on a brief but highly eventful performance in West Berlin on the seventeenth of the month. Although they had top billing, the band played to the excitable crowd at Waldbuhne Halle for just twenty minutes before hastily leaving the venue. Germany, like every other country the group visited that year, was in the grip of Stones mania.

93

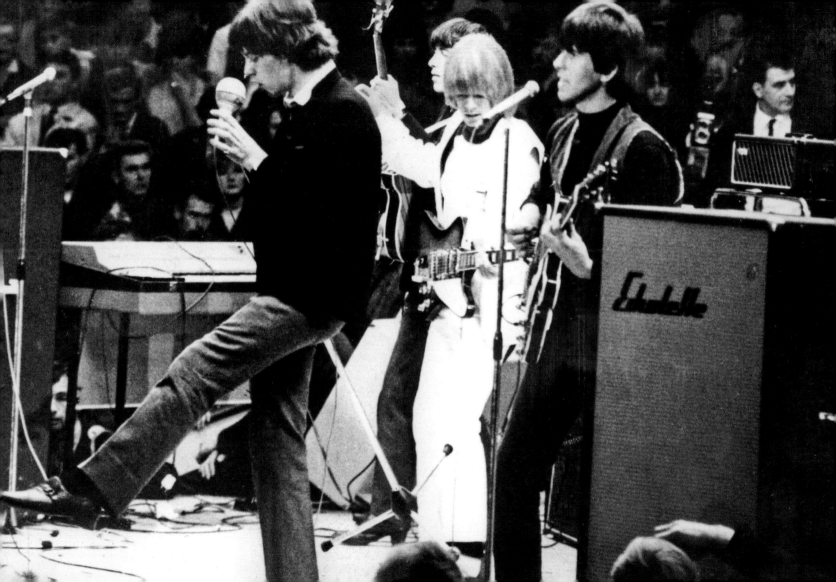

Back from Holidays

Mick arrives back at Heathrow on December 29, 1965, after a vacation in Jamaica with girlfriend Chrissie Shrimpton. Despite the close relationship, Chrissie's days with the cavalier Stone were numbered. Within the year the gradually advancing specter of Marianne Faithfull would drive them apart.

Chrissie Shrimpton: "When I first met him, I thought he was very weird and needed a head doctor. I had seen Mick on TV and thought he looked thin and pathetic. Anyway, when I finally met him at a party, I completely changed my mind about it. I fell for him right off."

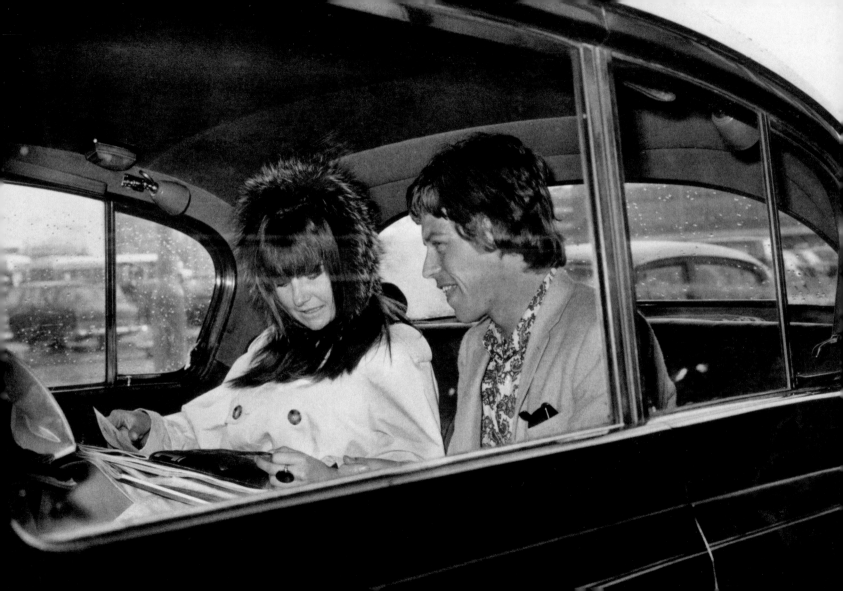

It's Not Finished Yet

Caught unawares prior to a January 1966 appearance on BBC TV's highly rated *Top of the Pops*, Mick emerges from under the dryer, hairnet still in place. Despite all the press given to the Rolling Stones' unkempt looks, Mick was extremely conscious of his image and would go to considerable efforts to maintain his appearance. Mick's sexuality has always provoked spirited debate, and even those close to him in the '60s were aware of the dichotomy between the virility he projected onstage and his almost womanly good looks.

Chrissie Shrimpton: "Mick was very masculine minded; he was very strong and very aggressive... But physically he was very feminine. Even to me he seemed outrageously camp."

95

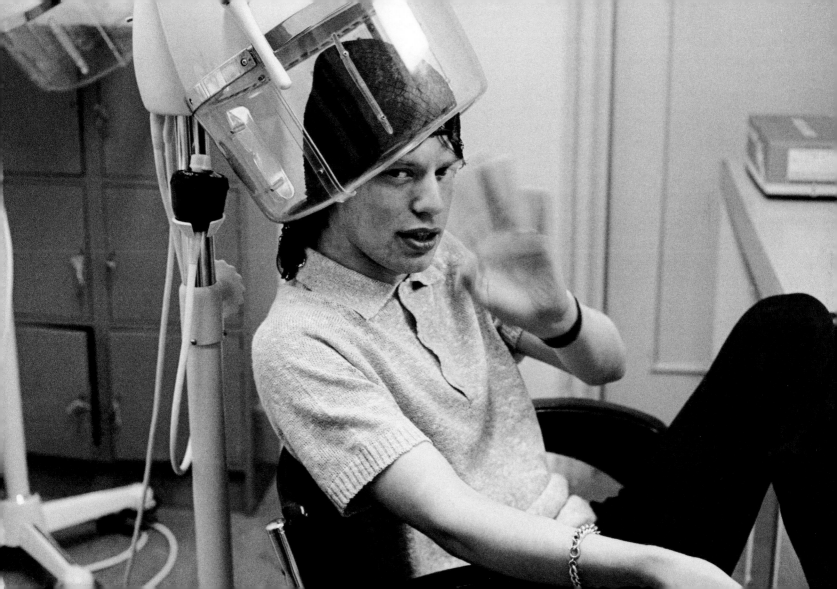

19th Nervous Breakdown

Practically regulars now on the *Ed Sullivan Show*, the band belts out their new single release "19th Nervous Breakdown" on February 13, 1966—their third appearance on the show in less than two years. The lyrical content the group had been known for, a mixture of blues and boy-meets-girl, was now taking a sharp turn into uncharted waters. "Breakdown" would prove prophetic for Jagger's girlfriend Chrissie Shrimpton, who would be driven into mental collapse on hearing of Jagger's affair with Marianne Faithfull later that year.

Mick: "People say I'm always singing about pills and breakdowns, therefore I must be an addict—this is ridiculous. Some people are so narrow-minded they won't admit to themselves that this really does happen to other people besides pop stars."

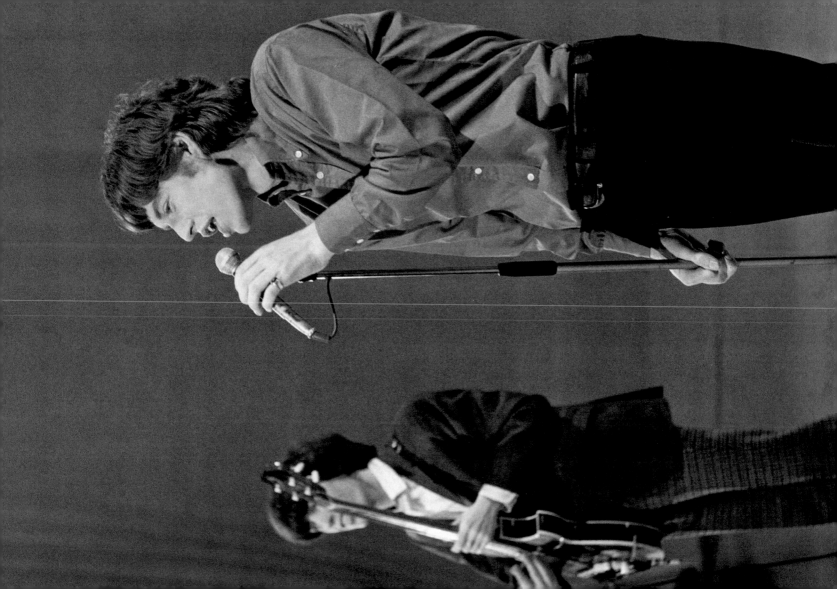

Duty-free Stones

Back from a European tour encompassing Holland, Belgium, Sweden, Denmark, and France, the Stones, sans Charlie, lark about the tarmac at Heathrow Airport on April 6, 1966. The tour's highlight was undoubtedly the two concerts on March 29 at the famed Paris Olympia theater. Young Parisians evidently adored the Rolling Stones and their anarchic style. Even Britain's *Daily Worker*, the mouthpiece of the British Communist Party, dispatched a reporter to cover the riotous events at the Olympia.

Daily Worker: "Some 3,000 teenage fans howled, wept, wrecked fifty seats and fought the police here last night during a performance by the Rolling Stones. Police took 85 fans into custody but released them all except one this morning—he had bitten a policeman. Said one of the Stones afterwards: 'It's one of the best nights we've ever had.'"

97

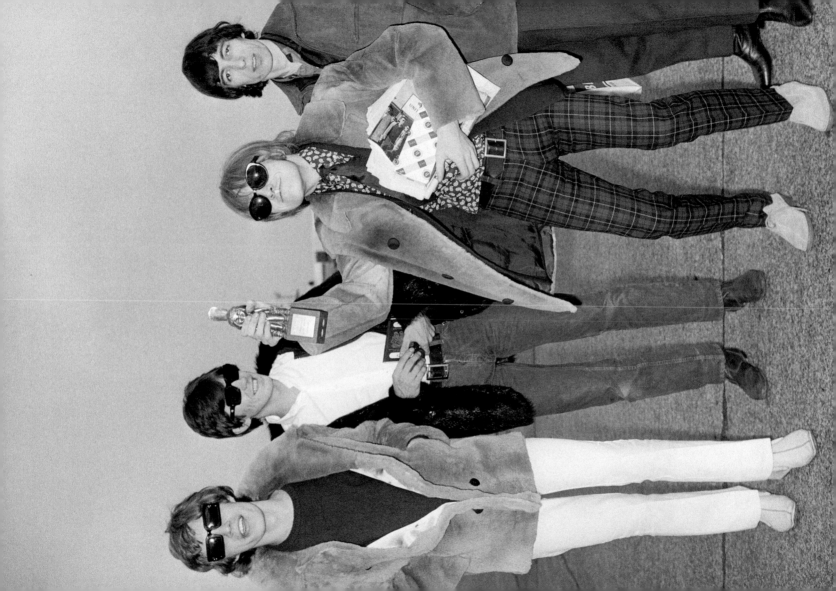

Autograph Duties

Clear of the runway, Mick signs some autographs as he makes his way out of Heathrow Airport on April 6, 1966. The blotchiness around his eyes was the result of an overzealous fan's hurling a chair at him at a gig on the French Côte d'Azur, although Jagger seemed relatively philosophical about how he received the injury.

Mick: "Somebody threw a chair at me while I was singing 'Satisfaction' in Marseille. They do it when they get excited. It was just enthusiasm—they go a bit wild. It's stupid behavior but it's a risk we take."

Reach Out

Mick points to the higher reaches of London's Wembley Arena during the *New Musical Express* Poll Winners show of May 1, 1966, where the Stones were making their third appearance at the star-studded event in just three years. Not surprisingly, the Beatles won the majority of the silverware that afternoon, although the Stones matched them, if not in votes then in cheers from the ten-thousand capacity crowd.

The Poll Winners show had become an annual TV spectacular, but mindful of the disruptions caused by rowdy fans in the past, the technicians' union ordered a temporary walk-out during the Beatles' and the Stones' appearances, and so no footage of either band at this show exists.

Cool, Calm, and Collected

Stones' Svengali Andrew Loog Oldham wanders along London's Strand in June 1966. Beyond his knack for commanding respect, Oldham had the permanent swagger, youthful arrogance, and supreme confidence that marked him as one of swinging London's prime movers. Oldham was the perfect embodiment of the new breed of self-made impresarios dominating the music world in the mid-1960s. Confronting the nepotistic hierarchy that existed in the entertainment world, Oldham's presence sent considerable shockwaves throughout the industry, and his cocky, self-assured presence established a template for all future music promoters to follow.

Andrew Loog Oldham: "Truculent, obstinate, teenage, excessive... yes. What do you expect from a 21-year-old kid driving around in a Phantom V who hasn't paid his taxes? But bad? Not at all; my universe is clear and I'm an asset to it."

100

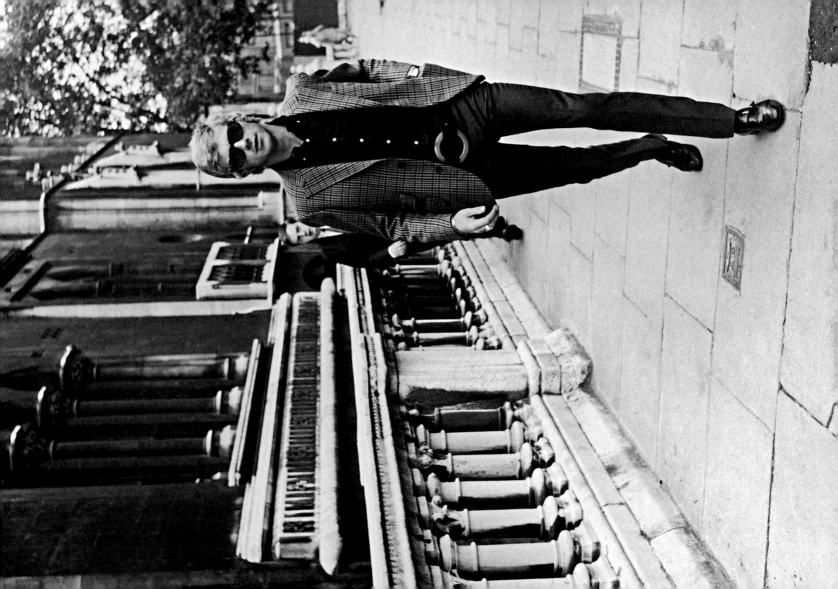

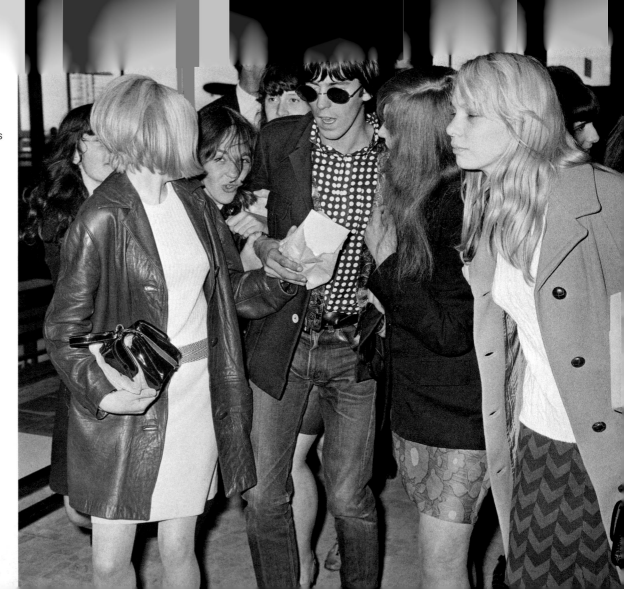

June 23, 1966, a date that staff at London Heathrow Airport will never forget. As the midsummer sun rose on the West London terminal, hordes of crazed fans were waiting to send the Beatles off on a tour of Germany and the Far East. No sooner had the Fab Four departed from the airport than a second shift—of hundreds of Stones' fans—took up residence to see their heroes off as they headed to New York for their fifth tour of America. Ian "Stu" Stewart, known as the sixth Stone, is standing on the sidelines, far right (opposite).

101

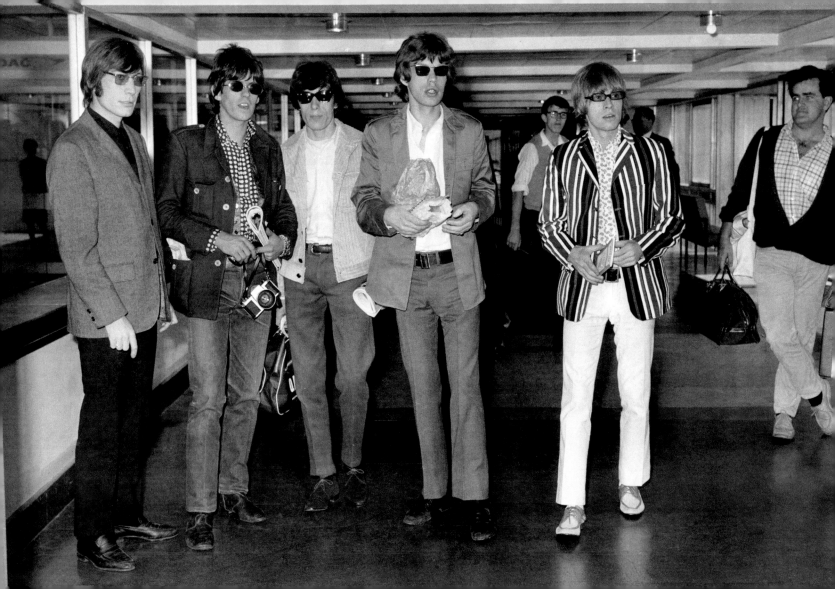

Taking Off

Leaving the tarmac at Heathrow, June 23, 1966, the Stones make their way up to their TWA plane bound for the States and their forthcoming American tour. Spanning more than six weeks, the series of dates took in all quarters of North America, with concerts as far flung as Hawaii and Vancouver. Also on the agenda were more recording sessions and meetings with the likes of Bob Dylan and Jimi Hendrix, or Jimmy James as he was called then.

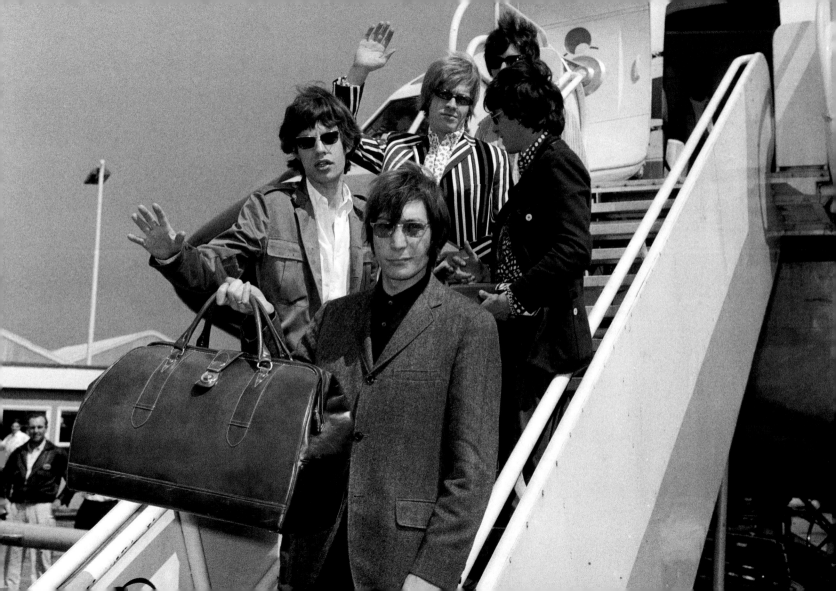

Dulcimer Duty

Brian Jones taking what was fast becoming his customary seat. The most musically adventurous Stone, Brian played electric dulcimer on "Lady Jane," adding new dimension to the band's evolving sound. The Stones' summer tour of the States was their fifth American tour in the space of two years. This appearance at Forest Hills Stadium (then famed as a venue for the U.S. Open tennis tournament) was the headlining act of an all-day music festival, and the Stones provided a suitably charged finale.

Brian: "It's an old English instrument which was used at the beginning of the century. It gives a kind of bluegrass sound, and you pluck it like a harpsichord—I use a sharpened quill."

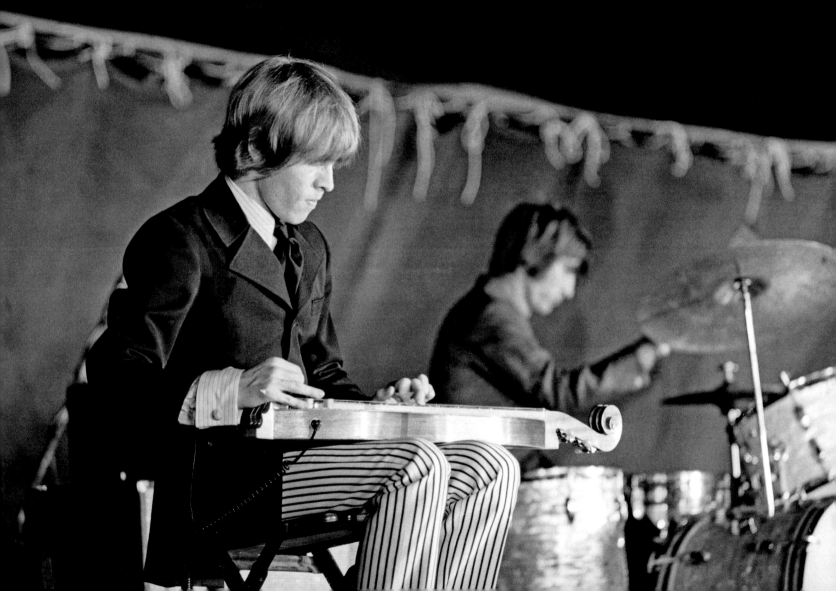

View from the Rear

Charlie attempts to keep time as the Stones battle the screams at Forest Hills on July 2, 1966. The musical set during this U.S. tour was hardly a predictable rerun of past glories; instead, it mixed tracks from the new album *Aftermath* with a few memorable songs from the last year. Only the opener "Not Fade Away" gave any hint of the band's earlier style; the set was limited to 1965 and 1966 releases so as to showcase the new, more experimental direction the band was taking.

Contained

With temperatures soaring into the high nineties, the Stones' set at Forest Hills that July 2 was met with some rioting—something that was becoming de rigueur at Rolling Stones concerts worldwide. New York fans were no less spirited than their peers on the Continent, and many had to be contained with police batons and tear gas.

Mick: "It's a strange thing. From the audience you feel a tremendous energy. It is directed to, or at, you. It is, you feel, as if they are trying to say something to you. I don't know, perhaps they don't know what they are trying to say, what they want from life, or what they want from me, as a person, as a performer."

105

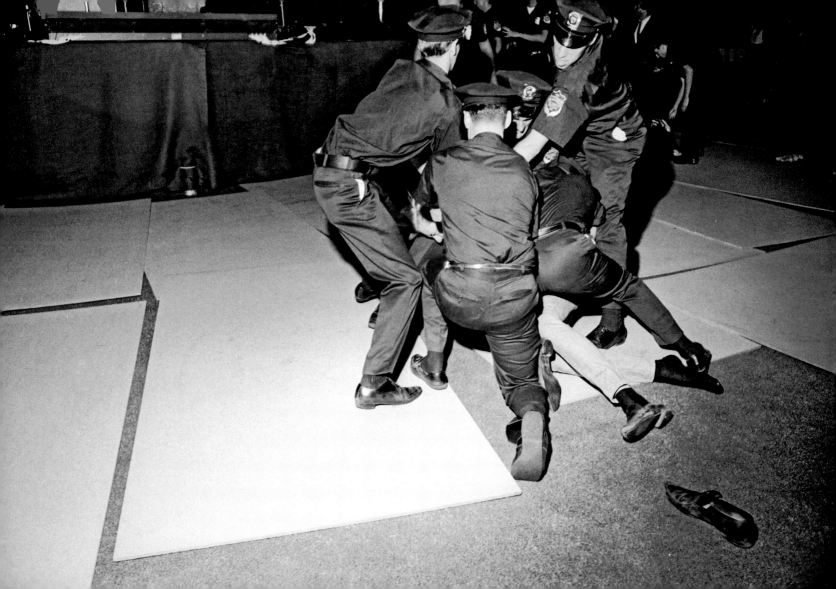

Frankly, Mr. Jagger...

There was to be a slight hitch in the Stones' fourth appearance on the *Ed Sullivan Show*. The group's hectic tour schedule (which had been virtually nonstop since early 1963) finally slowed in August 1966, allowing the band some well-earned time off. While the rest of the Stones visited traditional holiday destinations, Brian took off to Morocco with his sweetheart, model Anita Pallenberg, in search of sunshine, mystical pipe players, and good hashish. While climbing a mountain, the guitarist had a fall and broke his left hand in two places. The band's headlining appearance on the *Ed Sullivan Show*, scheduled for September 11, was of sufficient importance to warrant lining up a replacement guitarist—but in the end, Brian made it to the show.

Out of Time

Keith and Charlie share a joke with Chris Farlowe on ITV's top-rated *Ready Steady Go!* on October 4, 1966. Farlowe, a gifted young soul singer, had recently been signed to Andrew Loog Oldham's record label Immediate, created to expose raw new talent to a wider audience. The young Farlowe was greatly indebted to Mick and Keith for penning his top-rated single "Out of Time."

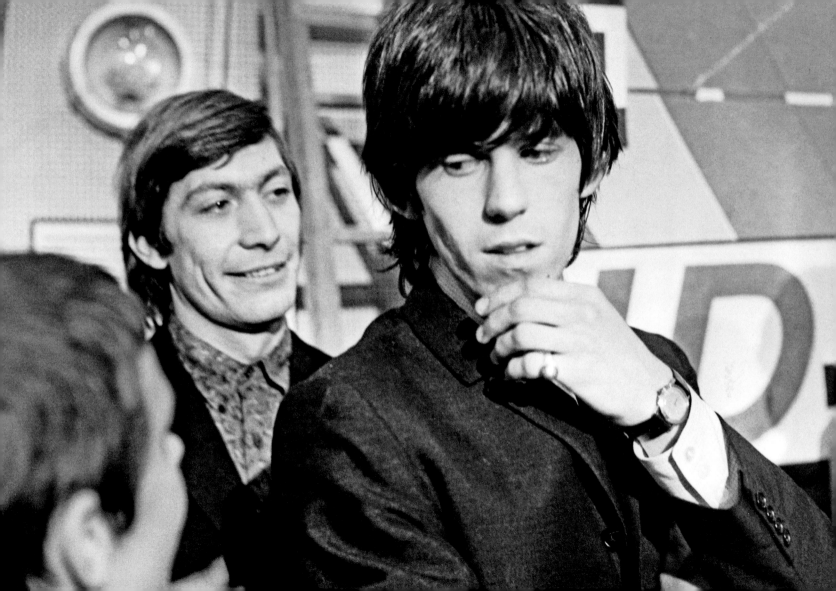

Deadlier than the Male

Brian Jones greets Anita Pallenberg on December 3, 1966, as she arrives at London Heathrow Airport after a modeling assignment in Paris. There to carry her bags is loyal Stones aide Tom Keylock (at left).

Pallenberg was at the peak of her career in 1966 and was courted—if not feared, given her capacity for drugs and flirtation with dark forces—within the Stones' camp as a figure of considerable power.

Andrew Loog Oldham: "Anita Pallenberg. An absolutely devastating lady, deadlier than the male and twice as attractive. If she had played guitar ... !"

108

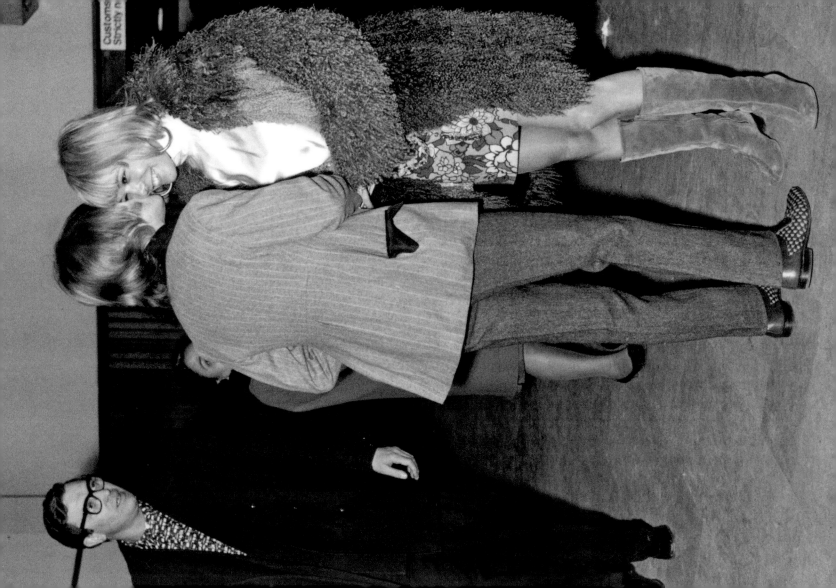

That Elfin Smile

In 1966, the party seemed as though it was never going to end. The climate was positively buzzing: London had been christened the center of the universe; young people were exploring freedoms never before imagined; and on the crest of this new wave was the Rolling Stones.

Before Marianne Faithfull's much publicized romance with Mick Jagger, however, she was involved with artist-cum-entrepreneur John Dunbar. Dunbar was a prime mover in London's avant-garde movement, and would later take credit for bringing John Lennon and Yoko Ono together at his Indica Gallery. Faithfull married Dunbar in 1965, and despite the birth of a son, Nicholas, the union was a troubled affair that would not last the year. Following the breakup, Faithfull immersed herself in the Stones' camp for a time before beginning her relationship with Mick.

Faithfull took to the Stones' hedonistic manifesto with gusto, gleefully lapping up the proliferation of sex, drugs, and mind-expansion that was on offer. But whereas Mick had a steely resolve that allowed him to dabble benignly in such activities, Marianne became totally absorbed in the culture, especially when it came to drugs. Riding high at the center of the hurricane, life, for a while at least, seemed perfect.

Marianne Faithfull: "Ahhh. It was magic; it was like a doorway had opened up to a world I didn't know.... The Stones were starting to get really powerful, and I was continually shooting my mouth off about how wonderful it was to take LSD. I was a real trouble like that. One of those joys about being young and strong."

109

Glassy-eyed Innocent?

Marianne Faithfull's smoldering appeal stemmed from her demure ex-convent-girl demeanor mixed with soft sexual overtones. Terry O'Neill's 1966 photographs of Faithfull in lingerie presented another image, one that was hinted at but rarely expressed—for many, she was just a convent girl possessed of a unique voice and friends in high places. Her romantic collision with Mick occurred in December of 1966, although she'd already made several inroads into the Stones' faction before their first serious encounter.

Marianne Faithfull: "When I was about sixteen, I wanted to be an actress, and a scholar too. But whatever I wanted to be, I wanted to be great at it. My first move was to get a Rolling Stone as a boyfriend. I slept with three and decided that the lead singer was the best bet."

New Year's Resolution

A cold, damp morning in London's Green Park—hardly ideal for a photo shoot, but publicist Les Perrin had arranged the January 11 session, prior to the Stones' early 1967 trip to the States, to satisfy a voracious demand for photographs. The Stones acquiesced but, ever mindful of certain segments of the media, barred reporters from attending.

The band started the day off in a small pub across from the park in Shepherds Market, Mayfair. Brian was in especially good spirits and happily showed off his new hat, which accentuated his pixieish looks. They downed a few drinks before wandering off toward the park and the mass of cameras.

Dezo Hoffman (photographer): "It was a very cold day and although the photographers were frozen stiff, they only cursed the weather. The Stones were very professional, dressing up to make the pictures more interesting, and behaving like gentlemen. It was a happy session."

111

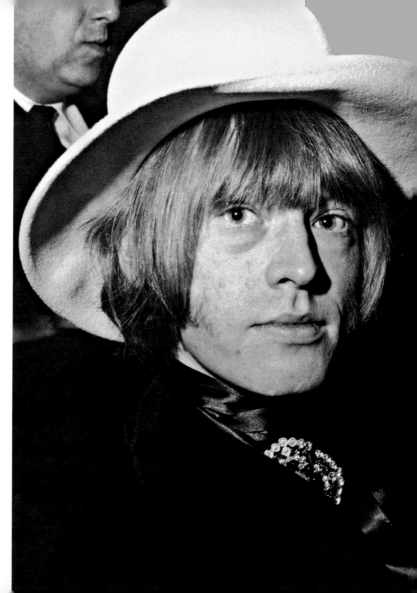

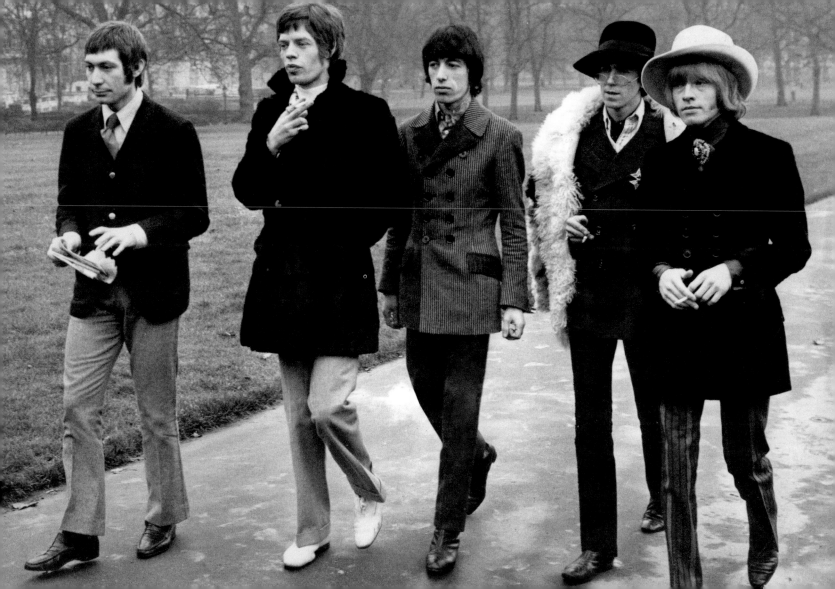

Well, Those Were the Times…

Keith, Brian, and Bill board the plane to meet Charlie for their transatlantic flight on January 12, 1967. According to press reports, when the group learned they'd be leaving for their U.S. tour on Friday the 13th, their delicate antennae picked up on the bad karma and they freaked. Four of them immediately changed the date so as to avoid any horror stories. Evidently assured of his safe passage, Mick went ahead with the original arrangements and flew out on the dreaded Friday.

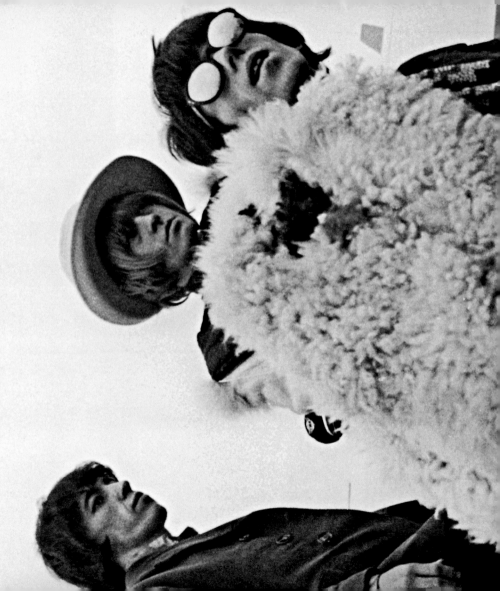

Green Room Politics

Backstage prior to a live appearance on the *Eamonn Andrews Show* on February 5, 1967. Incensed by revelations in the Sunday press, Mick used the opportunity to announce that he was suing the British newspaper the *News of the World* for falsely alleging that he was observed taking and sharing drugs in a London nightclub. The insinuation was indeed false: the reporters at the nightclub had actually mistaken Brian for Mick.

News of the World: "Another pop idol who admits he has sampled LSD and other drugs is Mick Jagger of the Rolling Stones. Investigators who saw Jagger at Blaises Club in Kensington reported: 'He told us I don't go much on it [LSD] now the cats [fans] have taken it up. It'll just get a dirty name.'"

113

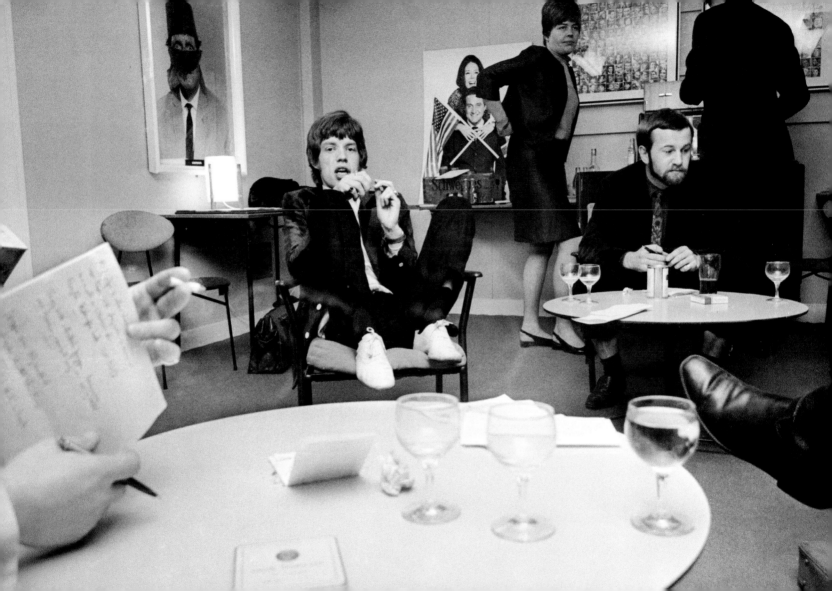

Keeping Quiet

Safely hidden behind a Hammond organ, Brian keeps quietly to his side of the stage as the Stones rehearse their new single "Let's Spend the Night Together" for their early February appearance on the *Eamonn Andrews Show*. Wisely, Brian kept hush-hush on the *News of the World* mix-up that had Mick using drugs in his stead. But the paper had yet to tip off London's drug squad officers to the mass of evidence they had collected on the Stones, and five days later, the wheels would soon start to turn.

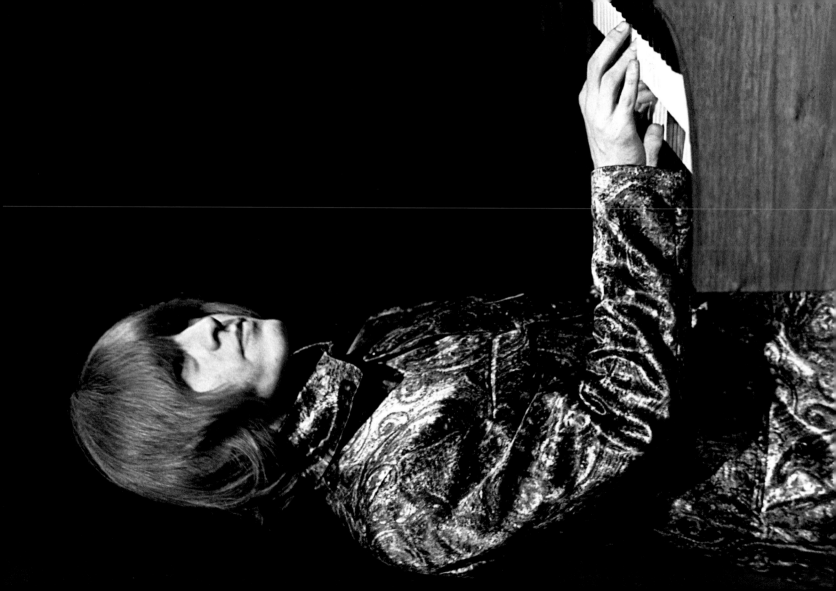

Telling the Truth

Mick Jagger was understandably livid about the front-page feature the *News of the World* ran entitled "Pop Stars and Drugs," replete with his name and photograph. Appearing on the *Eamonn Andrews Show* on the evening following the publication of the allegations alongside comedian Terry Scott, Hugh Lloyd, and singer Susan Maughan, Mick announced, much to the surprise of Andrews and the other guests, that he would sue the *News of the World*.

115

Comic Stance

While presenter Eamonn Andrews takes a cigarette break, Mick ponders less serious matters than drug allegations with comedy legend Terry Scott. Scott was an occasional member of Britain's *Carry On* team and a fixture on UK television during the '60s and '70s. Hovering in the background is comic actor Hugh Lloyd.

More than Ever

Despite the serious nature of Mick's conversation with host Eamonn Andrews, when it came to playing their new release, "Let's Spend the Night Together," the Stones put on a good show. The single, backed with the enigmatic paean to lost love "Ruby Tuesday," was a hit, despite reservations in certain quarters as to the overtly sexual nature of the song.

Mick: "I always say, 'Let's spend the night together' to any young lady I'm taking out. If people have warped, twisted, dirty minds, I suppose it could have sexual overtones. Actually the song isn't very rude. When you hear it you'll realize this. There are a few slightly rude bits, but I've covered them up."

117

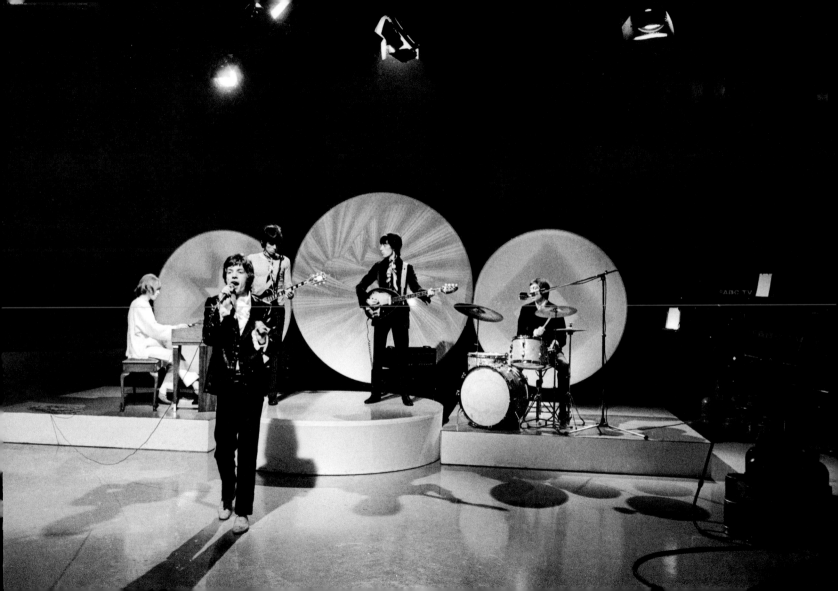

Taxi!

Very much a wanted man, Keith hails a taxi in central London after a meeting with his legal representatives on February 20, 1967. During the weeks leading up to their trial, there was considerable speculation as to how far the prosecution would go to bring the Stones down, promoting a sense of paranoia in the Stones camp.

Although the Stones as a unit were newsworthy during the 1960s, a Stone alone on the street wasn't worth noting. But the Redlands drug bust of early 1967 changed all that and raised their profile considerably—any sighting of either Mick or Keith going about his business regularly grabbed headlines in the day's newspapers.

Two's Company

While awaiting their flight to Tangier, Marianne Faithfull and Anita
Pallenberg wander through Heathrow Airport in search of refreshments on
March 11, 1967. The recent litany of controversy surrounding the Stones
was beginning to weigh heavily upon the group and their retinue. Although
Brian Jones had not been present for the February raid on Redlands, Keith's
home in East Sussex, he was battling with his own demons and had been
hospitalized at the Priory, a clinic for addiction and mental-health problems.
In an effort to lift Brian from his depression, Anita and Marianne encouraged
him to relinquish his sickbed and join them on a trip to Tangier.

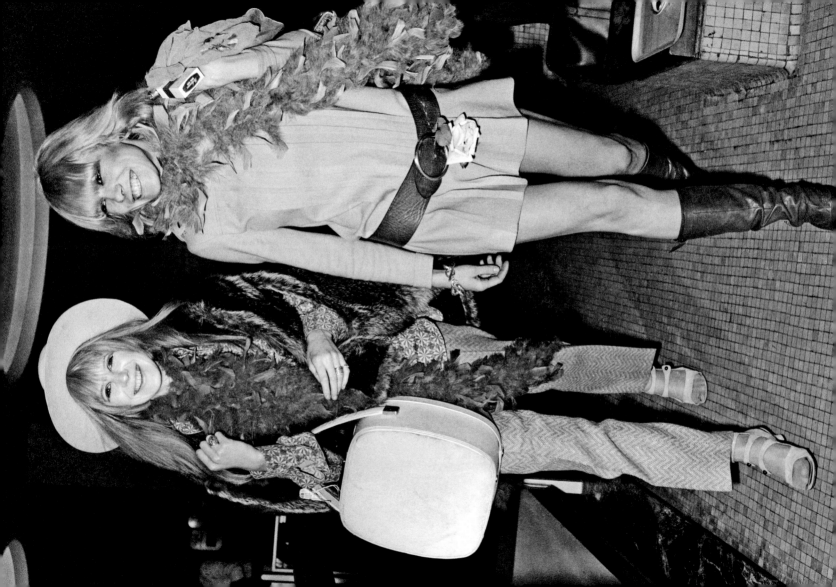

An Unholy Trinity

March 11, 1967. Still feeling the effects of an LSD-infused evening, Marianne and Anita do their best to cheer Brian up. He was in a particularly fragile state, suffering from a dose of mild pneumonia and coming off a recent drug withdrawal to boot. After recovering from the initial shock they had at the clinic over his pale and somber appearance, the women finally managed to get Brian onboard the plane.

Marianne Faithfull: "We went to get Brian, poor baby, from the nursing home. He was having a nervous breakdown, or a drugs breakdown perhaps… He was beautifully dressed, very solemn looking in a black and gray suit and white shirt and tie. Not at all his usual flamboyant clothes with spots and stripes."

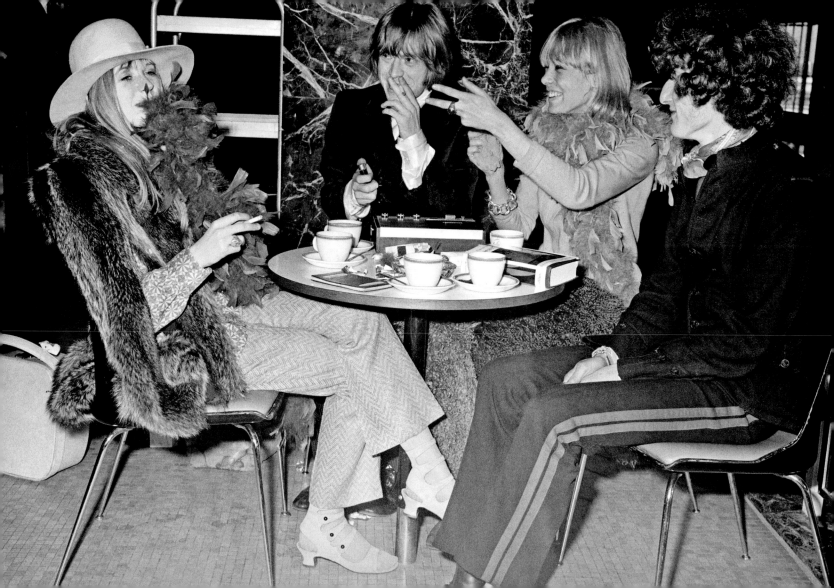

Hot Licks

Keith in an inspired moment at Olympic Studios, April 22, 1967. The Stones' forthcoming album, *Their Satanic Majesties Request*, was to be a coagulation of the new sounds, vibrations, and exotic experiences they were having on almost a daily basis during the heady days of 1967. But outside of the crowd on the acid-driven psychedelic bandwagon, the album was met with a lukewarm reception; many believed the group had abandoned their gutsy R & B heritage—for the worse.

Rolling Stone: "The Stones have been caught up in the familiar dilemma of mistaking the new for the advanced. In the process, they have sacrificed most of the values that made their music so powerful in the first place."

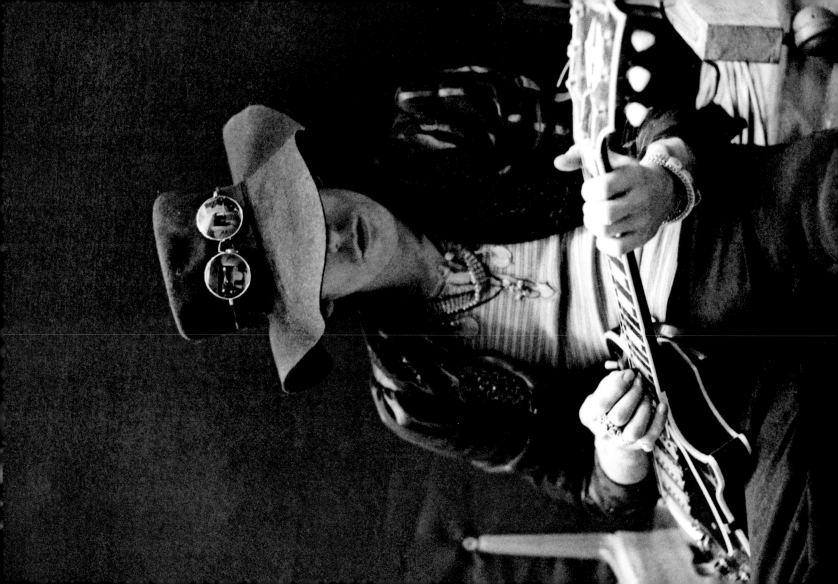

Giving Way

Brian, whose legs have evidently given out, on the floor of Olympic Studios in Barnes, West London, on April 22, 1967. The Beatles were by then well into recording their masterpiece, *Sgt. Pepper's Lonely Hearts Club Band,* and the buzz was starting to affect the Stones' musical direction. In hindsight, their decision to temporarily abandon R & B in favor of full-blown psychedelia on *Their Satanic Majesties Request* was a major error of judgment. Public perception of the group was already clouded by their various drug charges; now their music, too, seemed to be spiraling downward.

Rolling Stone: "It is an identity crisis of the first order, and it is one that will have to be resolved more satisfactorily than it has been on *Their Satanic Majesties Request* if their music is to continue to grow."

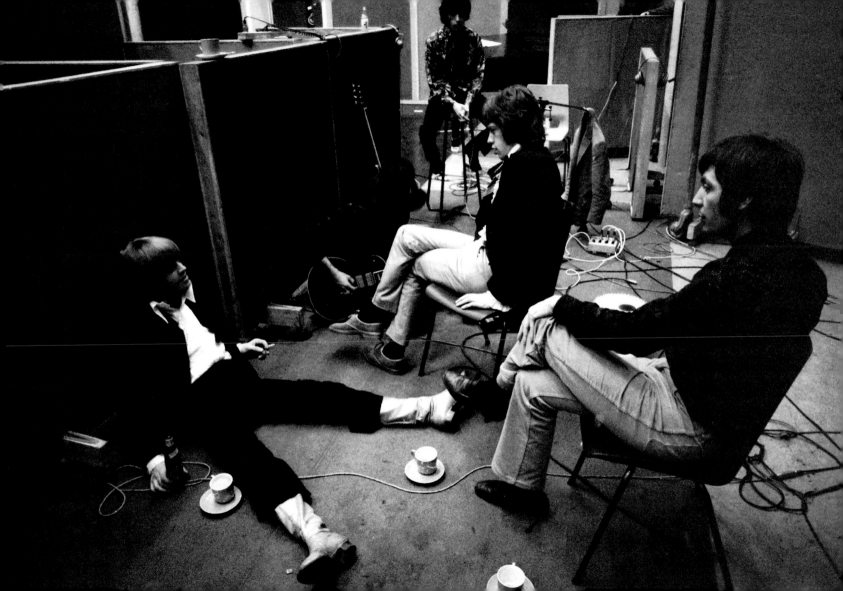

Three Sisters

Mick and Marianne in a huddle following Faithfull's opening night at the Royal Court Theatre in Chelsea, late April 1967. Since March, Marianne had been in rehearsals for William Gaskill's reading of the Chekhov play *The Three Sisters*. Marianne committed herself fully to the task of playing the role of Irina, performing with the likes of Glenda Jackson. Ever the attentive partner, Mick was on hand to lend support.

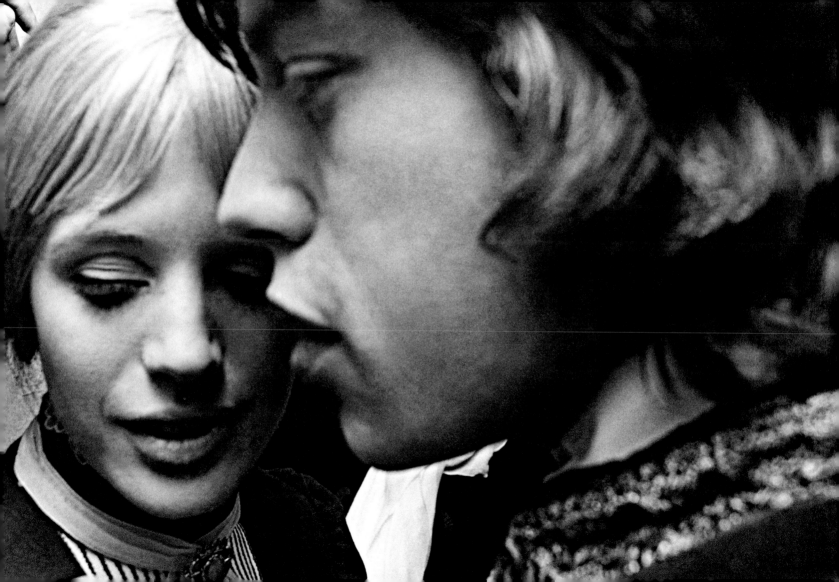

Destination Cannes

Brian and Anita at Cannes, May 5, 1967. The couple made the short trip to the film festival on the French Côte d'Azur to promote their involvement in Volker Schlöndorff's movie *A Degree of Murder*. Anita, who was starring in the film, had encouraged the director to hand soundtrack duties over to Brian. He relished the opportunity to showcase his musical prowess outside the Stones, and the finished product found him at his experimental best.

Brian: "I ran the gamut of lineups, from the conventional brass combination to a country band with Jew's harp, violin, and banjo. In the main, the musicians were established session men—though some of the boys from the groups also played."

Cannes' Luminaries

Anita and Brian put on a brave face at the May 5 after-show party for
A Degree of Murder. The Cannes trip was to be their final public appearance
as a couple. Brian's violent mood swings and downward-spiraling health
had damaged the already rocky relationship, and circumstances were
only compounded by Keith and Anita's liaison gathering pace. Once the
lights of Cannes had faded, the transference of Anita's affections to Keith
would be complete.

Anita Pallenberg: "He was quite a bully, you know? Like
small guys are. He's a small guy, like when he got drunk,
like what he would do if he felt threatened—that's when
I knew trouble was coming—break a bottle on the table
edge and put the glass in his pocket."

125

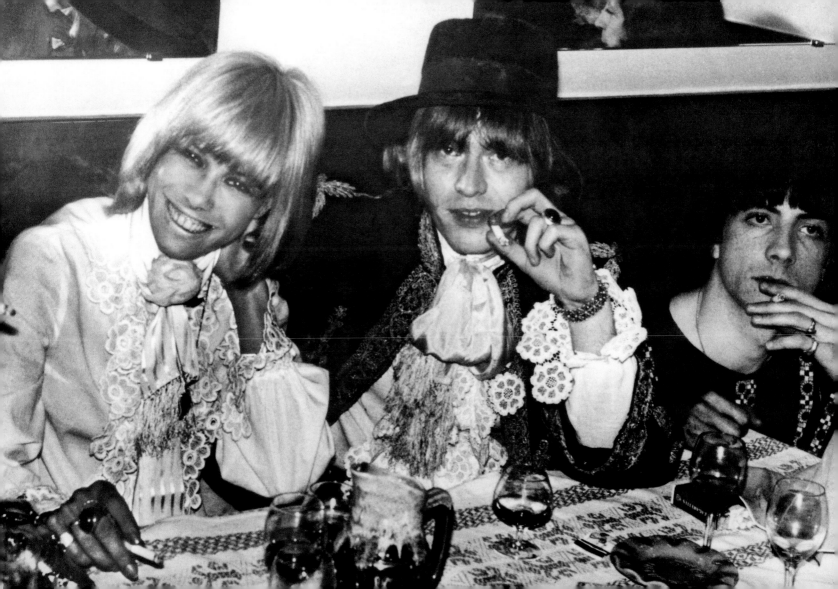

Hovering Around

Keith keeps cool in Cannes, May 1967. During a disastrous sojourn to Morocco, Brian and Anita's testy relationship had finally splintered, and Keith followed them to Cannes to draw the enigmatic blond into his clutches. Keith's presence had become a source of paranoia to Brian: at this point Pallenberg was obviously more attracted to Keith than to the gradually disintegrating Jones. Sensing finally that he'd reached the point of no return, Brian left for home—alone.

126

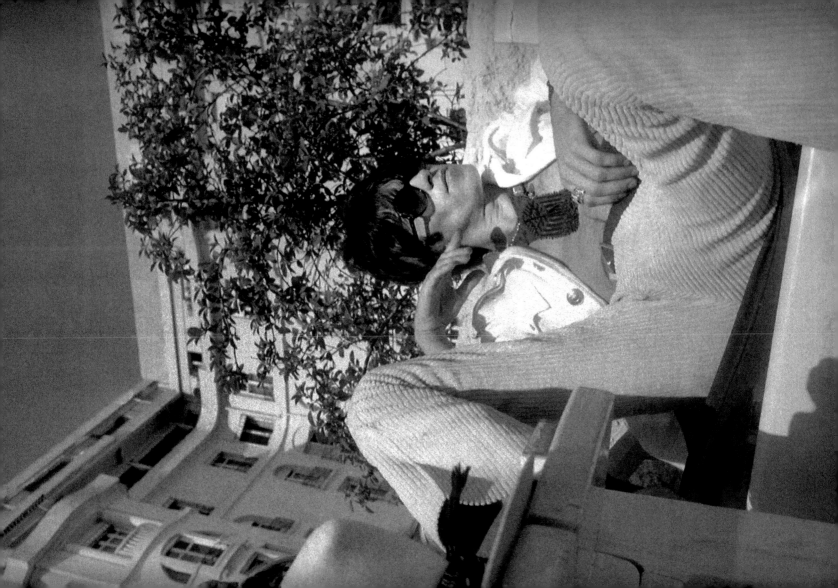

Courting Trial

Keith and Mick greet fans, well-wishers, and curious onlookers outside Chichester Magistrates' Court on May 10, 1967. The pair had been summoned on allegations relating to a February raid on Richards's home, Redlands. In the high-profile case, police allegedly uncovered a small quantity of amphetamine sulfate in Jagger's possession, and traces of cannabis in a pipe belonging to Richards. Art dealer Robert Fraser, a guest at the house, was charged with the more serious offense of heroin possession. But the press was far more enamored of the fact that Marianne Faithfull (or "Miss X," as she was called during the trial) was found naked, covered only by a fur rug.

Both Jagger and Richards pleaded "not guilty," elected for trial by jury at a later date, and were released on £100 bail. The crowd of six hundred fans and onlookers kept an all-day vigil outside the court, and many tried in vain to secure one of the coveted 42 seats in the public gallery.

127

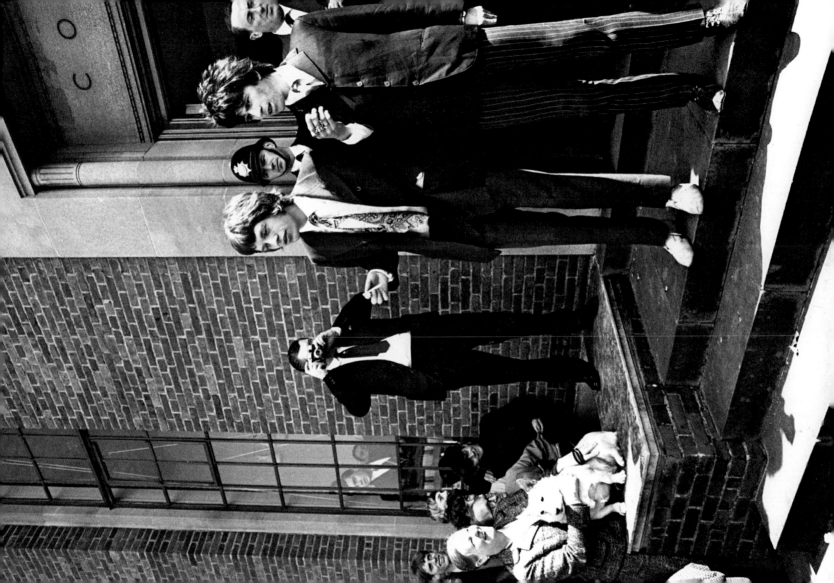

Lunch Is Served

In need of sustenance during their traumatic first day in court, Mick, Keith, and Robert Fraser (making their way through the crowd) all repaired to a local Chichester pub for lunch that May 10 afternoon. Journalists, keen to gauge the lavishness of the Stones' taste, noted, "For Jagger there was prawn cocktail, roast lamb with mint sauce, fresh strawberries and cream, followed by two half-bottles of Beaujolais."

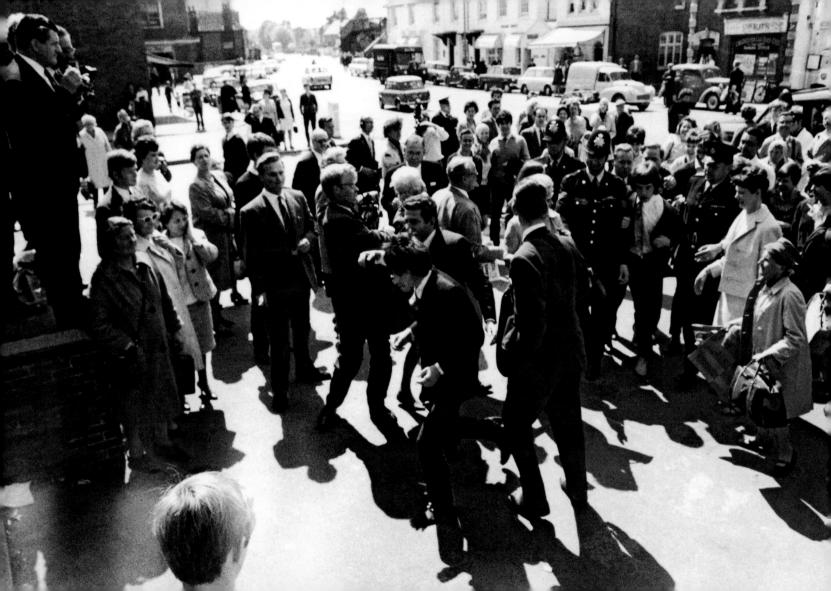

Hanging in the Balance

With a legion of fans and newsmen in attendance, Mick exits Chichester's Magistrates Court, May 10. Wisely, both Mick and Keith elected to keep quiet about the circumstances surrounding their charge, which was not surprising, given that the media had initiated the whole sorry tale.

Michael Havers (lawyer): "Within a week, this well-known national newspaper tips off the police to go to West Wittering—not just for anything, but for drugs. We know it was for drugs because the warrant was issued for drugs."

129

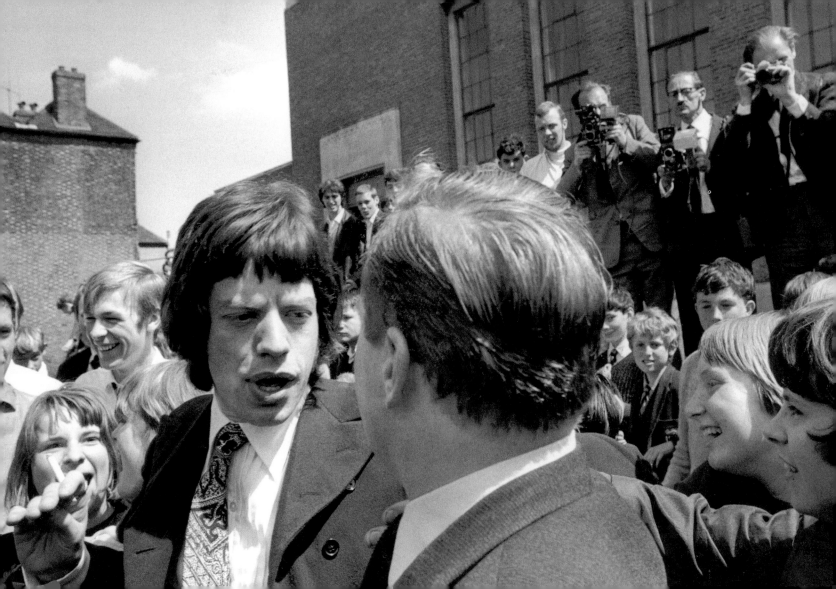

Wisecrackers

Keith and Mick make light of the situation as they drive away from Chichester Magistrates' Court on May 10. The case involving the two rockers garnered enormous press coverage—unlike the other charges that were heard in Chichester that day, which were much more in keeping with the district's rural nature. The volunteer magistrates supporting the judge—who equally determined Keith's and Mick's future liberty—were, outside of their unpaid court duties, two farmers and a local newsagent.

Geoffrey Leach (solicitor for Jagger and Richards): "Mr. Jagger and Mr. Richards strongly deny these allegations and [wish] to challenge the interpretation thought to be placed by the prosecution on the evidence in its possession."

130

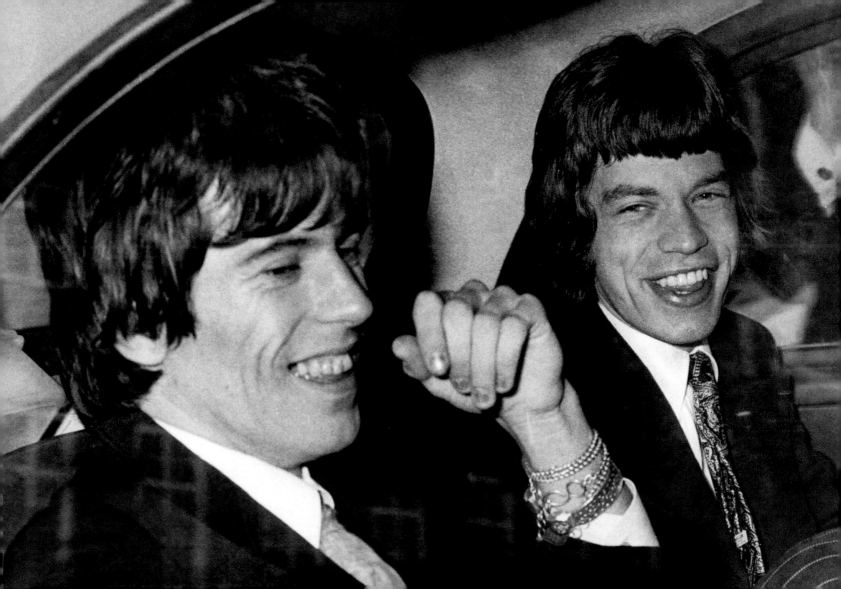

Charged

Brian leaves Magistrates' Court in Kensington, West London, on May 11, 1967, after being charged with drug offenses. He is accompanied by Prince Stanislas Klossowski de Rola. Open season had evidently been declared on the Stones' drug habits, and just hours after Mick and Keith had their first court appearance for the Redlands raid, Brian was raided by officers from Scotland Yard's drug squad. Ever since the *News of the World* had run its exposé on celebrity drug use, Brian had lived in fear of a police raid: since it was well known that the paper had erroneously substituted Jagger's name for his in botched drug allegations, a raid seemed an inevitable formality. The raid most certainly did happen, on May 10, much to the dismay of Brian and a European confidant to the Stones, Prince Stanislas Klossowski de Rola, Baron de Watteville (or just plain "Stash" to those who hung out with him)—who would be at court the next day with Brian, sharing the charges. The loyal gaggle of fans waiting outside the courthouse certainly did little to assuage Brian's increasing sense of unease, and he responded by descending further into a drug-induced depression.

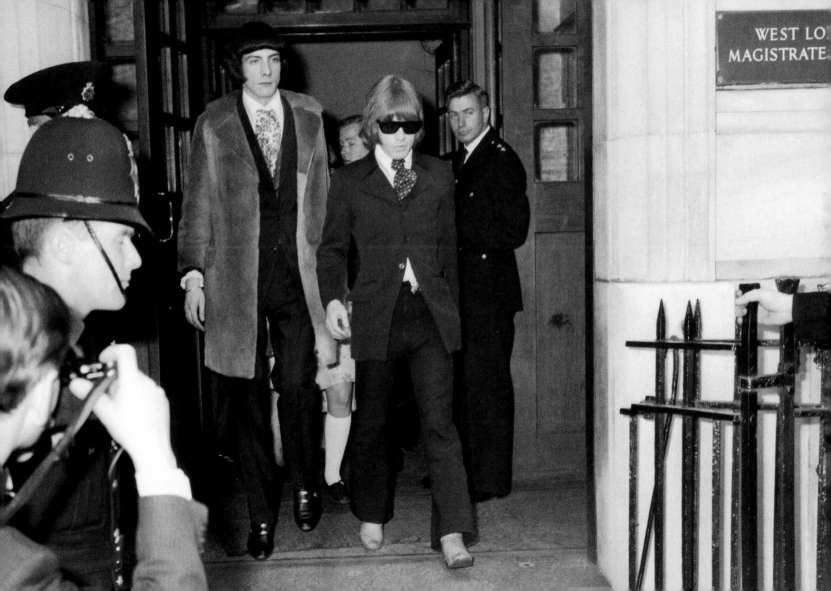

Possession

With Prince Stanislas following close behind, Brian finds his way to his car after being charged with drug possession on May 11. The sustained efforts by the establishment to bring the "itinerant" Stones to heel had managed to snare three of its protagonists. In the wake of these arrests, the tabloids went into overdrive—evidently, the appetite for the tawdry exposé of rock stars was insatiable. As if Brian's fragile sensibilities were not traumatized enough, the actions of the London drug squad and the hounding by the media only served to exacerbate his condition.

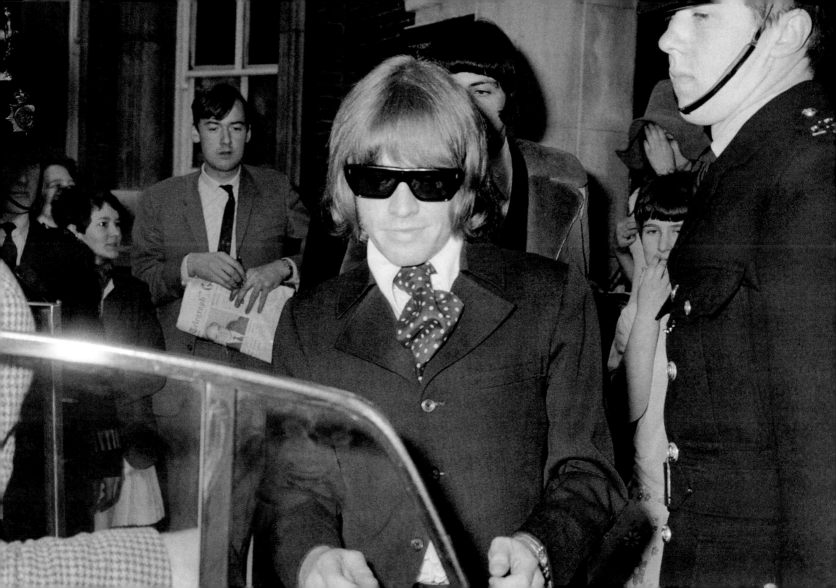

Stars and Stripes

Greeted by a coterie of Stones' fans, Brian leaves his residence for a hearing at the West London courthouse on June 2, 1967, the first formal hearing of his drug charge from May 11. The drug squad had evidently been thorough, and a cache of drugs including methedrine, cannabis, and cocaine had been retrieved from Brian's Chelsea home. Controversy surrounding the Jagger and Richards scandal had temporarily subsided, allowing the press to focus on Jones's misconduct. Concerned about what his parents were hearing back in Cheltenham, Brian sent them a reassuring telegram.

Telegram from Brian: "Please don't worry. Don't jump to nasty conclusions and don't judge me too harshly. All my love, Brian."

133

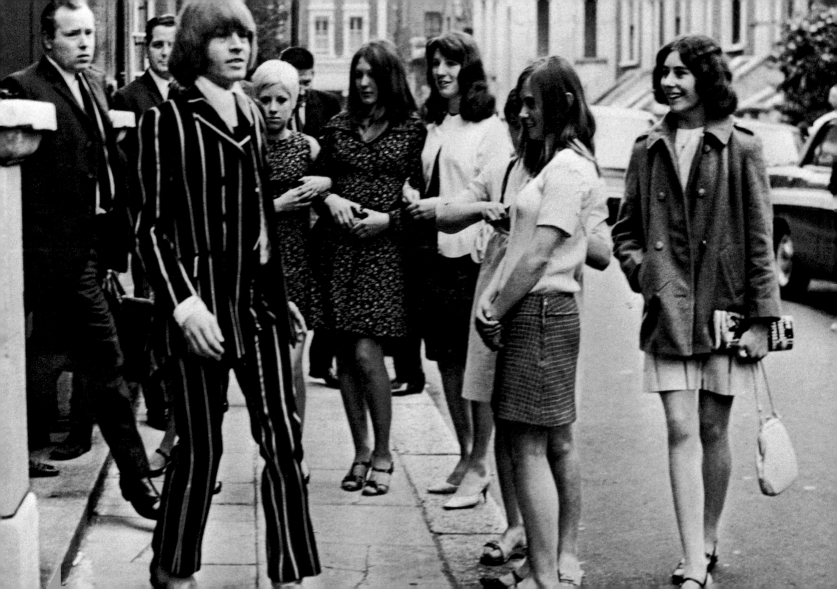

Femme Fatale and Lone Stone

Velvet Underground chanteuse Nico and Brian Jones catch the sounds at the Monterey International Pop Festival on June 16, 1967. The three-day event was the first rock-focused gathering ever held.

Over 200,000 fans drifted through the Monterey County Fairgrounds in California that June weekend. It was the dawn of the Summer of Love, and the Beatles' *Sgt. Pepper's Lonely Hearts Club Band* had just been released: the stage was set for one eventful year.

Although neither the Beatles nor the Stones played at the festival, each band was represented. Paul McCartney was a member of the organizing panel, and Jones—seeking some solace from the persecution he was experiencing at home—graced Monterey with his presence, happily making the rounds with his fellow musicians.

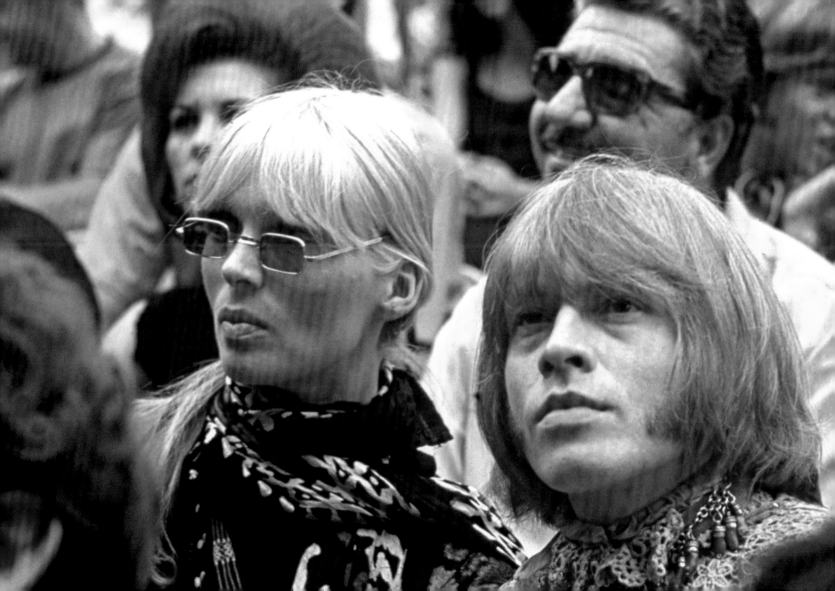

Fork in the Road

Mick and Marianne momentarily part after their return to London Heathrow Airport from Tangier on June 25, 1967. With Jagger's impending court appearance hanging over him, he was steadfastly avoiding the paparazzi. Generally, Mick was happy to pose for the press, but during the troubled months of 1967 any such good-natured consent was out of the question.

Mick: "You don't have to do a thing, the media will pick up on it and exaggerate it beyond recognition. If they just get so much as a smell of a story they'll make it up or get a quote and turn it around to suit themselves."

135

The Clock Is Ticking

Greeting fans before sentencing on the morning of June 27, 1967. Mick's day of all days started early, and a small crowd of fans was waiting outside his hotel to lend some support prior to the hearing. Jagger's trial at the Chichester courthouse was brief, and despite a spirited defense from his counsel, he was found guilty on possession of amphetamines.

136

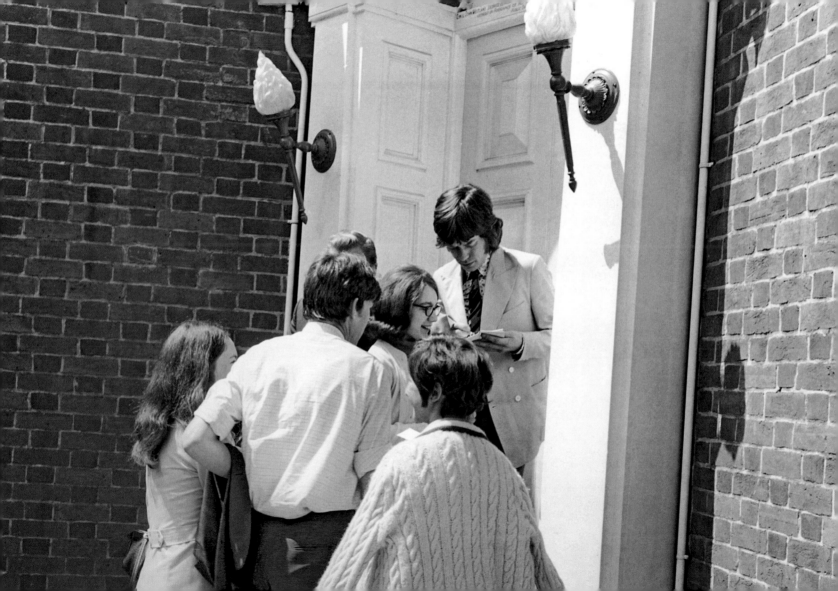

Mick, Cuffed

Mick is driven away from Chichester Magistrates' Court, remanded in custody before sentencing. The image of Jagger in cuffs has become one of the most iconic images of its generation—and at the time, sent shock waves around the world. Ironically, Jagger's charge was the least serious of the three defendants', and yet the judge, wishing to combine sentencing, refused Jagger his liberty and detained him in a local prison.

Q: "How did you feel about being imprisoned in Lewes Jail?"

Mick: "It was disgraceful. Disgraceful. I didn't feel alone while I was in there because I knew that a lot of people disagreed with how we were treated."

137

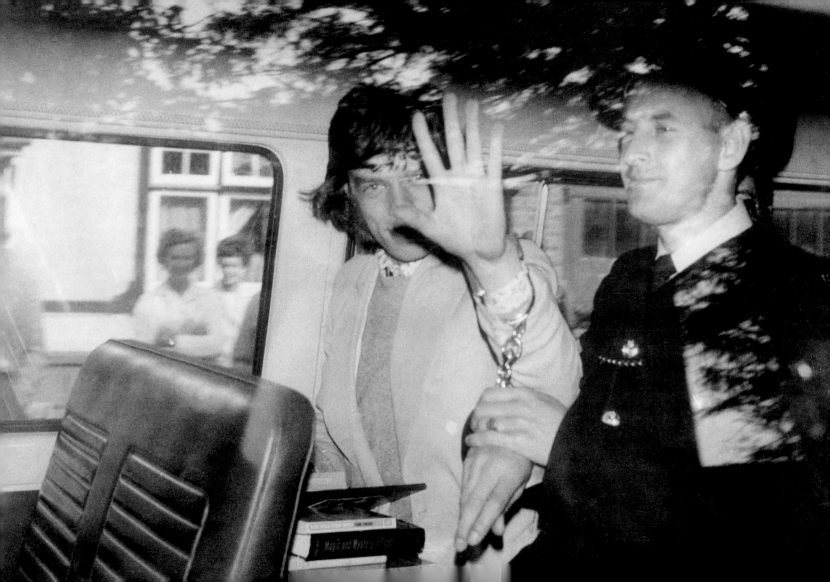

Prison Sentence

With Stones press agent Les Perrin attempting to ward off photographers, a distressed Marianne Faithfull walks away from the Chichester courthouse on June 27, 1967. Guilty verdicts had just been passed on Mick and Robert Fraser in relation to the Redlands drug raid, and despite cries of disbelief from the gallery, the pair were driven away into custody to await sentencing. The charges relating to Keith's case had yet to be heard, and while Keith was technically free on bail, Mick was beginning his first night in incarceration.

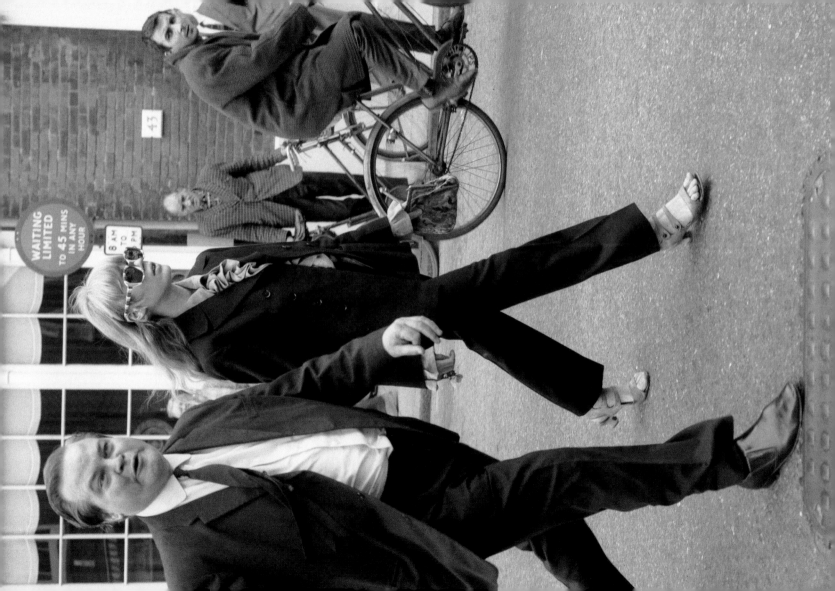

Waiting at Home

Keith counts down the hours, the night before sentencing. With Mick and Robert Fraser already in custody, it appeared that Keith's fate was similarly doomed, and that the full weight of the law would be brought to bear. The charge of allowing drug use in his home potentially carried a sentence of up to ten years. After sessions finally ceased on the afternoon of June 28, 1967, however, the intricacies of Keith's case still had not been resolved and his sentencing was postponed yet again to June 29.

Keith: "We are not old men. We're not worried about petty morals."

139

The Calm before the Storm

A clearly apprehensive Keith Richards makes his way to court after lunch in a Chichester pub. Richards's case was the last of the "Redlands Three" to be heard, and with Jagger and Fraser already in custody, he was still technically free until sentencing took place on the afternoon of June 29. The presiding magistrate, Judge Leslie Block, instructed the jury to disregard the enormous publicity that the trial had generated and to concentrate on the facts.

Judge Block: "The issue you have to try is a comparatively simple one. You have to be satisfied that cannabis resin was being smoked in the house when the police went there, and you have to be satisfied that Richards knew of it."

140

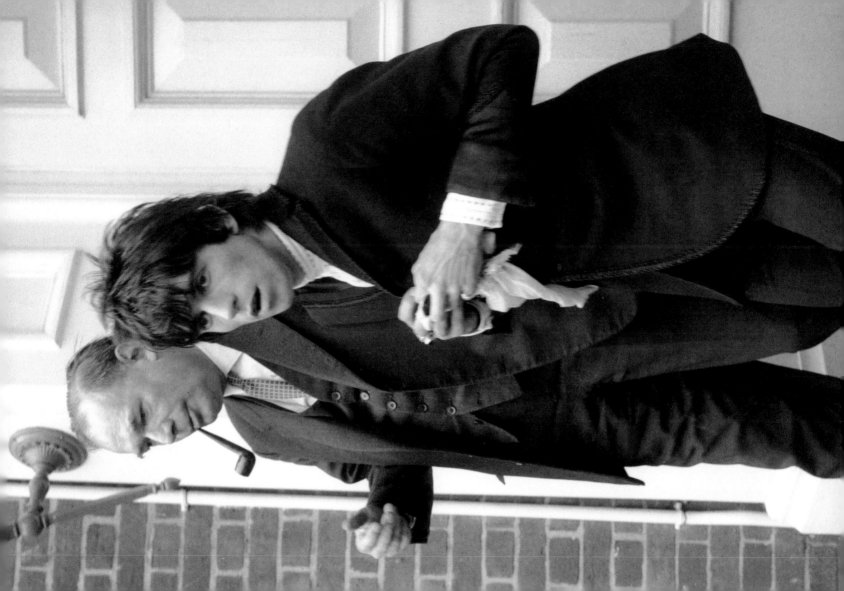

One Tie, One Scarf

Mick and Keith appear outside King's Bench Walk Magistrates' Court on July 1, 1967, after being freed from jail on appeal. A mixture of relief and shellshock is written all over their faces. Their time spent behind bars, albeit brief, would make a long and deep impression on both band members.

Keith: "It's amazing. I was going to have to make those little Christmas trees that go on cakes. And sewing up mailbags. There's the hour when you have to keep moving around in a courtyard… Most of the prisoners were really great—'What you doing in here?' They filled me in. 'They've been waiting for you in here for ages,' they said. So I said, 'I ain't going to be in here for very long, baby, don't worry about that.'"

141

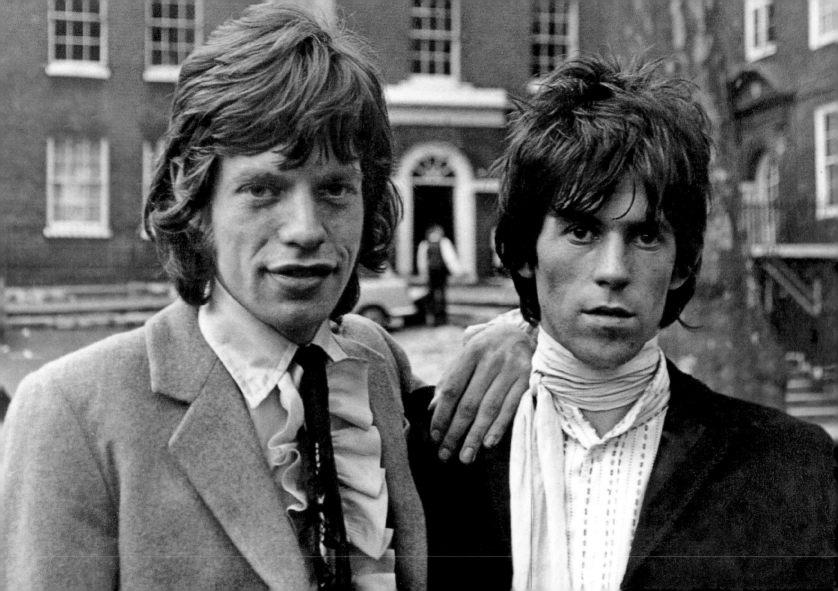

Keep on the Grass

Back at the scene of the crime on July 5, 1967, Mick and Keith wander across the greenery outside Redlands at West Wittering, East Sussex. Their appeal request had been granted, although it would take four weeks for the paperwork to be processed through the courts. But with none other than legal luminary Michael Havers handling the duo's appeal, the likelihood of a total acquittal was strong. Havers was indeed a fine—if costly—choice, and he would go on to become one of Britain's most eminent legal minds, achieving the position of Lord High Chancellor in 1987.

Mick: "It was a drag having to wait not knowing what was going to happen to us."

142

Still Smiling

Despite the appeal decision looming over them, it was business as usual for Mick and Keith. The Stones had decided to continue with the prolonged recording of their new album *Their Satanic Majesties Request*, and on the night of July 8, 1967, they convened for an all-night session. The group had chosen the quaint suburban location of Olympic Sound Studios in Barnes, West London, for the bulk of the recording; its location was far enough away from the 24-hour madness of central London for focus. Like the Beatles, the Stones found recording to be a welcome break from the hurly-burly of touring.

Mick: "We're at a funny stage. We are just making records and have time to gather our thoughts. It's impossible to do that when you're dashing around all over the place, worried about getting to gigs and things."

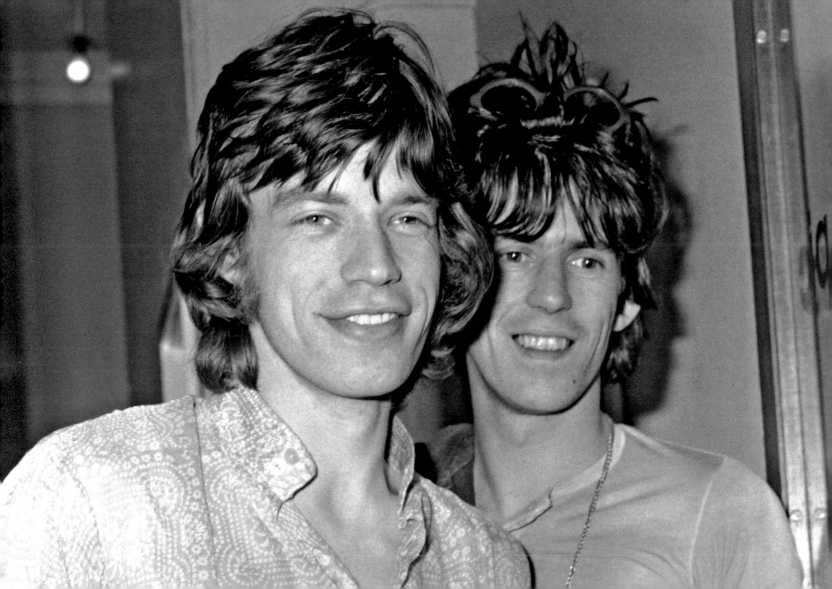

Appeal Upheld

With a pack of loyal fans close by, on July 31, 1967, Keith and Mick leave the appeal court free men. Since their appeal on the Redlands charge was lodged, their bail restrictions had been considerable—£5,000 each and the surrender of their passports—but the fact that their jail terms were immediately suspended was a great relief. The hard work of the Stones' lawyers in their negotiations with the representatives from the Crown Prosecution Service had paid off: Richards's charge was thrown out and Jagger's sentence reduced to conditional discharge. Judge Leslie Block (who had originally sentenced the pair to jail) later reflected his irritation over the outcome to an audience at a Sussex agricultural conference.

Judge Block: "We did our best, your fellow countrymen, I, and my fellow magistrates, to cut those Stones down to size, but alas, it was not to be, the court of appeal let them roll free."

144

The Ordeal Is Over

Mick, Marianne, and various TV personnel board a chartered helicopter at Battersea Heliport after Mick and Keith's successful appeal hearing. Jagger and Faithfull had attended a press conference immediately following the July 31 verdict, and Jagger was scheduled for a subsequent TV appearance at stately Spain's Hall in Essex. On the eminent current-affairs show *World in Action*, Jagger was pitted against a lord, a leading Jesuit, a former Home Secretary, and the editor of the *Times* newspaper. All four panelists were eager to quiz Jagger on the new generation.

Mick: "When you're young, sixteen, seventeen, you don't want anything to do with responsibility to society, you want to get on with one's own, very small life within a teenage group. You don't want to care about anything … The main thing to start off with is just to have as good a time as possible."

145

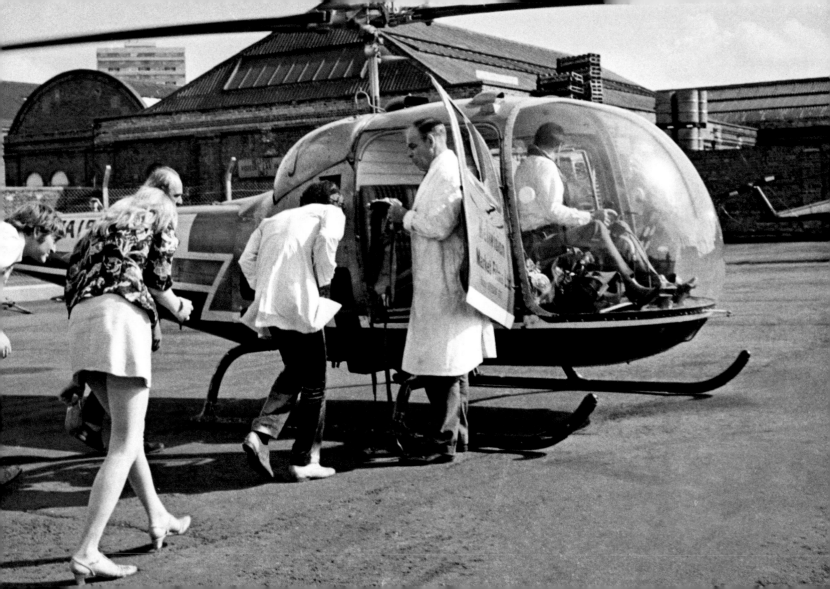

Dead Ringer

Brian relaxes on holiday in Marbella in August 1967 with his girlfriend Suki Poitier. The strain of his drug-possession charge and his breakup with Anita Pallenberg took a heavy toll on him, and for a while he lost himself in a cocktail of narcotics and booze. But like Jagger and Richards, Jones seemed to find some solace abroad, away from the latest controversy, and being in Spain with the young model seemed to lift his spirits. But it was obvious to anyone who saw her that Poitier bore more than a passing resemblance to Pallenberg.

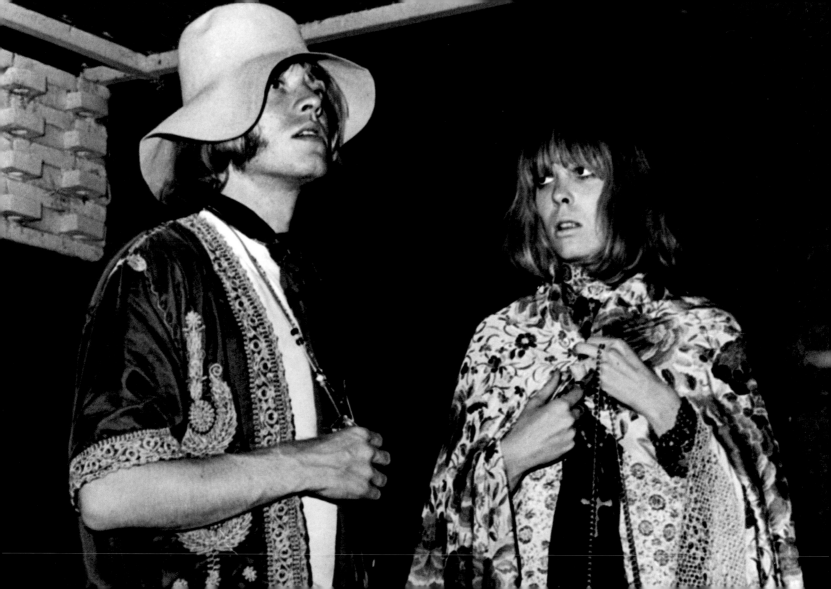

Bawdy and Predictable

Although Faithfull's relationship with Jagger was winning out over her singing career, acting still held her in its sway. Seen here with British film director Michael Winner, Faithfull rehearses a risqué bathroom scene from the movie *I'll Never Forget What's 'is Name*, an unspectacular bawdy romp in which Marianne plays an advertising executive's mistress.

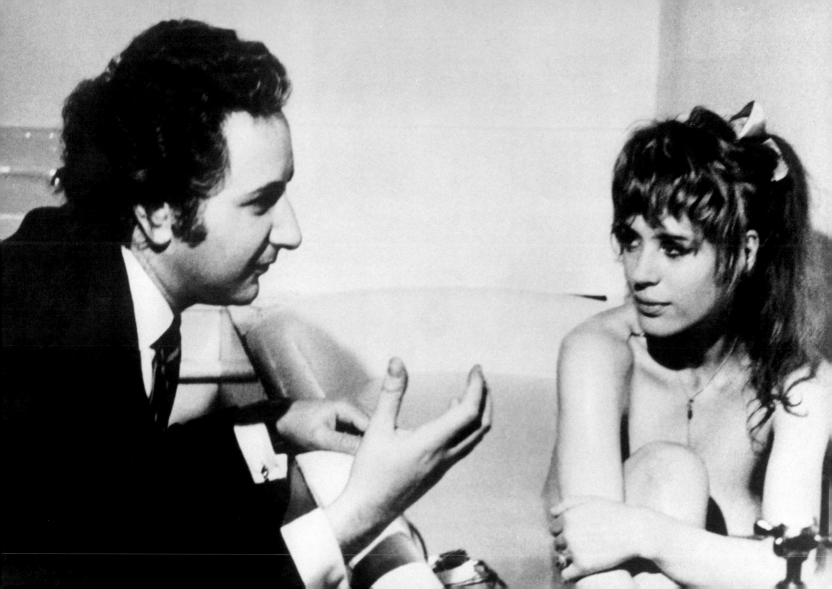

Alone

Brian surfaces, alone, at a launch party for the Beatles' Apple-sponsored group, Grapefruit (sitting at the table), on January 17, 1968. With him are, from left to right: singer-songwriter Donovan Leitch, Ringo Starr, John Lennon, singer Cilla Black, and Paul McCartney. By this time Brian was socializing less with the Stones and becoming more and more detached from them. Toward the end of the year, Brian would be having serious discussions with John Lennon about the fate of their respective careers: Lennon was hedging as to whether he should leave the Beatles and pour his energies into his new venture, the Plastic Ono Band, and Brian was looking for other avenues into which to pour his energies. By the end of 1968, Eric Clapton had signaled the end of his tenure with his band Cream, and the trio formulated tentative plans to form their own band. In the end, nothing came of the idea.

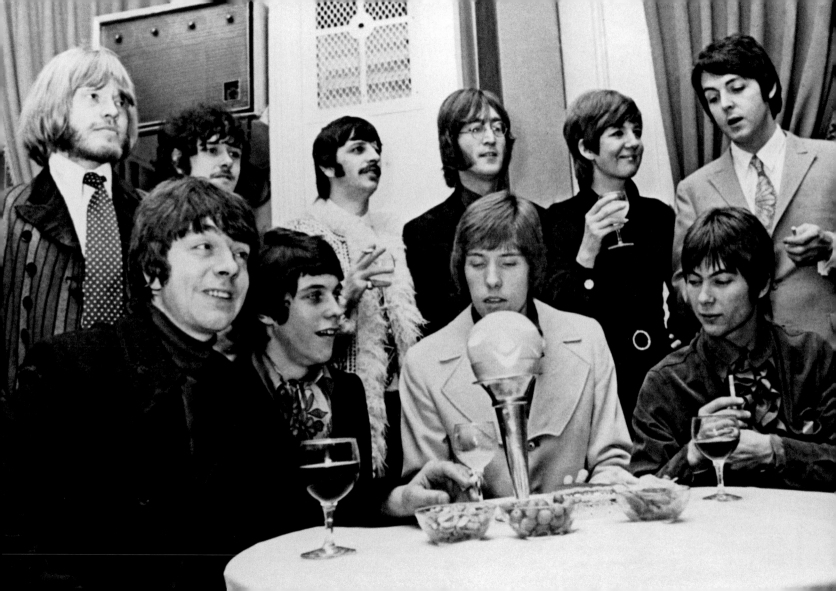

Supreme

Brian, out and about with the first lady of soul, Diana Ross. The distance
was building between Brian and the rest of the Stones' camp, and he was
increasingly prone to venture out in London without the other members
of the group in tow. For this night, Brian had accepted an invitation from
the Duke and Duchess of Bedford to introduce Ross and her Supremes to
London society. The soiree took place following their appearance on the
television variety show, *Sunday Night at the Palladium*.

149

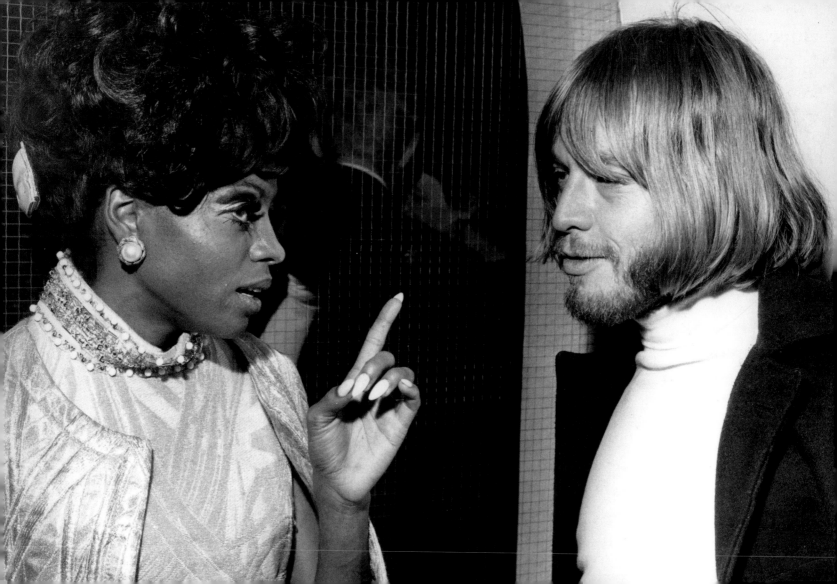

Busted Again

Arrested once again on possession of narcotics, Brian—seemingly the target of a prolonged police investigation—is driven to Marlborough Street Magistrates' Court to be charged on May 21, 1968. The previous morning, officers from the London Drug Squad had gained entry to Jones's Chelsea home and raided it for drugs for the second time. The officers, led by the now infamous Sergeant Norman Pilcher, found 144 grains of cannabis resin hidden in a ball of wool. After being formally charged for the offense, Jones was released on £2,000 bail. Understandably, the trauma of the arrest sent the already fragile Stone further into turmoil.

Brian: "When the ball of wool was shown to me I was absolutely shattered. I felt everything swim. I don't knit and I don't darn socks and I don't have a girlfriend who darns socks."

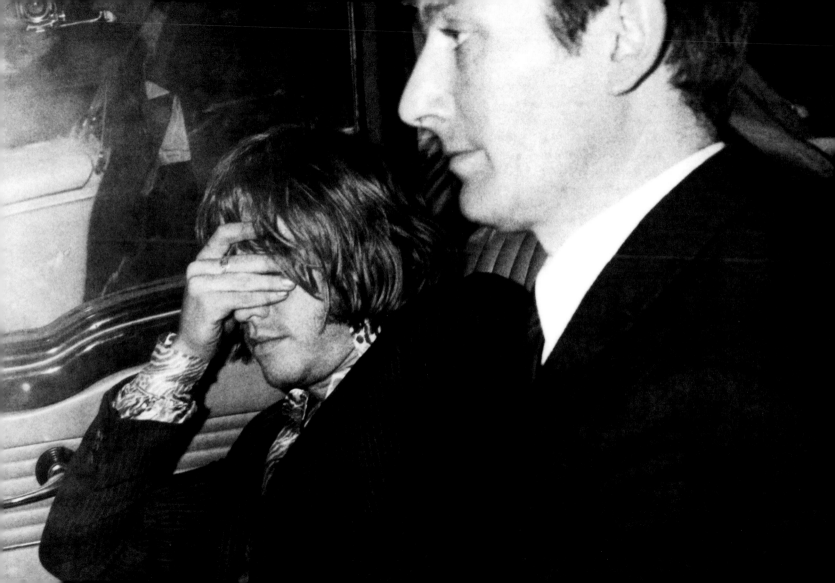

Auteur

Film legend Jean-Luc Godard during the filming of *One Plus One* (aka, *Sympathy for the Devil*), July 1968. Godard, like many experimental minds of the period, was smitten with the Stones. Combined with the frisson of the times, the Stones were fertile territory indeed. Godard's vision for *One Plus One* was to show the Stones' creative process as they recorded their revolutionary LP *Beggars Banquet*, especially the song "Sympathy for the Devil"; he wanted it to be a "work in progress." But the producers insisted that a finished version of the song be shown at the film's conclusion. Godard's plans to title the film *One Plus One* were also thwarted, and when the film hit screens around the world, *Sympathy for the Devil* was part of the title. Ultimately, *One Plus One* would be dropped from the title.

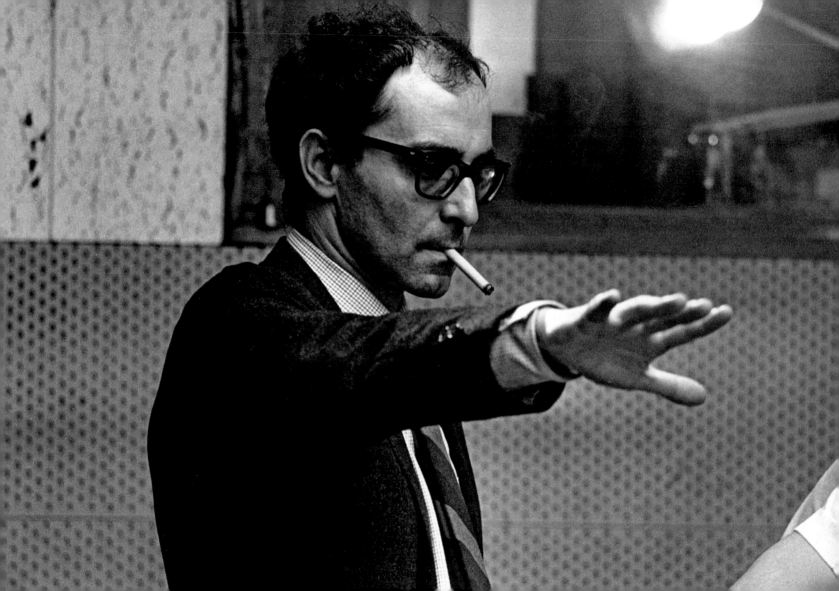

A New Direction

With Godard's cameras turning in the background, the Stones set about recording *Beggars Banquet* in July 1968. The album marked a welcome return to the band's R & B roots, especially after the mass of psychedelic trinkets on the last album, *Their Satanic Majesties Request*.

Looking for a return to a more fundamental sound, Mick hired producer Jimmy Miller, then famed for his work with Traffic and the Spencer Davis Group, and renowned in the industry for his unique production style. Miller was an instant hit with the group in the studio, and in March 1968 recording began. Trailing the collection was "Jumping Jack Flash." The gamble paid off, and the song became a huge hit worldwide.

Jimmy Miller: "I came in at a crucial time. The night Jagger phoned I just knew he was going to ask me to produce them. I just glided over to his house on a cloud. Before I was there ten minutes he asked me if I'd be interested. Besides being excited, I'd always been a Stones' fan."

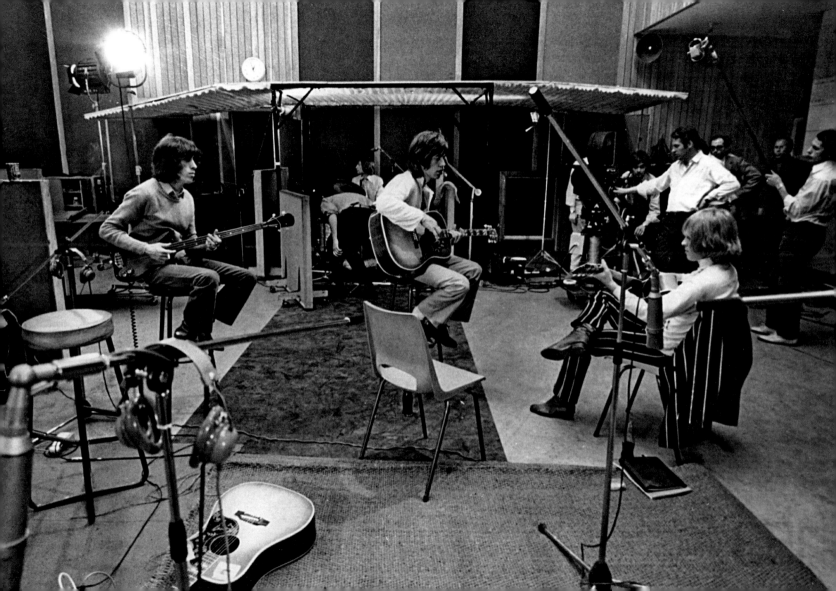

Hummingbird

Mick pores over his acoustic Gibson Hummingbird during filming and recording sessions for "Sympathy for the Devil," July 1968. Guitar duties were rare for Jagger, but this was an experimental period, and he was eager to develop his talents beyond singing and songwriting. This spirit is reflected in the lyrical content on *Beggars Banquet,* which broke out of the status quo and explored new territory as well. Picking up from the mood on the streets, the Stones' brash approach fed off the zeitgeist that was empowering demonstrations and riots around the world. Songs such as "Street Fighting Man," "Midnight Rambler," and "Sympathy for the Devil" reflected the frustrations and impatience that spawned this approach to solving the world's problems. Whether the album actually influenced real action in the streets is a matter of speculation.

Mick: "It's stupid to think that you can start a revolution with a record. I wish you could!"

153

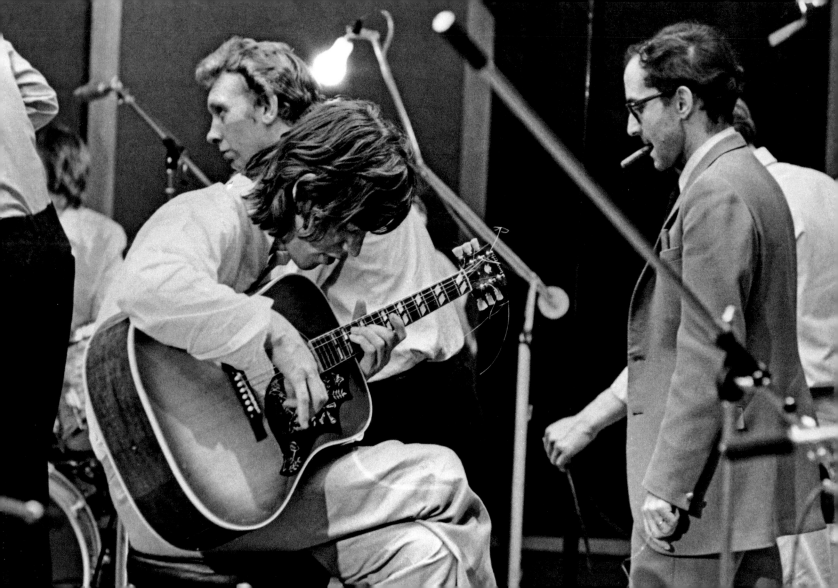

Work in Progress

A rare glimpse of Mick and Keith engaged in some guerrilla songwriting, July 1968. The group's abrasive new sound for *Beggars Banquet* dovetailed with the atmosphere developing in the streets, and tapping into this ethos was Mick. Although he'd held his political views close to his chest, he did take part in the historic demonstration against the Vietnam War on March 17, 1968. The march turned into a pitched battle between police and protesters as it reached the U.S. embassy in Grosvenor Square. It wasn't surprising then, that this experience would find expression in both "Street Fighting Man" and "You Can't Always Get What You Want."

Mick: "There was all this violence going on. I mean, they almost toppled the government in France; De Gaulle went into this complete funk, as he had in the past, and he went and sort of locked himself in his house in the country. And so the government was almost inactive. And the French riot police were amazing. Yeah, it was a direct inspiration…"

154

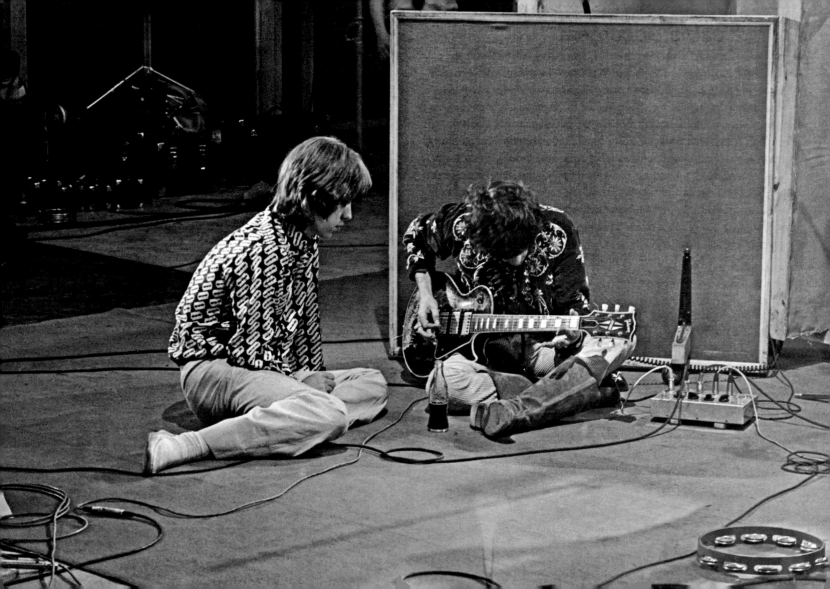

An Invaluable Document

The Stones lay down the backing track to "Sympathy for the Devil" on July 29, 1968, while Godard films *One Plus One*. The decision to allow the French auteur access to the band's recording sessions would prove to be a mixed blessing. Initially Godard had planned to integrate the Stones' footage with a vague story line regarding a couple of revolutionaries struggling to accept their own political leanings. But the footage was then cut with other disparate images, with an expectation that audiences would construct their own understanding of the collage of sequences. The prevailing criticism of the film called it tedious and self-indulgent, and only the Stones' footage garnered any interest. But from a historical perspective, since precious little footage exists of the group recording in the studio in the 1960s, the film is of inestimable value.

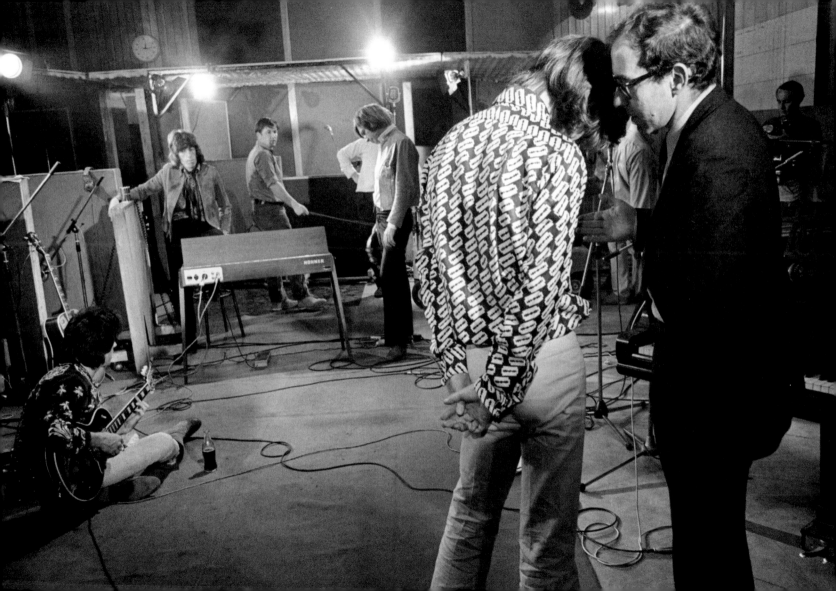

Beauty and the Beat

While Keith hits the deck, Bill and Mick conjure up some magic during sessions for "Sympathy for the Devil." The relationship between Bill and Mick remains something of a mystery. The two seemed to share little in common, aside from a voracious appetite for the company of women.

In the 1960s, a unique feature in a British music newspaper, *Disc*, allowed each of the Stones to offer candid insights about their colleagues. Bill's take on Mick was rather interesting.

Bill: "He's changed considerably. He was a lot quieter and less confident. He was very friendly when I first met the group. In fact he was the only one who spoke to me for the first couple of hours. Now he's more difficult to get on with. He's automatically on guard with people he's not sure about—as if they're trying to hang on."

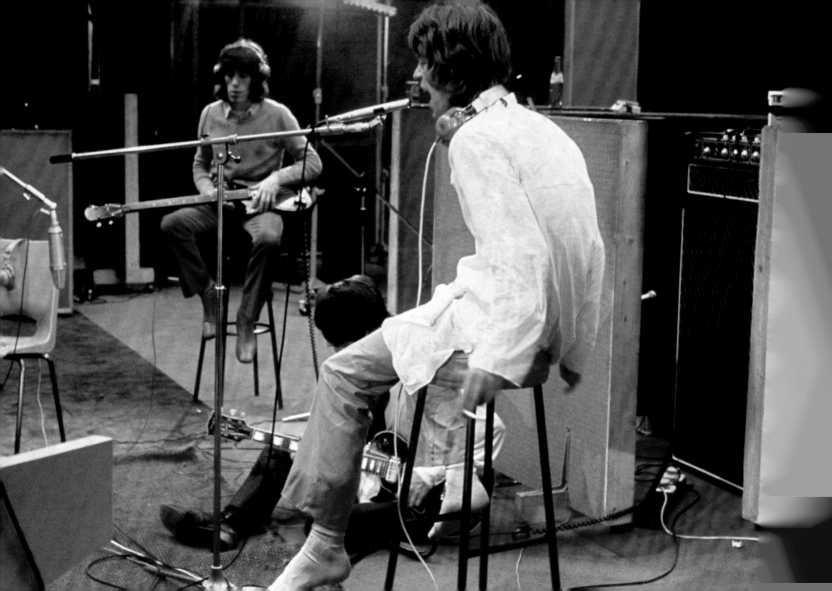

Laying Down with the Devil

Keith keeps Mick in view as they lay down the bare bones of *Beggars Banquet*'s finest moment, "Sympathy for the Devil." The song, which, it is said, Mick wrote after reading Mikhail Bulgakov's *The Master and Margarita*, captured themes that grew out of their own dabbling in satanic worship and the atmosphere of revolution emanating from demonstrations occurring at the time. Anita Pallenberg and her associates were on hand for the session, and they happily joined in the backing vocals in the second half of the song.

Jimmy Miller: "Anita was the epitome of what was happening at the time. She was very Chelsea. She'd arrive with the elite film crowd. During 'Sympathy for the Devil' when I started going 'whoo, whoo' in the control room, so did they. I had the engineer set up a mike so they could go out into the studio."

157

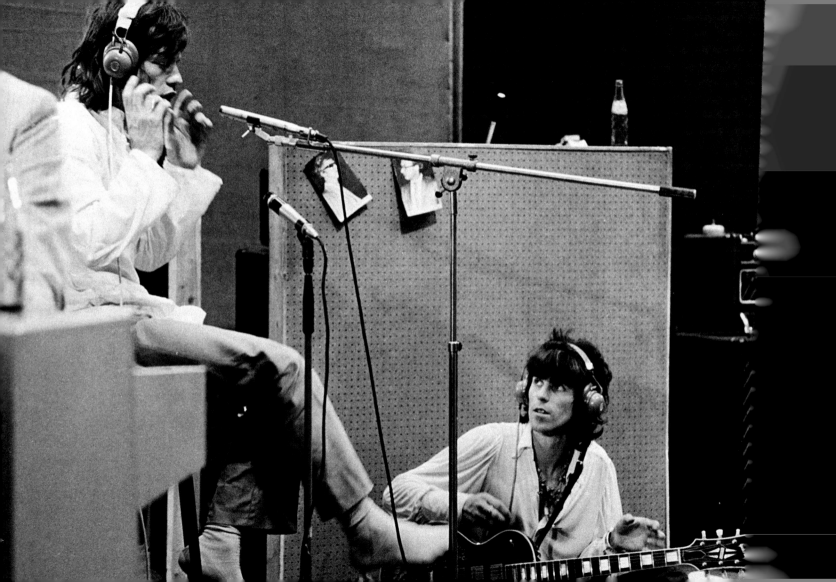

In Need of Direction

Jones and Godard converse during filming of *One Plus One.* Brian was barely there at the recording sessions for *Beggars Banquet,* the culmination of years of drug abuse and ill health that had left him a mere shadow of his former self.

It was during this period that Brian began negotiating the purchase of Cotchford Farm in Hartfield, Sussex. The pretty cottage was a revelation to him—it was in this house that A. A. Milne had created the world of Winnie the Pooh—and something about the place spoke to him. With the discovery of this house, he began to pour his energies into extricating himself from the London scene and into the considerably safer environment, or so he thought, of rural England.

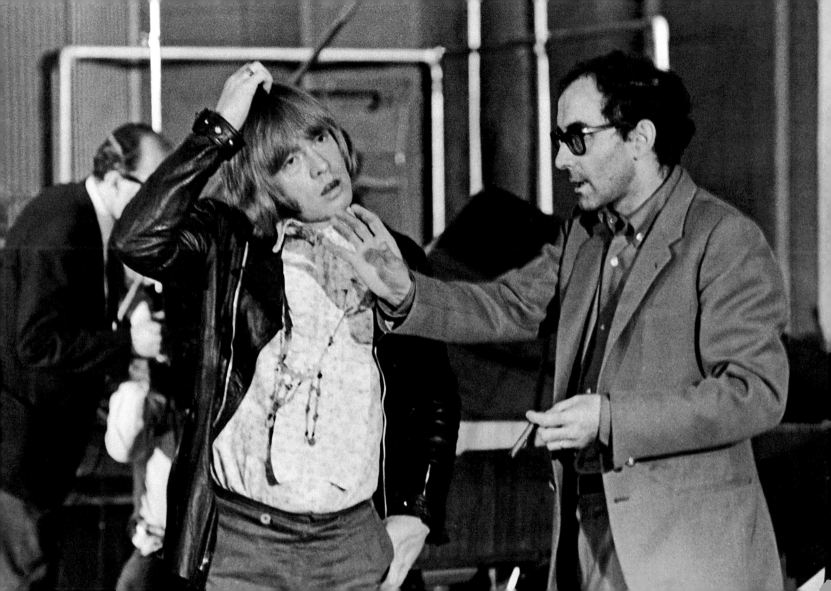

In Time on Bass

Keith takes over Bill's bass during a break from recording *Beggars Banquet* at Olympic Studios. Having disposed of the baggage of psychedelic paraphernalia, and exhilarated by their rediscovered studio dynamic, the band proceeded with sessions that July at a brisk pace. And what with Jagger's and Richards's soul-searching lyrics, the recording of *Beggars Banquet* was taking the Stones in a direction they had never imagined.

159

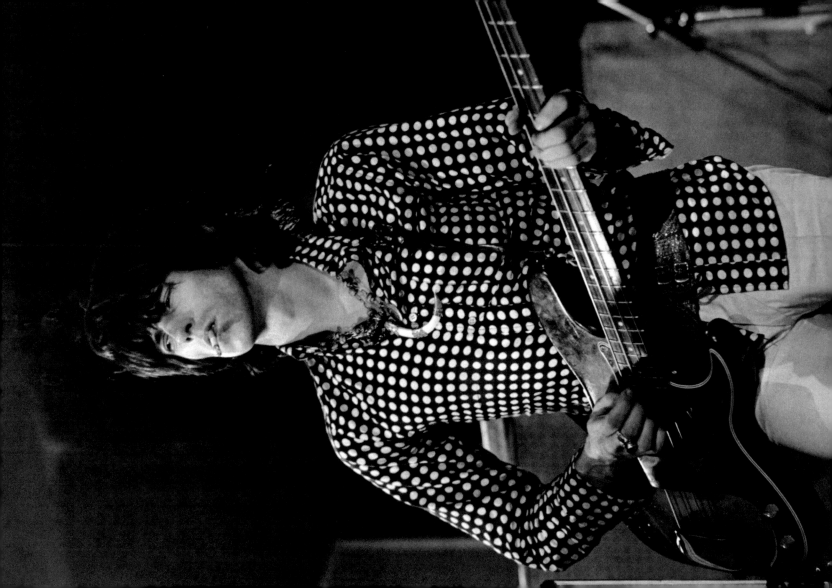

Trying to Please

Mick attempts to show Brian the sound he's looking for during the *Beggars Banquet* sessions, July 1968. For all intents and purposes, Brian's ongoing drama had reached a crisis point and was having an enormous effect on the rest of the band. Musically, Brian appeared to be contributing little to the overall sound of the group, prompting Mick to ask him at one point during sessions: "What can you play?" Given the otherwise positive vibe the group was enjoying with *Beggars Banquet*, Jones was becoming a distinct liability.

Mick: "Brian wasn't really involved on *Beggars Banquet*, apart from some slide on 'No Expectations'; that was the only thing he played on the whole record. He wasn't turning up to the sessions and he wasn't very well. In fact we didn't want him to turn up."

160

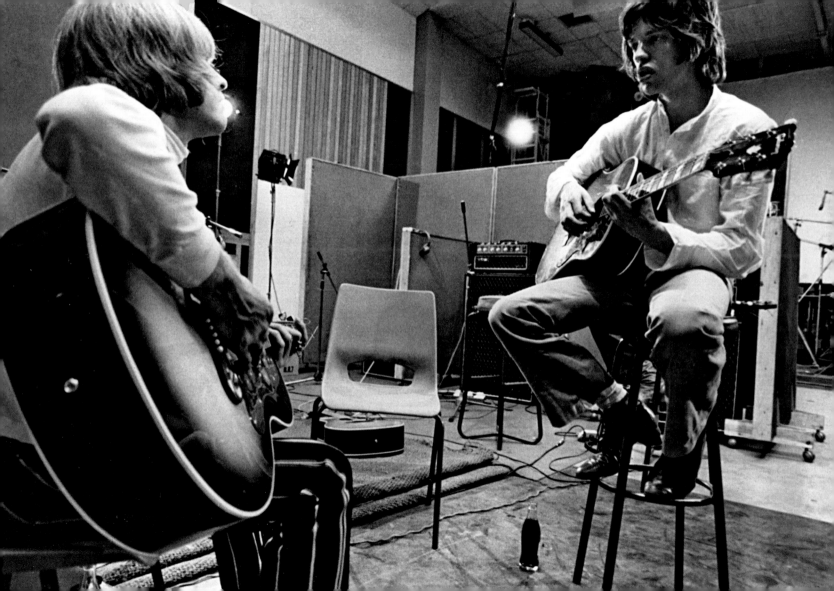

Frenetic Pace

Mick keeps the audience of one enthralled during filming for Jean-Luc Godard's *One Plus One*. Cinematically, 1968 was turning out to be a prolific year for Mick. In addition to his duties for Godard in *One Plus One,* he was slated for top billing in the film *Performance*, due to commence shooting in the fall of that year. Later that year, the Stones' *Rock and Roll Circus* would be committed to celluloid. At the same time, plans were already afoot for a lead role in Tony Richardson's *Ned Kelly*.

161

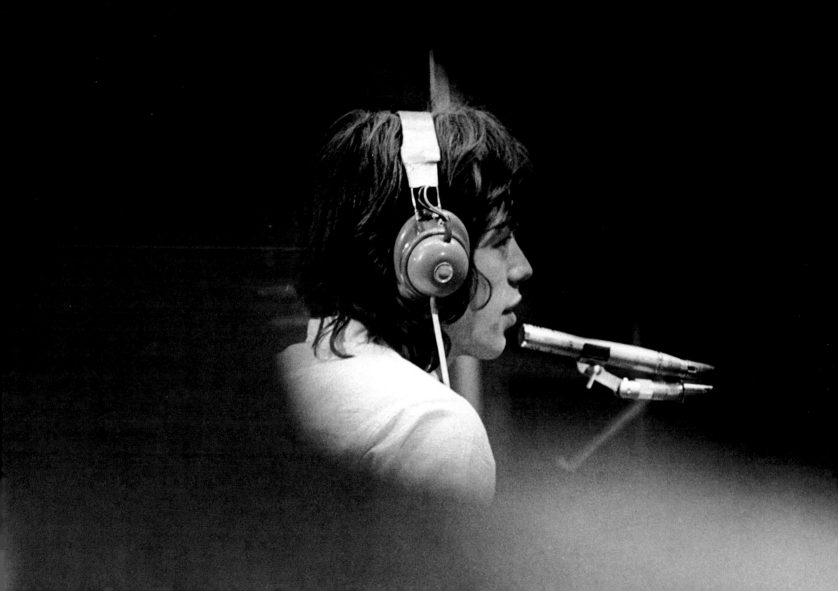

Behind the Sound

Coming to grips with the latest musical demands, Brian concentrates on his guitar parts during the *Beggars Banquet* sessions at Olympic Studios. Contrary to what Mick and the rest of the group were expressing at the time, producer Jimmy Miller felt that Jones, however troubled, still had much to offer when he was in the right frame of mind.

Jimmy Miller: "Brian is very insecure. He has to have people around him all the time, and he has a lot of hang-ups. But when he's doing something that really interests him, he's almost a different character."

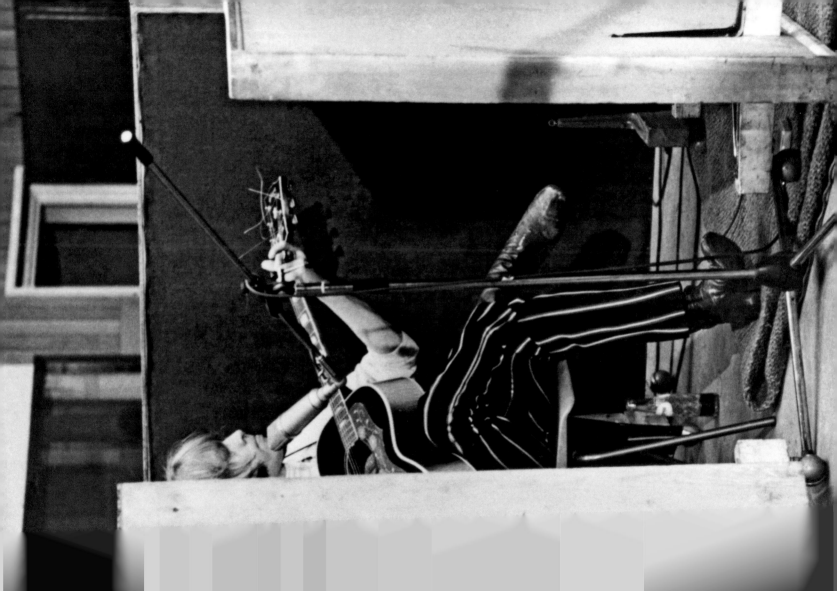

With the Nun on the Run

Awaiting a flight to Ireland, Mick and Marianne—looking for the entire world like any other normal couple—count down the minutes in the departure lounge of Heathrow Airport. Presumably like the nun to their right, the couple was seeking solace in the serenity of rural Ireland. Marianne was in a delicate state, carrying Mick's child, and it was generally agreed that she should be far away from the vast array of temptations that swirled around the Stones' camp. Mick had been involved in some seamy activity on the set of his new film *Performance,* so he maintained some diplomatic shuttling to and from London to be with Marianne when breaks allowed.

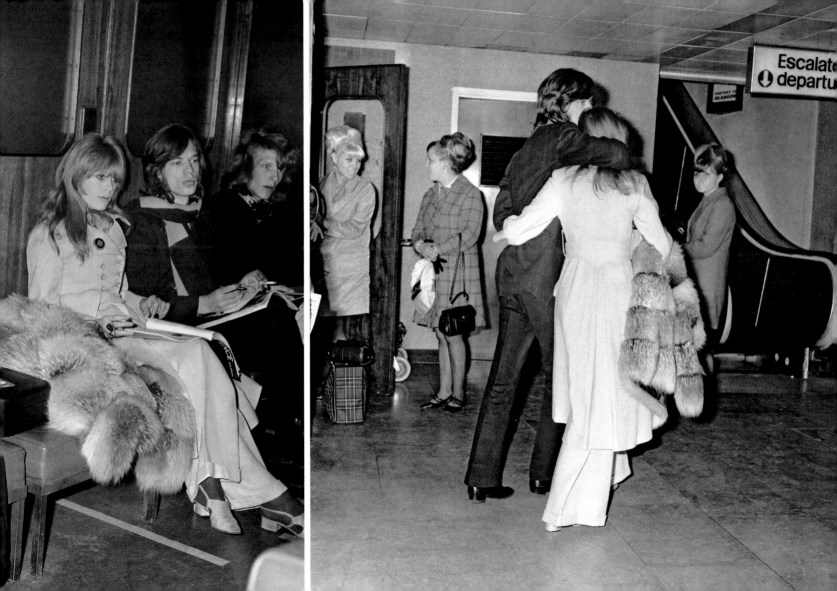

Portrait Gallery

Mick and Marianne enjoy a night in at the castle with the Honorable Desmond Guinness. Nestled on the banks of the river Liffy in County Kildare, the stately Leixlip Castle—home to the couple's mutual friend Guinness—was a world away from the drug-saturated clubs and parties of swinging London. Marianne could now focus on her pregnancy while looking for a more permanent residence in the province. Mick, on the other hand, remained distracted by to-dos on the *Performance* set, and would only pop over on occasion.

A Long Walk

A visibly anxious Brian and his aide, Tom Keylock, trudge up to the imposing doors of the Inner London Session Court for Jones's drug-possession hearing on September 26, 1968. Already under probation for a previous bust, Jones was distraught over the seemingly inevitable prospect of a prison sentence. Psychiatrist Dr. Anthony Flood took the stand in Brian's defense, adamant that the Stone was innocent.

Dr. Flood: "Nothing suggested to me that Jones was playing around with drugs. If I put a reefer by this young man, he would run a mile."

165

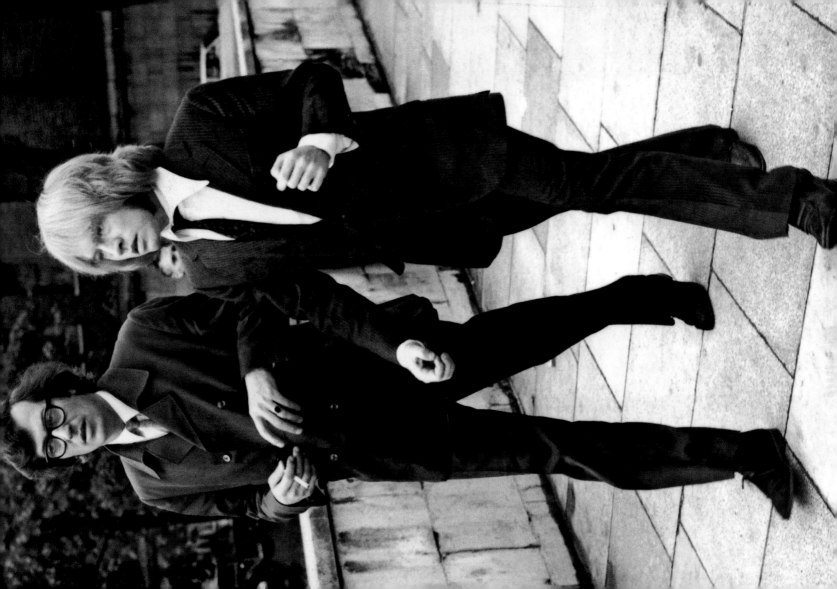

Brotherly Love

Flanked by his two soul brothers Keith and Mick, Brian receives a kiss from girlfriend Suki Poitier and breathes an enormous sigh of relief on being spared a prison term at his September 26 hearing. The charges relating to the May 20 raid on Jones's London home could easily have resulted in time served, and although the jury found Jones guilty of possession, the chairman of the Magistrates' Board, a Mr. Reginald Seaton, found several flaws in the presentation of the police evidence and imposed a lenient fine of £50, with costs. Outside the courthouse on Marylebone High Street, West London, Brian's relief was palpable.

Brian: "When the jury announced the guilty verdict, I was sure I was going to jail for at least a year. It was such a wonderful relief when I heard I was going to be fined. I'm happy to be free."

166

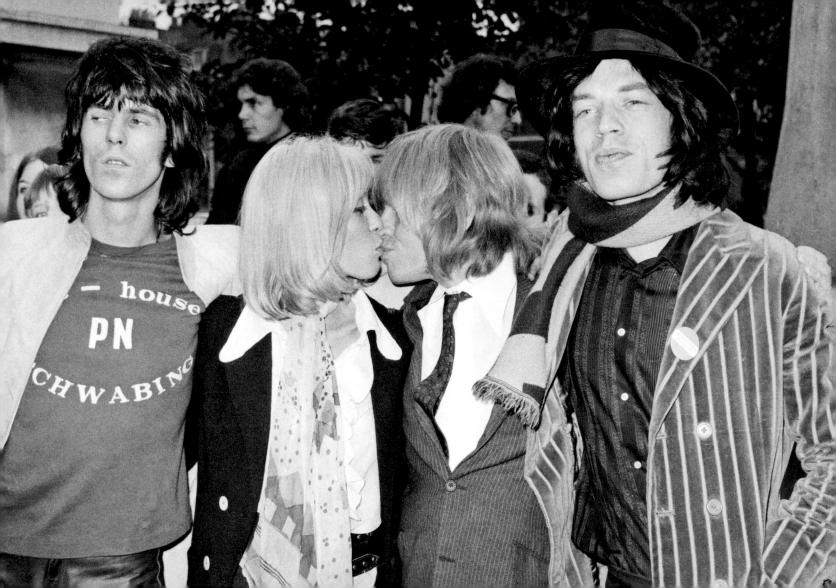

Getting out of Hand

Brian gets a bit carried away at the press launch for *Beggars Banquet*. Held at the Elizabethan Room in the Queensgate Hotel, Kensington, on December 5, 1968, the party afforded the Stones the opportunity to let off some steam. Journalists were agape by the goings-on at the event and were left with plenty of material to draw from, concerning both the launch and the album itself.

Rolling Stone: "Violence. The Rolling Stones are violence. Their music penetrates the raw nerve endings of their listeners and finds its way into the groove marked 'release of frustration.' On *Beggars Banquet* the Stones come to terms with violence more explicitly than before, and in so doing are forced to take up the subject of politics. The result is the most sophisticated and meaningful statement we can expect to hear concerning the two themes—violence and politics—that will probably dominate the rock of 1969."

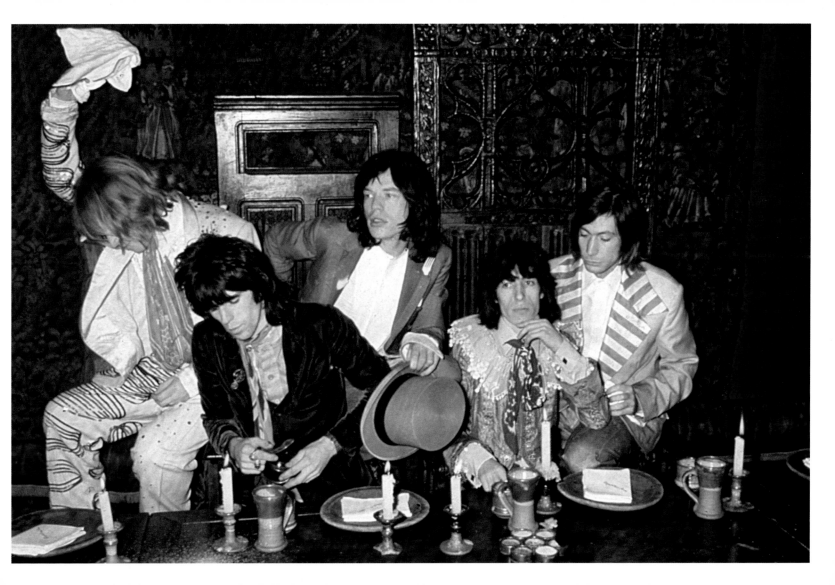

Custard Pie in the Eye

The target of everyone's attention, Mick gets clobbered in the eye at the *Beggars Banquet* launch party. In true banquet style, more than 120 media personnel trooped in to be served a sumptuous seven-course meal by ladies dressed in period costumes. The menu included such delicacies as boar's head and artichokes soused in Canary wine. Then someone started the food fight, and portly press-agent Les Perrin ended up with a sizable dollop of custard on his suit. The Stones occupied the head table of the Queensgate Hotel's Elizabethan Suite that December night, and the baronial banquet theme was extended to the guest list, with none other than Lord Harlech invited to join in the pie throwing. Brian was in particularly good form that evening and can be seen at right launching a pie in some poor soul's direction.

The internal politics dogging the band and Brian's ongoing battle with drugs had come to a head that year, but the group could now—in light of the positive reviews coming in—allow themselves some rare public carousing.

Lord Harlech: "Not quite the sort of party I'm accustomed to but thoroughly enjoyable. I'm here because Mick is a friend of mine. He has been very kind to my children."

168

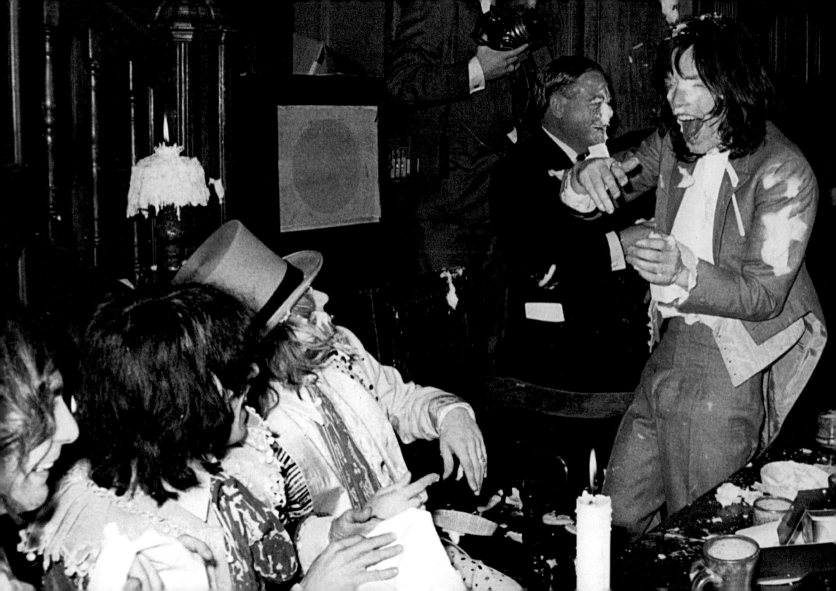

Pleased to Meet You?

Mick, Keith, and a circus clown do their best to lift spirits while filming a TV spectacular on December 11, 1968. The group had announced with some fanfare that they would be producing and starring in their own show entitled *The Rolling Stones Rock and Roll Circus*, following a trend set by the Beatles, who had self-produced their (albeit ill-fated) *Magical Mystery Tour* the previous year. Mick was especially keen for the Stones to go ahead with their own TV special with pop promo director Michael Lindsay-Hogg on hand to keep things on track. But things didn't go exactly as planned, and the production the band had envisioned as being a fun day for all turned into a nightmarish 48-hour marathon.

169

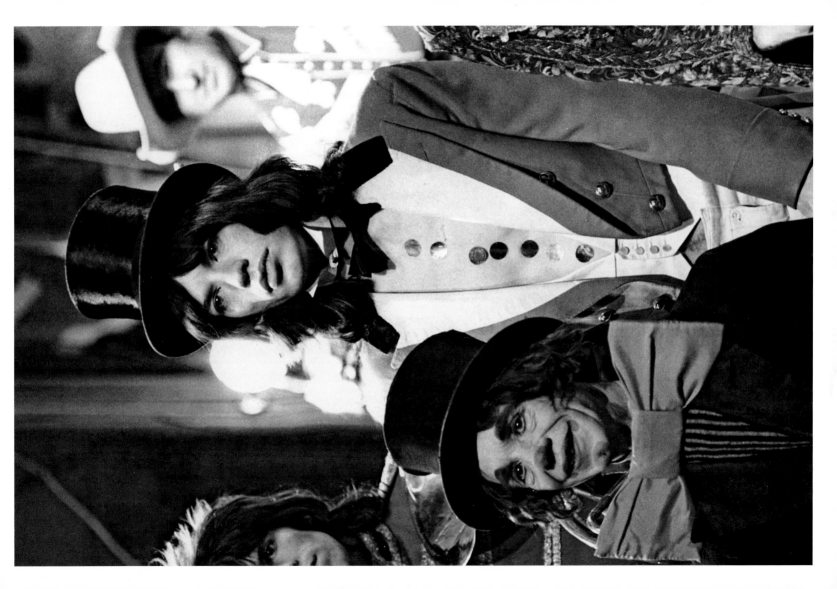

Spilling Over into Daylight

Between takes, Mick shares a joke with drummer Keith Moon and guitarist Pete Townshend of the Who. For the *Rock and Roll Circus*, a mock circus tent had been erected inside Stonebridge Studios in Wembley, London. The show's lineup included such acts as the Who, Taj Mahal, Marianne Faithfull, and Jethro Tull—and John Lennon would appear in his first-ever non-Beatles performance. Lennon had agreed to perform as part of a supergroup entitled the Dirty Mac, which included such rock luminaries as Eric Clapton, Keith Richards, Mitch Mitchell, and the classical violinist Ivry Gitlis.

Filming began early on the afternoon of December 11, but technical problems besieged the production and shooting went way overtime. Ultimately, the Stones didn't appear until well past 4:00 a.m., when most of the band members were visibly exhausted. Upon later viewing the results, the Stones, particularly Jagger, were dismayed with their limp performance, especially in contrast with the powerful set delivered by the Who. Mainly on Jagger's insistence, they shelved the project to the archive, where it lay until its eventual release in 1996. The day after filming, the band sent a bouquet of flowers to the Who, with a handwritten note from Jagger.

Note from Mick: "Thank you for working so hard on the television show—really. Mick."

170

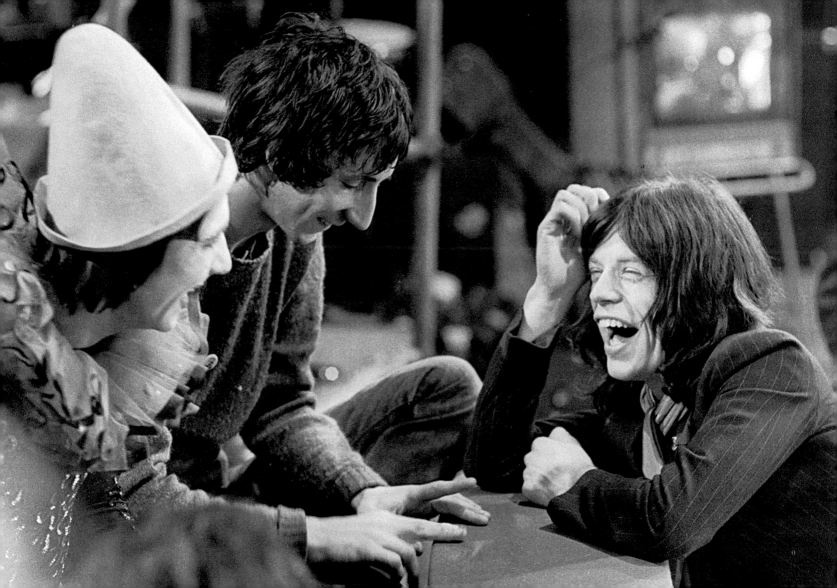

A Touching Moment

Filming for the *Rock and Roll Circus* ran into several technical hitches and, as a result, there was a fair amount of waiting around on set. John Lennon, then four months into his high-profile relationship with avant-garde artist Yoko Ono, had brought along his five-year-old son, Julian, for some quality time. The press had been swarming outside the studio and were momentarily allowed in to take some pictures on the set, where they found a contented John, Yoko, and Julian sitting alongside Brian and other assorted revelers.

John Lennon: "[Brian] was different over the years as he disintegrated. He ended up the kind of guy that you dread he'd come on the phone, you know, because you knew it was trouble. He was really in a lot of pain. But in the early days he was all right, because he was young and confident. He was one of them guys that disintegrated in front of you. And he was all right, and he wasn't sort of brilliant or anything, he was just a nice guy."

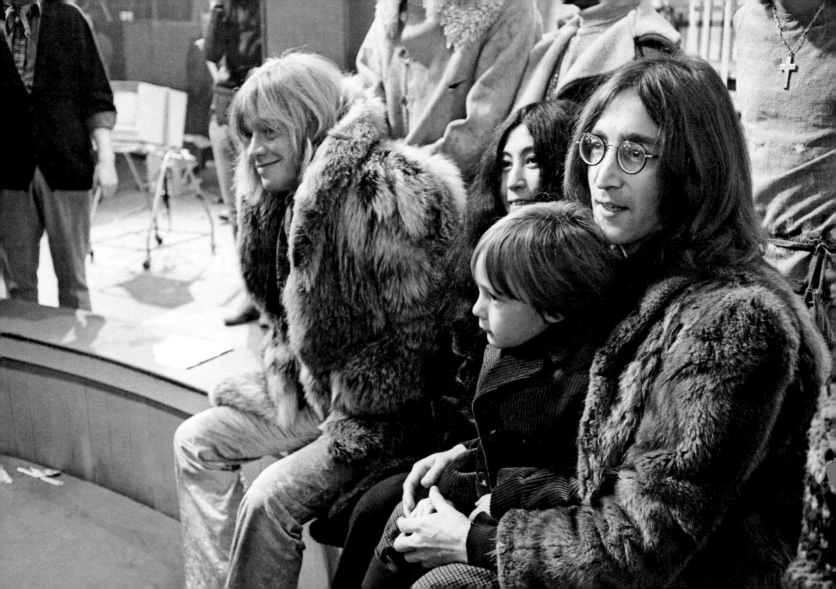

In Search of Magic

Mick, Keith, and Anita Pallenberg at Heathrow Airport en route to Brazil, December 18, 1968. They, along with Marianne Faithfull, are purportedly on their way to find a shaman. The group invented this bizarre excuse for a vacation, which was actually an attempt to repair strained relations brought on by the filming of *Performance*. Mick and Anita had key roles in the film and managed to have an affair to boot. Needless to say, things had become somewhat awkward in the foursome.

Despite the circumstances, Keith—who acted as media spokesperson—seemed in high spirits on the group's departure from London. He had good reason: Anita was expecting their first child.

Keith: "We've become very interested in magic and we're very serious about this trip. We hope to see this magician who practices both white magic and black magic. He has a long and difficult name, which we cannot pronounce. We call him 'Banana' for short."

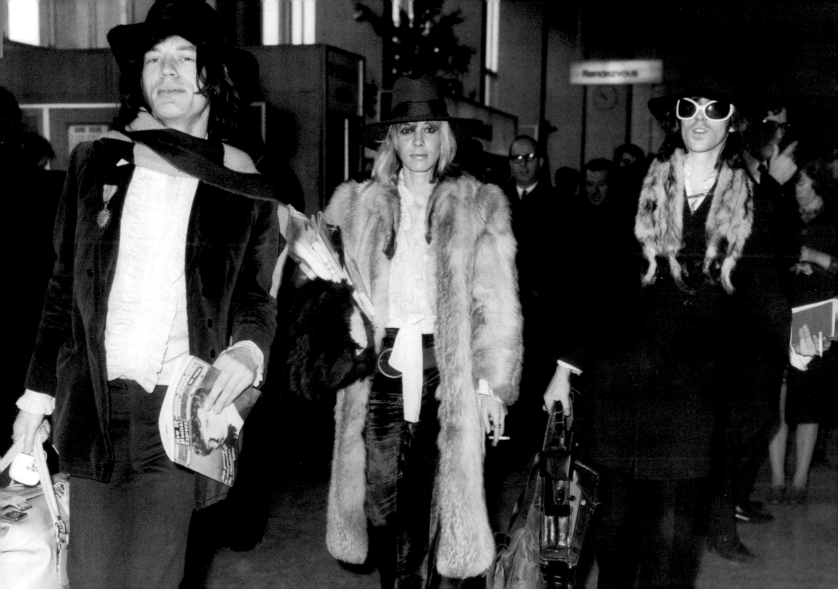

Eye Candy

Just weeks before his imminent dismissal from the Stones, Brian enjoys a
rare night out with girlfriend Suki Poitier, for the premiere of the film *Candy*
at the London Pavilion, March 6, 1969. The soft-porn movie, based on Terry
Southern's novel of the same name, was getting a lot of attention from
critics for its sensational content. Ringo Starr's involvement—in his first non-
Beatles film appearance—added interest: any film featuring rock's illuminati
garnered a large smattering of personalities at its premiere. Brian was an
associate of both Ringo Starr's and Terry Southern's, but he rarely socialized
with the other Stones by this point, and their view on the disintegrating
relationship was telling.

Charlie: "He wasn't showing up, and you know what
happens when people don't show up—you do without
them. And then, when you do without them, suddenly
they are not needed, and then it was a decision, 'Shall
we get someone else?'"

173

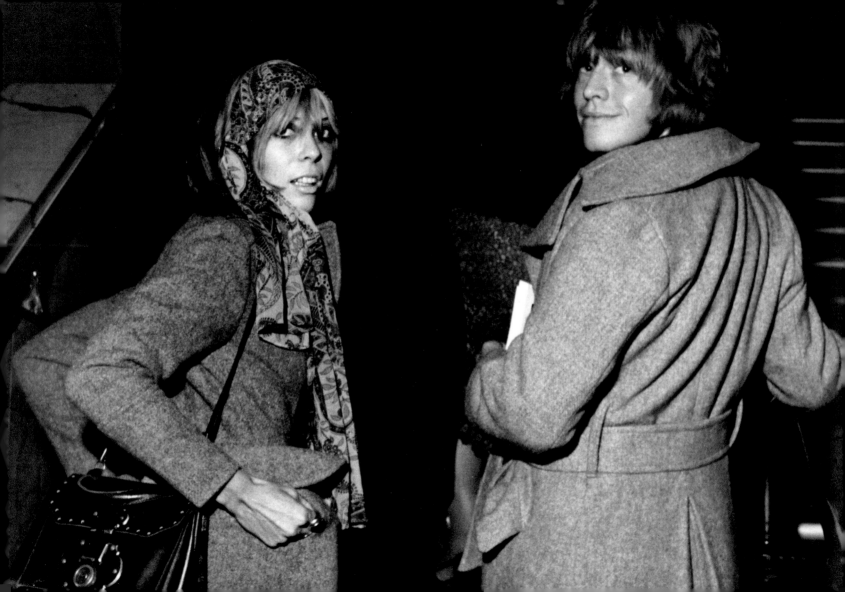

Another Day, Another Stone, Another Charge

Alighting from their open-topped Morgan, Mick Jagger and Marianne Faithfull arrive at London's Marlborough Street Magistrates' Court on May 29, 1969, to answer drug charges. Any illusions that the police were done pursuing the Stones were dashed when there was a knock on Mick's oak-paneled door the previous morning. Six police officers from the London Drug Squad entered the home at 48 Cheyne Walk, Chelsea, and confined Jagger to the dining room while they set about searching the premises. The officers found a small wooden casket containing a quarter ounce of cannabis. At the courthouse, the couple entered a plea of "not guilty" and was released on bail, but their case wouldn't be heard until December of that year.

Mick: "I didn't get the chance to do anything. One of them stuck his foot in the door and the rest came barging in."

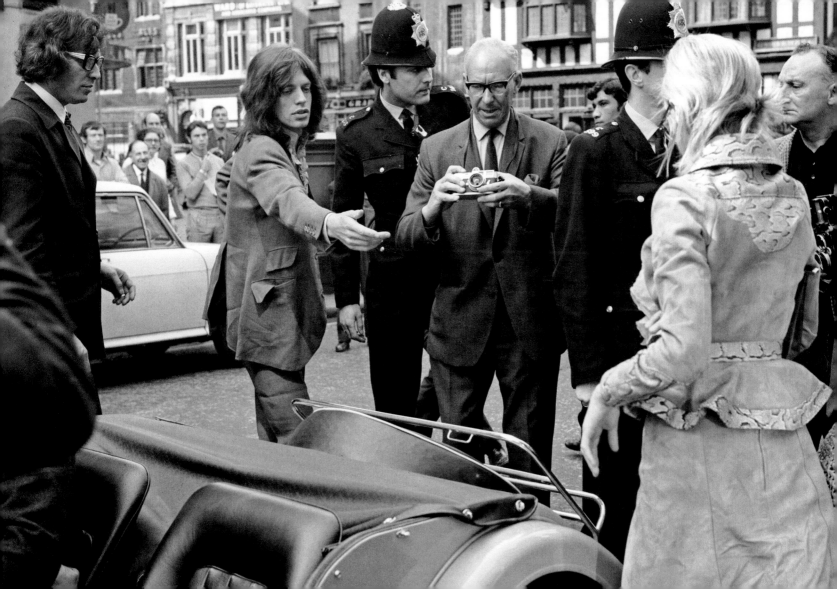

Hyde Park and the New Boy

On June 13, 1969, only five days after their "amicable" dismissal of Brian Jones, the Rolling Stones formally presented new guitarist Mick Taylor to the world's press. Appropriately enough, the band convened on a bandstand for the report, which dovetailed perfectly with their announcement of an upcoming free concert in London's Hyde Park, set to take place on Saturday, July 5.

Mick Taylor was every inch the gifted guitarist. He had begun playing the instrument at the tender age of nine, and had garnered considerable respect for his work with blues maestro John Mayall. At the time the Stones recruited him, he was just 21. Taylor had performed some perfunctory studio duties on *Let It Bleed*, but his public debut with the Stones was at the Hyde Park concert. He was suitably nonplussed by the attention the new post brought him, and somewhat bemused by his rapid induction into the group.

Mick Taylor: "It was so unexpected. It's all a bit strange for me, but I don't really feel a part of the group yet, and I won't do until I have been with them for quite a while and played with them on gigs."

175

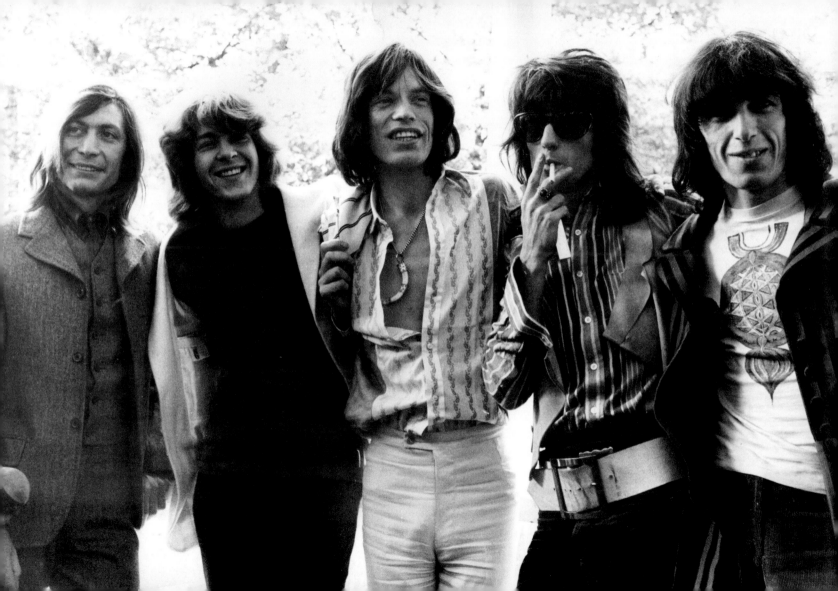

Grass Loungers

Swarms of London paparazzi surrounded the Rolling Stones as they posed near the Hyde Park bandstand June 13. Much to the photographers' delight, the group good-naturedly agreed to take a seat on the grass. They were at that point suitably gung-ho about their future prospects: Mick Taylor was joining the band. The upcoming Hyde Park concert was to be in essence an overture to a tour. And the release of their new single "Honky Tonk Women" was forthcoming. However, the events of July 2 would take everybody by surprise.

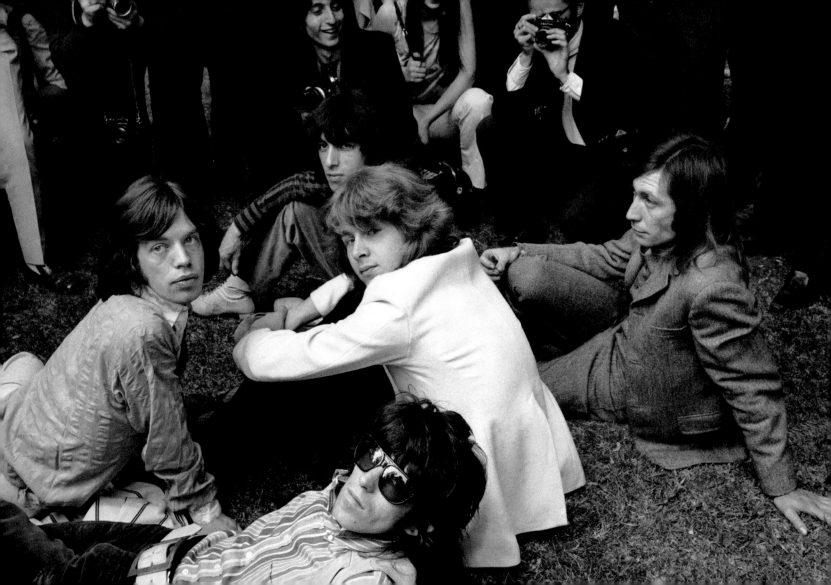

Where Once Did Pooh Play

On the morning of July 2, 1969, Brian Jones was found dead in his pool. Brian had played out the last few pages of life at his home, Cotchford Farm, located at the end of a rural track in Hartfield, Sussex. The property evoked childlike imagery that Jones, the eternal outcast, had reveled in. Its most famous tenant prior to Jones had been A. A. Milne, of Winnie-the-Pooh fame. Milne had drawn inspiration from the lush green foliage of Ashdown Forest, which surrounded the little cottage, and at every turn there were reminders of the dream world the writer had created. Jones's dismissal from the Stones in June 1969, although not entirely unforeseen, had devastated him, and he retreated further into his own fantasy world. Brian had lived a frugal life at the little house; the only evidence of affluence was the swimming pool. Ironically, this addition to the property would play a damning role in Jones's demise.

The *Times*: "Brian Jones, aged 25, a former guitarist with the Rolling Stones pop group who died early yesterday after a midnight swim at his country home, might have had an attack of asthma while bathing, it was suggested yesterday. Mr. Tom Keylock, aged 43, the Rolling Stones' tour manager said Brian had suffered from asthma for some years and it was particularly bad when there was a lot of pollen about. There was an asthma inhaler, which Brian used to help him breathe, by the side of the swimming pool and there was a very high pollen count yesterday."

"He is not dead, he doth not sleep."

Mick momentarily tames the July 5 Hyde Park crowd with a reading for Brian. The Stones had become used to turbulent times in their career, but the sacking of Brian Jones, the induction of new member Mick Taylor, and Brian's subsequent death had left them emotionally drained. The free concert would have greater implications than the band had formerly imagined; it was to be Brian's send-off from the Stones.

Mick Jagger had appealed to Marianne Faithfull to uncover a spiritually appropriate reading (her literary knowledge far exceeded his). They settled on a few lines from Shelley's poem "Adonais." Its sentiment resonated deeply with the 250,000-plus crowd and, for the most part, they kept quiet as Mick read.

Mick: "Brian will be at the concert. I mean, he'll be there. But it all depends on what you believe in. If you're agnostic, he's just dead, and that's it. When we get there this afternoon, he's going to be there. I don't believe in Western bereavement. I can't suddenly drape a long black veil and walk the hills. But it is still very upsetting. I want to make it so that Brian's send-off from the world is filled with as much happiness as possible."

178

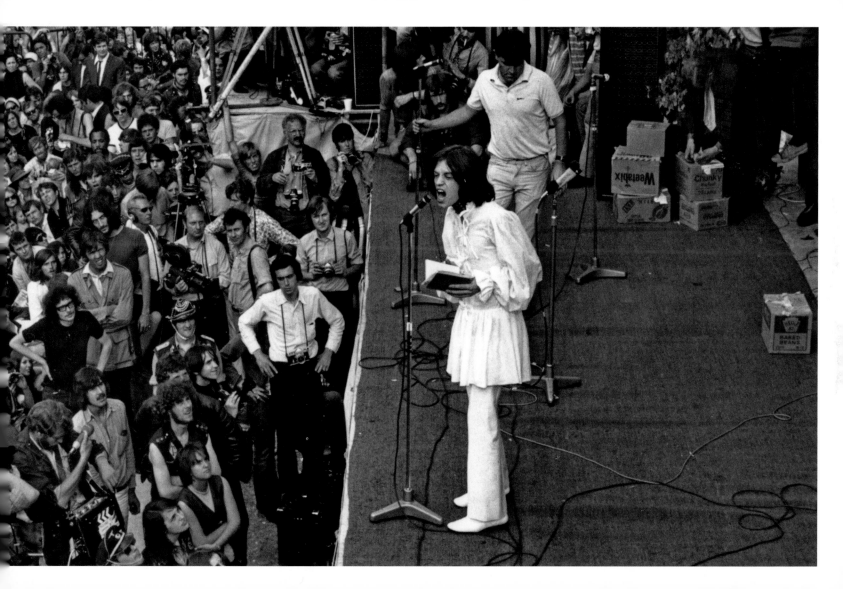

Butterfly Minds

After Mick Jagger's reading, the Stones came to grips with the task of entertaining a quarter of a million fans at Hyde Park. They hadn't toured for two years while they worked in the studio, so they were totally unprepared for live work. At a single gathering they had managed to formulate a set list, and at John Lennon's suggestion, they convened the night before at the Beatles' Apple Studios to rehearse. Given the bittersweet nature of the event, any ostentatious stunts were out of the question. However, the group did use one prop: the release of hundreds of butterflies into the audience. The effect was short-lived—the majority of the half-dead insects flopped onto the stage, while the rest presumably wilted in the mass of sound.

Letter to the *Times*, July 11, 1969: "Sir, It is indeed a pity that Mr. Jagger and his promoters should have prevailed upon a butterfly breeder to sell such a vast stock of carefully reared insects for such a trivial gimmick in terms of entertainment and for such a meaningless purpose in terms of conservation. I trust Mr. Jagger will redeem himself by offering to buy as many again and entrust them to my society so that they can be released throughout Britain, not only to give pleasure to many who are saddened by the disappearance of butterflies, but to assist us in our endeavours to re-establish species in natural habitats. Yours faithfully, Thomas Frankland, Chairman, British Butterfly Conservation Society"

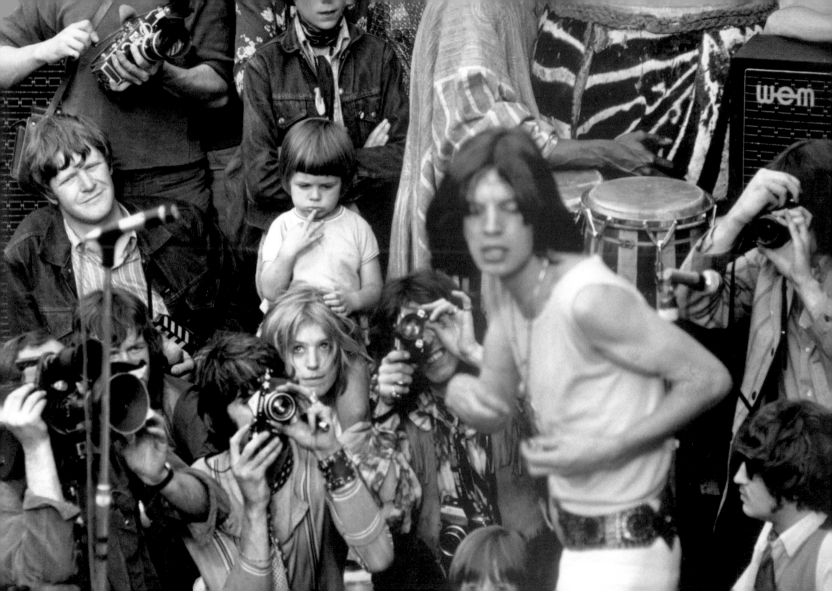

Breaking In

Mick Taylor hides behind his flowing locks during the Hyde Park concert. Stepping into Brian Jones's shoes must have seemed a daunting task to say the least. Whereas Brian's innovative guitar technique had been markedly different from Keith's relatively conventional approach, Taylor's considerable abilities only highlighted any failings on Keith's part. As a result, an uneasy distance would have to be brokered between the guitarists. Initially, though, the rookie was welcomed into the group.

Mick Taylor: "I feel I am a Rolling Stone now. I didn't at first. It wasn't like being part of the group until we did that concert in the park."

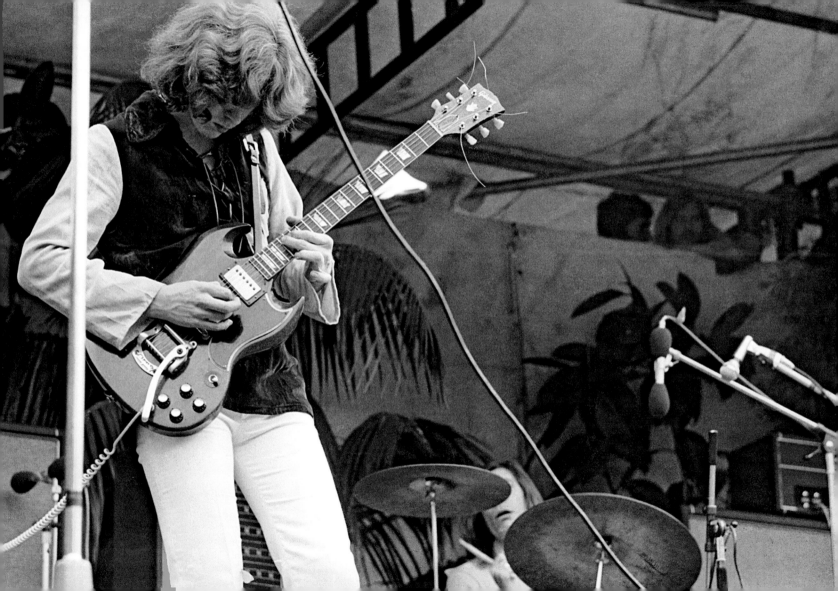

Up Close and Personal

Marianne Faithfull with son Nicholas in a huddle onstage at the Stones' concert in Hyde Park. Marianne had arrived with Mick and had taken a seat at the side of the stage reserved for friends, wives, and girlfriends. By her own admission, she was sick and weak from her recent heroin withdrawal, and the specter of Brian's death was haunting her every step. Adding to her worries was the attention Mick was receiving from *Hair* musical diva Marsha Hunt. Marianne's hunch turned out to be founded when Mick left the show with Hunt, and Marianne and son returned home alone.

181

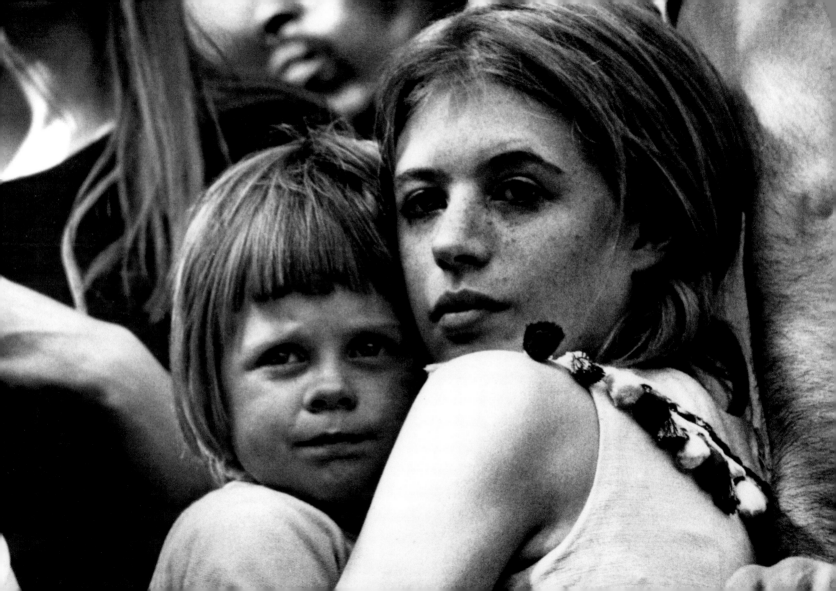

Hells Angels at Hyde Park

Giving orders at Hyde Park, a swastika-bearing Hells Angel attempts to keep the peace. In view of the Stones' flirtation with the dark side, it seemed appropriate that the Angels would handle security at the concert. The biker gang found their tasks to be somewhat more diverse than just crowd control. Indeed, one of their duties that afternoon was reuniting lost children with their parents; many kids were more interested in the Serpentine River at the bottom of the park than in the Stones, and wandered off to play during the concert.

Hells Angel: "The Stones are real live people. Not like the Beatles with this seven day in bed; they're true to life."

182

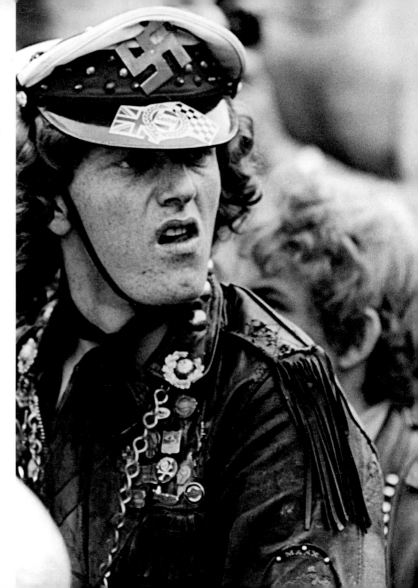

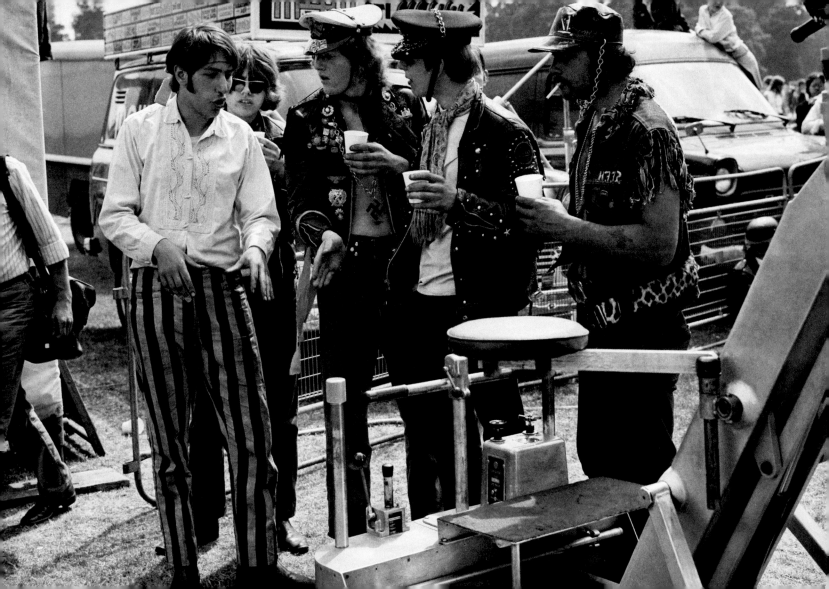

Crowd Scenes

With the Hells Angels peacefully shepherding the crowd, the Hyde Park crowd of a quarter million was on its best behavior and happily acquiesced to organizers' demands. Master of Ceremonies Sam Cutler's authoritative voice helped ensure that things went smoothly, and remarkably, no incidents were reported to the police. All in all, the concert was seen as a demonstrative token of the "peace and love" generation. The single blemish on the event was a spot of tree climbing, undertaken by fans attempting to get a better view.

Sam Cutler: "Trees have branches. This particular tree has decided to shed its branch, mainly because it is not used to three hundred people sitting in its midst. Could we ask people to respect this park and to respect the trees. We don't want to destroy trees."

183

"Please don't judge me too harshly."

The somber cortege at Brian's funeral makes its way to the small Hatherley Road Parish Church in Cheltenham, Gloucestershire, on July 10, 1969. It was a tearful caravan of friends, family, and colleagues, there to witness the final page in Brian's life being turned. Fellow Stones Bill and Charlie were present to pay their respects, but Jagger and Richards—despite having reasonable excuses—were conspicuous in their absence.

During the funeral service, Pastor Hugh Hopkins read from a telegram Jones had sent his parents while he was under arrest for drugs in 1967. Its sentiment, "Don't judge me too harshly," resonated deeply with those who had known Jones during his short but eventful life. But, somewhat out of keeping with the reflective nature of the service, the pastor used the occasion to deliver a thinly veiled attack on the destructive lifestyle of the 1960s, which he saw as being propagated by the Stones.

Pastor Hopkins: "He had little patience with authority, convention, and tradition. In this he was typical of many of his generation that have come to see in the Stones an expression of their whole attitude to life. Much that this ancient church has stood for in nine hundred years seems totally irrelevant to them."

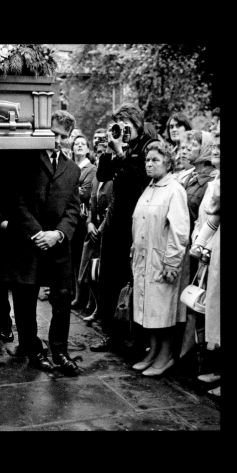

Reflections on a Life

The Joneses' family home on Hatherley Road in Cheltenham was situated across the street from the parish church that hosted Brian's funeral. Leading the trail of mourners were, from left to right: Brian's parents, Louisa and Louis Jones, Brian's grandmother, and sister Barbara. The mix of cultures at Brian's funeral was representative of the chaotic roller-coaster ride his short life had been. As patchouli and incense wafted throughout the church, Brian's parents were left to reflect on the troubled life of their son, which was particularly harrowing, as they had seen him recently in good spirits despite his recent dismissal from the Stones.

Louis Jones: "We spent an intensely happy weekend with him, the happiest and closest weekend we had spent with him since he was a child. It was the last time we ever saw him."

185

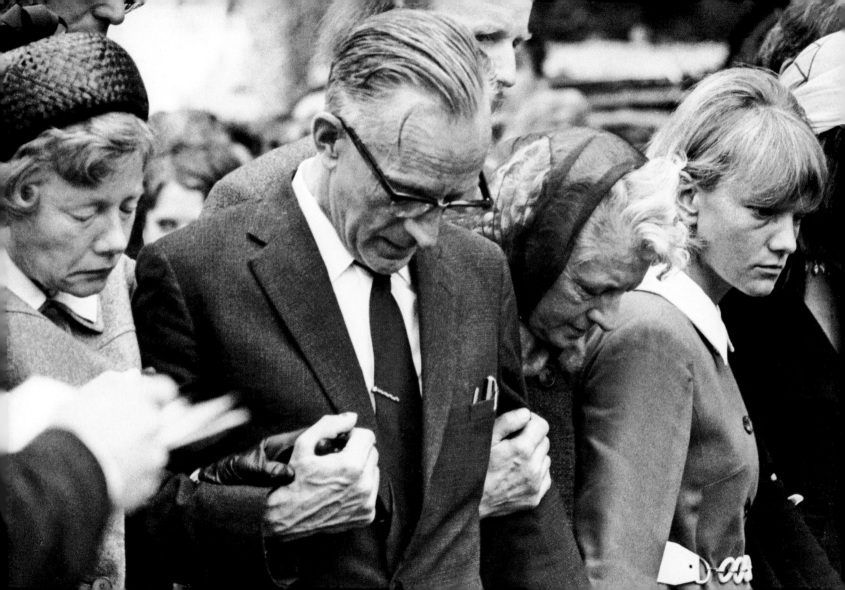

Absent Healing

Any anger over Mick and Marianne's noticeable absence from Brian's funeral was partially assuaged by their sending an exquisite wreath for the occasion. Both had been deeply shocked by Brian's untimely death, but they had to head off to Australia to begin shooting on the film *Ned Kelly*. Faithfull took it the hardest, though, and while the wreath's lilies rustled in the wind atop Brian's grave, Faithfull was deep in a coma caused by a massive tranquilizer overdose.

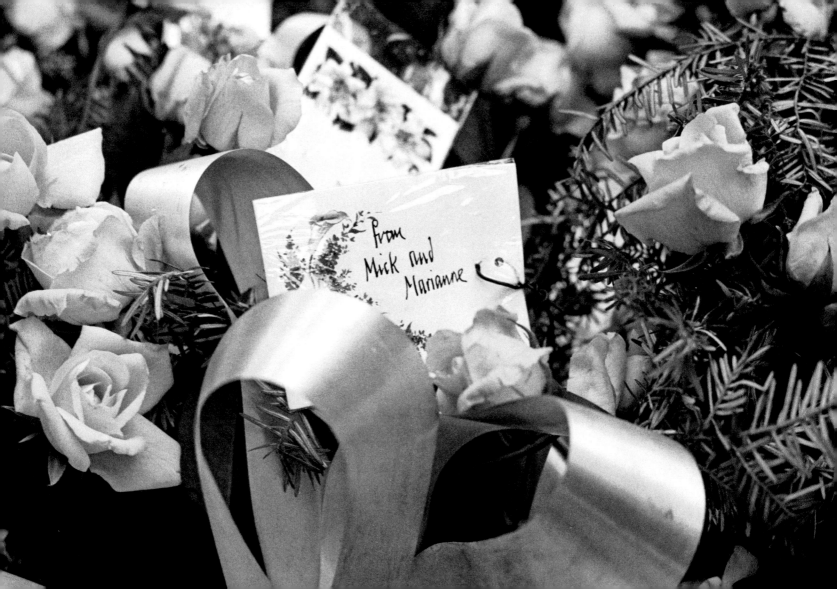

Convalescence

Mick dutifully poses for a press photo on the lawn of Mount St. Michael Hospital on July 27, 1969. Jagger was dividing his time in Australia between the set of *Ned Kelly* and the hospital, where he looked in on Marianne as she convalesced following her overdose. The couple's stay in Australia had aroused considerable controversy, and the press used every tactic to get an exclusive on the unfolding drama.

Mick wisely covered up his hand for this shot: he had received a severe injury when an explosive had gone off during filming. The whole *Ned Kelly* experience was a miserable one for him. He'd clashed with British director Tony Richardson over the script, and the hard-nosed Australian press was appalled by his being cast. The only happiness he felt came from his surreptitious daily phone calls to Marsha Hunt, who even inspired Jagger to write a new song—"Brown Sugar."

Mick: "I wrote 'Brown Sugar' in Australia in the middle of a field. They were really odd circumstances. I was doing this movie *Ned Kelly*, and my hand had got really damaged in this action sequence… I was trying to rehabilitate my hand and I had this new kind of electric guitar, and I was playing in the middle of the outback and wrote this tune."

187

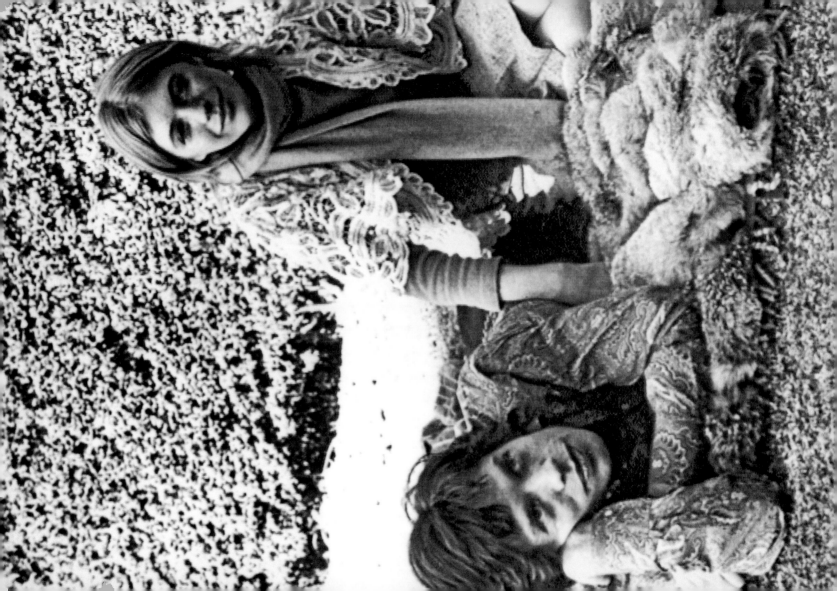

New Life

In the midst of all the tragedy that was dogging the Stones, there was one ray of sunlight: the birth of son Marlon to Anita Pallenberg and Keith Richards. Pictured here outside Kings College Hospital in London on August 10, 1969, the couple was beaming with happiness. Given Keith's image as a roistering rock and roller, fatherhood wasn't something most people would have expected him to embrace with much conviction. Yet an interview with Keith's mother proved quite revealing as to her son's paternal instincts.

Doris Richards: "I didn't know Anita was expecting. Keith simply asked me if I could do some knitting for them. I remember when they came back from South America, Anita pointed to her tummy and said, 'Marlon's been to Brazil.' Keith looked like Jesus Christ then, wearing this big white robe. It seemed like he was floating on air."

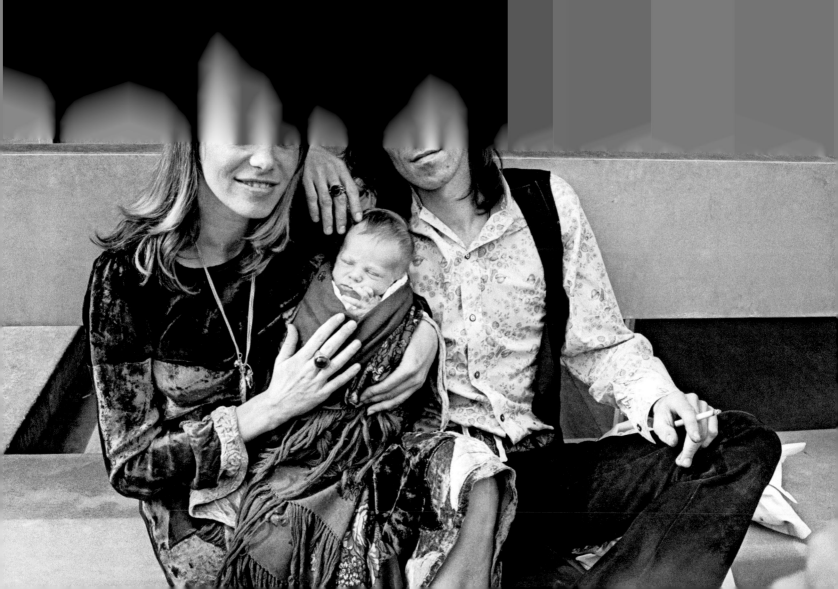

Just Three Doors Away

Keith and Anita at home in their Chelsea riverside home, August 1969. Keith had bought a house for himself and Anita at 3 Cheyne Walk, Chelsea, just a couple of houses down from Mick and Marianne's home. The birth of their son, Marlon, brought the couple closer together, and with the added sparkle from their ever-increasing use of exotic drugs, they seemed to be quite content with their new domestic duties.

Keith: "Anita's an amazing lady. There are some people who you know are going to end up all right. That's why we had Marlon, because we knew it was the right time. We're very instinctive people."

189

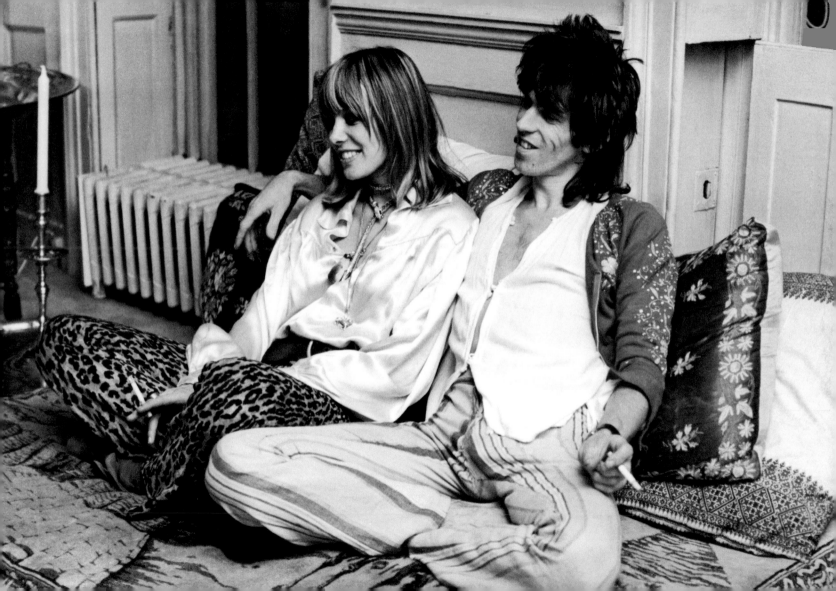

On the Road Again

Charlie, thrilled to be going on tour again—not! After a prolonged spell in the studio recording *Let It Bleed*, the Stones announced on September 14, 1969, that they were going back on the road for their first tour of the States since early 1967. The decision was prompted by the success of their July concert in Hyde Park. It had been a triumph, but more live appearances were required before the Stones' renaissance would be complete. Mick Taylor's virtuoso guitar skills were by then fully absorbed into the band, and the group was ready to wow audiences once again—with the possible exception of Charlie.

Charlie Watts: "I'm not really looking forward to going back on the road because I never ever liked it."

190

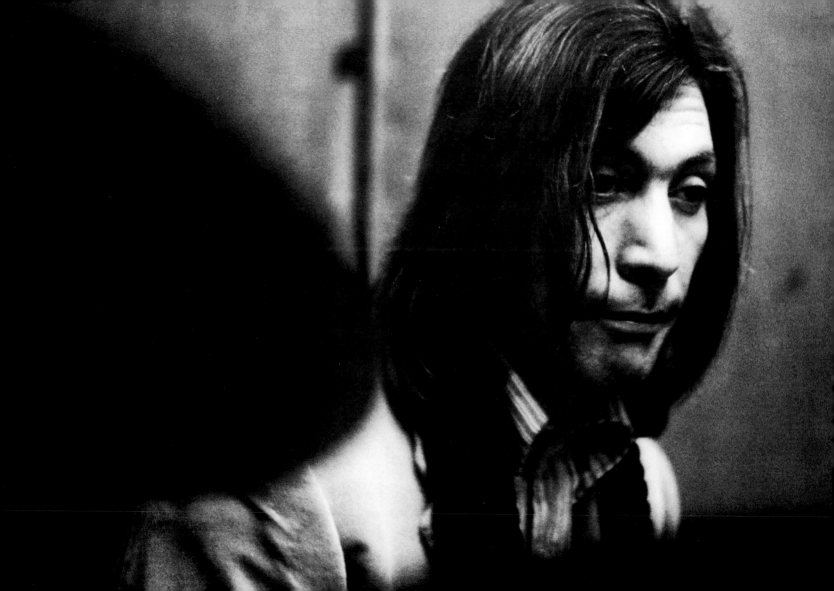

Partners on the Road

Bill Wyman and long-term girlfriend Astrid Lundstrom wander through Heathrow Airport on October 17, prior to the Stones' 1969 American tour. Wyman had a voracious appetite for women and was said to have notched up a thousand partners over the years, so his relationship with model Lundstrom, which carried on from 1967 to 1983, was an uncharacteristically steady one.

191

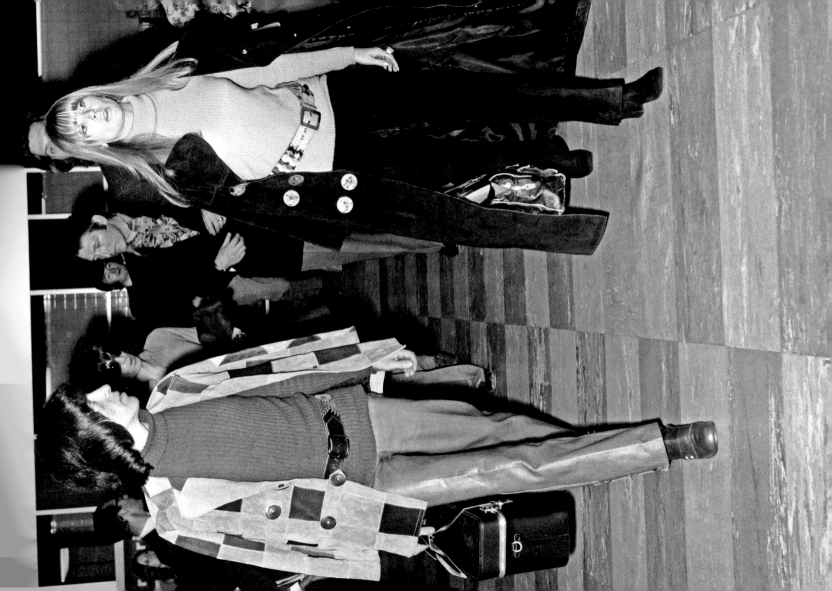

Frail, Fragile, and Home

Marianne Faithfull arrives back in London in late summer 1969, after the ordeal of her overdose. Despite Mick's cavalier romancing, he maintained close contact with Marianne, especially following her overdose and subsequent breakdown in Australia. After being released from the hospital, Marianne, chiefly on the instructions of her mother, Eva, sought refuge in a nunnery before moving onto the *Ned Kelly* set to be with Mick. When filming on *Ned Kelly* was complete, Marianne went off to Switzerland for more rest before her return to London.

Marianne Faithfull: "I didn't just want to die. I wanted to die in a special, maelstrom way on the 'De Quincey' path, to take it to its extreme. It is childish, I knew it was extremely childish, but that's what I thought."

Lounging

Mick takes a time-out at musician Stephen Stills's Hollywood house to strum a few notes, October 1969. The Stones arrived in Los Angeles on October 13 for their long-awaited U.S. tour. They allowed themselves nine days of preparation before their first show. Conveniently, their friend, the country/rock star Stephen Stills, offered the use of his basement studios—under his Laurel Canyon mansion—for rehearsals. Mick and Keith evidently took to the quiet refuge in the Hollywood Hills, as they ended up moving into the house. Marianne Faithfull would make a surprise visit during their stay there—complete with gift wrap and bow.

193

Angel in Their Sights

Word of the Stones' arrival in Benedict Canyon in October 1969 swept like wildfire through the area. Predictably, a huge posse of fans made their way to the property to try to get a glimpse of the band. One such fan was a blond called Angel, who was happy to strip down for a series of images, two of which appear here, taken by trusted friend and photographer Terry O'Neill.

Stephen Stills's expansive manor had its own rock heritage, having been designed by the composer Carmen Dragon and previously owned by Peter Tork of the Monkees. The basement studio had been a favorite hangout of the likes of Joni Mitchell, Gram Parsons, and Neil Young. Stills's friends Graham Nash and David Crosby also liked to play there. It was in this basement that the Crosby, Stills & Nash trio began in earnest.

Free Love and Concert

There was no question who'd be the one to straddle the *Easy Rider* bike dragged in for the shoot at Stephen Stills' house.

Tickets for the Stones' 23 U.S. concerts had flown out of box offices, despite their hefty price tags. The band had hired impresario Bill Graham, and with his powerful promotion machine behind them they easily filled venues the size of Madison Square Garden and the LA Forum. The Stones had missed the legendary Woodstock festival, but not to be outdone, they announced their intention to stage their own one-day festival at the end of the tour, in San Francisco. The fact that admission would be free at the event also helped placate concerns over the steep rise in ticket prices.

Mick: "We are going to do a free concert. It's going to be on December 6 in San Francisco. But it isn't going to be in Golden Gate Park. It's going to be somewhere adjacent to Golden Gate Park and a bit larger."

Symphony for the Devil

Mick shouts it out for a capacity house at Madison Square Garden on November 29, 1969, in one of three concerts the band would play at the 20,000-seat New York arena. The Stones' new album, *Let It Bleed*, had been released that day, and audiences were able to accompany them on their new material. Additionally, the superb acoustics at the Garden made for a perfect environment in which to capture the Stones live. The concerts were so successful, in fact, that they would be the basis of the live album *Get Yer Ya-Ya's Out*. Mick is wearing one of the outfits he would don for the concert at Altamont Speedway in San Francisco the following week.

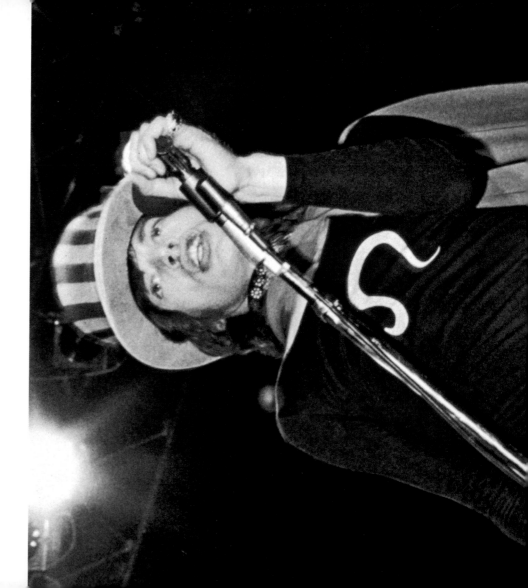

Just Call Me Lucifer

Mick contains the sound in his head during the concert at the Garden on November 29, 1969. Mick and Keith's dalliances with the dark arts seeped into both their music and deportment during their U.S. tour. It conjured up some remarkable moments onstage embellished by the lighting the group used to illuminate the satanic verses.

197

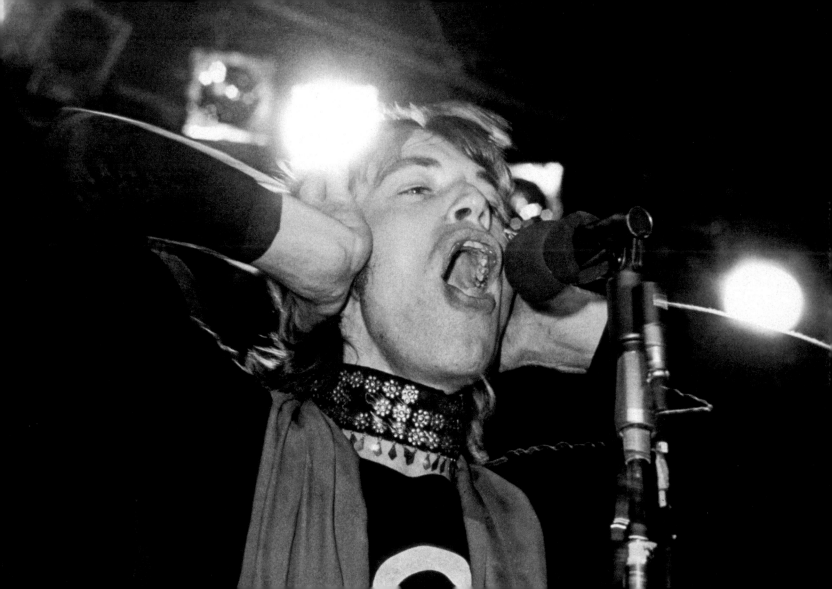

Altamont: "Rape, murder—it's just a shot away."

The Stones' well-intentioned free concert on December 6, 1969, was marred by abominable planning, outbreaks of violence, and even death. When the Stones originally announced the West Coast gig back on November 25, it was slated to be held in San Francisco's Golden Gate Park, renowned for its hippie connections. However, the logistics were never properly addressed, and the city's elders denied the band use of the site. After a few false starts, the band settled on Altamont Speedway, on the outskirts of San Francisco—with only hours left until the show. More than 300,000 revelers were expected, and essential facilities were sorely lacking.

The Hells Angels provided security, as they had at the Hyde Park event, but unlike their UK counterpart, the West Coast chapter was easily disposed to violence. As remuneration, the Angels received five hundred dollars worth of free beer, which they consumed in conjunction with the potent LSD that was omnipresent at the concert.

On the bill that day, the supporting acts included Crosby, Stills & Nash; Santana; Jefferson Airplane; and the Flying Burrito Brothers—some of whom were justifiably intimidated by the scenes of violence breaking out throughout the day, and by the ridiculously low, four-foot-high stage, which offered little protection from the mayhem below. After one altercation in which Marty Balin of Jefferson Airplane was knocked unconscious by the Hells Angels, the Grateful Dead split without playing a note.

When the Stones finally appeared at dusk, their set was peppered with outbreaks of violence that resulted in the death of one Meredith Hunter. Hunter, an 18-year-old Afro-Caribbean, made the mistake of pulling a gun on the Angels during a fight at the front of the stage and was stabbed to death. The Stones were unaware of the young man's death and, although they'd witnessed various altercations from the start of the show, carried on playing. All told, four deaths occurred on the Altamont site that day. It was only after the Stones had escaped by helicopter that the grizzly details of the day's event began to emerge.

Mick from the stage: "What are we fighting for? This could be the most beautiful evening. You know if we really are all one, let's be all one!"

198

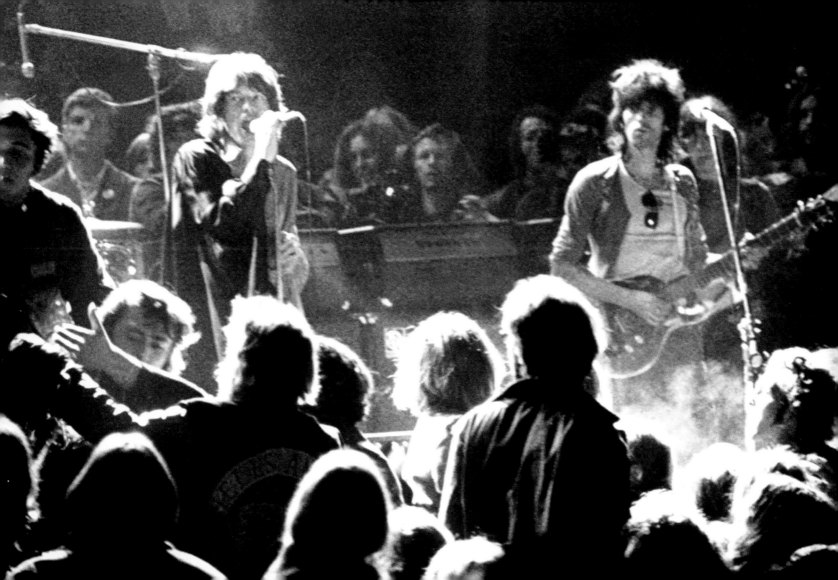

No Time to Talk

With the British press full of reports on the Altamont tragedy, Keith and Charlie beat a hasty retreat out of Heathrow Airport after returning from the U.S. tour on December 8, 1969. Initial reviews had proclaimed the show a tremendous success, but eventually the full story emerged and the scale of the event's terror became evident. While the Stones were on the plane home, Altamont's Angel in chief, Sonny Barger, was unrepentant over the actions of his cohorts, and pointed his finger squarely at the organizers and the Stones themselves.

Sonny Barger: "I didn't go there to police nothing; I ain't no cop. I ain't never ever pretended to be a cop, and this Mick Jagger put it all on the Angels, man. Like he used us for dupes, man, and as far as I am concerned, we were the biggest suckers for that idiot that I can ever see."

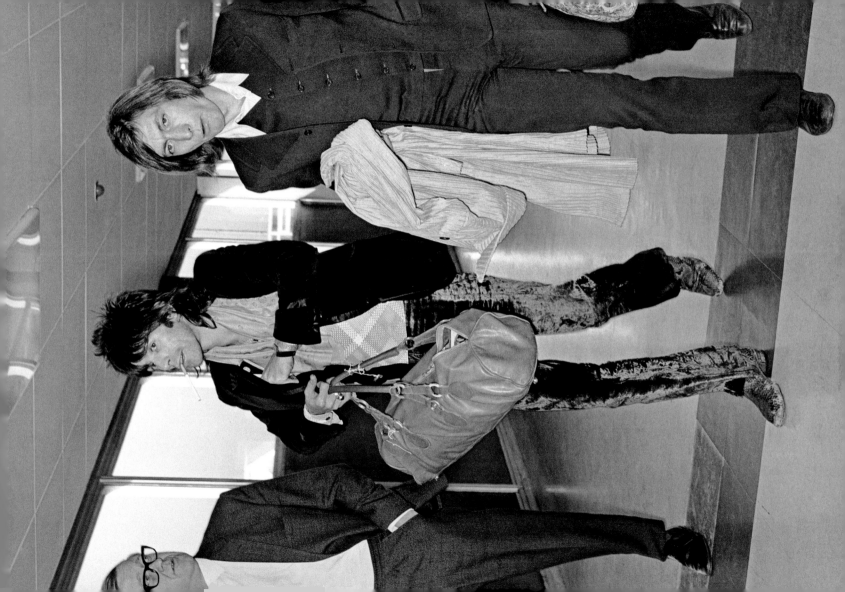

Happy Homecoming

After the horror of Altamont, the initial sight of Anita Pallenberg and son Marlon at Heathrow Airport was a welcome one for Keith. But Anita's greeting wasn't exactly conventional—she held the baby in the air and screamed: "Keith, they're going to throw me out of the country!" Evidently, while Keith was in the States there had been a Home Office investigation into the current status of Pallenberg's British citizenship. Thus Keith was provoked into making a statement on his marital status.

Keith: "It's a drag that you are forced into marriage by bureaucracy. I refuse to get married because some bureaucrat says we must. Rather than do that I would leave Britain and move abroad."

Back in Court

Despite reports in the press that Marianne had left Mick for Italian pop artist Mario Schifano, Mick and Marianne arrived at court hand-in-hand on December 19, 1969, to continue hearings on drug charges dating back to May. At the Marlborough Street courthouse, the couple reiterated their plea of "not guilty." Their representatives lodged various appeals, and the case was postponed yet again, until January 1970. Although Mick and Marianne presented a united front, both were, in fact, looking elsewhere for their individual happiness.

Marianne Faithfull: "I truly didn't want to damage Mick any more than I had. People always assume I became a junkie while I was still with him, but I didn't. It was an experiment I was making with my eyes wide open. I started on heroin knowing exactly what I was doing. I did love Mick very much, and he loved me. But I felt that era was over and nothing could ever be the same again."

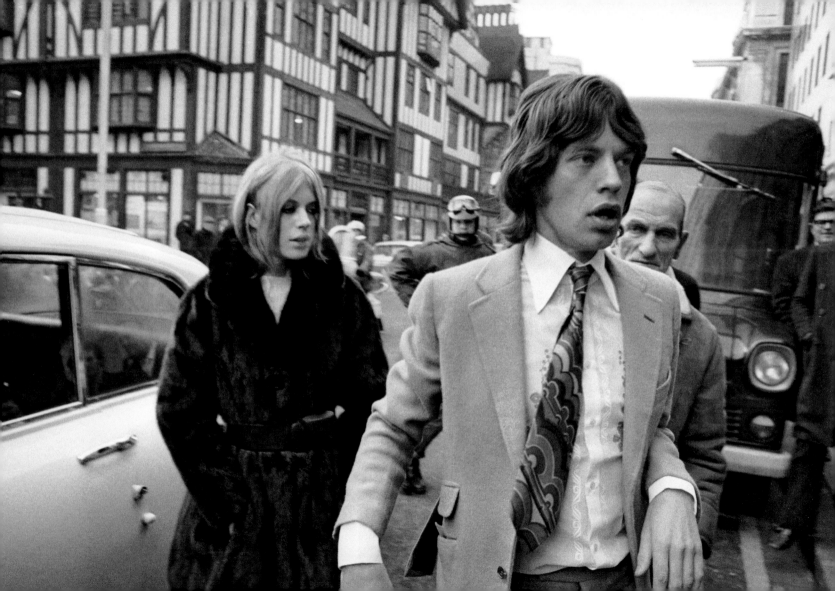

London Town

The Stones closed out the year with two shows at London's Lyceum Ballroom on December 21,1969. After their mammoth tour of the States, the group was pleased to play some shows in London and show off their renewed confidence. Their new album *Let It Bleed* was about to be released, and spirits were high.

The band had played a couple of warm-up shows at London's tiny Saville Theatre on December 14, mostly to a sedate crowd of journalists and various media personnel. In contrast, the nine thousand fans who passed through the doors of the elegant Lyceum lapped up the no-frills rock-and-roll show and partied hard into the night.

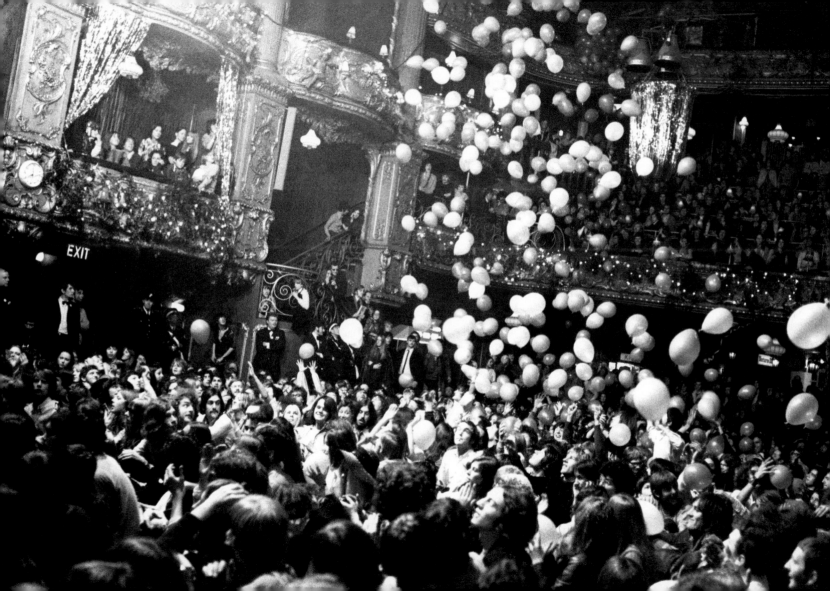

Good-bye to the Sixties

The Stones' end-of-year shows at the Lyceum Ballroom were a fitting send-off to the 1960s. The feeling that a seismic change was about to occur was prevalent throughout London that year. For some, the end of the hedonistic decade signified an entry into an even more unsettling—and less optimistic—era. The 1960s manifesto of love and peace had ultimately given way to greed and despondency, and the implications for the new decade were not good.

The sixties had been a mixed bag for the Rolling Stones. On the one hand, they had garnered fantastic success and global notoriety. On the other, it had all come at an enormous price. Ultimately the death of Brian Jones, Altamont, Marianne Faithfull's disintegration into a drug haze, and the litany of drug offenses weighed heavily upon any idealism the decade had at one time represented. And despite selling countless millions of records and performing thousands of sold-out concerts, the group's finances were at a low ebb. The seventies would see a radical shift in the group's fortunes, and with the dawn of the stadium-rock era, the Stones, especially Jagger, would secure their place on the top of rock's aristocracy.

203

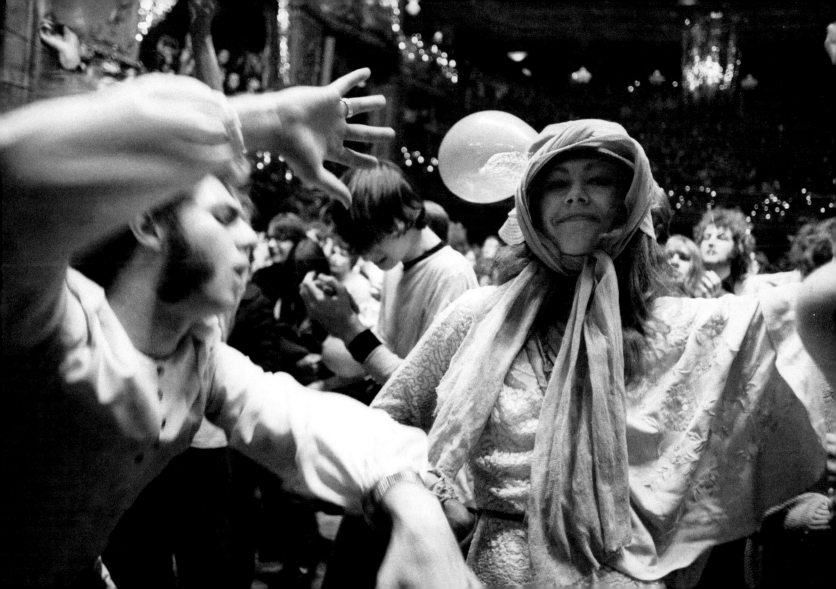

1970

Mick Jagger: "I consider myself very lucky, and one of the reasons for that is that when I'm singing or acting or playing or anything—even at home—I feel just like a baby, like I'm 10 or 11 or 12. Whether that's my fantasy, whether it's right or wrong—I know that it's something that other people can't do."

Keith Richards: "I'll just keep on rocking and hope for the best. I mean that's really what in all honesty it comes down to. I mean why do people want to be entertainers or do they want to listen to music or come and watch people make music? Is it just a distraction or is it a vision or God knows what? It's everything to all kinds of people."

Ron Wood: "The Stones are very inspiring to play with because they don't have any restrictions at all."

Bill Wyman: "We may have thousands of fans around our feet, but you're a pretty lonely man if you haven't got a family to go home to."

Charlie Watts: "I wouldn't want my wife associating with us."

Exhibit A

At right, the seized cannabis and attendant paraphernalia as presented to court during the trial of Mick Jagger and Marianne Faithfull, which reached its conclusion on January 27, 1970. Having had eight months to prepare, the prosecution used every weapon in its armory to pin a narcotics conviction on Mick. He retaliated with cogent evidence, alleging that the detective in charge of the raid, Sergeant Robin Constable, had suggested turning a blind eye to the drugs in return for a cash payment of £1,000—and although the judge ordered an immediate investigation into the serious allegation, it was ultimately dropped on insufficient evidence to warrant a prosecution for corruption. The court found Mick guilty and fined him £200, with costs, but acted more leniently toward Marianne and upheld her "not guilty" plea.

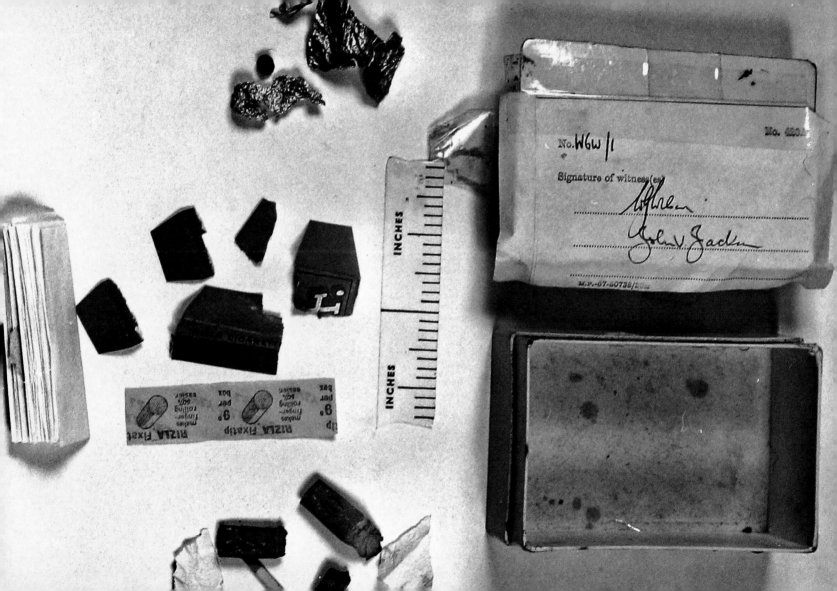

Designs on Interior

The January 1970 trial provided a rare glimpse into Mick and Marianne's Chelsea home, which was usually off-limits to photographers. The interior of 48 Cheyne Row mixed French blinds, Persian carpets, and surrealist artwork, while the sitar nestled against the chair completed the eclectic look. This photo was part of a routine evidence-gathering mission to aid the police in their prosecution of the couple on charges of narcotics possession.

"Vice. And versa."

Mick dissolves into his alter ego in the film Performance. Originally released in August 1970 (after two years of heated negotiations), Performance has by now established itself as one of the all-time great cult films, and its enigma continues to unravel as time goes on. Performance is a hallucinogenic account in which crime meets swinging London via the dark world of celebrity rock and roll. Mick plays Turner, a musician on his way out, and Anita Pallenberg plays Turner's occasional partner, Pherber. James Fox acts in the lead, as a criminal on the run from a gangland killing, who ends up at Turner's pad. Characteristic of its time, the wholly nebulous Performance deals with role-playing and labyrinthine mind games; it was initially poorly received by critics and audiences alike, condemned as being a redundant psychedelic hangover. Despite failing to resonate with the wider public, however, the film reflected an overt detachedness that was common in the 1960s among the likes of Jagger and Pallenberg.

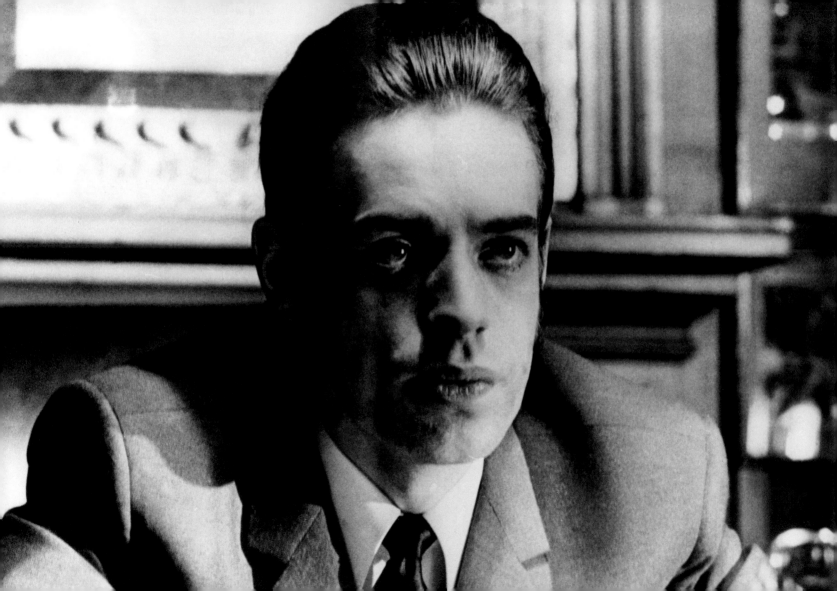

Ménage à Trois

Mick, Anita Pallenberg, and costar Michele Breton share an intimate moment while filming Performance. Donald Cammell, one of the film's codirectors, had become a confidant to the Stones and had shared in many of their mind-expanding adventures during the late 1960s. A noted artist, Cammell had long harbored dreams of a career in film, and when the opportunity arose, he secured a codirector role with Nick Roeg. Marianne Faithfull was originally slated for the role of Pherber, Jagger's hedonistic partner, but she was removed from the production as a result of her troubled pregnancy with Mick's baby and increasing drug use. Anita was an excellent substitute, and she assimilated herself into the role with consummate ease. So well, in fact, that the lines between art and life became blurred and an affair between Mick and Anita flared up. Filming took place in 1968 in Knightsbridge, London; the three-story building that was the set took on the appearance of a hallucinogenic Grand Central Station. As Cammell coaxed Jagger, Pallenberg, and Breton into convoluted sexual gymnastics, word seeped out, enraging Keith Richards. Such was his jealousy that he took to surveying the property from the back of a limousine, even enlisting confidant Robert Fraser to make his way inside and covertly check on the action under the sheets. Fraser's cover was duly blown, and Cammell threw him out. The codirector had good reason to remove Richards's interloper—unbeknownst to Jagger and Richards, he too was sleeping with Pallenberg.

207

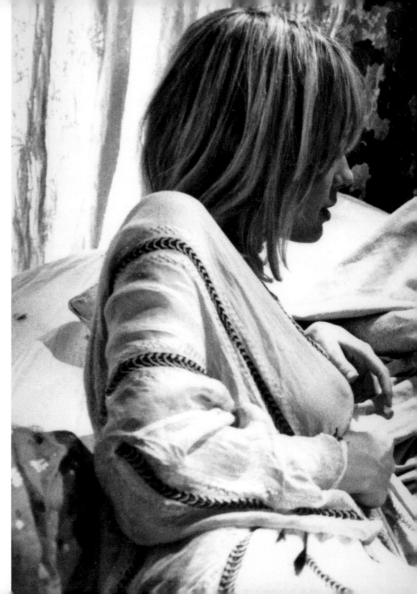

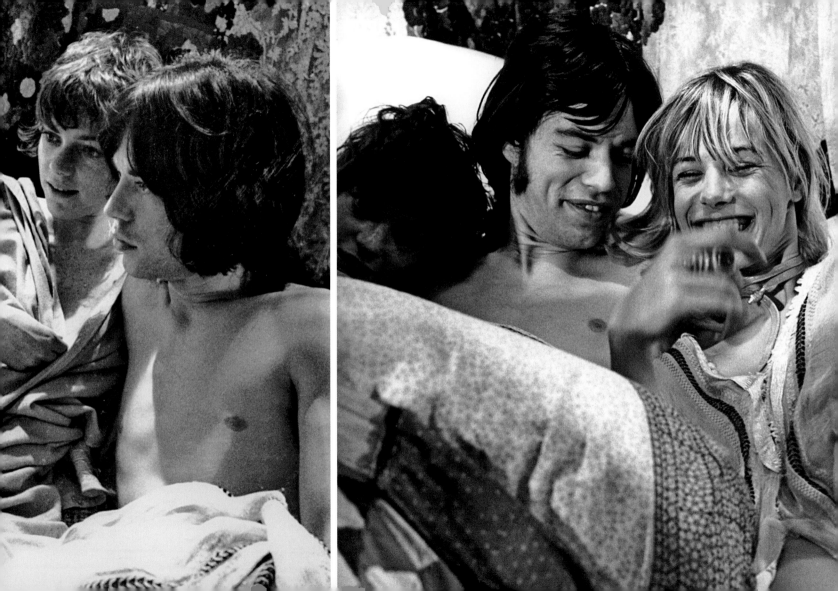

Veteran Psyche

Donald Cammell's insistence that the Performance actors identify emotionally with their characters both on- and offscreen was triggering a volcano of emotions. Hardest hit by the intense method-acting approach was lead James Fox, who bounced between the personas the script demanded while his real-life personality disintegrated. Allegedly as a result of his time on the film, Fox later fled England and spent years coming to terms with the circumstances that had caused him to veer so far off-balance. In contrast, Anita Pallenberg—her seasoned psyche versatile enough to withstand any meddling—effortlessly shifted from the torrid set, where she was engaged in dalliances with both Mick and Donald, to moving back in with Keith. Mick avoided repercussions by shuttling back and forth to Ireland to placate Marianne Faithfull, who, during this time and by her own admission, turned a blind eye to the on-set shenanigans, which did more harm than good to her delicate physical (pregnant) and emotional state at the time. But despite all the actors' efforts on behalf of the film, the reviews at the time were scathing.

Richard Schickel (*Time*): "The most disgusting, the most completely worthless film I have seen since I began reviewing."

208

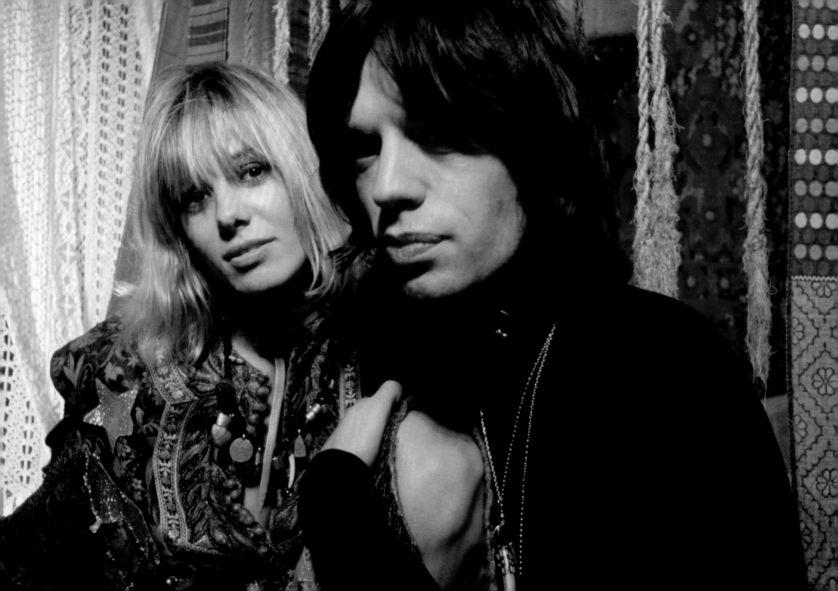

Bed Games

Anita and Mick gaze upward on the set of *Performance*. While Mick tiptoed around the heightened sensitivities of both Marianne and Keith as a result of his affair with Anita, Anita seemed to revel in the complications that resulted from their dalliance. *Performance* had helped her realize many fantasies. She had the bed the two of them are sitting on in the photo, the one in which she and Mick had shared intimacies, transported back to her Chelsea flat she shared with Keith as a keepsake of the film.

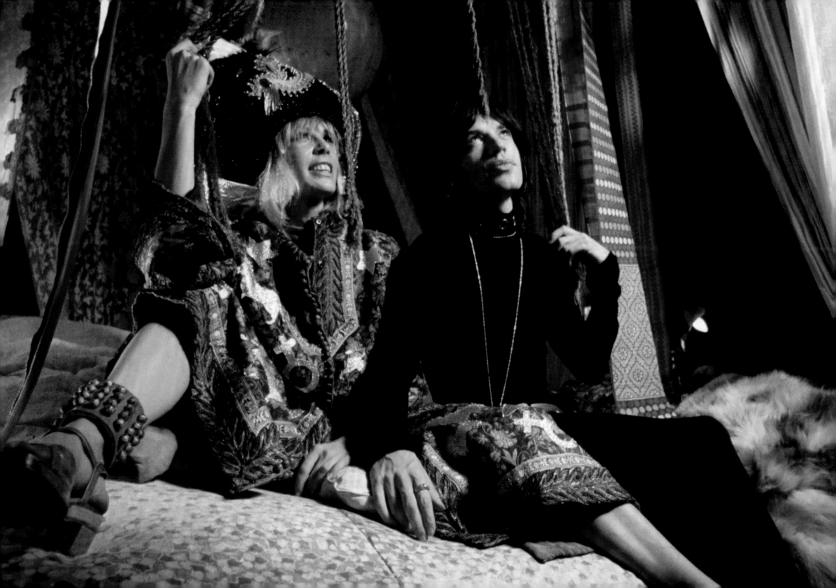

Looking out of John's Car

Mick as James Fox, or was it James Fox as Mick? Who knew? Was it that important? Jagger's *Performance* character drove off into the sunset, but few were aware that John Lennon had loaned his limousine for the final shots.

The troubled film was the subject of much internal squabbling after shooting ceased, and it took over two years to be granted a release. Once the film hit preview screens back in Hollywood, however, all hell broke loose, as outraged directors and their spouses exited the theater vomiting. Such was the collective distaste for the project that the head of the film-processing lab took what he thought was the finished negative into a car park and tried to destroy it with a hammer and chisel. As a result, release was thwarted for 18 months, before extensive reediting had been completed. In the interim, Jagger and Cammell both got involved, sending a telegram to executives at Warner Bros. with a plea to get the film released in its original edit.

Telegram from Mick Jagger and Donald Cammell: "You seem to want to emasculate the most savage and most affectionate scenes in our movie. If *Performance* doesn't upset audiences, it's nothing. If this fact upsets you, the alternative is to sell it fast and no more bullshit!"

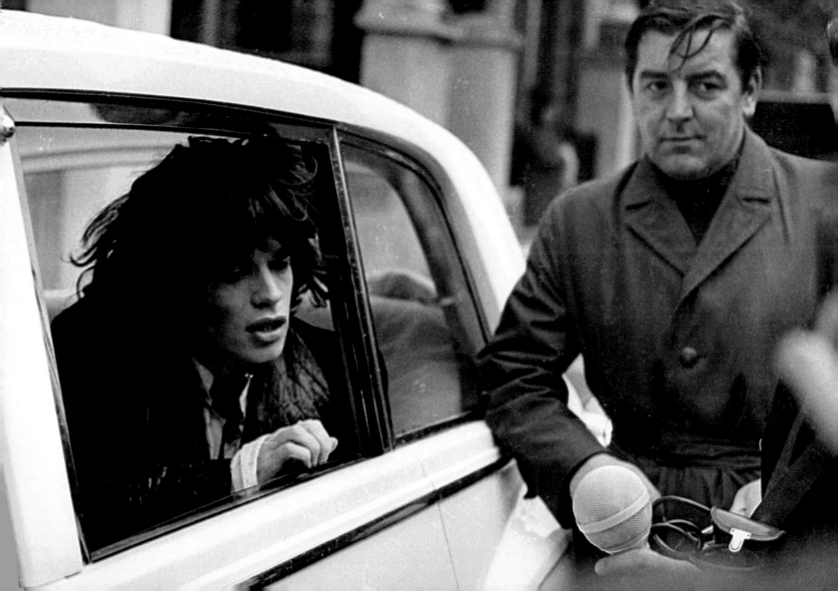

"Je suis un rock star."

With a hairstyle that owes more to The Munsters than to the Rolling Stones, Bill Wyman relaxes in his palatial home. The year 1970 marked a watershed in the band's otherwise bohemian attitude toward finances: the British taxman suddenly made serious inroads into the Stones' accounts (as had recently happened to the Beatles). Jagger and Richards had to face up to their own fiscal trials, but Wyman was overdrawn and faced a £100,000-plus debt to the Inland Revenue.

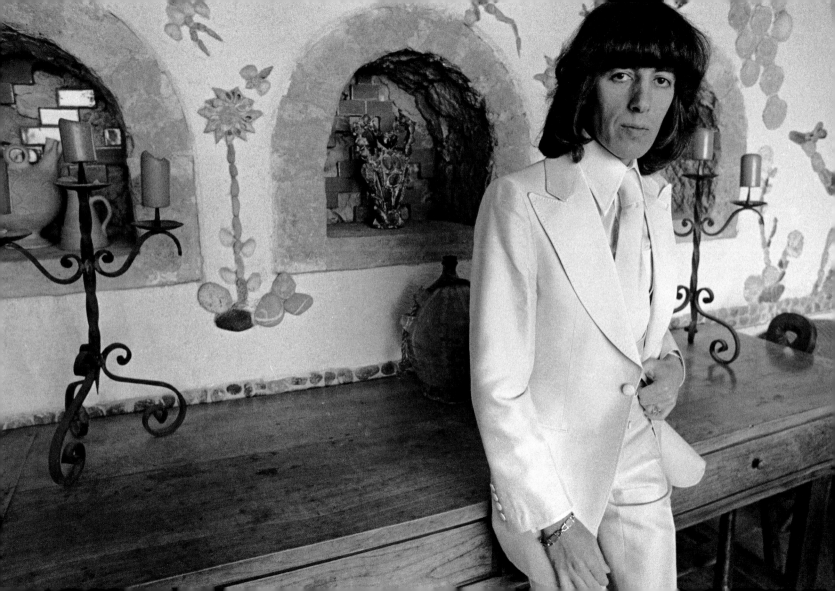

Rehearsal, Rehearsal

Getting back to work, the Stones rehearse in deepest Surrey for their upcoming European tour, August 5, 1970. The overhaul of the group's finances required an immediate renegotiating of commitments to both management and recording contracts; as a result of dwindling assets, the Stones' relationship with manager Allen Klein had diminished, so Mick employed the services of the Austrian aristocrat Prince Rupert Lowenstein to reverse the band's fortunes. The prince, a director of a major London merchant bank, instructed the Stones that their financial future would be bleak unless they relocated abroad. By the end of the year, the Stones were making plans to move en masse to France.

Les Perrin (Stones' press officer): "It's not a case of running away from the taxman. The Stones love France tremendously."

212

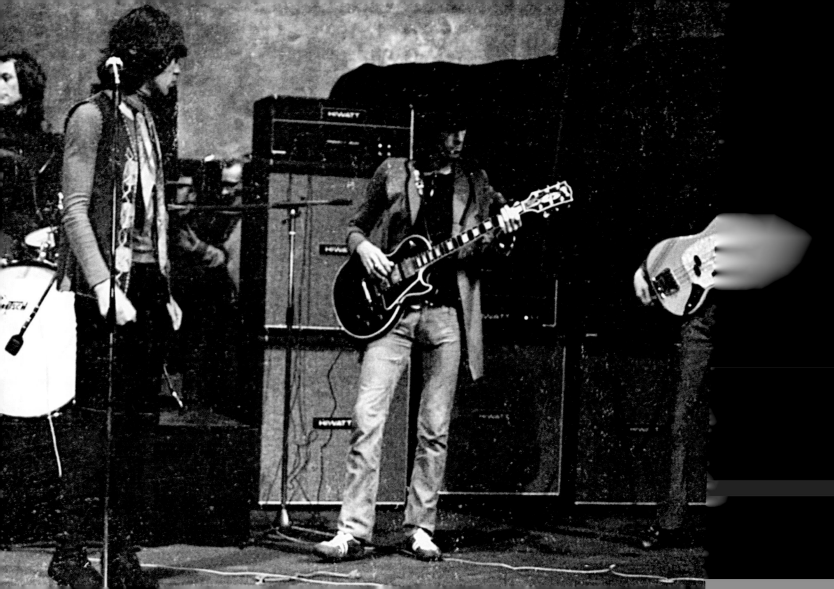

Stones on the Road

Keith, baby Marlon, Anita Pallenberg, and Mick make their way to their Denmark-bound plane at Heathrow Airport, August 29, 1970. The Scandinavian leg of their massive European tour encompassed dates in Sweden, Finland, and Denmark. For the first time, the group featured a brass section, which included Bobby Keys on saxophone and keyboard virtuoso Nicky Hopkins.

213

Calm Before a Storm

Mick Taylor, Jagger, and Charlie enjoy a little piece of Parisian bonhomie prior to their concert at the Palais des Sports on September 23, 1970. Given that the Stones were about to make France their home, the reception they received from fans there was nothing short of explosive. Baton-wielding police had their work cut out for them as over a hundred ticketless fans bombarded the Gendarmerie outside the venue with a barrage of missiles such as iron bars and pieces of concrete.

Keith: "We're more subversive when we go onstage. Yet they still want us to make live appearances. If you really want us to cause trouble we could do a few stage appearances."

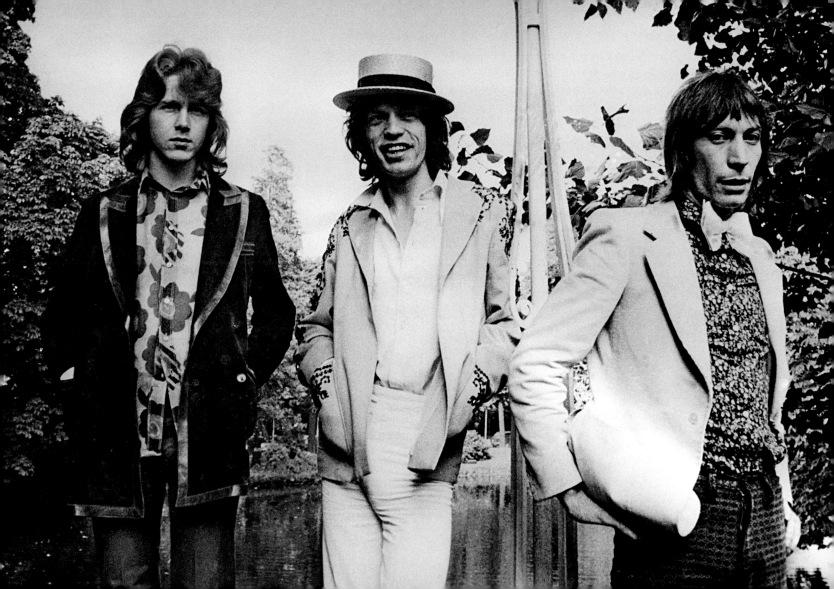

What a Performance!

Keith and Anita Pallenberg saunter up to the Warner West End Cinema in Leicester Square for the London premiere of *Performance*. It had been well over two years since filming on *Performance* had wrapped, but intense squabbling during editing had held up the movie's release until August 1970. British audiences had to wait until January 4, 1971, for the UK opening. Despite the tensions experienced during filming, Keith and Anita appeared quite jolly among London's beautiful people on opening night.

215

Good-bye, Britain!

The Stones raise the roof with a storming live set at the Roundhouse in North London, March 14, 1971. This was to be their last tour before moving to France as tax exiles. The Stones' announcement of their decision to leave the country provoked hysteria among UK fans, and copious stories in the press. Distraught fans who had supported the band over the years ran to the box offices in anticipation of the farewell tour. The band's first sustained trek up and down the United Kingdom since 1966, the tour included the two nights at the Roundhouse, as well as gigs in such far-flung locales as Glasgow, Leeds, and Bristol.

216

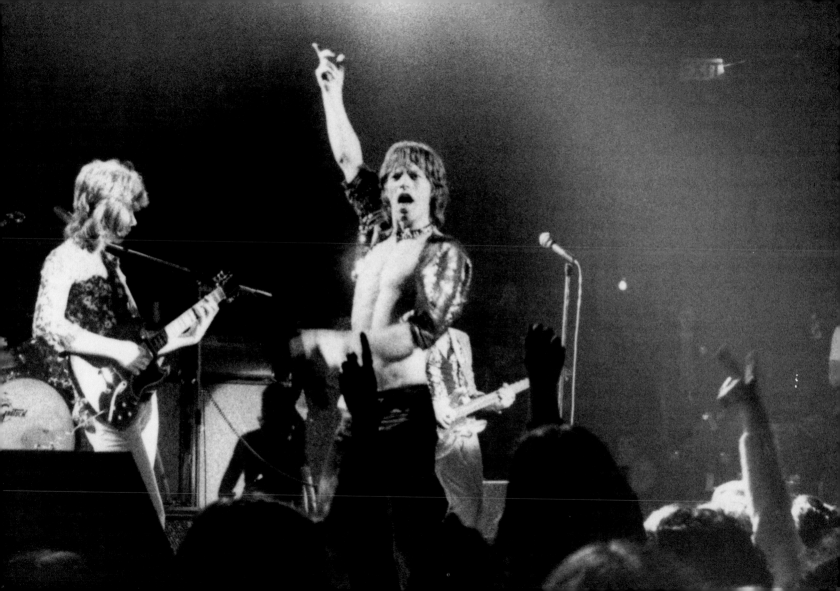

A Walk in the Park

With rumors circulating of their union, Mick Jagger and Bianca Perez Mora de Macias take the air in the south of France, early 1971. Mick had met the beautiful Nicaraguan during the 1970 European tour, and had been instantly smitten with her extraordinary beauty, sharp intellect, and a resemblance in her features that eerily mirrored his own. But Bianca's serene appearance belied a dogged determination to succeed, coupled with strong humanitarian principles. Despite an affluent upbringing, she had sensed that she was meant for greater things than her country could offer her and had moved to Paris at the age of 18. She was awarded a scholarship at the renowned Paris Institute of Political Science, where she studied for two years, until her finances evaporated. Forced back to her home country, she secured a position in Nicaragua's diplomatic corps. Within two years she found herself back in Paris, attached this time to the Nicaraguan Embassy. Performance director Donald Cammell introduced Bianca and Mick when the Stones played at the Paris Olympia on September 23, 1970. The attraction was immediate, and within weeks they were seeing each other regularly.

Donald Cammell (on introducing Mick and Bianca): "You two are going to have a great romance; you were made for each other."

217

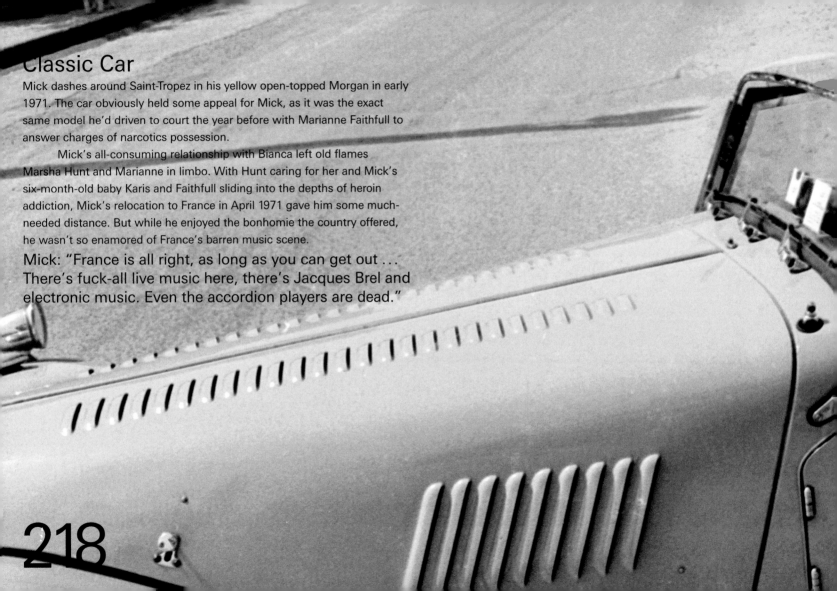

Classic Car

Mick dashes around Saint-Tropez in his yellow open-topped Morgan in early 1971. The car obviously held some appeal for Mick, as it was the exact same model he'd driven to court the year before with Marianne Faithfull to answer charges of narcotics possession.

Mick's all-consuming relationship with Bianca left old flames Marsha Hunt and Marianne in limbo. With Hunt caring for her and Mick's six-month-old baby Karis and Faithfull sliding into the depths of heroin addiction, Mick's relocation to France in April 1971 gave him some much-needed distance. But while he enjoyed the bonhomie the country offered, he wasn't so enamored of France's barren music scene.

Mick: "France is all right, as long as you can get out … There's fuck-all live music here, there's Jacques Brel and electronic music. Even the accordion players are dead."

218

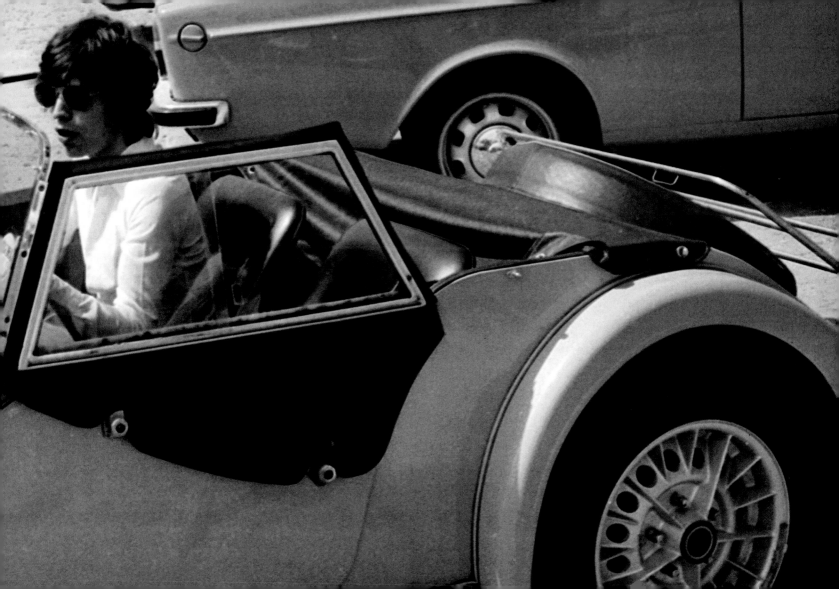

Springtime in Saint-Tropez

Caught shopping in Saint-Tropez in early 1971, Bianca acquiesces to a photographer's request. The press relentlessly pursued the love-struck Mick and Bianca throughout France that year. For the seasoned photographer, it wasn't that hard to track Bianca down. Given her acute fashion sense, it was a good bet she'd be popping into the most fashionable and exclusive shops on a regular basis.

219

As if They Could Keep It Quiet

Chaos ensues outside Saint-Tropez's town hall during Mick and Bianca's wedding, May 14, 1971. As the news broke of the couple's forthcoming union, the media, fans, and curious locals descended on the French town in an attempt to join the party. Initially, Jagger had intended the civil service and blessing to be a discreet affair, with only close family and friends in attendance. But invitation requests caused the guest list to swell to over one hundred, giving rise to some logistical problems.

 Inside the venue where the civil ceremony was held, a feud erupted between Jagger and the local authorities: much to his dismay, over a hundred media personnel were already waiting when they arrived. Jagger refused to go ahead with the ceremony, claiming he didn't want to "get married in a goldfish bowl," and threatened to call the wedding off unless all uninvited visitors were ejected. After ninety minutes of heated debate, Jagger's protestations were upheld. However, as press members were marched out of the office, scuffles broke out, and many of the invited guests, including fellow Stone Keith Richards (and best man), seen here negotiating with the guardsmen, had difficulty gaining entry. Aside from Keith, in fact, none of the other Stones were present—they apparently hadn't been invited.

Bill: "We were shocked that, apart from Keith, none of the Stones were invited to the wedding."

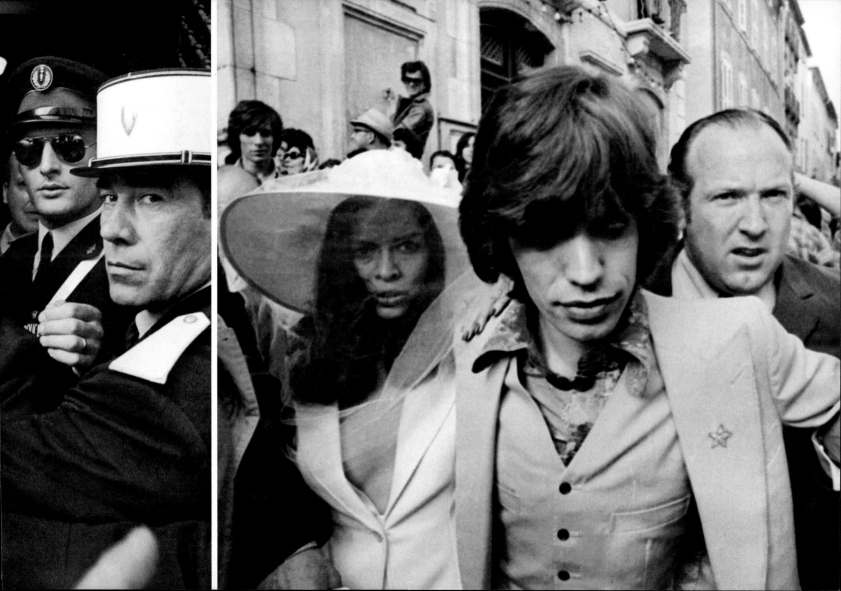

Vows

A kneeling Mick and Bianca repeat their vows to the Reverend Lucian Baud on May 14, 1971. After the frenzy experienced at the registry office, the wedding party convened at the peaceful Church of St. Anne where quiet reigned for the blessing. The reverend informed the small congregation— which included Keith Richards and Anita Pallenberg, and French film director Roger Vadim and his wife, Nathelie Delon, as witnesses—that Jagger chose the Saint-Tropez chapel because he celebrated his own birthday on St. Anne's Day. Mick and Bianca had settled on two pieces of music for the ceremony: a piece by Bach—played as they exchanged rings—and a selection from the film, *Love Story*. In preparation for the Catholic ceremony, Jagger had spent several hours in instruction with the reverend.

Father Lucian Baud: "You have told me that youth seeks happiness and a certain ideal and faith. I think you are seeking it too, and I hope it arrives today with your marriage."

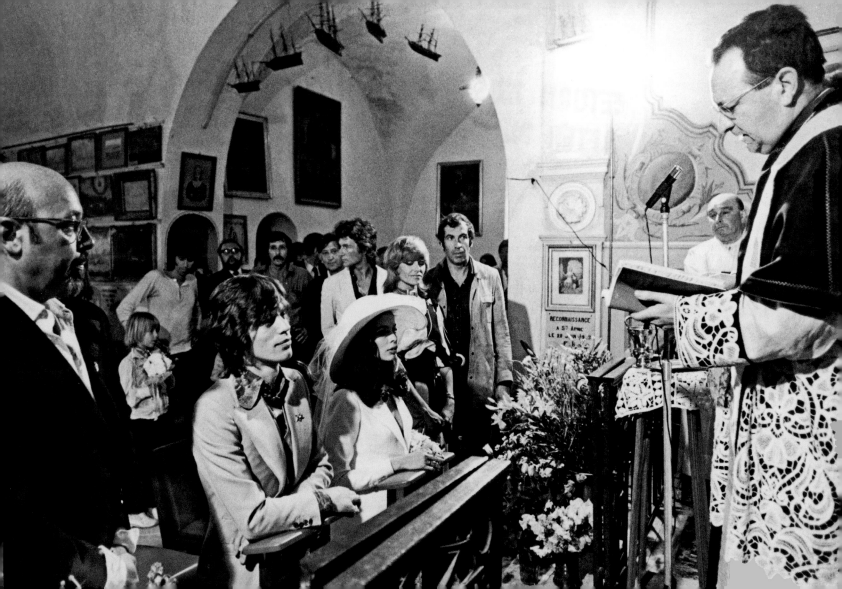

And Now They Exit

Mick and Bianca take their first steps as a married couple as they exit
the Church of St. Anne into the Mediterranean sunshine. Fans and
photographers had formed a phalanx outside the front door of the tiny
chapel, so the couple left via a side exit and headed off for their reception in
an annex of Saint-Tropez's swanky Café des Arts.

More than two hundred guests attended the event; most of the
British contingent flew in by specially chartered jet. The celebrations ran
on into the early hours, and as Mick and Bianca boarded the honeymoon
yacht—replete with a six-man crew—the guests continued partying well
until dawn. Fittingly, Keith Richards, an outspoken critic of the marriage,
passed out behind a sofa.

Keith: "I think Bianca has had a bigger negative influence
on Mick than anyone would have thought possible.
Mick, Anita, and I used to go around an awful lot before
he met Bianca. Mick marrying Bianca stopped certain
possibilities of us writing together because it happens
in bursts; it's not a steady thing. It certainly made it a lot
more difficult to write together and a lot more difficult to
just hang out."

The City of Love

Mick and Bianca Jagger's 18-day May/June honeymoon found them visiting various points along the French Riviera and the Italian coast, including Venice—well known for crystallizing countless romances over the centuries. The love-struck couple wandered through the narrow thoroughfares surrounding Piazza San Marco and accessed the city's highlights from a gondola. Although the newlyweds were pursued by a swarm of paparazzi, they blithely carried on with their romantic journey.

Bianca Jagger: "When Mick first saw me he had the impression that he was looking at himself... Mick thought it would be amusing to marry his twin. But actually he wanted to achieve the ultimate by making love to himself."

223

Love from the Water

While on honeymoon, Mick and Bianca take in the sights of Venice from their gondola. After Venice, the couple would repair briefly to New York. As soon as the honeymoon was over, Mick was back into Stones business, negotiating the details for the recording of their next album, *Exile on Main Street*, which, ironically enough, would take them back to the French Côte d'Azur.

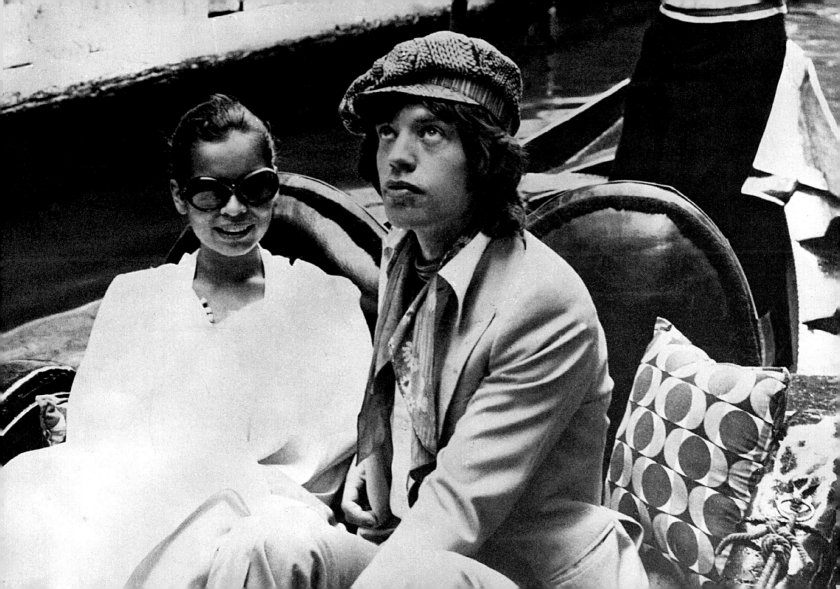

Dapper and Dandy

Looking every part the English gentleman, Mick Jagger leaves London for the Stones' upcoming tour of the States, on May 24, 1972. Bianca, who would join Mick toward the end of the tour, dutifully waved her new husband good-bye.

The hectic nature of the 30-date tour was somewhat mitigated by U.S. audiences' enthusiastic support of the Stones' latest album, *Exile on Main Street*, which expanded upon their musical influences. Enhancing the tour was soul legend Stevie Wonder, who was the Stones' opening act for the U.S. leg of their tour.

In an attempt to reverse the negative image the Stones had gained from the Maysles brothers' documentary film, *Gimme Shelter*, the group arranged for the tour to be captured on film. But the resulting movie, under the working title *Cocksucker Blues*, was hardly the right antidote: it mixed the occasional stellar performance with backstage sex, drugs, and fragile egos spiraling perilously out of control. It has yet to be officially released.

Mick Taylor: "I nearly saw Mick and Keith have a fight in a seafood restaurant in Seattle. Keith was really pissed off because Jagger had thrown this beautiful leather jacket into the audience at the end of the gig. At the dinner table they were yelling across at each other. After that I don't think Keith ever again lent Mick anything to wear onstage."

225

Festival of Bianca

Barely managing to keep the mud off her boots, Bianca wanders around the Bardney Festival in Lincoln, on May 27, 1972. The impossibly chic Bianca appeared somewhat incongruous sweeping through the festival in her black cape. While Mick was away touring in the States, Bianca had accepted an offer from friend and festival co-organizer Lord Harlech to add some much-needed glamour to the three-day concert. Despite her involvement, however, massive local opposition ensured the festival would not become a fixture on the town's social calendar; even performances by the likes of Genesis, Helen Reddy, and Buddy Guy couldn't save the three-day event.

British Vogue: "Bianca spends a lot of time at home. Their daughter, Jade, is two, very beautiful and civilised and happy because she gets a lot of love and you can tell it. When Jade was five months old, they went to the Far East with 400 boxes of Evian water. 'I'd like to divorce Mick so I could get married to him all over again,' says Bianca while watching Princess Anne's wedding on television."

Jagger in Clover

Mick sucks on a clover during a press conference in Sydney for the Stones' forthcoming tour of Australia, on February 26, 1973. The band certainly needed some extra help from lady luck, as Australia had initially forbidden Keith's entry into the country because of his drug record—before relenting at the last minute. The Australian immigration official charged with the case went out of his way to explain his position when the Stones arrived.

Al Grasby: "I told them I was putting my faith in them and hoped they would do the right thing. I have no regrets that I let them in. Yes, I went out on a limb to give them visas. To give a man a bad name and hang him is immoral and un-Australian."

227

Rootless

Emerging from Island Studios in London on June 20, 1973, Mick Jagger plays the dutiful father to Jade after sessions for the Stones' new album, *Goats Head Soup*—recorded in both London and Los Angeles. Still tax exiles, the Stones were increasingly feeling the pull of their home country. By early 1973 Mick had announced his intention to leave France, but despite owning several properties in Britain, he could only spend three months a year there without being hammered for revenue duties.

Mick had to face certain responsibilities on his brief return to the United Kingdom. Marsha Hunt, still pursing Mick for money to care for their daughter Karis, officially filed for child support in July 1973. Jagger retaliated by ordering blood tests to determine the paternity of the child, and Hunt eventually settled out of court.

Marsha Hunt: "I don't even discuss the father. He was just a friend. We had a baby. We weren't living together."

228

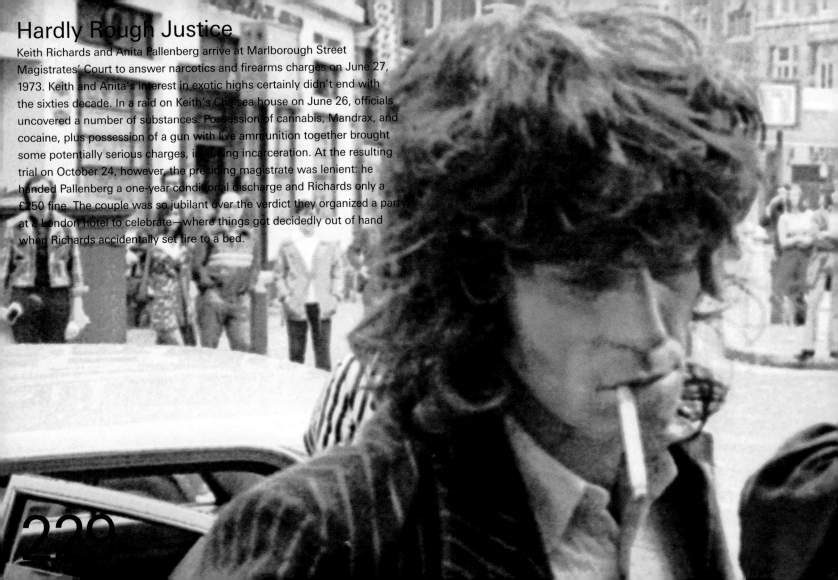

Hardly Rough Justice

Keith Richards and Anita Pallenberg arrive at Marlborough Street Magistrates' Court to answer narcotics and firearms charges on June 27, 1973. Keith and Anita's interest in exotic highs certainly didn't end with the sixties decade. In a raid on Keith's Chelsea house on June 26, officials uncovered a number of substances. Possession of cannabis, Mandrax, and cocaine, plus possession of a gun with live ammunition together brought some potentially serious charges, including incarceration. At the resulting trial on October 24, however, the presiding magistrate was lenient: he handed Pallenberg a one-year conditional discharge and Richards only a £250 fine. The couple was so jubilant over the verdict they organized a party at a London hotel to celebrate—where things got decidedly out of hand when Richards accidentally set fire to a bed.

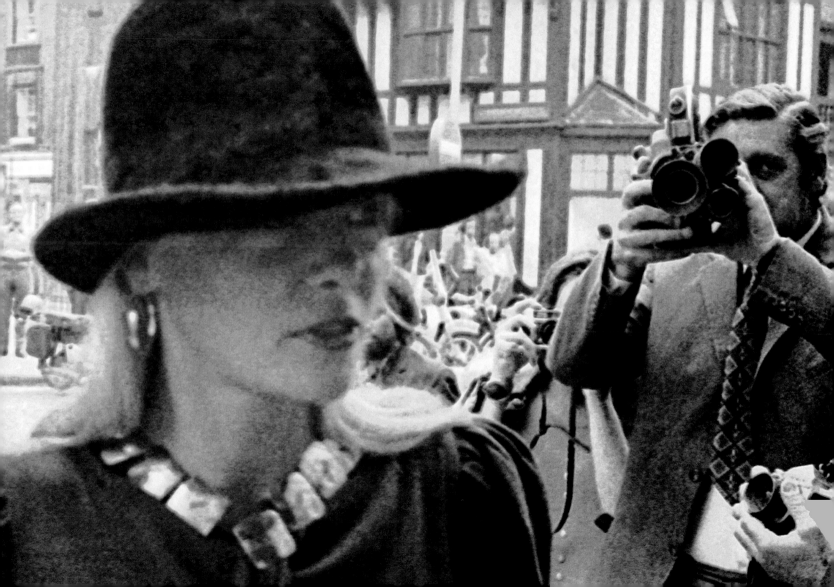

Redlands Ablaze

As of August 1973, Keith and Anita had not yet faced trial on the narcotics and firearms charges, and the possibility of a jail sentence hanging over them was cause for great anxiety. Their trauma was exacerbated on August 1, 1973, when Keith's beloved Sussex home, Redlands, caught fire. Site of the infamous drug raid in 1967, the pretty cottage blazed overnight, causing substantial damage to the upper half of the house. Luckily, Keith, Anita, and their two children, Marlon and Dandelion, fled to safety before the fire could fully take hold. Although the couple was prone to extreme behavior as manifested in their drug use, any attempt at blame was groundless: the fire proved to be the result of a faulty electrical connection.

230

ick with Wigg

Mick relaxes with journalist David Wigg in August 19__. Wigg was a prominent entertainment reporter for the *Daily Express* newspaper and had gained considerable respect from rock's fraternity. Many stars enjoyed his easygoing manner and style of questioning and happily acquiesced to his gentle requests.

Wigg covered a range of topics in his interview with Jagger and managed to draw out some thoughtful responses. As the thirty-year-old father of two children, Jagger was asked how he'd cope if his daughter Jade acted as pruriently as he had as a teenager.

Mick: "It wouldn't upset me at all if she [Jade] had sex at an early age. When I was thirteen all I wanted to do was to have sex. I just desperately wanted to—didn't you?"

231

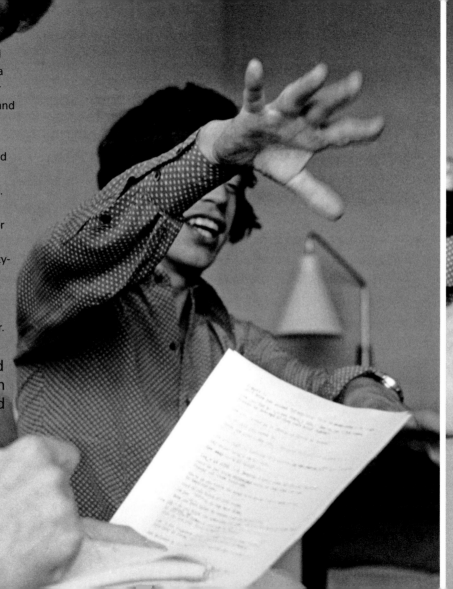

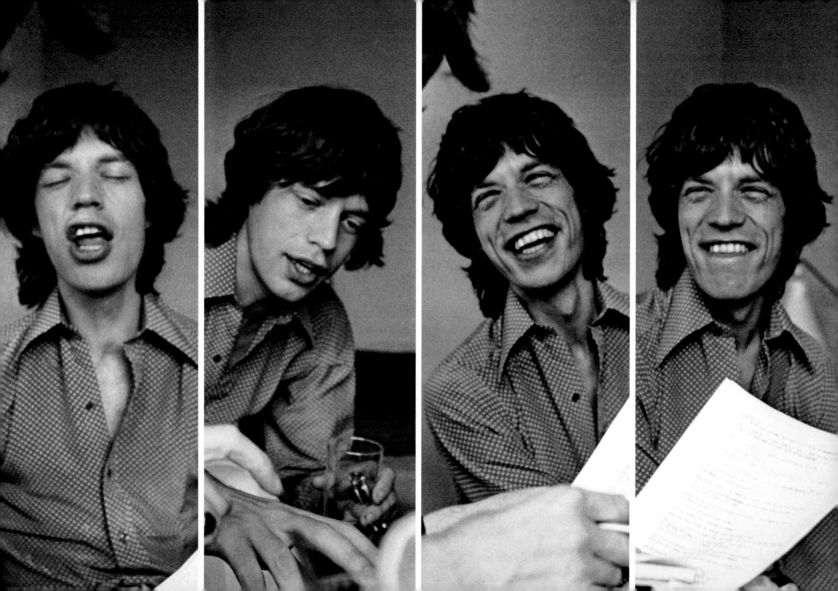

From the Sofa

Although it may have been of minor significance to the Stone himself, to the rest of the world, Mick's thirtieth birthday on July 26, 1973, was a landmark celebration. Magazines and newspapers devoted enormous coverage to this all-important anniversary. Jagger's transformation in the media from uncouth lout to psychedelic renegade to society darling was complete, and with A-list celebrity status, Jagger now asserted himself with supreme confidence.

Mick: "To a certain extent I could go along to a press party in an old pair of jeans, but it's probably better if I go along wearing something sort of flashier or smarter or more to the point. One dresses for the occasion, a simple rule of dress, you know."

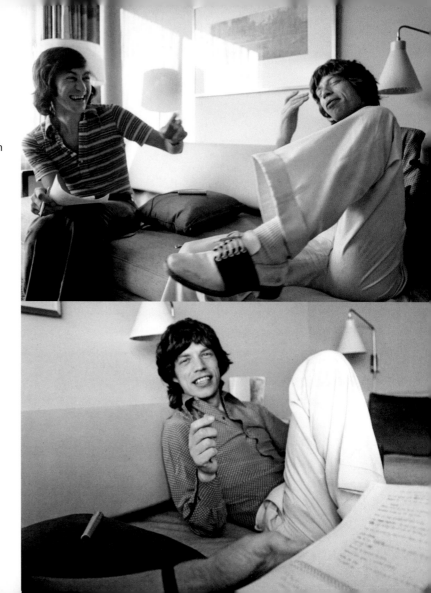

Home Again

They're back! The Stones hit the stage for the beginning of their 1973 UK tour at Wembley Arena, September 10, 1973. For over two years the band had not played to UK crowds, so major newspaper coverage and sell-out concerts were guaranteed. The greater demand naturally ensured larger arenas. Beyond that, the Stones' newly found affluence, by dint of their tax-exile status, meant that touring would provide some return on their efforts. Prior tours had been a different matter.

Charlie: "The last time we toured Europe we actually lost money. Can you imagine that? Having to slave around playing all these places and then finding out you've lost money. This might just be the first European tour we make any money."

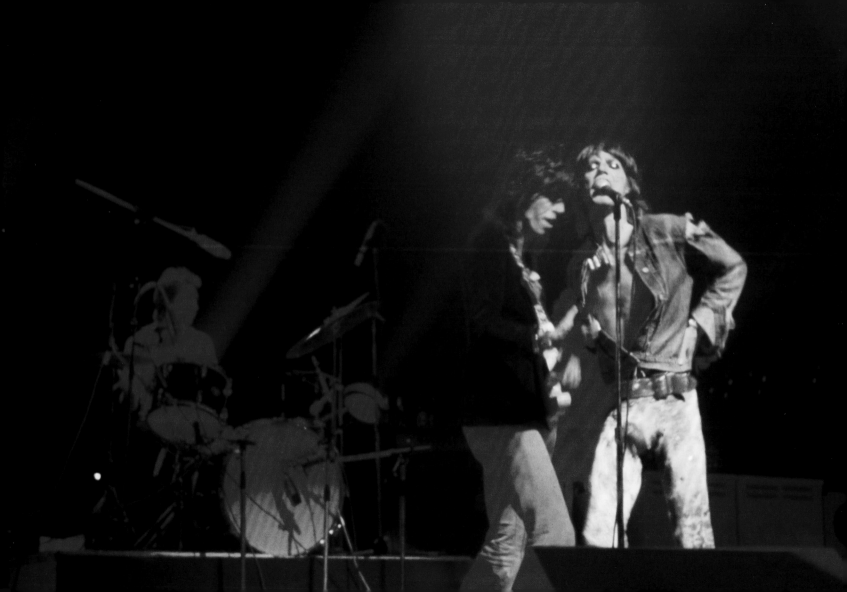

Enter the Spectacular

Resplendent in gold lamé, Mick sings into the microphone at Wembley Arena on September 10, 1973. The four sold-out shows at Wembley reintroduced the Stones to their home fans. As if to make up for their unpopular move abroad two years prior, the rockers rewarded British disciples with a spectacular musical and visual performance. The 40,000 fans ate it up, and the press, who'd been more than keen to write the group off, heaped praise on the performance.

The *Times*: "It was a rock event to experience, as from their entrance, light beams sprayed out from the stage up to the roof to be reflected back again piercingly, like those 20th Century Fox beginnings to films. All through the performance, the lights changed colour, from blue and red to orange and pink, returning each time between numbers to their original white. Mick Jagger, of course, dominated events, dressed in skin-hugging gold lamé."

234

Lip Smacking

Displaying the most famous pair of lips in history, Mick pulls out all the stops at Wembley Arena on September 10. The Stones' 20-date UK tour was set to bring in a cool million pounds—an unprecedented amount at the time in Britain, and further proof that the Rolling Stones were in a class of their own.

The *Times*: "They played with such energy, in a stage show of expertise seldom known in Britain, that any group who wishes to challenge these one-time rebels of the early sixties will be hard put to do it."

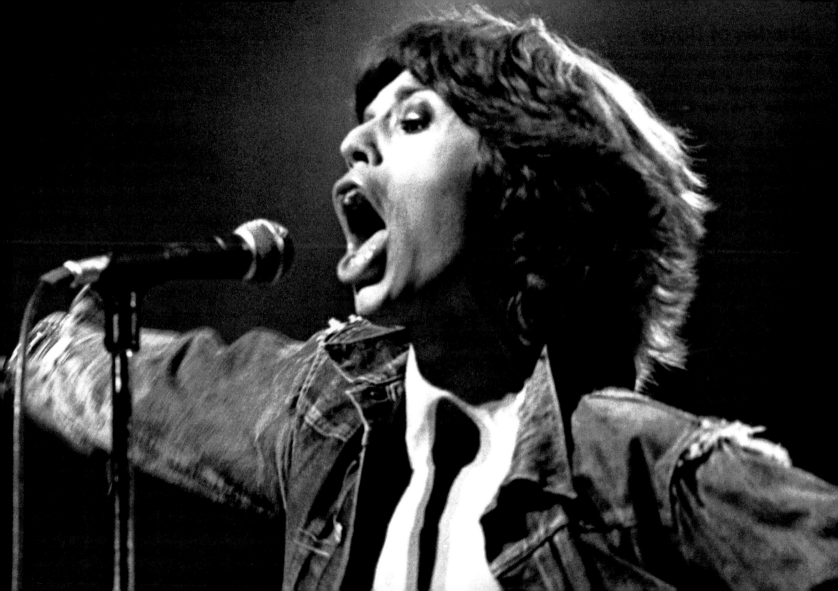

Shades of Bowie

Charlie Watts's new hairstyle sparked interest in fashion circles when it debuted at the Stones' concert at Wembley Arena on September 10, 1973. The new feather cut had been popularized by David Bowie, who was then in the midst of his Ziggy Stardust phase.

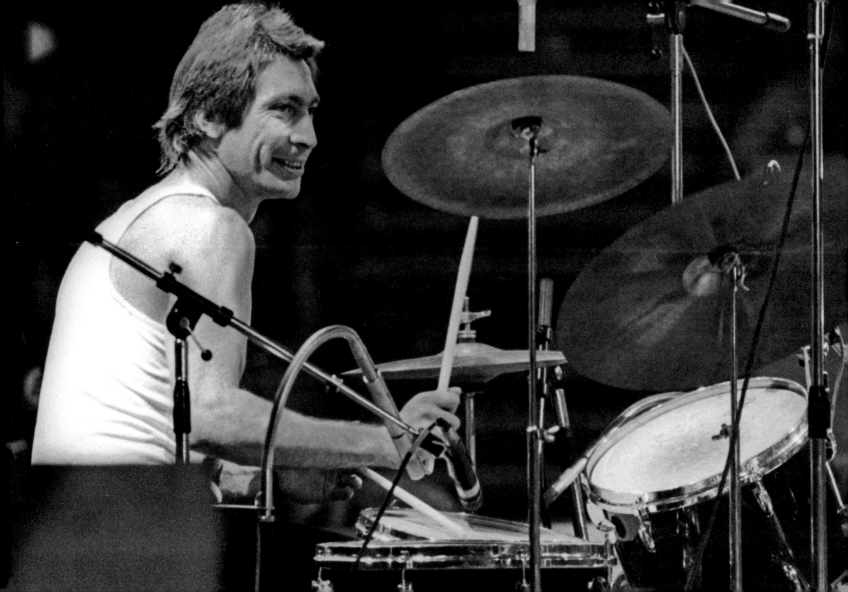

Stone-in-waiting

In the empty seats of London's Kilburn Gaumont, Keith Richards relaxes with Ronnie Wood's band after a show on July 13, 1974. Aside from their strong physical resemblance, Wood and Richards shared another similarity in that both backed up and supported extraordinary leading men. Wood, a talented singer and songwriter in his own right, was facing the breakup of the Faces—lead singer Rod Stewart's solo career was on the rise—and he was contemplating the next step in his career. With speculation mounting as to the extent of Wood's relationship with the Stones, Keith appeared onstage with Ronnie to sing a few numbers, providing more grist for the rumor mill.

New Musical Express: "It was a great night. A grand meshing together of sublime musicianship and the archetypal dishevelled get-down. When Messrs. Wood and Richards step to the mike for harmonies on 'Cancel Everything' it's difficult to tell them apart; the effect is not unlike a degenerate Everly Brothers."

237

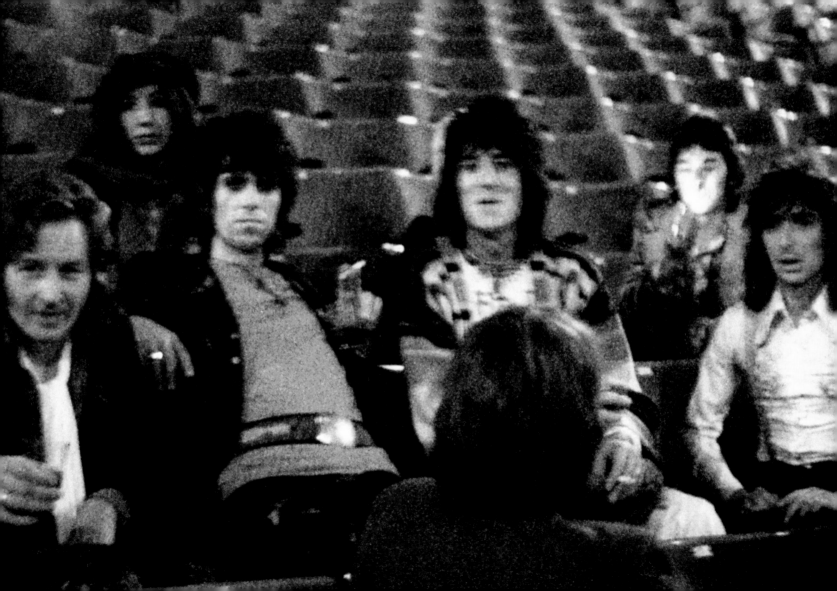

Elton and Rod

Elton John and Rod Stewart socializing backstage at Ron Wood's solo show at the Kilburn Gaumont in London on July 13, 1974. Rock's disparate fraternity took advantage of every opportunity to get together and show some loyalty and support. That, coupled with Wood's genial personality and expansive list of contacts, would ensure a star-studded presence at this show. Elton and Rod were only two of the A-list members from rock's royalty in attendance, and while Stewart may well have been checking out his partner's future direction, Wood's solo debut was warmly received.

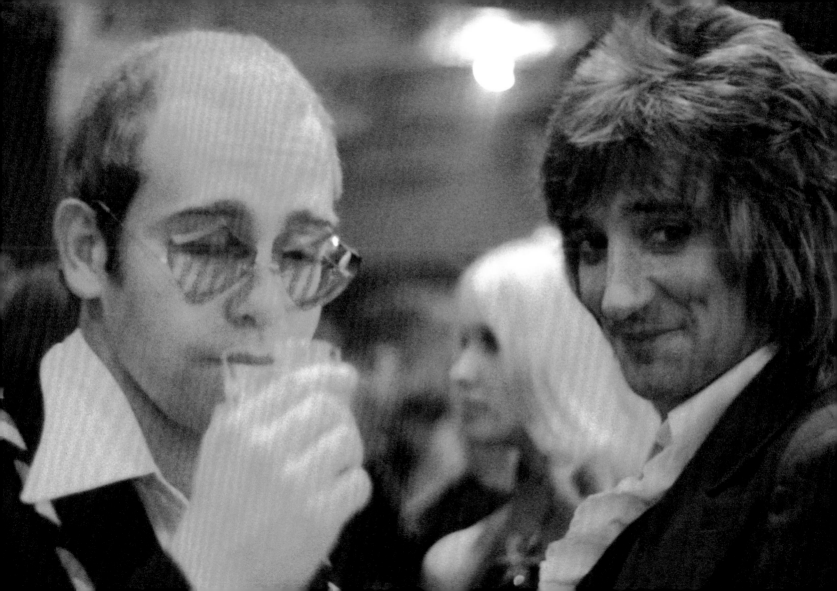

A Reason to Celebrate

Ronnie Wood breaks out the champagne with Mick and Bianca backstage at London's Rainbow Theatre during a Billy Preston concert, August 3, 1974. Preston had dazzled audiences with his virtuoso playing of the Hammond organ on the Stones' last few tours. He also had built up a close friendship with the Stones. Increasingly, the Stones' and Wood's paths were colliding. Earlier in 1974, Wood had invited Mick, Keith, and Mick Taylor to help contribute to his solo LP *I've Got My Own Album to Do*. Ronnie's easygoing manner and uncomplicated guitar style ensured that eight months later he'd have even more reason to celebrate.

Mick: "I wanted someone that was easy to get on with, you know, that wasn't too difficult and that was a good player and was used to playing onstage. It's quite a lot to ask of someone to come and do a big American tour with a band like the Stones… I wanted someone that wasn't going to be phased out."

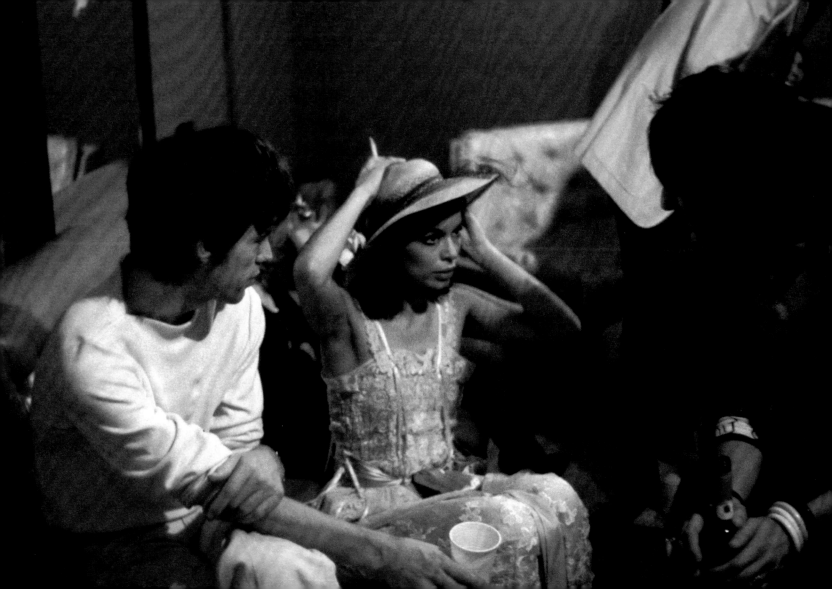

Young, Gifted, and Stoned

Quintessential rock and roll: Keith Richards, backstage at the Kilburn Gaumont for the Faces' final concert, December 23, 1974. Somewhat appropriately, Ron Wood's new mate, Keith, was on hand as star guest for the night. Keith's friendship with Ron had deepened to such an extent that they had been privately recording together during 1974.

Ironically, unbeknownst to Keith, Jagger allegedly asked Wood if he'd stand in if the group was denied entry to the States because of Keith's narcotics record. At the same time, Mick Taylor had missed many of the *It's Only Rock 'n' Roll* album sessions, and with a world tour being planned for the following year, auditions for a new guitarist were duly held. Wood found himself trying out among the likes of Peter Frampton, Rory Gallagher, and Steve Marriott. But, really, there was no competition.

Keith (on auditioning Wood): "After just one number we thought, 'That's it, it's obvious.'"

240

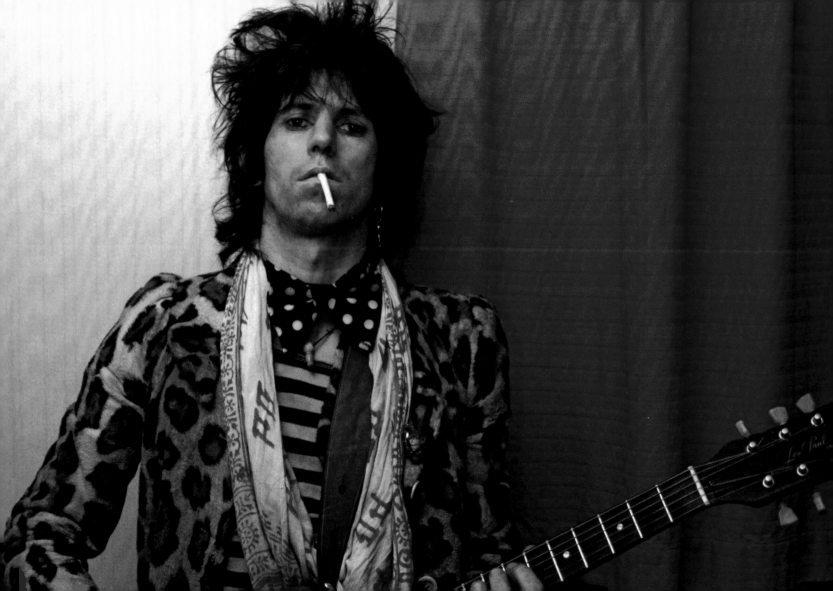

Party Time

Keith and Anita backstage at the Faces' last concert. The December 23 event sparked a huge turnout, with London's rock illuminati showing up to pay homage to the influential band. Little had been seen of the enigmatic Miss Pallenberg since the high-profile drug raids of the previous year. The reasons were twofold: she had been battling her heroin addiction, and Keith had been secretly romancing German model Uschi Obermeier.

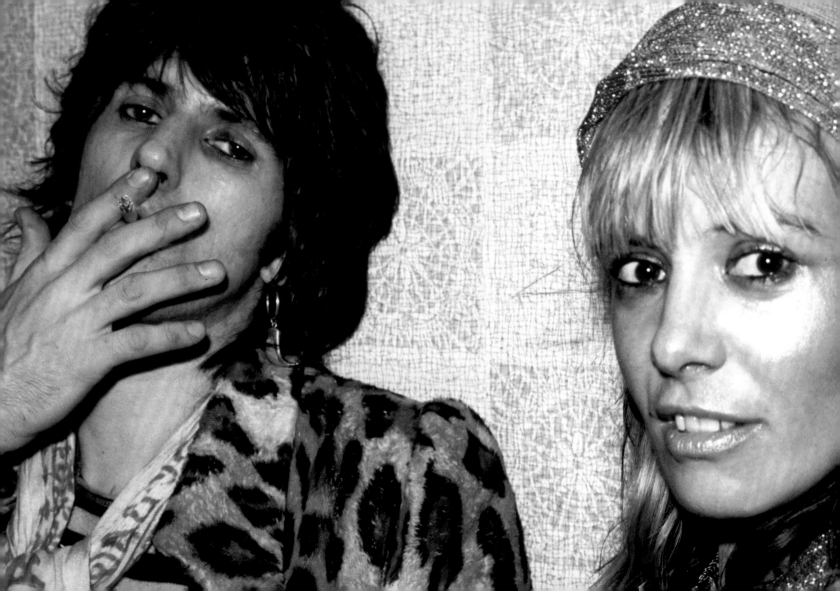

He's a Stone—Nearly

On April 16, 1975, the formal announcement was made that Ron Wood was joining the Stones as a temporary replacement for Mick Taylor. It was turning out to be a hectic year for the Stones, with the album *Black and Blue* already in the can and an ambitious tour of the States slated to take up the remainder of the year. Mick had to rubber stamp any major changes in the band's makeup, and he'd been stealthily checking out Wood's potential flexibility—as well as his durability.

Ron Wood: "I think Mick's been dying to get his hands on another guitarist. He came up to me and said: 'If I come and attack you, you don't mind, do you?' He really loves it to look real."

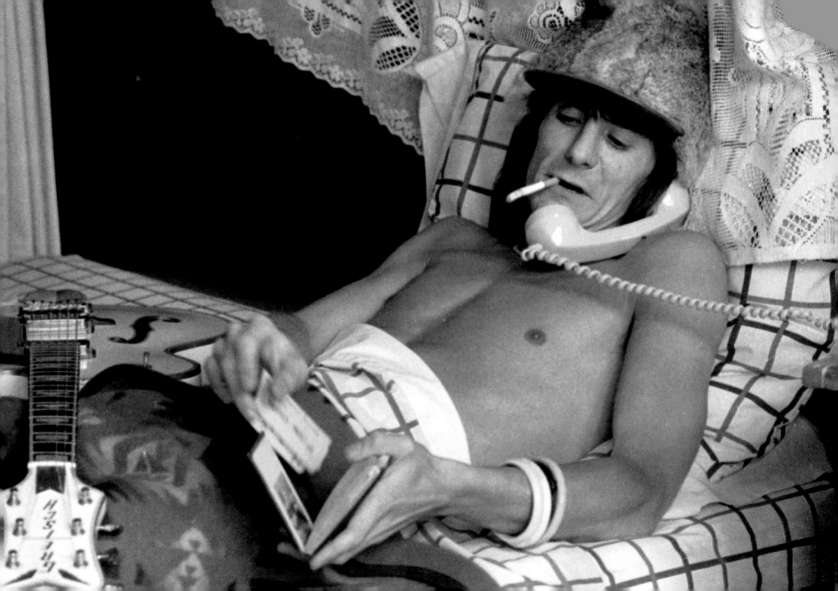

At Home with Ron

Ron Wood at his Surrey home in Richmond, early 1975. The London suburb seemed to hold an appeal for the Rolling Stones. Their first tentative gigs were played at Richmond's famed Crawdaddy Club in 1962, and later, Mick and partner Jerry Hall would buy a property—which Mick still owns—on Richmond Hill. Wood's house, once owned by actor John Mills, benefited from a large studio that Ron had built in the basement.

243

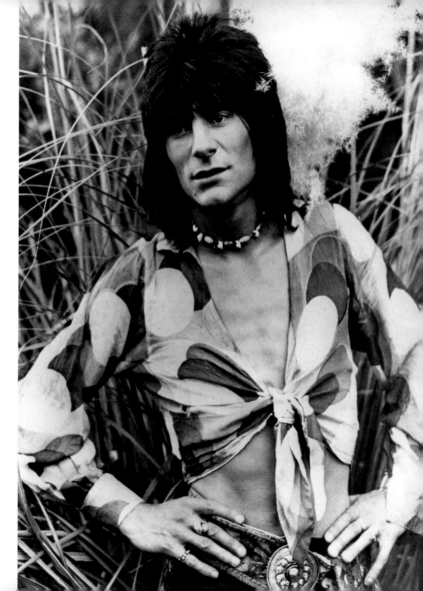

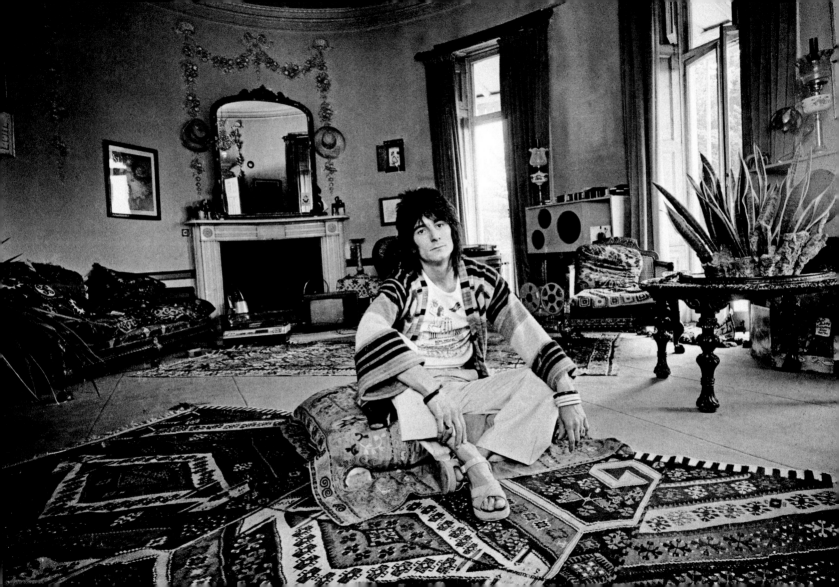

Bathing Woods

Ron and wife Krissie sidle up to each other in the swimming pool in front of ace snapper Terry O'Neill. An important element that Wood brought to the group was some much-needed humor. For years, the Stones had been a strictly no-nonsense operation; they had even been ridiculed for taking themselves far too seriously. Wood's jovial manner would alter the chemistry within the band for the better and bring out a lighter mien in each member's stage persona.

Bill: "Woody's really pulled us all in, because he talks to Mick and Keith and Charlie, and it's all very amusing and light-hearted—he's always joking—and he can always make you laugh."

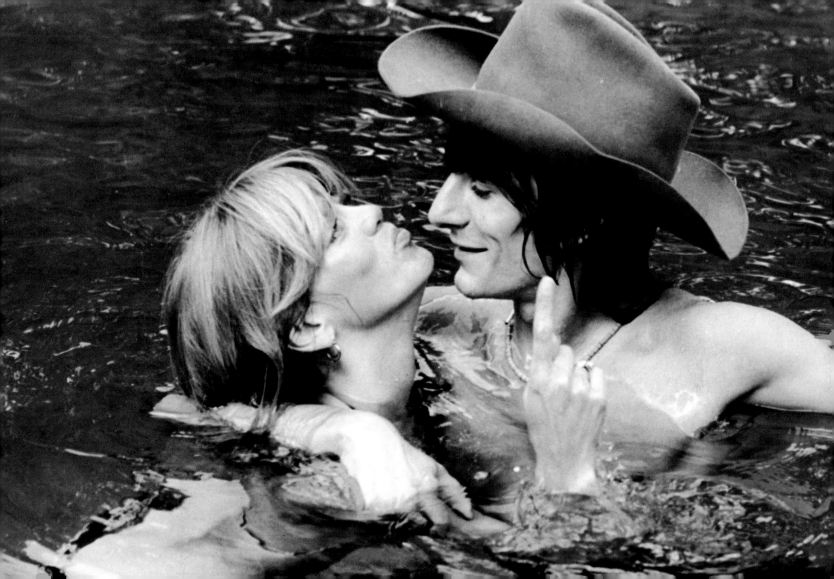

On Your Knees

Mick Jagger takes a Zen break between rehearsals for the Stones' Madison Square Garden shows, June 1975. Jagger was a huge sports fan, an appreciation that his father passed down to him in his very early years. The sweater he's wearing was a tribute to his beloved English cricket team. Mick kept up with the team's fortunes wherever he happened to be.

245

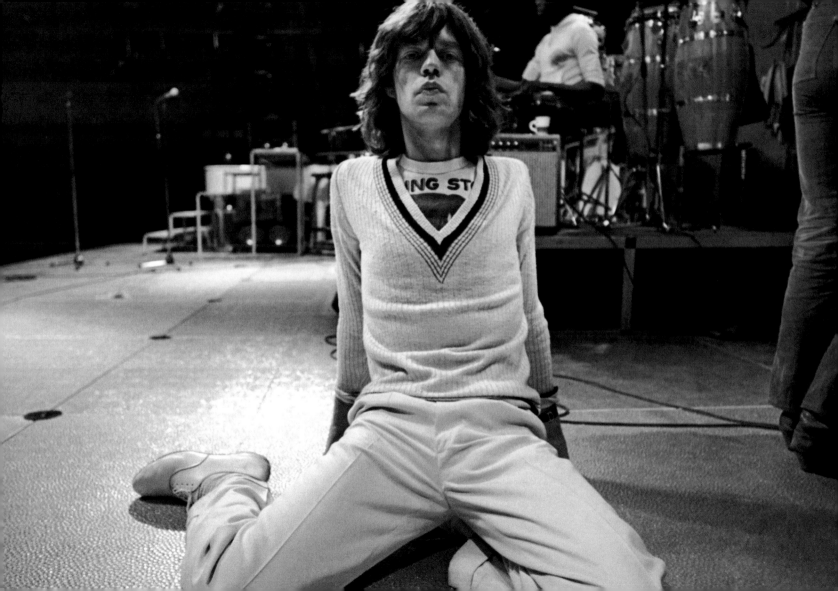

Bigger and Better

With Mick looking on, Keith strums his cherished Fender Telecaster at Madison Square Garden, June 26, 1975. The Stones' popularity in the States had never waned, and the demand for tickets was starting to outgrow the arenas they were playing. The Garden had long been a de rigueur stopover for major bands on tour, but the Stones' six-night residency that June broke new ground, boosting promoters' confidence that they could book even larger arenas in the future.

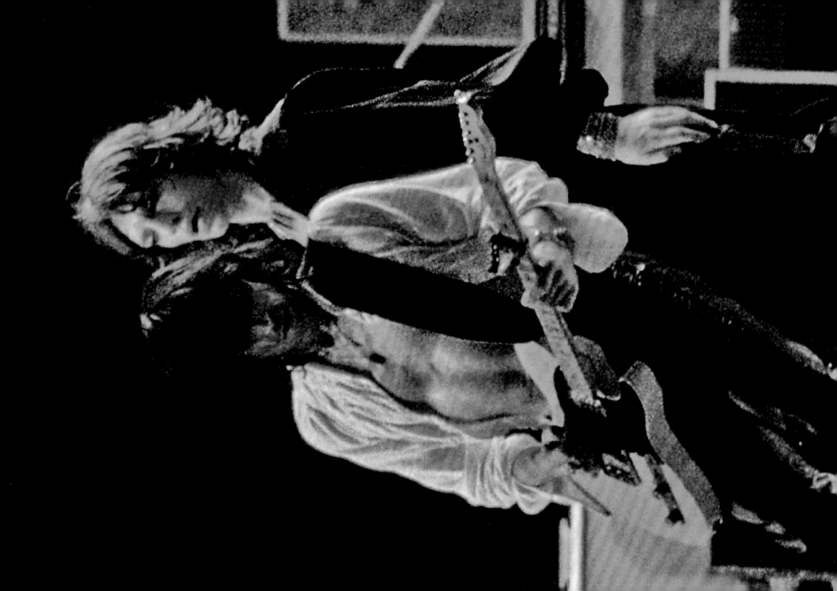

Still Bill

While Mick and the rest of the band give it their all at Madison Square Garden on June 26, 1975, Bill Wyman maintains his sedentary position. The Stones' intensified stage antics during the 1975 tour did little to inspire Wyman, who stuck rigidly to his largely immobile stage persona.

Bill: "When we come offstage, everyone feels my brow and says, 'Not a bloody drop,' and they're all dripping wet, shirts clinging to them, and there's me, all cool and dry. I just don't sweat much."

247

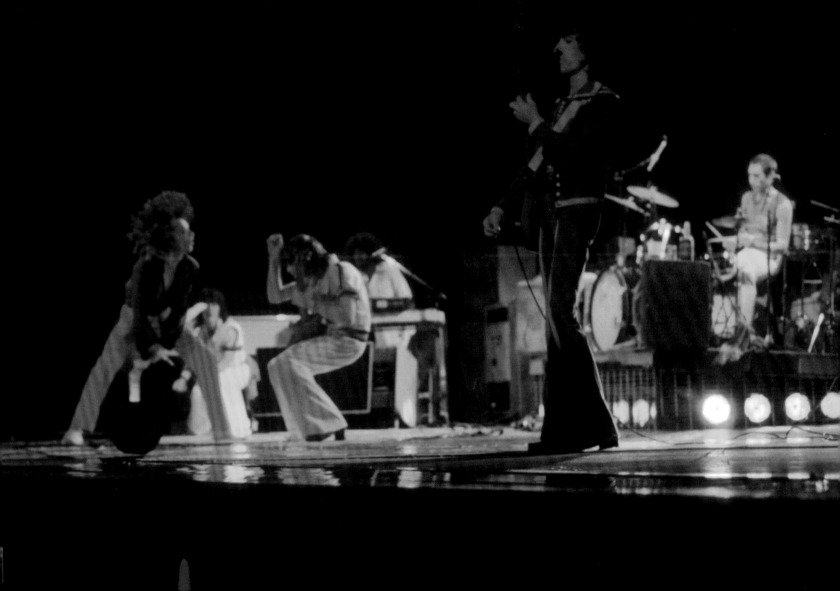

Lighting Up

Pete Rudge, the Stones' road manager (smoker, center), personally escorts Mick to the Madison Square Garden stage on June 27, 1975. The Stones' concerts at the Garden have gone down in rock folklore as being among the group's most memorable performances ever, enlivened as they were by a plethora of stage theatrics and intricate lighting. Beyond the lotus-shaped unfolding stage, the sensational highlight of the tour was a giant inflatable penis, which Mick straddled as it billowed out toward the audience. The lead Stone further teased the front rows with buckets of water and other assorted delights, even flying across the stage from a rope.

248

Giving it Large!

Classic Stones action at the Garden, June 27, 1975: Mick wows the audience while Ron slashes away at the guitar. Thirteen years together as a professional unit and still the Stones were defying audiences with their innovative and imaginative live antics. The band appeared onstage to the prophetic strains of Aaron Copland's Fanfare for the Common Man and then proceeded to let it rip. Most critics were impressed.

Rolling Stone: "As the first notes of 'Honky Tonk Women' cut through the haze, looking as if he didn't need any makeup to look bizarre or sinister, Keith ground into the down-and-dirty opening chords. The next song, 'All Down the Line,' led by Keith's savage metal attack, redeemed the Stones."

249

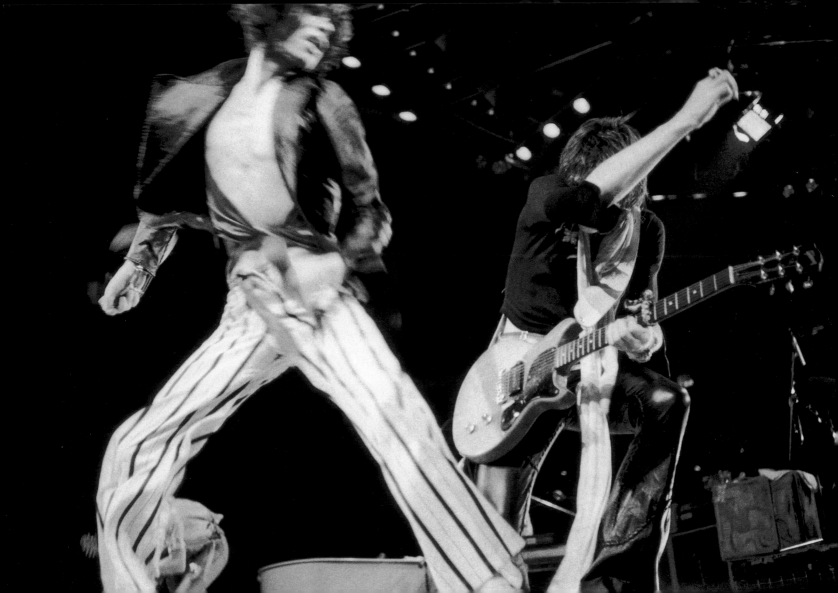

Jumping Jack Flash

Defying any notions that he ought to be slowing down now that he had reached the grand old age of 33, Mick takes to the air at Madison Square Garden on June 27, 1975. Although the group still privately reveled in having some shock appeal, for the most part the Stones' image as hedonists was set in the media's hoary past. Keith was still exploring the boundaries of excess, but Mick, now united with Bianca on tour, was beginning to outgrow the late nights, endless partying, and monumental hangovers.

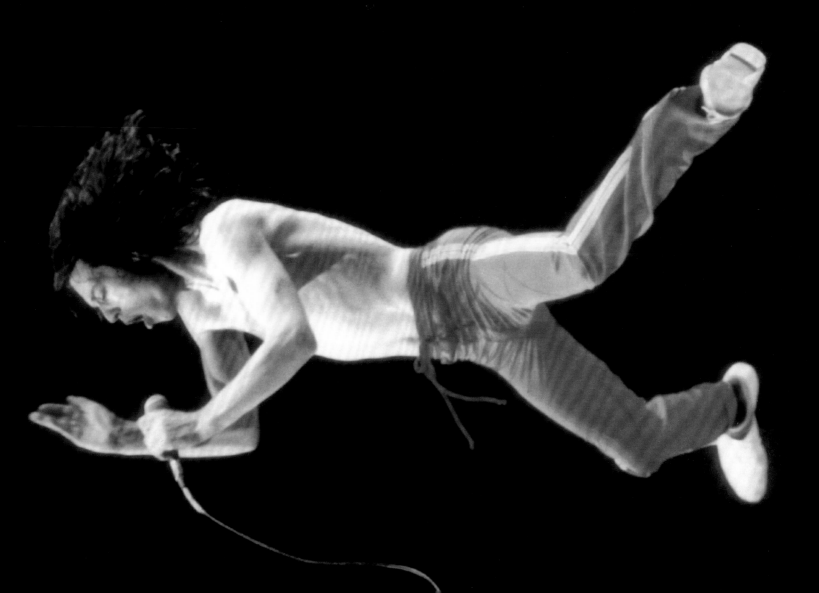

Diva

Flying high, Mick comes in for a landing at Madison Square Garden in New York, June 1975. The group's residency at New York's Garden came midway in its 1975 U.S. tour. As was becoming the norm for their concerts in the Big Apple, ticket applications were at an all-time high. To meet the demand, the group performed six consecutive nights with some added stardust from the likes of Eric Clapton and Carlos Santana, who joined the band for encores on various nights during the run.

251

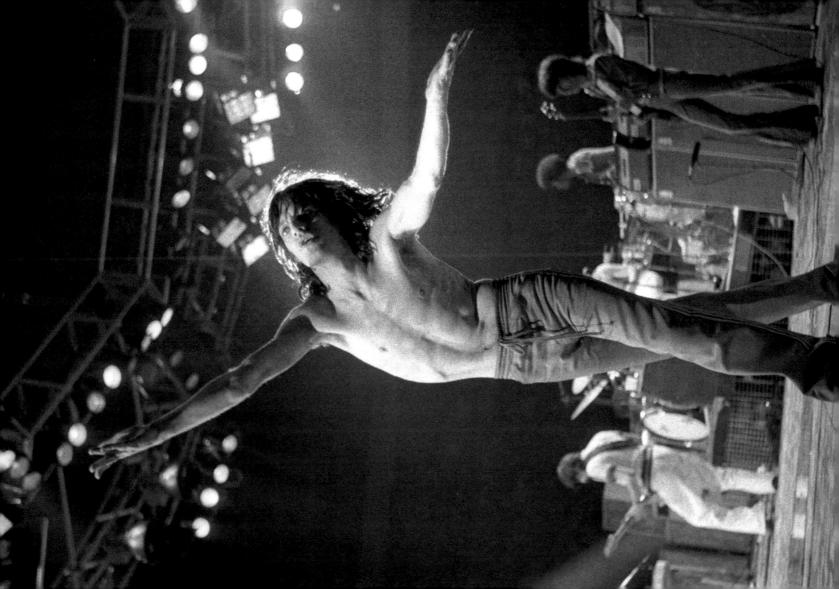

Narcissus

Mick enjoys some personal attention, courtesy of tour stylist Pierre Laroche, during the Stones' 1975 U.S. tour. Anyone familiar with the fashion history of the Rolling Stones would acknowledge Mick Jagger's adept straddling of both male and female fashion. Mick was also heavily into cosmetics. Perhaps this interest stemmed from his mother's having been an Avon representative during Mick's youth. In the Stones' early days, Mick would apply his own makeup—often with disastrous results—but at this point in the Rolling Stones' career, a multimillion-dollar tour of the States called for a stylist attending to Mick's every need.

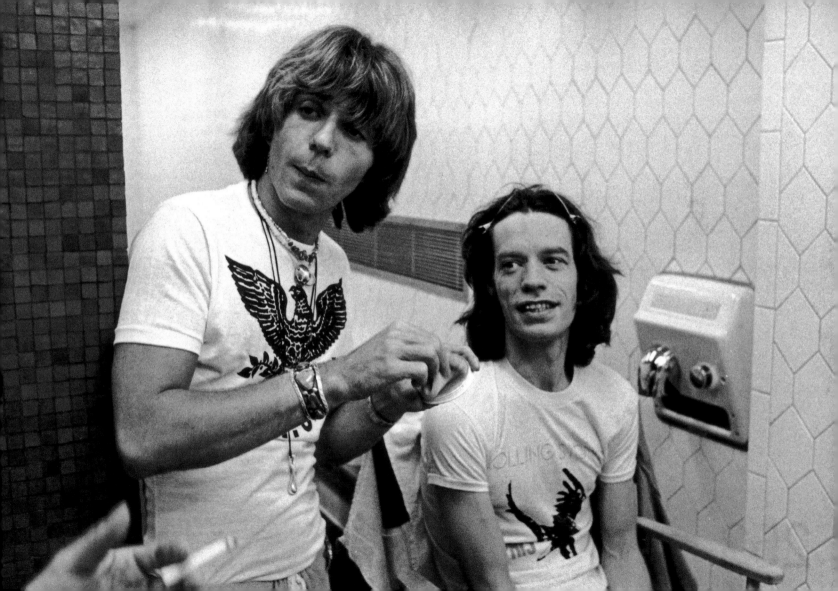

War Paint

While Mick was more than happy to allow the stylist to work his magic, Keith took matters into his own hands. Strictly in the masculine camp, Keith was not known for his use of cosmetics, aside from the occasional application of eyeliner. For the 1975 tour, however, he opted for a startling war-paint effect.

253

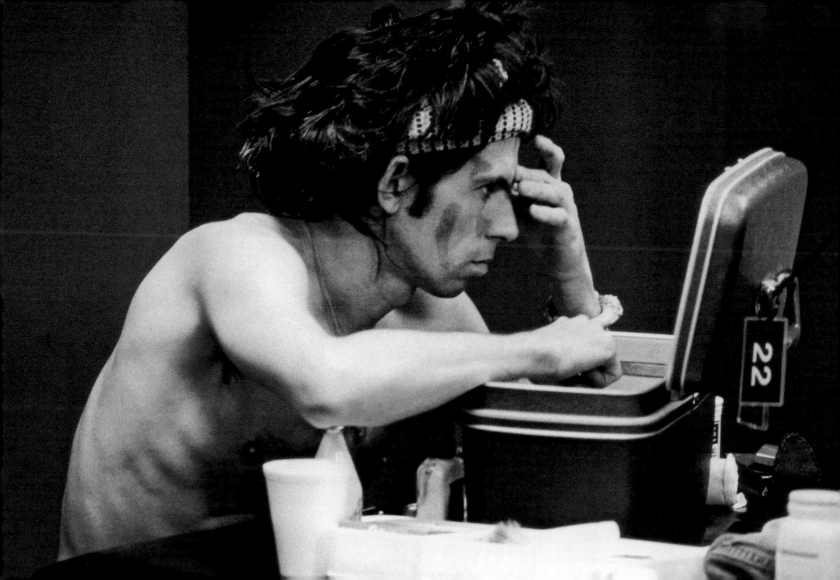

Brothers in Soul

Charlie and a heavily made-up Mick await the call to showtime backstage on the 1975 tour of the States. The two were polar opposites in terms of social mores and personality, but their relationship was built on deep mutual respect: while Mick appreciated the drummer's no-nonsense anchoring of the band, Charlie was in awe of the front man's ability to captivate audiences.

Charlie: "I think Mick is the best entertainer in the world, live onstage."

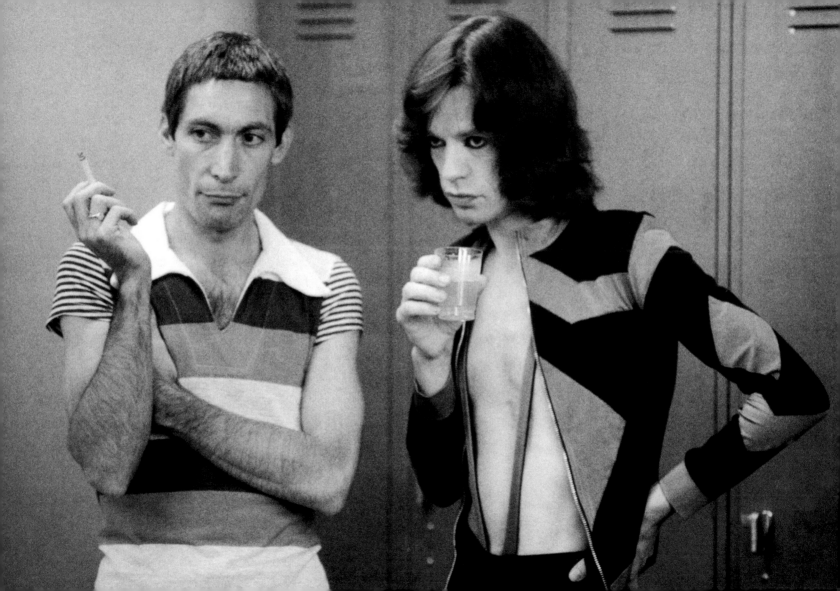

Workout

Mick stretches before showtime on the Stones' American tour, August 1975. Dazzling audiences with seemingly boundless energy for over two hours required some serious preparation. Aware that as the years rolled on he would need to think seriously about his body's limitations, Mick employed his own personal trainer to keep his body trim and in good shape.

Mick: "I'll be keeping it up until my body starts to fall apart, and that's a long time off. The Stones might not last forever but we'll be going until this side of ever."

255

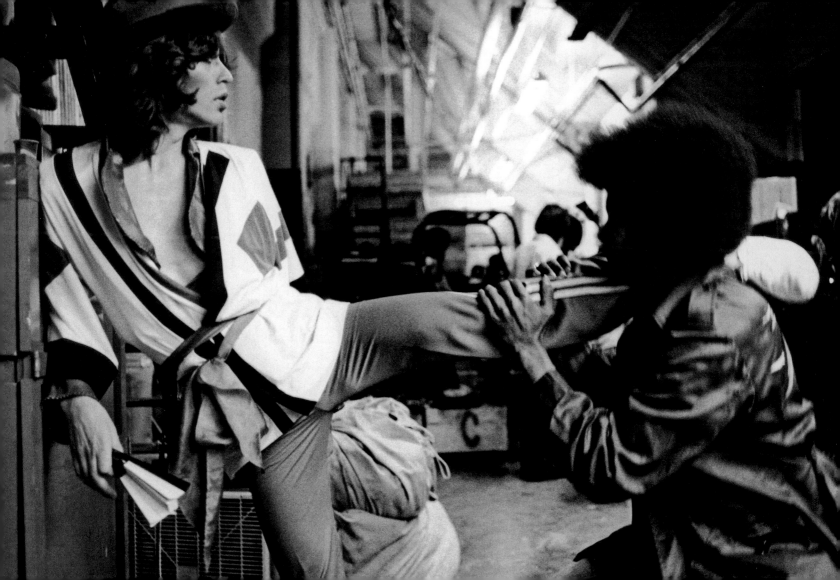

Preening for the Crowd

Classic Jagger caught mid-tour in 1975. Mick's androgynous characteristics were never more evident than during the mid-1970s. His look provoked acres of media interest, especially around the question of his sexuality. Onstage Mick's alter ego may have explored a variety of appetites and persuasions, which of course appealed to a wide cross section of people, but offstage Mick remained a relatively quiet and conservative figure.

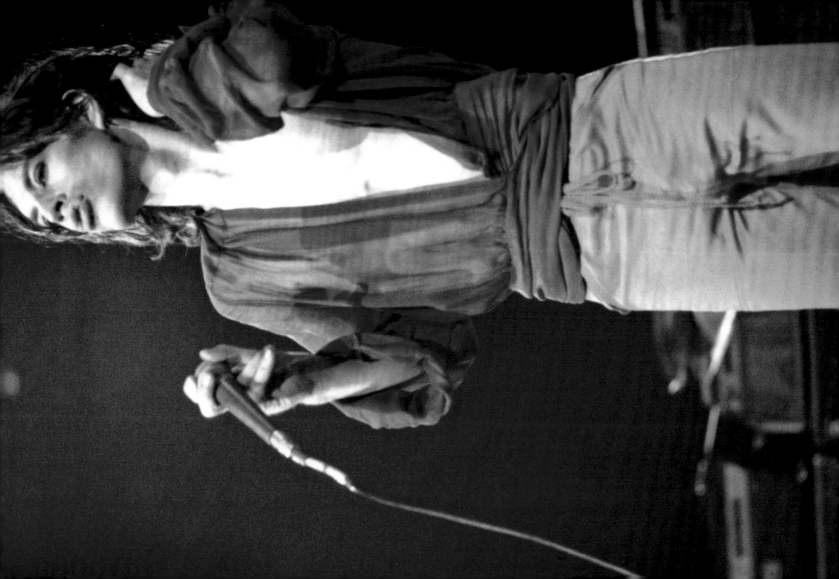

Down at the Heel

Bianca Jagger's famous foot. By 1975, Bianca was a reluctant traveler on the Stones' tours. While four-year-old daughter Jade was in the care of Mick's parents back in Kent, Bianca was in the vanguard of the band's tour caravan. More at home on a catwalk or a fashion shoot, she tolerated the touring schedule as best she could and wasn't interested in any reflected glory.

Bianca Jagger: "I don't want to be a rock-and-roll wife. I don't want to be Mick Jagger's wife—I want to be myself."

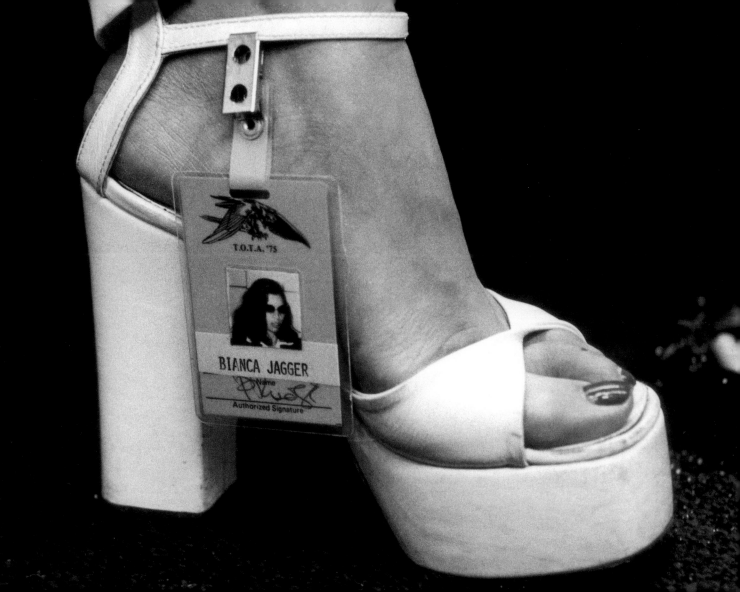

Fine-tuning

Ron Wood tunes up backstage during the 1975 U.S. tour. Ron, or Woody, as the Stones liked to call him, was no stranger to the excesses of rock and roll, and he gleefully lapped up all the fringe benefits of being a Rolling Stone. Wood's unruffled demeanor was immediately welcomed by the rest of the band members, who'd reached an uneasy impasse with the never-ending treadmill of album/tour/album.

Bill: "Woody's fabulous. He's made this band come back to life again!"

An Englishman on Board

While crisscrossing the USA in August 1975, Mick keeps abreast of the news aboard the Stones' private jet. Behind him, equally engrossed in reading, is keyboard giant Billy Preston. Although Mick reveled in his onstage image as the eternal rock-and-roll outlaw, privately he stayed on top of what was happening in the world and could hold his own in any conversation, however erudite the topic.

Mick: "I'm very lucky, I don't have to pack my bags, I don't have to worry about my airplane, I don't have to worry about my cars. But then you have a lot of people who have emotional problems, and I don't…. I'm very happy."

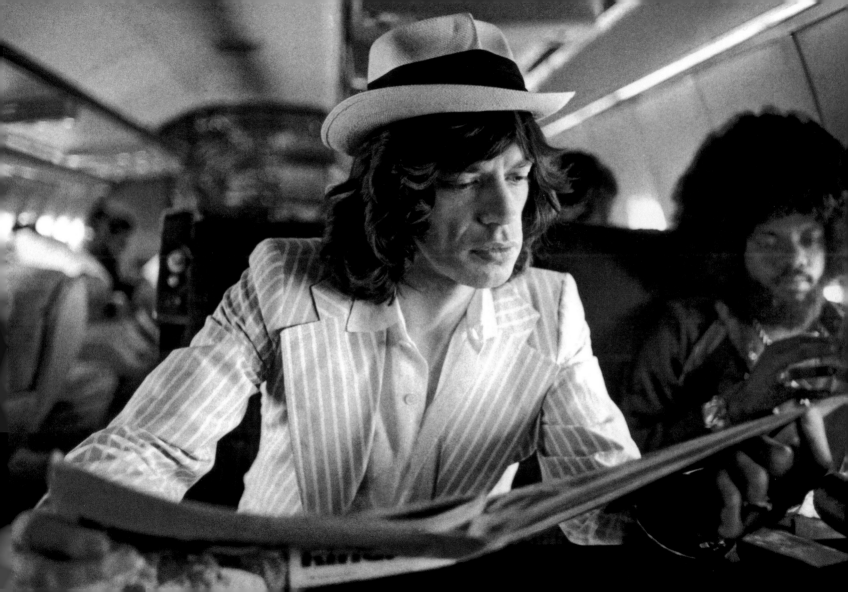

Here Comes the Sun

At the back of the Stones' private jet, best mates Keith and Ron share a drink and a cigarette while traversing the States for the 1975 tour. The pair had become virtually inseparable, and while the other members of the band enjoyed their own adventures offstage, the two guitar players delighted in late-night carousing and partying. Ron's easygoing nature erased any potential for paranoia on fragile Keith's part.

Keith: "You could be sick as a dog, but as long as you've got a suntan, everybody thinks you're in great shape."

260

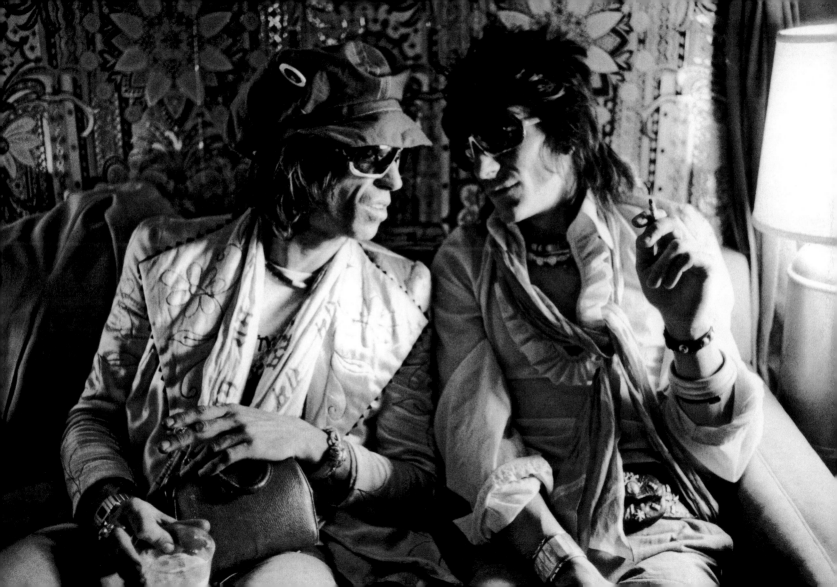

Proud Maryland

Mick teases a capacity crowd during the first of two shows at Maryland's Capital Centre on July 1, 1975. The Stones' eight-week tour of the States courted triumph and controversy as it blitzed its way across the country. While certain authorities were enraged at the group's giant inflatable "penis," which made its appearance onstage every night, ample returns for the price of a ticket was had by all, with the shows now running over two hours and containing well over twenty songs each.

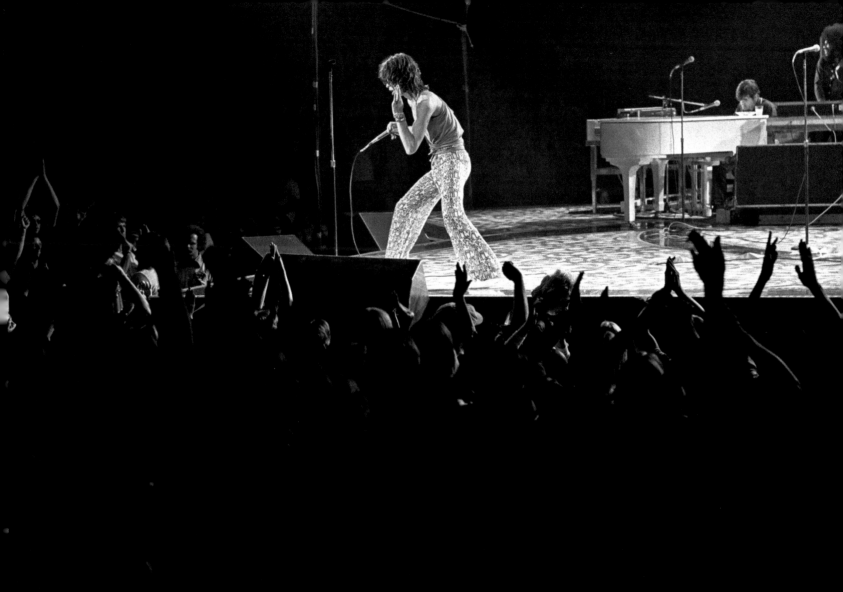

Pleased to Meet You

Mick offers a hand to U.S. crowds. During the Stones' 1975 world tour—as always—Jagger, with his overt showmanship, was the focus of attention. The ostentatious stage presentations on the '75 tour were, likewise, universally extolled by fans. The press was a different story, however: most reviewers were positive, but some more observant commentators saw the overt theatrics as being reflective of a descent in the group's musical proficiency.

Newsweek: "Here was rock royalty gone cynical, perhaps because they sensed they could coast on their past and titillate new fans by flaunting their celebrity."

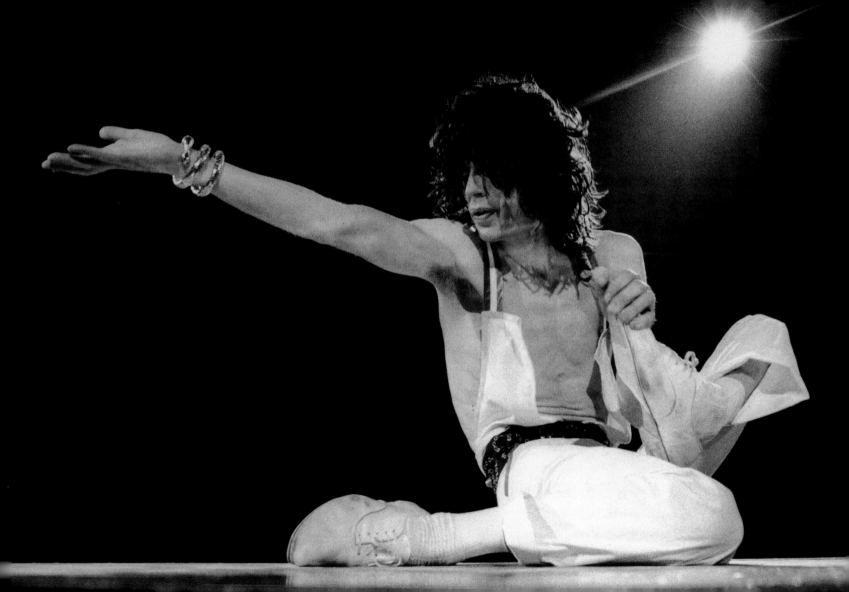

Frankfurt

Keith, Mick, and percussionist Ollie Brown at the opening concert of the Rolling Stones' tour of Europe and the United Kingdom at Frankfurt's Festhalle, April 28, 1976. After circling the States the previous year, the Stones dedicated 1976 to making the rounds closer to home. They rehearsed prior to the circuit in both France and Germany and were prepared to roll across the length and breadth of the continent along the way to a final concert at Knebworth Park in England.

The band's latest album, *Black and Blue*, had received a lukewarm reception, and sections of the media were starting to write the group off. To boot, with the advent of punk rock, the Stones were being characterized as aging rockers, and many fans attending the '76 tour were firmly under the impression that it was to be the group's last. Britain's *New Musical Express*, newly converted to the punk craze, dispatched a correspondent to Germany to report back.

New Musical Express: "Jagger prowls and struts and minces and flounces like a faggot chimpanzee, his whole body one big pout. His moves are athletic/gymnastic rather than balletic, like a calisthenics programme designed by the Royal Canadian Air Force."

263

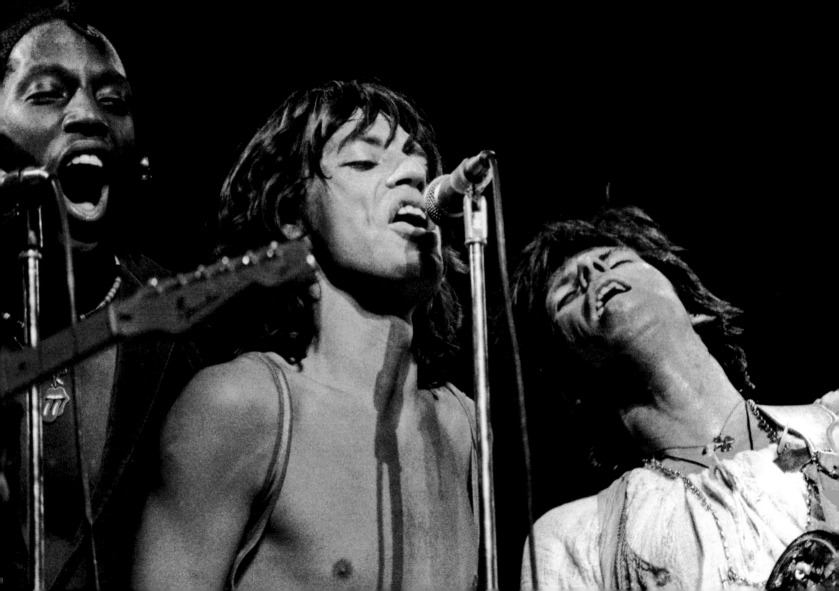

Partying Hard

Back at Mick's hotel room on May 19 following a second show at Birmingham's Bingley Hall, the Stones party with musical guests Billy Preston and Ollie Brown (holding Keith's six-year-old son Marlon). Although the Stones were notorious for keeping late hours, Keith appears uncommonly done in on this occasion. Indeed, a few hours after this shot was captured, Keith took to the wheel with his son and headed off for London. In his sleep-deprived state, he passed out at the wheel before careering off the M1 motorway into a field. Although no one was hurt, on seeing Richards's state the police strip-searched him on suspicion of drugs possession. They found a spoon encrusted with cocaine and traces of LSD in a jacket pocket, and Richards was held overnight before being released on bail.

Police Constable Sibbert (arresting officer): "He has much more experience in the concealment of drugs than I have."

264

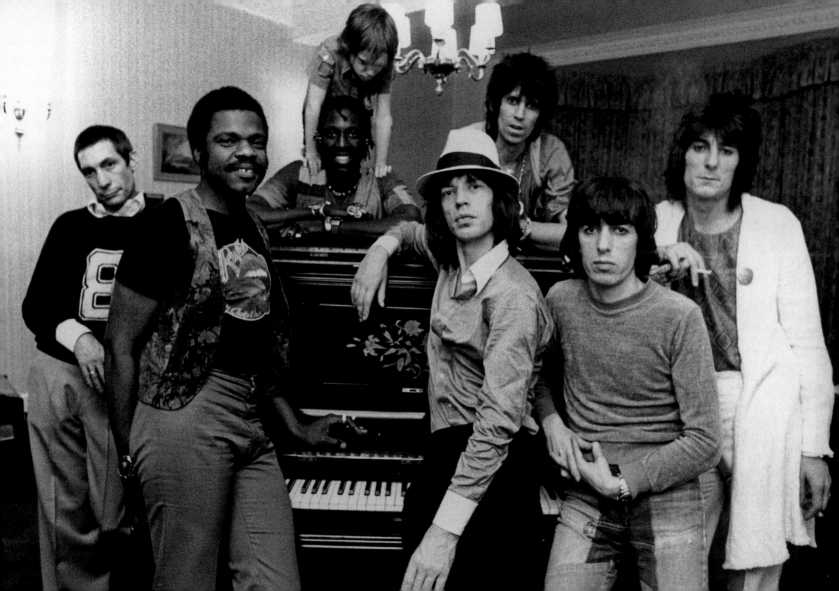

Taking to the Air

Mick Jagger lifts off at Earls Court, London, on May 22, 1976. High on ticket sales from their latest American tour, the Stones booked Earls Court Exhibition Centre in swanky Kensington for six dates that May. At the time, Earls Court was the largest indoor arena in the United Kingdom, holding upward of 18,000 spectators. Nevertheless, the six nights weren't enough to meet public demand: ticket orders for the shows topped one million.

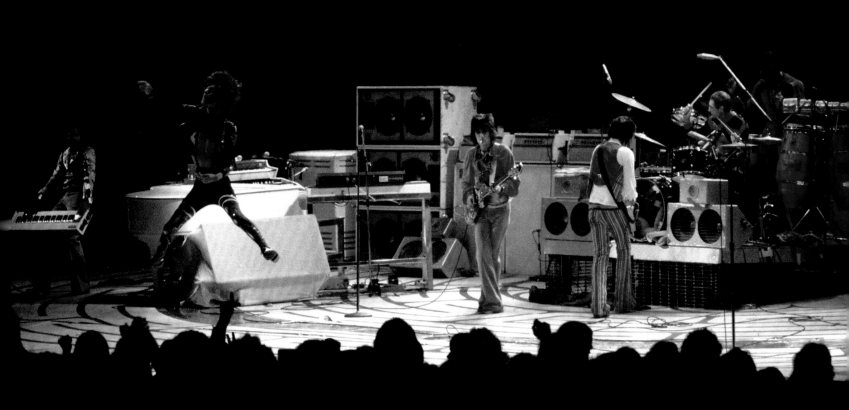

Beyond the Pale

Mick beats the heat at Earls Court. British fans had always been militantly loyal to the Stones, particularly in London, where they came out in force that May 22 to salute the band. One devotee of distinction popped in backstage: Princess Margaret. The princess with a penchant for pop, socialized with band members as they prepared for the concert. Years later, allegations that Margaret had retreated to the backstage toilets to "powder her nose" were swiftly denied by palace representatives, who dismissed any claim of drug taking as "preposterous and laughable." Furthermore, the spokesperson added, Margaret was "vehemently anti-drugs."

Cool It!

Mick keeps the front rows cool on May 22 at Earls Court. Jagger's total commitment to the band, coupled with his savvy grasp of public desire, meant he was always looking for new ways to dazzle audiences. With some assistance from Charlie, who'd kept up his design skills, Mick came up with the stage design for the '76 London performances; a special slipway protruded into the audience, allowing the main man to tantalize the front rows. Fans marveled at Mick's leaps and bounds as he propelled himself into space via a trampoline, and during the encore, they reached near-delirium as Mick threw equal amounts of water and confetti their way.

Mick: "Basically the sort of people who like the band now aren't old ladies in Cheltenham, or the Bishop of Lambeth. Well, maybe he might . . ."

267

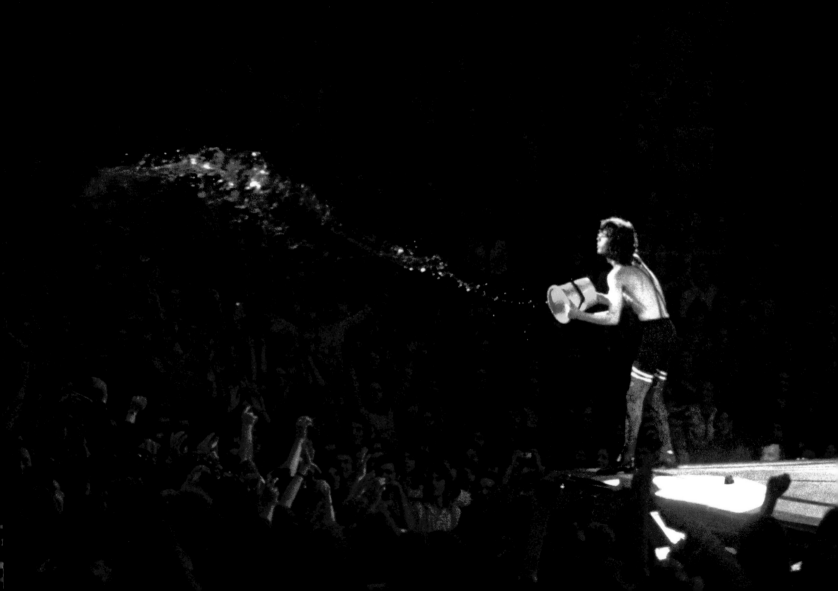

Courting Triumph

Mick wows the partisan crowd at London's Earls Court Arena on May 25, 1976. Although a whole new generation of bands was by now enjoying pop stardom in the UK, the Stones' reappearance on UK stages after their lengthy U.S. tour was greeted with unflagging enthusiasm. They assimilated themselves back into the highest echelons of top-grossing acts with ease: European dates sold out within hours of the first announcement. Not that certain segments of the press were all that impressed.

New Musical Express: "The trouble is that Jagger's cosmic inflation of spoiled bratishness has been so crudely exaggerated that's it's stylised itself up its own ass. It's a good show, but he comes on so strong that it just degenerates into hamming."

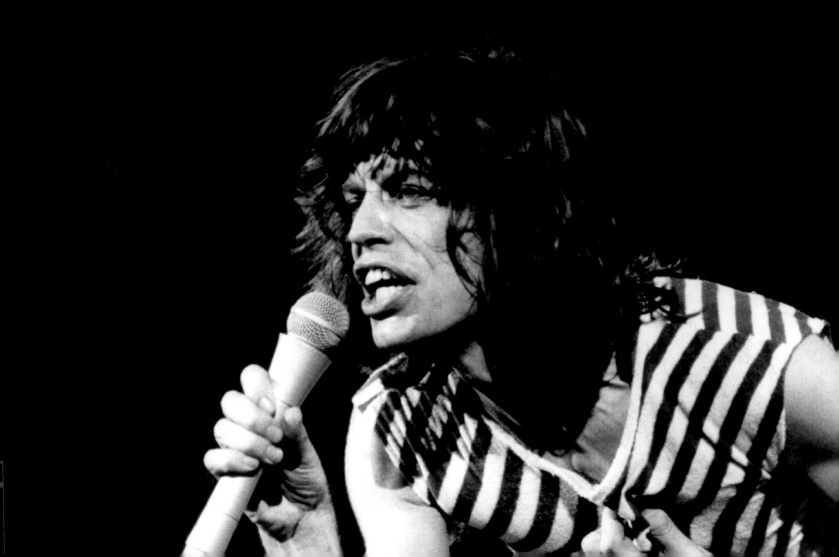

Call Me Brother

Mick shows off new boy Ron Wood to British audiences for the first time at the group's Earls Court gigs. Ron had been fully broken into the band by dint of their 1975 tour of North America, but European fans had yet to witness Wood's talents onstage with the Stones.

Ron: "The Stones are pretty worldly characters and a lot can bounce off them. If I turned round and slagged them off they could just as easily do without me, but I did feel more wanted with them, which is good. There are a lot of lap dogs around the Faces tours."

Between the Petals

The last night of the Rolling Stones' six-date residency at Earls Court Exhibition Centre, May 27, 1976. Although the U.S. concerts the year before—mostly in massive arenas—had benefited from the band's spectacular theatrics, in Britain's smaller venues, they lost a lot in translation. Many fans and media personnel found the Stones' entrance— from between the petals of a giant lotus leaf—somewhat pretentious, but after thirteen years of headlines devoted to the band, even the most verbose Fleet Street journalists were easing up on the hyperbole.

The *Times*: "Predictably but inevitably, the old favourites that filled the final part of the show went down best. Four songs from their new album had been accepted rather than seized upon. But at the end of the evening and the frenzy, I felt that we were cheering a vision of things past rather than things present."

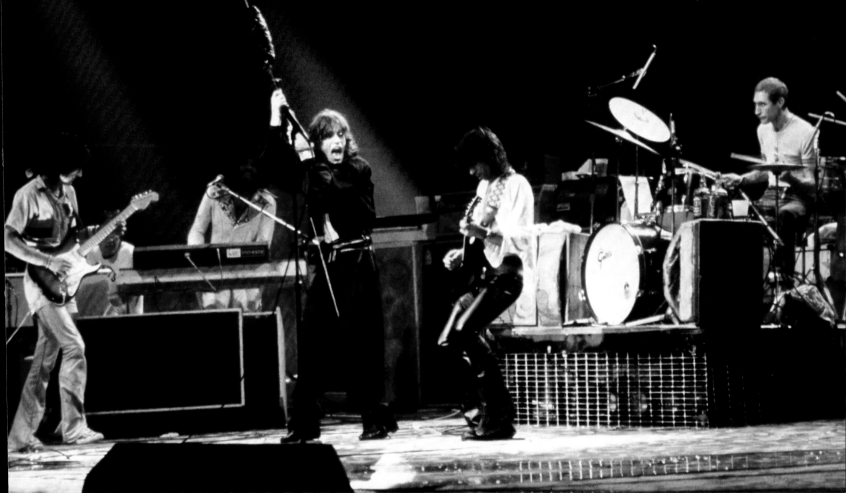

Traits of a Stone

Ron Wood draws hard on a cigarette while Charlie and percussionist Ollie Brown keep up the rhythm at Earls Court, May 27. By that point in 1976, Wood's assimilation into the Rolling Stones was complete. No longer the temporary outsider, he was now a bona fide member who easily fit into the complicated group dynamic both on- and offstage. Audiences warmed to his humor and his laid-back nature; he was worlds away from his enigmatic predecessors, Mick Taylor and Brian Jones.

Ron: "Yeah, I'm a Rolling Stone now. I'd like to devote a lot of time to it now. I suppose I could go off at a tangent, but I'd like to pile some energy into the Stones for a while and see what comes out."

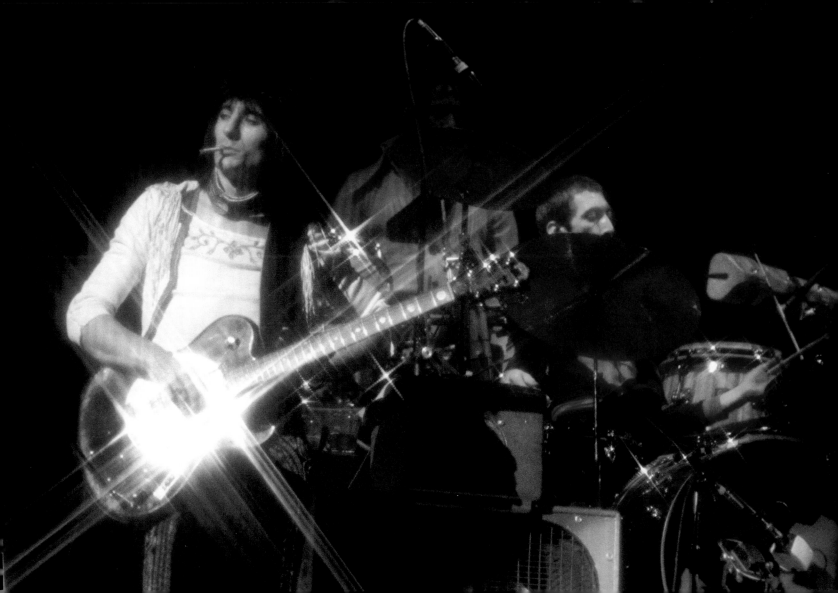

Meat Heads

Mick gets things moving at Les Abattoirs in Paris while Billy Preston takes his portable organ out for a roam mid-stage on June 4. Paris remained an essential stopover for any band touring Europe, and masses of French followers showed up in June 1976 ready to shower praise on the Rolling Stones. In the City of Light, the Stones usually stayed at the Hotel George V, where they fully enjoyed the exceptional hospitality and regal glamour. But that elegance hardly extended to the venue for their four sold-out concerts—an old converted slaughterhouse. Many eyebrows were raised by the choice, yet the arena provided exceptional acoustics, which ultimately found its way onto the 1977 collection *Love You Live*.

272

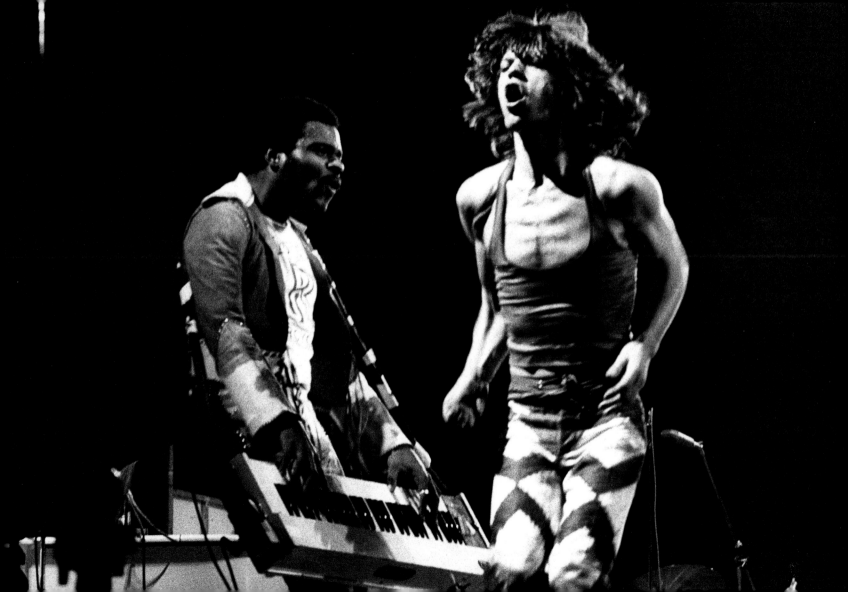

The Common Bond

Mick and Keith on the Stones' European tour of 1976. The media often touched on the love-hate relationship that seemed to exist between Mick and Keith. During the 1970s, it occasionally reared its head, generally sparked by an offhand remark during a solo interview. Disparaging comments aside, the two rockers were more than aware that the alchemy between them was the true essence of the band's appeal.

Keith: "When it comes down to it, Mick and I can never be divorced."

273

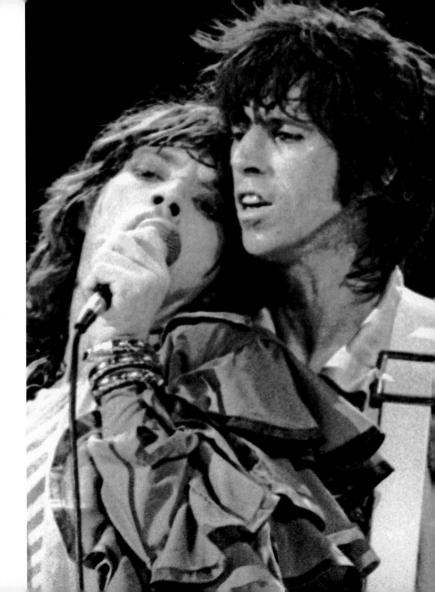

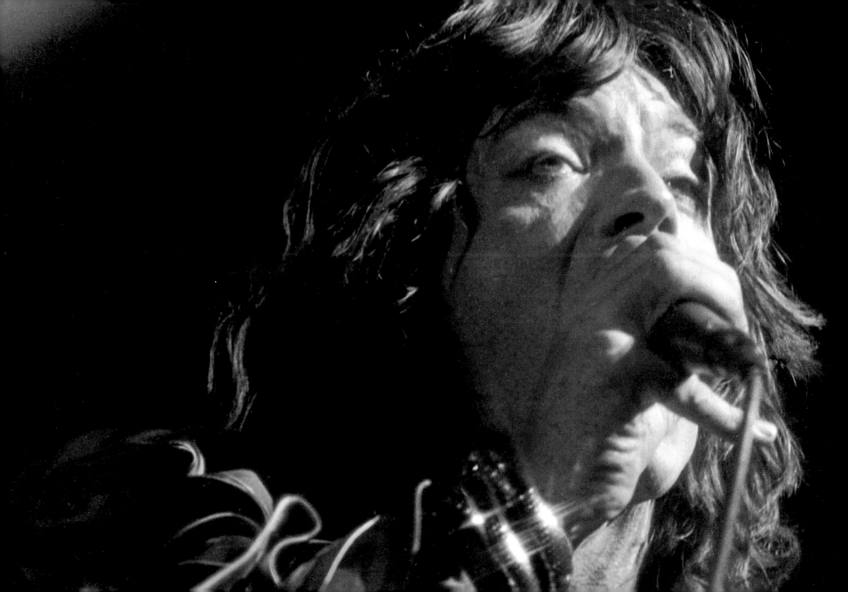

Taking a Tumble

The Stones blitzed their way through country after country on their 1976 European tour, visiting regions they'd never covered before in a touring itinerary that was among the most ambitious ever undertaken by any supergroup. Their energy and endurance was drawn from their own enjoyment of playing live.

For Keith, touring was his constant inspiration, and its irregularity and detachment from worldly affairs seemed to gel with his unconventional lifestyle. The recurrent question of whether the band's '76 tour would be its last elicited a variety of responses from the Stones, but Keith's answer was the most unequivocal.

Keith: "The last time? I don't know where that comes from. Nobody in the band gives off that impression or even thinks that. They said it in '69; they said it in '72; why the fuck should this be the last time? What else are we going to do? Get a job in an ad agency?"

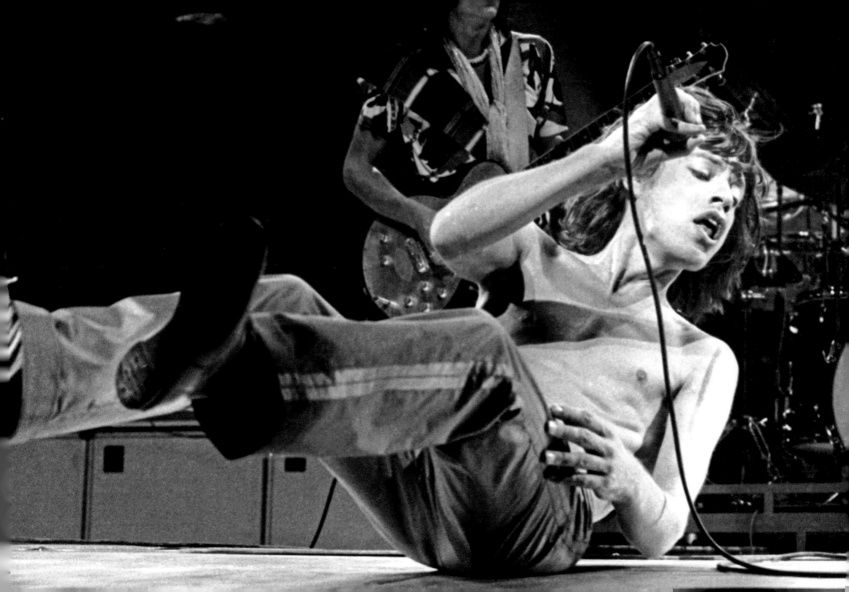

Charlie and Stu

Under the scaffolding, Charlie Watts and Ian "Stu" Stewart take in the air prior to the Knebworth House August 21 show. Ian Stewart was the Stones' "nearly man." Despite being a founding member of the band, Stu was removed from the lineup after Andrew Loog Oldham determined that his slicked-back hair and heavy-set build didn't fit the group's image. Nonetheless, his boundless enthusiasm and loyalty to the band he helped create kept him closely linked with the Stones as a musician, road manager, and friend until his untimely death in 1985 at the age of 47.

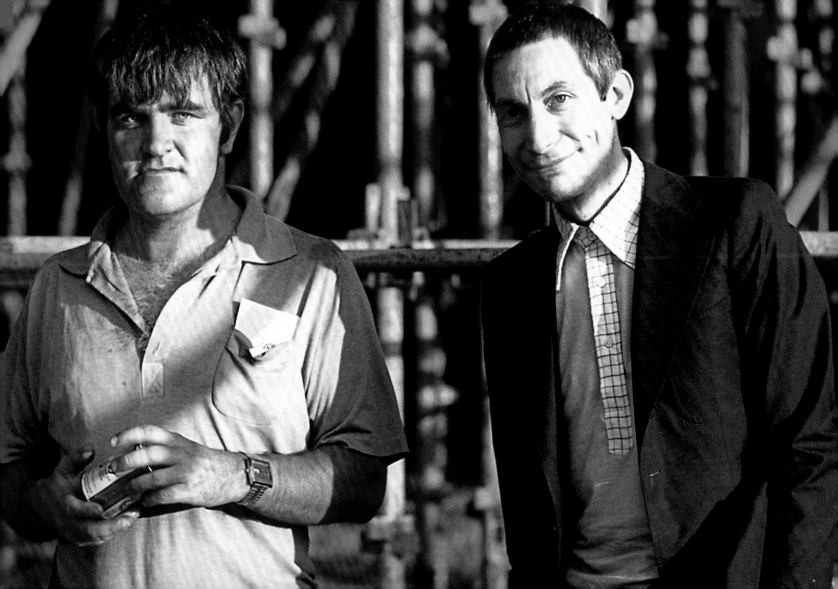

Knebworth

The Stones' European tour came to a close at Knebworth House on August 21, 1976. After three years, the festival at Knebworth Park was beginning to establish itself as a major event on the rock calendar; the natural amphitheater on the estate lent itself perfectly to outdoor music. The Stones joined a superb lineup, which included 10cc, Lynyrd Skynyrd, Hot Tuna, and Todd Rundgren. The setup was certainly impressive: an extended stage was fashioned in the shape of a gigantic mouth and a protruding tongue.

276

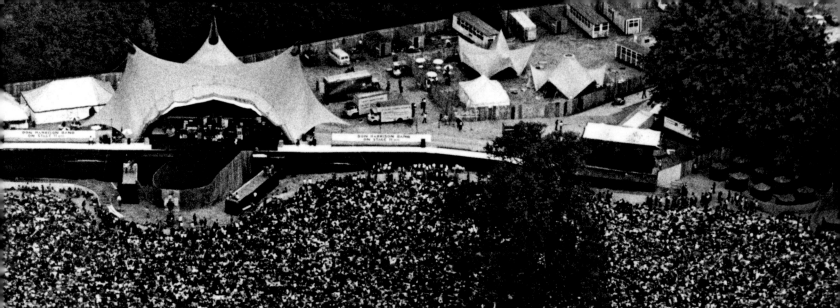

Parted Lips

The Stones had employed some not-so-subtle promotion to publicize the Knebworth festival, even sending clowns into the Wimbledon tennis finals with banners advertising their appearance at the upcoming event.

As was customary for musicians playing at the stately venue, the Stones partied hard at the historic house overlooking the festival grounds; Mick Jagger even cheekily left a pair of underpants hanging off the four-poster bed that Queen Elizabeth I had once slept in. (To this day, they are preserved in the mansion's safe.)

Despite the adoration of the massive crowd, some sections of the press were not overly impressed with the event, citing the mass of theatrics over the quality of the music.

The *Times*: "When they appeared onstage some four hours later than scheduled, expectations and hopes were high... Their opening number 'I Can't Get No Satisfaction' [sic] lived up to its name and set the standard for a shambolic parody of a performance that used volume as a substitute for tension."

277

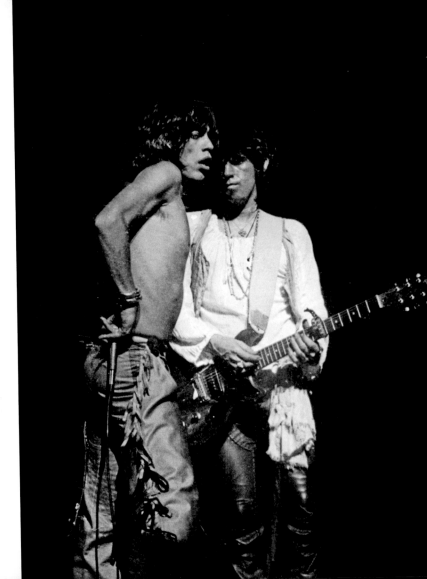

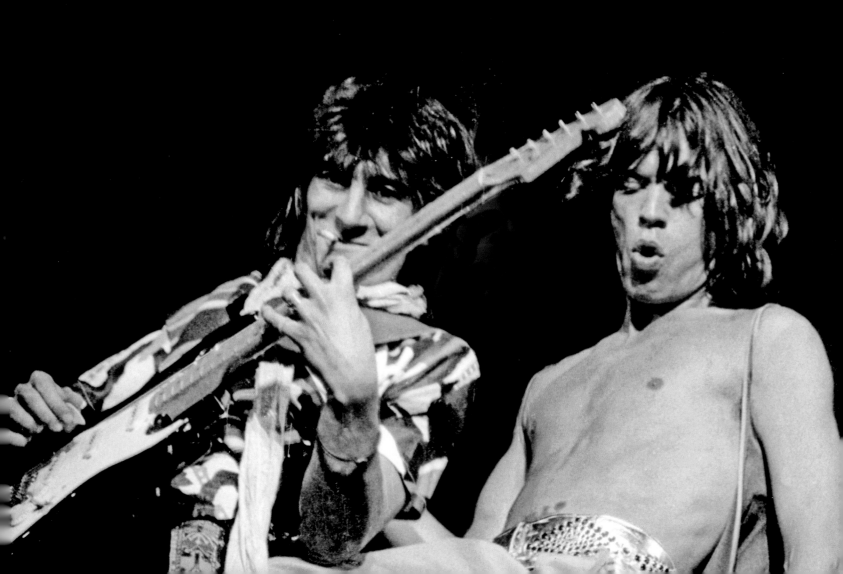

Hot Stuff

Keith, Mick, and Ron facing a quarter of a million British fans at Knebworth Park on August 21. In 1976, Britain was enduring one of its hottest summers in over two hundred years, with record temperatures and major drought restrictions. The Stones' appearance at the end of a sizzling 12-hour day ensured that the heat would go up even further. On this day, they were up against some spirited competition, music-wise: Lynyrd Skynyrd (just months before the tragic air crash that would claim three of its members) performed a version of "Free Bird" that has become an all-time rock classic. Some four hours later than advertised, the Stones eventually shambled onstage, and the fans, who had largely held out for the Stones, were treated to a two-hour performance.

Russell Elliott (fan at Knebworth): "The tension of the massive throngs in anticipation of the Stones was building up, and for some reason, their appearance was delayed by about one and a half hours (or so it seemed). Hot Gossip, a foxy dance troupe from the Kenny Everett TV show put on a bit of a distraction for the wait, and finally the best rock band in the world at the time hit the stage to a phenomenal reception. They played for about two hours, with Mick Jagger bumping, grinding, and running all over the stage and the band playing just about all my favourite Stones' songs."

278

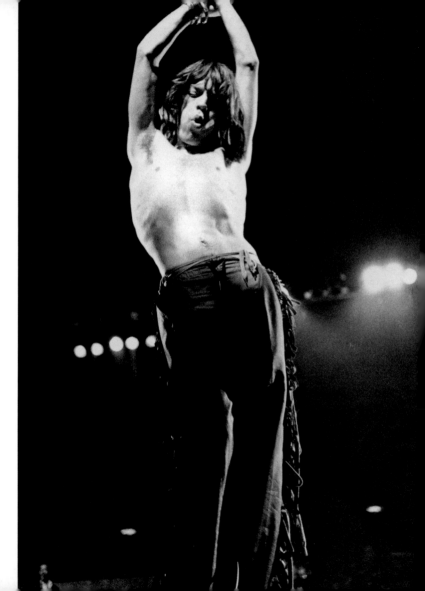

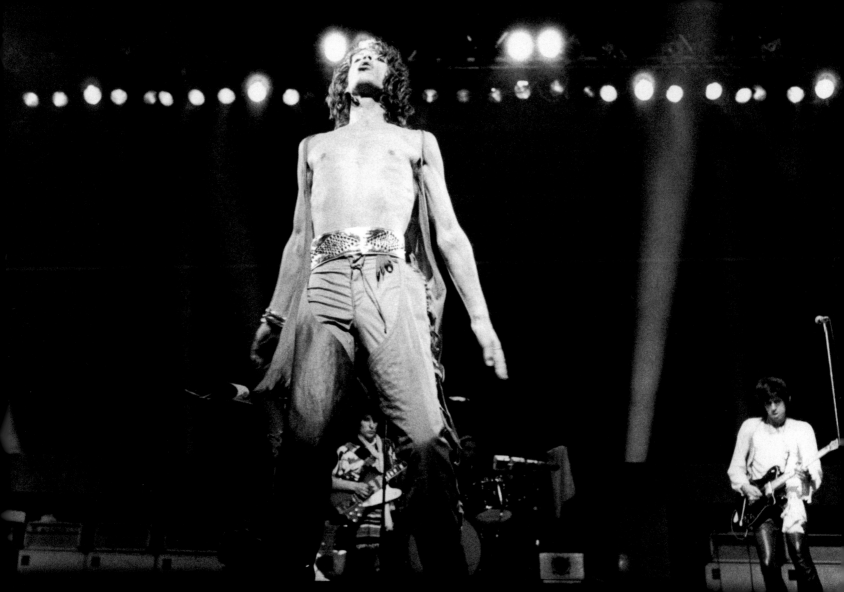

Come Together

From left to right: Billy Preston, Ron Wood, Ollie Brown, Mick, and Keith at the massive Knebworth festival. After 15 years in the public eye, the Stones could still pack in a quarter of a million people in a concert arena. With the advent of punk, the term "supergroup" had become anathema, and yet the Stones' massive, forever faithful fanbase ensured they could weather even this criticism. Characteristically, punk would indeed call for the group's immediate decommissioning, as would, ironically, a familiar voice from the past.

John Lennon: "For me personally when you listen to the Stones' music nothing's ever happened. It's the same old stuff that goes on and on forever. I've never heard anything different from them. So I think it would be good seeing if they broke up, and made some individual music . . ."

279

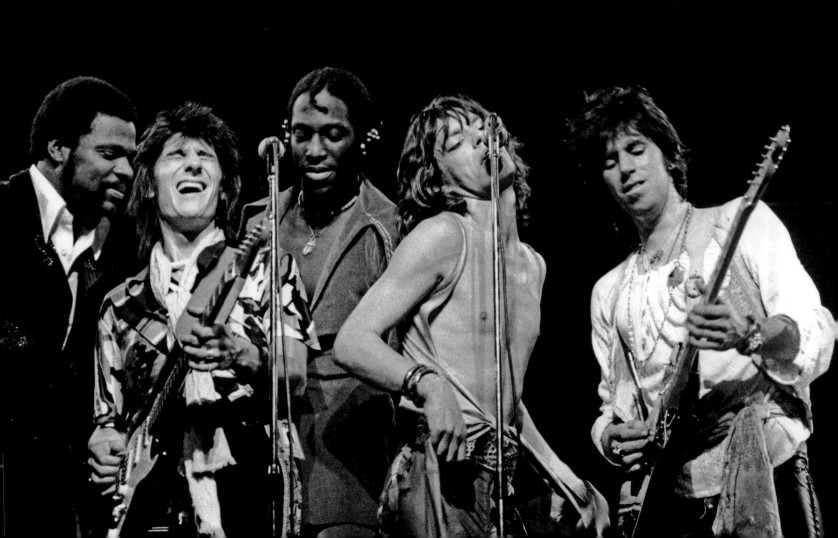

Long Wait

By 11:30 p.m. on August 21, the crowd at Knebworth was starting to get restless. The festival had been billed as ending at 11:00 p.m., yet there was still no sign of the Stones. To boot, conditions around the festival site were starting to get desperate. The food vendors had all but run out of their wares, and the standpipes around the edges of the grounds were about to run dry. But suddenly the anthemic strains of Aaron Copland's Fanfare for the Common Man flooded the arena, and the Stones arrived onstage and launched into a spirited rendition of "Satisfaction."

Jim Buckman (Stones fan): "After a long wait the Stones came on and played a pretty good show, but once again those at the back could not hear very well, and the video screens were out of sync with the music. Still, most people seemed to be having a good time from what I remember."

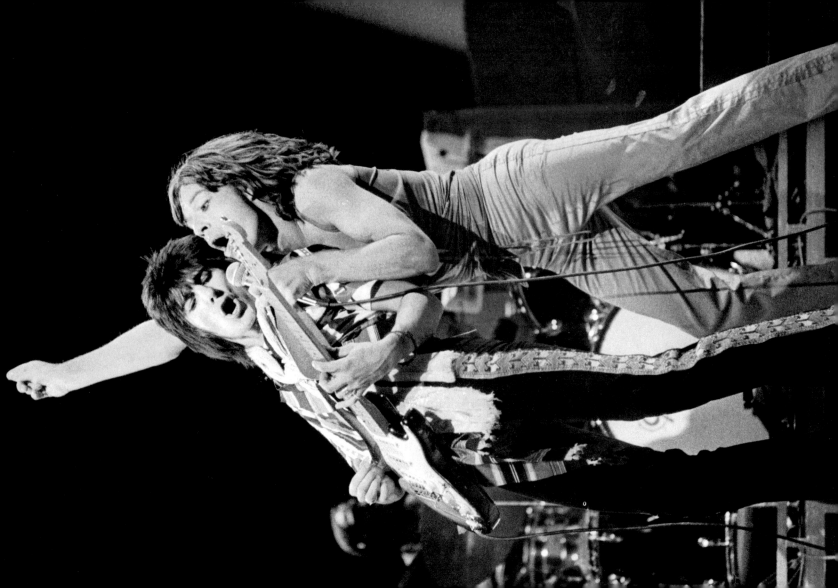

It's All Over Now

The Stones' concert at Knebworth went down in rock-and-roll history as another high point in the band's formidable career. But one hilarious incident, which took place the day before the concert, has rarely been told. As was customary, the Stones were given time to check their sound and iron out any irregularities before the performance. Their amplification being what it was, it boomed out over the surrounding, largely rural, area. In an adjoining field, a party of Girl Guides was having an end-of-holiday sing-along—which was being hampered by the noise wafting in. In a fit of rage, the girls' mistress stormed over to the stage area and, pushing security men out of the way, grabbed Mick Jagger by the arm and told him to stop the music as it was interfering with her campfire sing-along. Jagger's response was curt and unprintable, but at least the mistress had set an example for her girls and made her point.

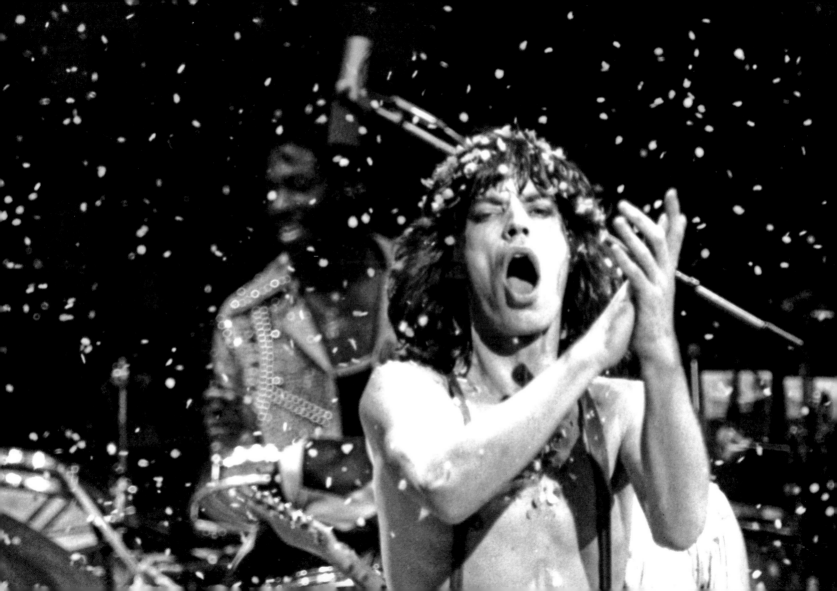

Look Punk

The Rolling Stones display a new look for a 1977 publicity shot. This could easily be the Stranglers, the Clash, or even the Ramones, with Bill's hairdo. But no, it's the Rolling Stones—reinvented for 1977. The punk movement was vociferous in rooting out those bands it perceived as having sold out to the corporate money machine, and it was unbridled in its contempt for the Stones, singling them out for the bulk of its criticism. In what can only be seen as an act of retaliation, the Stones reverted back to a simpler look and even took to wearing some of designer Vivienne Westwood's famous punk T-shirts. While the Stones proclaimed that their antics made them the forerunners of new wave, punk rockers weren't the slightest bit convinced.

Johnny Rotten: "I don't even consider the Rolling Stones to be a band: they're more of a business."

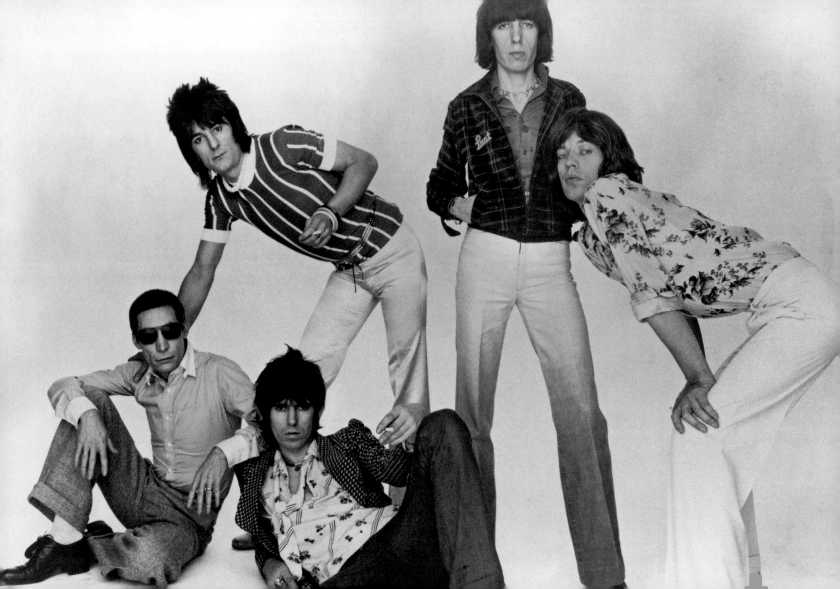

Dressed to Impress

Mick Jagger displays the classic businessman look for Terry O'Neill's lens. By 1976, the Rolling Stones' fortunes were at an exceptional high. Rock had now become a multimillion-pound industry, and the Stones, under astute management, could command enormous sums for both concert and recording work. Despite his penchant for eccentric antics, Mick Jagger had an acute business sense—honed during his time at the London School of Economics—and he was highly instrumental in determining the group's path both creatively and financially.

Mick: "When we first started out, there wasn't really any money in rock and roll. There wasn't a touring industry; it didn't even exist. Obviously there was somebody maybe who made money, but it certainly wasn't the act. Basically, even if you were very successful, you got paid nothing."

283

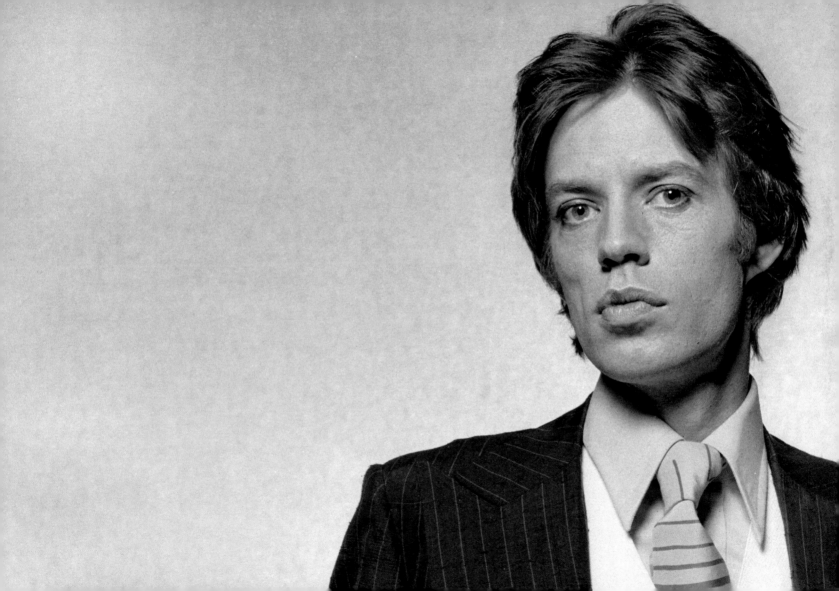

Tooth Fairy

You wouldn't think that the most famous mouth in entertainment history would require embellishment, but then, we're talking about Mick Jagger. Fast approaching middle age and ever conscious of his appearance, Mick was well ahead of his time when he decided to enhance his upper right incisor. Initially he'd had an emerald chip adhered to his tooth, but people remarked that it looked like a stray piece of spinach. He then changed it to a ruby but soon grew tired of people mistaking it for a drop of blood. Eventually, he settled on the more camouflaged diamond, courtesy of Cartier. For a few years at least, it worked as a conversation starter.

Mick: "How come all the teenies ever wanna do is tongue my diamond tooth?"

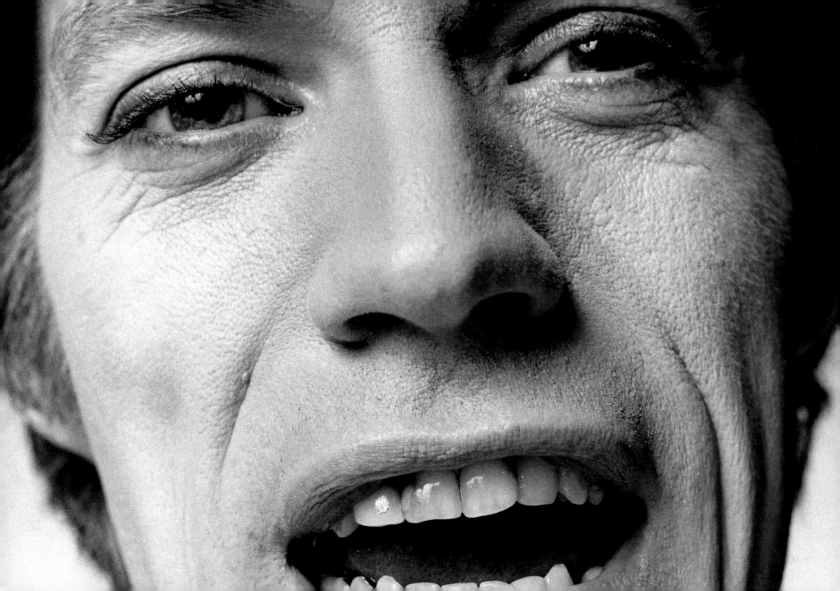

Answering the Charge

Keith Richards arrives at Aylesbury Crown Court on January 12, 1977, to answer two counts of narcotics possession stemming from his car accident the previous May. In response, Richards's defense protested for three full days that the drugs could well have been passed onto the Stone by an unsuspecting fan. Loyal road manager Ian Stewart argued in support of Keith that if band members had to squeeze past fans "it was possible that things could be put in their pocket." Ultimately, Richards was lucky. Despite being found guilty on one count of possessing cocaine, he was simply fined: £750 plus costs. However, the judge did issue a warning that any future encounter with the police could well end in jail time.

Keith: "What is on trial is the same thing that's always been on trial. Dear old them and us. I find this all a bit weary. I've done my stint in the fucking dock. Why don't they pick on the Sex Pistols?"

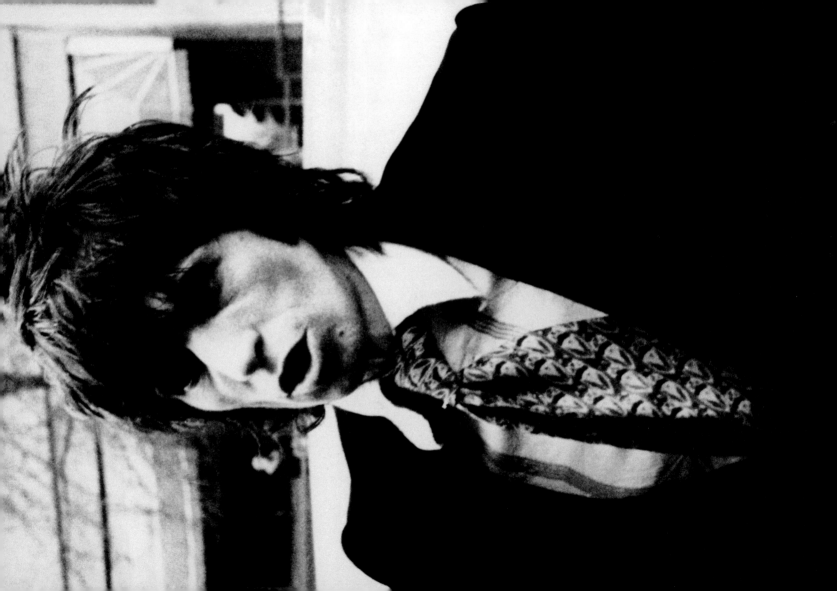

Live Launch

The Stones hold court at New York's Trax nightclub, September 23, 1977. Through most of the seventies the Stones rarely had to court publicity for a new album, but perhaps in reaction to media reports citing a slight dip in sales, they convened launch parties in London and New York to promote their latest collection, *Love You Live*. The album, a snapshot of recordings made on the 1976 tour of Europe and the British Isles, was received well by both press and fans, and the band's recent appearances in arenas around the world ensured that concertgoers would be keen to own it.

Creem: "Maybe it's because this band that has meant so much to rock 'n' roll isn't worrying about anything, but is just doing it by instinct... Maybe their contention that they really do care more about playing live than they do about making studio albums is a bit more valid than previously thought."

286

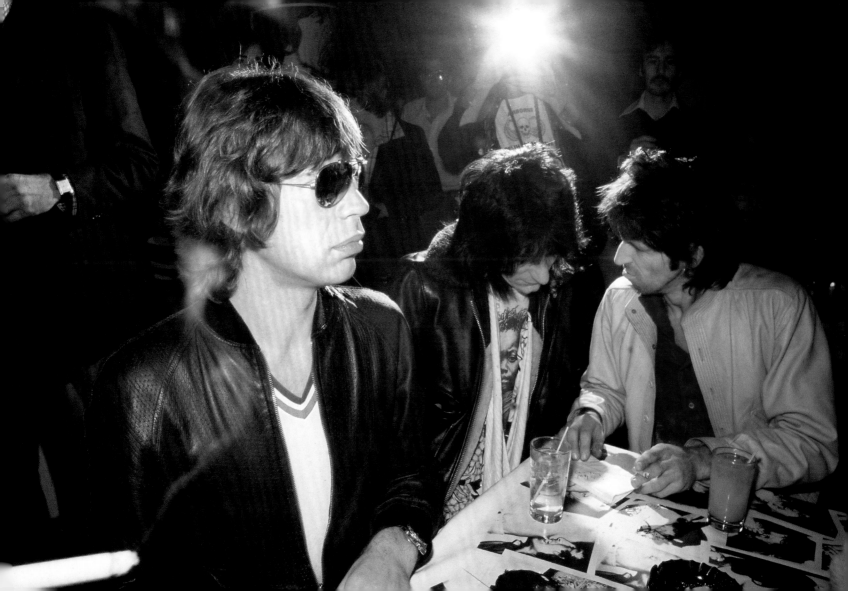

Club Daze

Showing no signs of flagging, Mick gives it his all at the Fox Theatre in Atlanta, Georgia, on June 12, 1978, as part of a series of club dates in America. The three shows, effectively warm-ups for the band's sold-out stadium tour later that year, established a tradition of playing small venues before rolling out larger shows. To this day, the practice continues: whenever the Stones embark on a major tour, they first book a smaller venue to get the band back to grassroots playing.

Mick: "At a club you can take risks and do things, but it is more difficult to do that the bigger place you get."

287

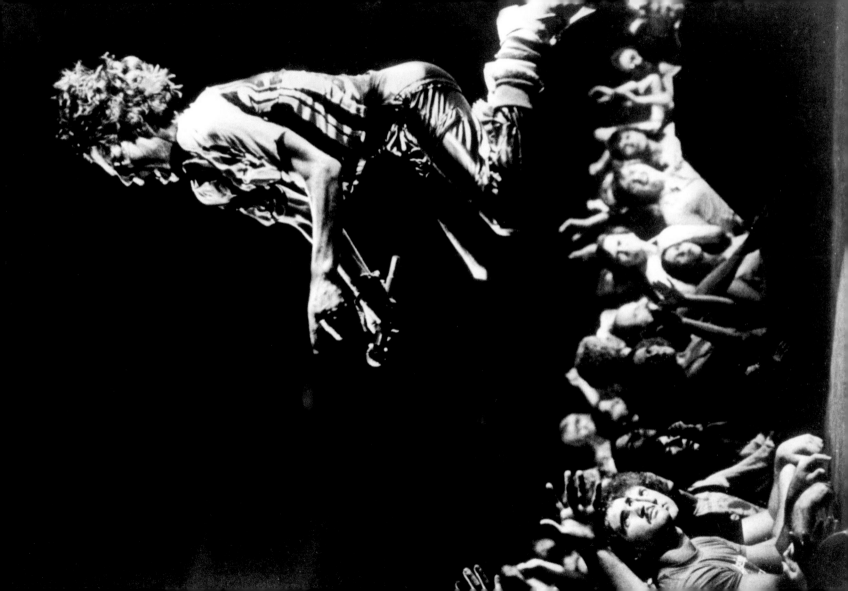

Rocket 88

Charlie stretches his shoulders during a gig with blues consortium
Rocket 88 at London's Dingwalls' club in early December 1978. The loose
collective featured Charlie, Jack Bruce on bass, blues doyen Alexis Korner
on guitar, and Stones aide Ian Stewart on piano. Although Charlie was at
that point a resident of France, the scratch band played a few gigs around
London during the tail end of the 1970s. Best of all, it allowed the sixth
Stone, Stewart, to fully indulge his talents as piano player, a prowess he'd
expressed on only a handful of Stones recordings.

Ready to Rock the Dock

He could easily be mistaken for a student on his way to college, but it's Mick Jagger, taking the scenic route on his way to London's High Court, May 4, 1979. Proving that he could effortlessly straddle the worlds of rock and dock, Mick arrived fully prepared to do battle with Bianca's lawyers in the couple's divorce settlement.

289

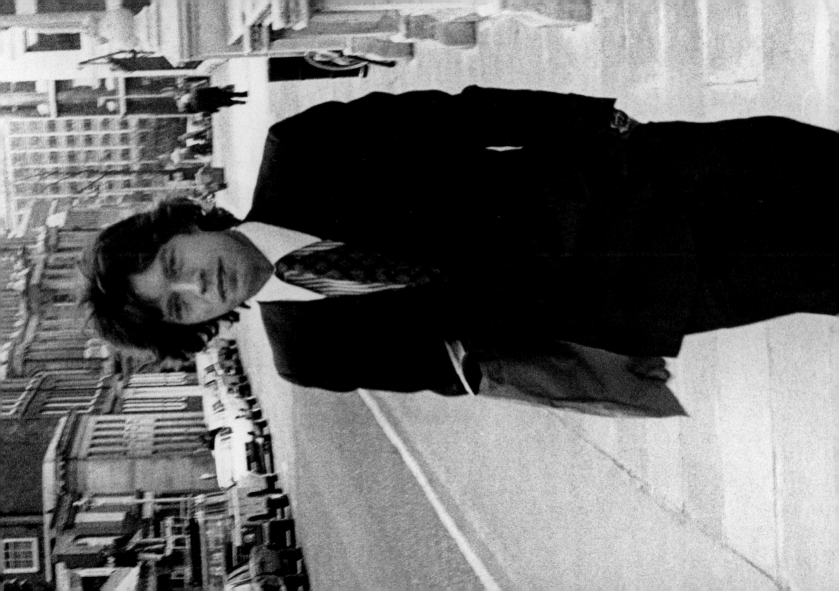

Mick Flash!

Mick Jagger dashes past paparazzi gathered outside London's High Court on July 3, 1979. The impromptu sprint was a quick bit of movement in Mick's otherwise sedentary day spent listening to lawyers thrashing out a divorce settlement for Bianca. Mick Jagger's lifestyle as a diehard lothario, coupled with his relationship with model Jerry Hall, had driven 32-year-old Bianca—after eight years of marriage—to the courts in search of an annulment. In anticipation of a spirited defense from Mick, she'd employed the services of powerful "palimoney" lawyer Marvin Mitchelson, who'd previously won a landmark victory against actor Lee Marvin.

Bianca Jagger: "All I need is to find a human being who is truthful. It's so sad when I discover that someone that I cared for isn't truthful. If I have deep feeling for someone and they do something to me I get very hurt. That I can get over. But if someone I care for lies to me, I can't forgive lies. Lies are offensive to the intelligence."

Sober and Defiant

Bianca Jagger arrives on July 9, 1979, at the High Court in London's Strand for further divorce hearings. Bianca had weathered the last few years of her marriage to Mick, but with her strong commitment to truthfulness and her humanitarian leanings, she hadn't been able to bear Jagger's litany of conquests being spread across the gossip pages, and she was forced into litigation.

Despite Mick's protests, the case would be transferred to the States, where Bianca would secure custody of their daughter Jade, plus a settlement of £1.25 million. But Bianca's emotional turmoil was far from over: her relatives were caught up in the bloody civil war in Nicaragua, and payment from Mick Jagger was still not forthcoming.

Bianca Jagger: "Although Mick was told by a judge in the United States to pay me money, he hasn't. After the divorce hearing I intend to fly back to Nicaragua to work for the Red Cross, although it will be a very stiff task to raise my fare."

291

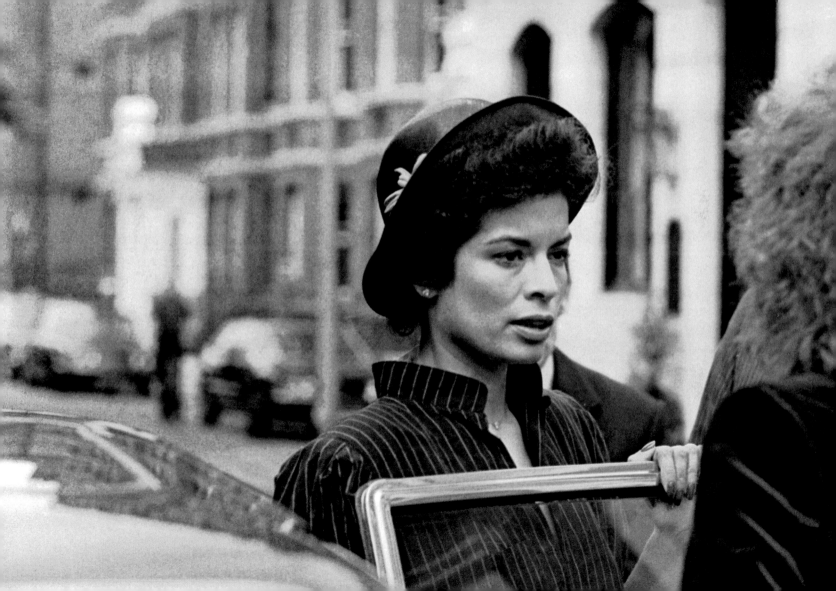

July in Paris

While the Stones were riding out storms from all quarters, Ron Wood wisely arranged some quality time with girlfriend Jo Howard in Paris on July 16, 1979. The band had few live commitments that year, and all five Stones were pursuing activities outside the group. Ron being Ron, he just smiled and enjoyed himself. He had gleefully acclimated to the good life that came with being a Rolling Stone, and he possessed the necessary durability for the job—evidently as a result of robust genealogy.

Ron: "In my family, they were all big boozers, but they all lived to ripe old ages. My dad lived till he was 78, my mum was in her eighties and I've got two uncles who are in their nineties."

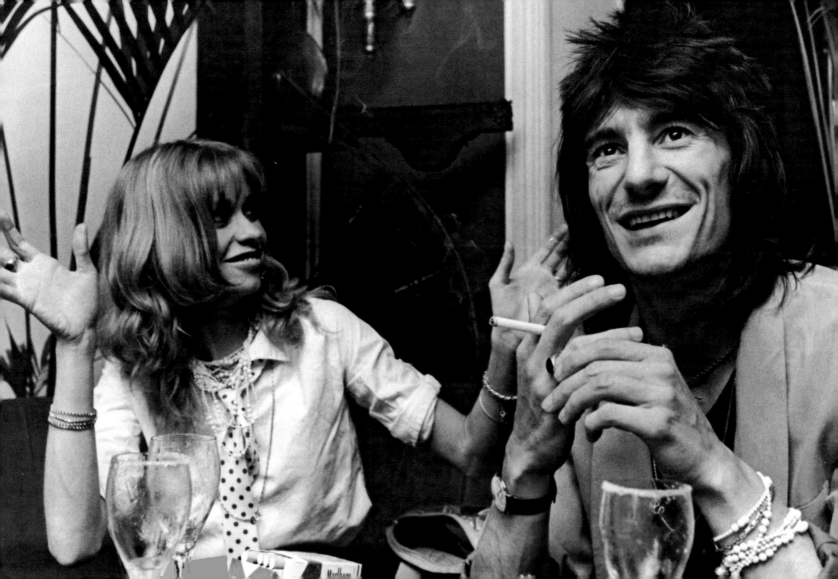

Emotional Rescue

Keith makes a quiet return to Knebworth on August 11, 1979. After two disastrous years, Richards had reached an uneasy crossroads in his life. During a tour of Canada in 1977, his Toronto hotel suite had been raided, and a huge quantity of heroin and cocaine was uncovered. Given the size of the haul, the police charged Richards with intent to supply, something that could have landed him in jail for seven years to life. The international furor over the arrest reached the highest levels of Canadian government, with Margaret Trudeau, wife of the Canadian prime minister, rallying to Richards's side. Trudeau's involvement with the Stones had raised eyebrows before, when gossipmongers had speculated as to the exact nature of her relationship with Mick Jagger. Ultimately, the prosecution's claims were largely dismissed in court. Richards was put on one-year probation, with the proviso that he attend rehab clinics and probation meetings. The judge further demanded that Richards organize a series of concerts to benefit Canada's Institute for the Blind. Keith duly acquiesced and put together a scratch band composed of fellow Stone Ron Wood, bass legend Stanley Clarke, keyboard maestro Ian McLagan, and drummer Ziggy Modeliste. The New Barbarians, as they called themselves, played a series of concerts in Canada before taking to the road. At right Keith takes the stage with his new bandmates.

Keith (in a statement to the Toronto court): "It was a rewarding experience for me also to have been given an opportunity to assist in my small measure the blind people of Canada. I can truthfully say that the prospect of my ever using drugs again in the future is totally alien to my thinking."

293

Hitching a Ride

A virtually unrecognizable Mick Jagger steps out in Paris, October 1979.
Just what the bearded Jagger was doing in the French capital was the
subject of spirited speculation; he certainly was employing some subterfuge
to avoid detection. Lately Mick had been doing some romantic globetrotting,
and he was having repeated run-ins with paparazzi desperate to capture
him with latest love Jerry Hall. But on a less amorous note, he was also
dodging the attentions of Marsha Hunt's legal representatives, who were
desperate to collar him and secure further maintenance payments for Hunt
and Jagger's daughter Karis.

Grizzly Jagger

Caught at the social event of the Paris racing calendar: the Prix de l'Arc de Triomphe, October 1979. Unkempt appearance aside, the principal Stone was fast becoming a permanent fixture on A-list celebrity events, and he could slip between royalty and rock cultures effortlessly. Between races, Mick based himself at the swanky Parisian hotel George V and spent time with model Jerry Hall and shipping magnate Stavros Niarchos.

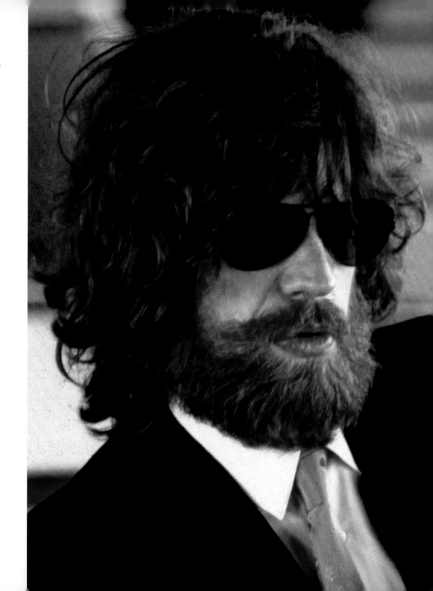

Irresistible Jerry

Mick and Jerry Hall are caught by paparazzi in Paris, October 18, 1979. Hall was every inch the leggy blond supermodel. As Jagger's relationship with Bianca was drawing to an inglorious close, the lead Stone was bowled over by Hall's beauty, apparent intelligence, and independent spirit.

Born in Mesquite, Texas, on July 2, 1956, Jerry was one of five children. Her early years were dominated by an abusive father, and Jerry would abandon her family at age 16 to flee to Paris in search of a modeling career. With her classic features, cascading golden hair, and endless legs, Hall was soon in demand around the globe. While appearing on the covers of the world's leading fashion magazines, she caught the attention of Roxy Music star Bryan Ferry, who used her image on the cover of his band's album Mermaid and started an affair with her. But among the gilded rock circles that supersmooth Ferry mixed in, Hall would soon cross paths with Jagger—and the attraction was instant.

Jerry Hall: "Mick Jagger and I just really liked each other a lot. We talked all night. We had the same views on nuclear disarmament."

1980

Mick Jagger: "We do enjoy ourselves. Everyone has been saying, 'How can they enjoy themselves, they should be bored to death doing this.' If we were bored to death, we would not be doing it."

Keith Richards: "We're always asked what we're going to do when we get too old for rock and roll. But what can you say? It's the only thing we've done—the only thing I've done. It's the only thing I want to do."

Ron Wood: "You know, I never thought, How long is this going to last? I always thought, This is it. Rock till you drop."

Bill Wyman: "When I joined this band we thought we would last two or three years with a bit of luck and come out with a few shillings in our pockets."

Charlie Watts: "I always have this image of me playing in the Stones, and there are all these sixteen-year-old girls in the front screaming. My daughter's that age. I find it embarrassing."

Across the Sofa

Jerry Hall keeps her eyes fixed on Mick in early 1980. Despite being at the tail end of his thirties and attached, Mick remained the object of many a female's most primeval desires. And Jerry was determined to keep any interested party well away from Mick, lest he stray into his old wayward habits. She was not beneath a well-aimed stiletto heel or a shove from her six-foot frame if any competitor got too close to her man. For the most part though, Jerry just oozed with adoration for Mick.

Jerry Hall: "On tour I get so proud looking out at the audience. There'll be tens of thousands of people wanting Mick and I'll think, 'That's my man!'"

A Model Relationship

The beginning of the 1980s marked a watershed for Keith Richards on a number of fronts—he'd finally overcome his addiction to heroin, and his troubled relationship with Anita Pallenberg had come to a close. The end came in a tragic episode in 1979, when a seventeen-year-old boy shot himself at the couple's apartment in Connecticut in Anita's presence, and with that bizarre incident, the curtain finally fell on their relationship.

Throughout his time with Anita, Keith had had brief affairs with other women, but it was the beautiful model Patti Hansen who ultimately captured his attentions. The pair soon became inseparable, her sweet looks belying a tough brand of loyalty to Keith.

Patti Hansen: "When I first met Keith all I could think was: 'This is a guy who really needs a friend.' I gave him the keys to my apartment after only knowing him two weeks. There was no sexual thing going on. I knew he just needed a secret place where he could get far away from the madding crowd. It wasn't love at first sight, though it feels like that now. It just sort of mutually grew."

The Art of Wood

Besides being a gifted guitarist, Ron Wood was an exceptional artist. From the age of twelve—prior even to his obsession with the guitar—he had been passionately interested in art, and at Ealing Art College he initially harbored dreams of an art career before music ultimately won him over. Within the gilded corridors of rock, however, Ron found he had ample time to study the contours of his fellow musicians' faces, and during the 1980s his reputation as an artist took hold.

Ron: "I never really lost touch with my drawing and painting. It was a talent I was born with, so I thought I may as well exploit it. Music and art both go pretty much hand and hand. Even though they're two different forms of expression."

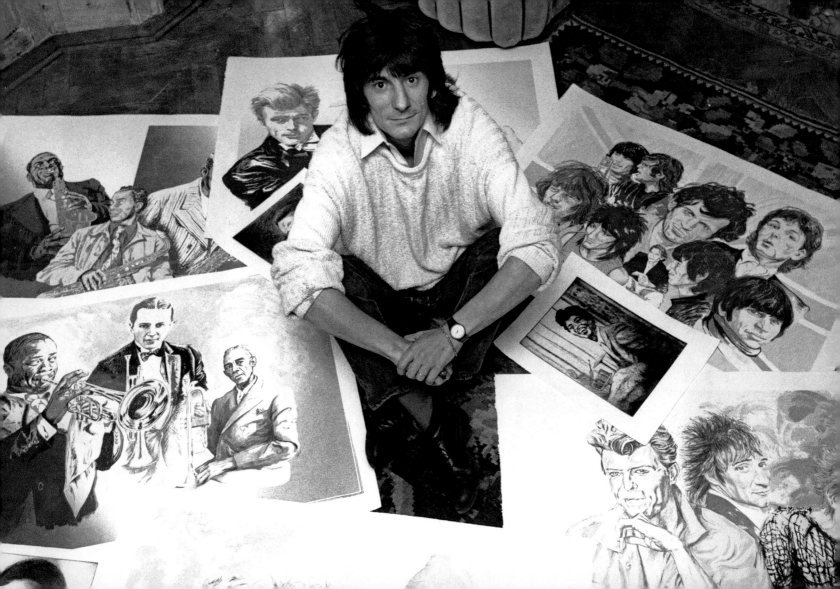

That's My Man!

Jerry Hall keeps a firm grip on her man at a backstage gathering in 1982. Despite being the couple of the moment, Hall was well aware of Mick's roving eye, especially as the media were only too ready to report any philandering on his part. Not that it was a solitary pursuit, as reports suggested that Jerry engaged in outside activities with the wealthy racehorse owner, Robert Sangster.

Mick: "For any relationship to last, there has to be a bit of playing about."

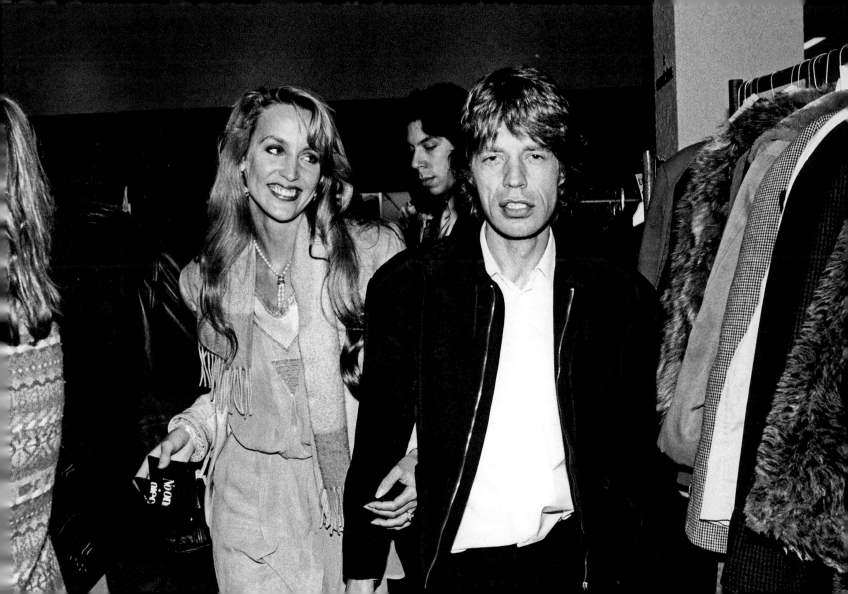

Between the Scaffolding

A solitary Mick takes stock of his newly acquired French residence, La Fourchette. Although Mick had forsworn France after his enforced exile there in the early 1970s, he did in fact return to the country in 1980 to acquire a 17th-century estate nestled in the Loire Valley. To this day, Mick spends part of each year ensconced at the remote yet lavish abode. It is reported to be his favorite residence of the half-dozen properties he owns around the globe.

Château Jagger

Even under scaffolding, the splendor of La Fourchette is evident. Mick bought the property for £300,000 and then spent an additional £1 million in renovations. The entire project took three years, during which time Mick and Jerry slept in a hastily converted chapel on the enormous grounds.

302

Waiting on a Friend

It could well be a scene from *Cheers*, but no, it's the Rolling Stones, gathered in New York City for the video shoot of "Waiting on a Friend," on July 2, 1981. Although their new album *Tattoo You* was already in the can, the atmosphere around the Stones camp was unsettled. The 1980s had started with dark foreboding: the shattering news of John Lennon's murder had made many 1960s icons all too aware of the fragility of their existence.

Nonetheless, the band intrepidly braved the streets of Greenwich Village for videotaping and enjoyed the bonhomie of St. Marks Bar, both on camera and between takes.

303

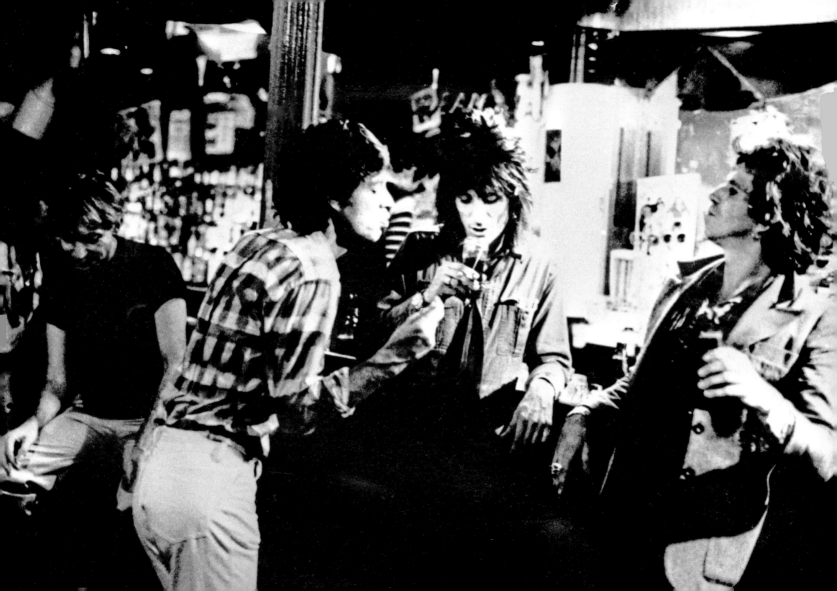

Digging Deep for Sound

Keith pulls some amazing sounds from his guitar at the cavernous Carrier Dome in Syracuse, New York on November 28, 1981. The cracks within the Stones' camp began to widen considerably during the 1981 tour of the States.

Keith, who by this time was branching out with his own solo material, wanted the group to revert back to its simpler roots, playing at smaller venues and reigning in on some of the fantastic stage sets and the theatrics that went along with them. Mick, on the other hand, was keeping a watchful eye on other leading bands and instructing the group's promoters to book enormous stadiums and arenas. This led to considerable friction between the Glimmer Twins, and although Mick ultimately had the last word, Keith consoled himself with the prospect of a few smaller dates along the way.

Mick: "I don't think Keith's interested in much else besides music. But he realizes that there are things to be taken care of, decisions to be made that involve a lot of money. The Rolling Stones is a huge business machine that needs to be kept track of. I really don't mind doing it."

Kiss This!

Mick gives the punk finger to waiting cameramen after a night out with Jerry Hall. While Mick had had a few spats with the paparazzi since he began his high-profile relationship with Hall, he was still a hot property with the media. He was still doing the rounds at the clubs and expounding eternal bachelordom, and stories of his penchant for stepping out with a host of women continued to enjoy wide circulation.

Mick: "As far as I'm concerned, marriage is just legalistic, contractual claptrap. . . . Sex is important to me. For an artist, it's another form of expression."

305

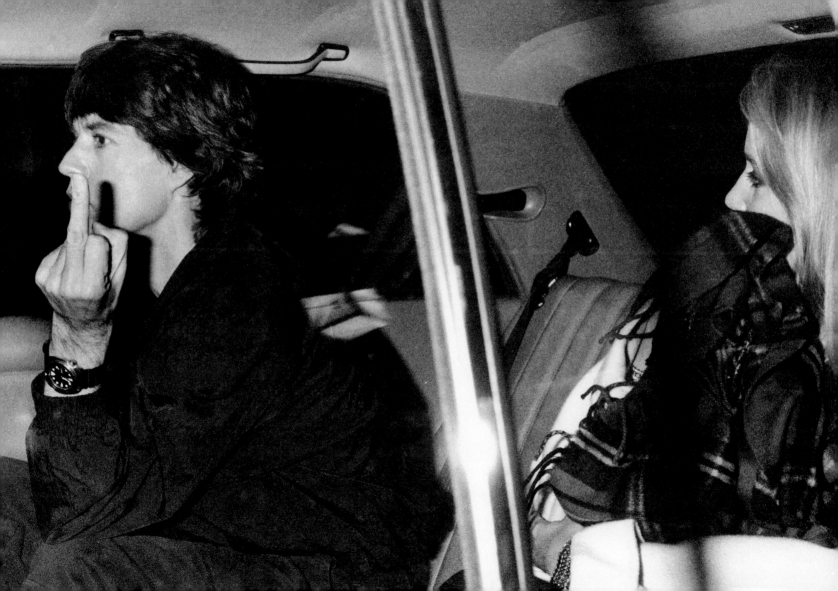

Rocking the Basement

Lucky fans get up close and personal as the Stones take over the 100 Club on May 30, 1982. This tiny club, situated halfway along London's frantic shopping mile, Oxford Street, had seen it all in its time. Renowned for its jazz connections in the '50s, for the British beat boom in the '60s, and the punk explosion in 1976, the club had become legendary. The Stones had frequented the nearby Marquee Club several times over the years, but remarkably the 100 Club's dark recesses remained virgin territory. Thus, as nostalgia was in the air, the group got back to basics for what was becoming their customary warm-up for a tour.

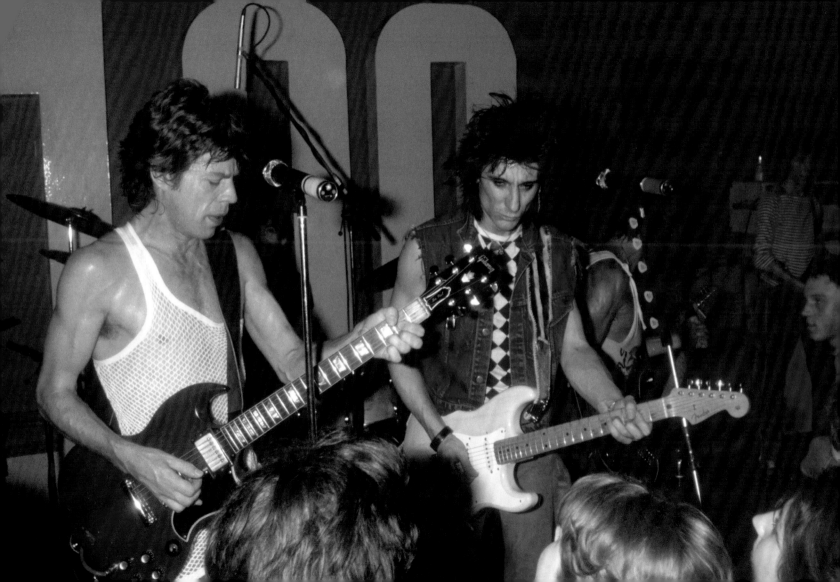

Back to Roots

The Stones warm things up with an impromptu concert at London's 100 Club on May 30, 1982. The Stones were about to hit their twenty-year anniversary, and where better to celebrate than at the types of clubs where they first played and honed their unique sound? (Although the group had never played the legendary 100 Club.) The queues stretched the length and breadth of Oxford Street, and those lucky fans who did manage to get in witnessed a sensational evening.

307

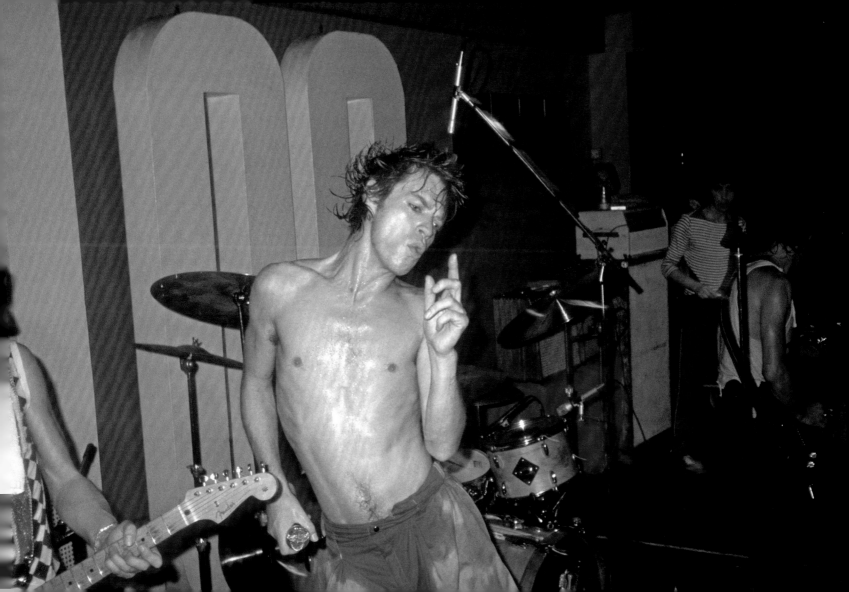

Back to Bristol

Ron and Keith at Bristol's Ashton Gate, June 27, 1982. Since the Stones had not played Britain since 1976, demand for tickets was enormous. More than 10,000 fans came out to hear them play at Bristol City's soccer stadium. The area had a large Caribbean community, and the Stones were supported onstage by local roots reggae band Talisman.

Rock music had come to an uneasy juncture at the turn of the decade, and with John Lennon's death in December 1980, the Stones now represented Britain's elder statesmen of rock.

Mick: "I was in a restaurant one night, a nice one in New York, and there was a family at the next table. No one was paying any attention to anyone else, but then I heard—you couldn't help it—the kid ask his father something. He wanted to know which band was better, the Beatles or the Rolling Stones. 'Well I don't know,' says the father. 'You better ask him,' meaning me. It made me feel like something out of history."

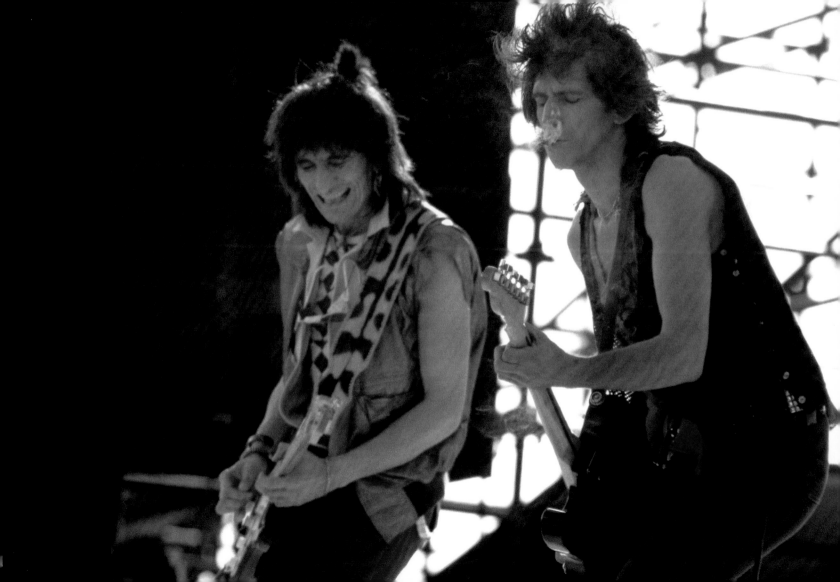

A United Front

Doing their thing onstage at Ashton Gate, June 27, 1982. Although they were fast approaching twenty years of live performances, the Stones showed no signs of flagging. Mick, who was rarely seen with a guitar, took to playing one on tour, while Keith, now free of the horrors of heroin, filled the void with the rush he got from performing.

Keith: "I need this to keep me young. When we started this band we thought we had about two or three years. Now it's habit and it's absolutely vital that it works on the road. We need constant contact with a living audience. We're so excited about the prospect of doing Britain again after so long. Wherever we might make our home now, Britain is where our roots are."

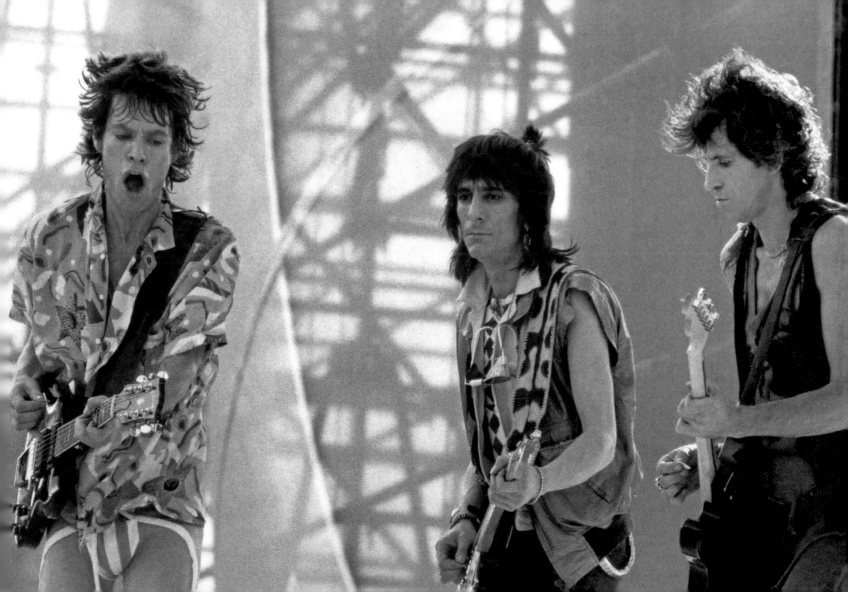

Solitary Figure

Appropriately dressed, Bill checks the sound at Newcastle's soccer stadium in St. James Park on June 23, 1982. In nearly twenty years onstage with the Stones, Bill's stage presence had changed very little. He might have embraced new technology along the way, such as the "headless" bass he's playing here, but otherwise Bill's stage action remained as immobile as the day he first stepped onstage.

310

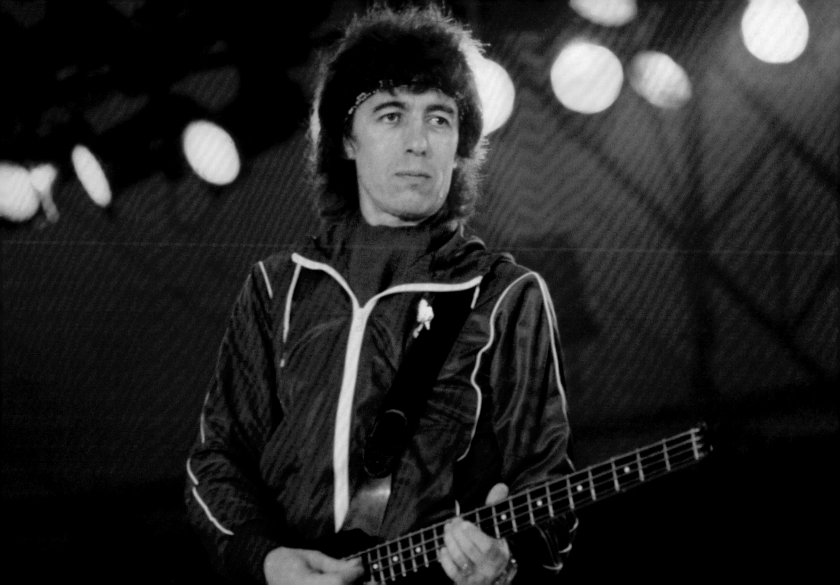

Sell-out Stardom

Mick bows to his congregation of 70,000 at Wembley on June 25, 1982. Just how the Stones' all-action, no-holds-barred stage show would fly in the UK had been a matter of speculation. Traditionally, British audiences— London especially—were the most particular and hardest to please. However, the Stones' popularity at home proved to be going strong when they sold out two concerts at London's Wembley Stadium—the first time they ever played the UK soccer venue.

The *Times*: "An outdoor concert by the Rolling Stones is an interesting piece of large-scale theatre; the fact that it has no musical value whatsoever is cancelled first by the evident pleasure of the spectators who simply enjoy the massiveness and sense of occasion."

311

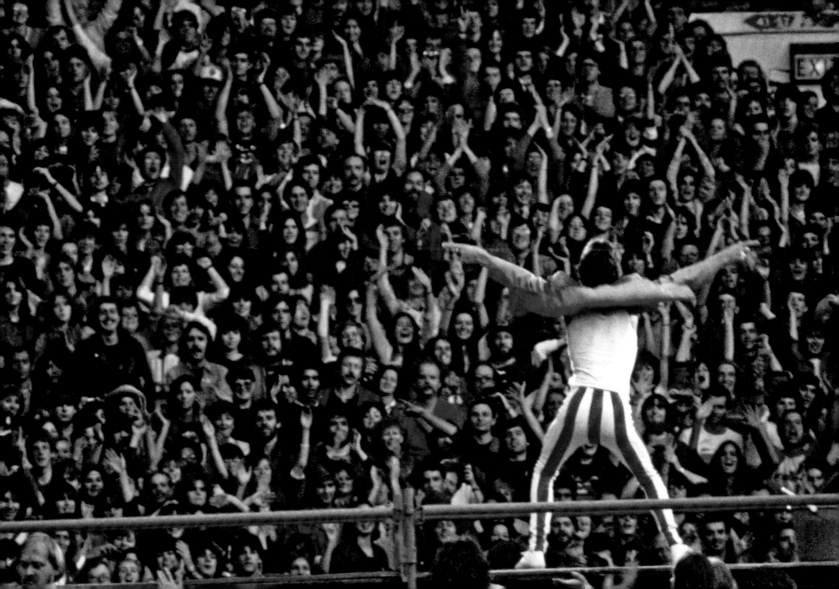

Into the Groove

Mick gets down and dirty at Le 78 nightclub in Paris, summer 1982. After a heavy night onstage the Stones often needed to wind down, and for Mick there was nothing better than tearing it up on the dance floor. There was always a bevy of beauties on hand, providing the perfect opportunity for a little window shopping. Naturally, the press was in hot pursuit, and to their delight, on this occasion they would witness Mick strutting across the Parisian tiles in his inimitable style.

Mick: "I don't particularly enjoy being the center of attention. I'd rather slide into a room and observe the room, and then if I want to make some point, make it. But I don't like people in show business to do that whole number. I don't particularly want to be noticed above anyone else, and I don't want to be less noticed than anyone else. I mean, I don't want to be ignored and stuck in a corner and not given a drink. It's just that I'd rather not do things in a *showbizzy* way."

Catching Hell

Jerry confronts a sheepish Mick during a night out. Relations between Hall and Jagger had always been under the microscope of the world's press, but reports of Mick's conquests seemed to reach a peak in 1985. During the '80s, kiss-and-tell headlines proliferated and attracted wider audiences, so whenever a Rolling Stone was implicated, there was always a huge payout involved. Nonetheless, when quizzed, Jerry would always maintain that her man had sufficient reserves to keep her emotionally (and otherwise) satisfied upon his return to her boudoir.

Jerry Hall: "Making love is by far the best way to keep my figure. That is why I hate those times when Mick is far from me. But when we are back together we make up for lost time, believe me."

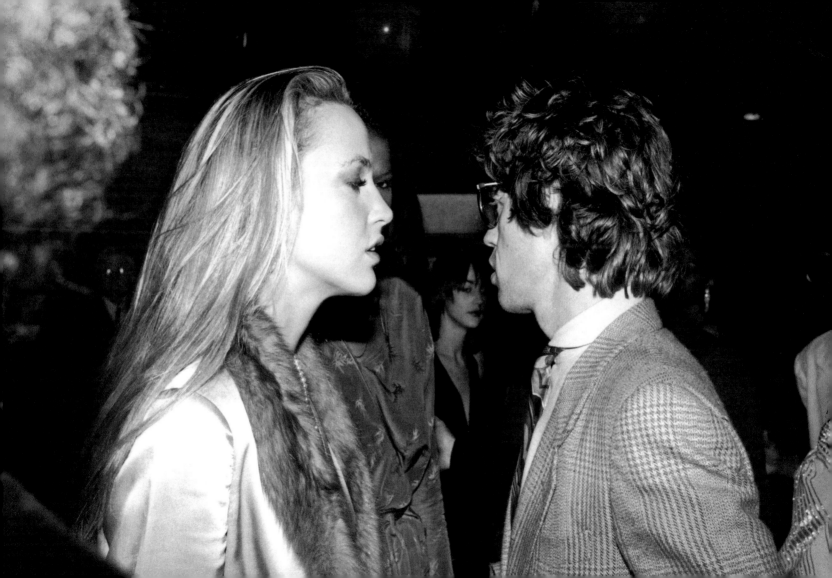

A Jagger Christening

Christenings of newborn Jaggers became a regular occurrence during the eighties and nineties. All of Mick and Jerry's children received traditional blessings in church settings, and the ceremonies allowed the disparate elements of their families to join together in celebration.

With the Jagger household resonating with the sound of children, it was apparent to many observers that Jagger was slowly adapting to the rigors of family life. While Mick may have found the transition difficult, for Jerry, this descent into domesticity was a poignant scene.

Jerry Hall: "Mick told me he read somewhere that rock stars have breakdowns because they lose touch with reality. He said he was thinking about it the other day when he was loading up the station wagon with baby stuff and said, 'There's no fear of that now.'"

Enduring Love

Charlie and wife Shirley arrive at a Jagger christening. Whereas each of his fellow Stones had been through various relationships over the years, Charlie had remained firmly rooted in a marriage that had somehow managed to withstand the demands of his rock-and-roll lifestyle. Evidently, the attraction was still as vibrant as it had been back in 1964.

Charlie: "She was so funny and clever, and she had the most infectious laugh you'd ever heard. And I loved the world she was in, the world of art and sculpting. I just admired Shirley very, very much... I still do."

Wedding Bells, Finally

Charlie and Keith support newlyweds Ron and Jo at their wedding reception in Gerrards Cross, Buckinghamshire, on January 2, 1985. Although the Stones as a performing unit was in a holding pattern, there was plenty of domestic action to engage in. Ronnie chose 1985 as the year to finally tie the knot with his girlfriend of eight years, Jo Howard.

The couple had first met at a party at Jo's ex-husband's house in 1977. Ron was instantly taken with the model's impish beauty, and eagerly courted her charms. Initially, although interested, Jo employed a subtle ruse to determine the nature of Ron's interest.

Jo Howard: "He followed me 'round the house, showed me the album cover for *Black and Blue* and asked me: 'Do you know who I am?' I liked him, but I thought I'd teach him a lesson. So I told him I worked on the broken biscuit counter at Woolworths in Oxford Street. He believed me! The next afternoon, I came back to the house and he was there, with his chauffeur. He'd spent hours outside the staff entrance of Woolies, asking for a Jo Howard."

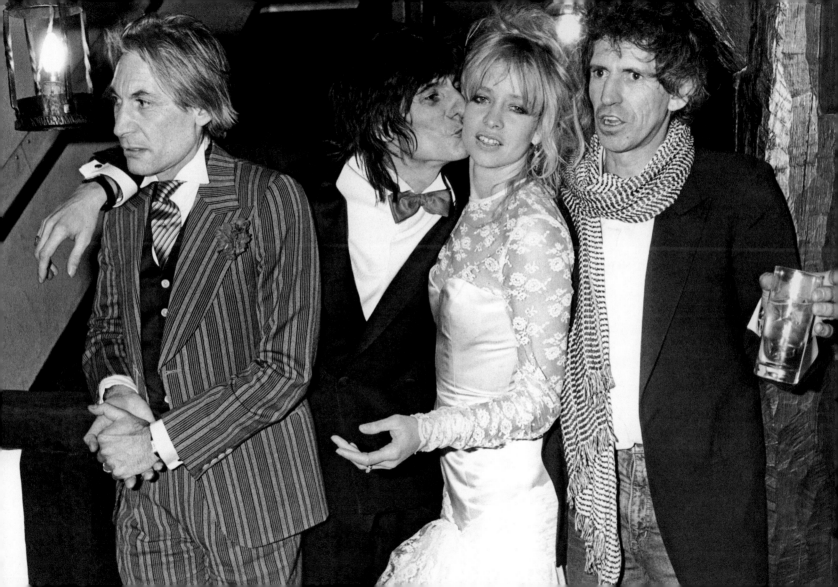

New Romantics

A promotional shot for the Rolling Stones' 1985 album, *Dirty Work*. After the hiatus of the previous two years due to tensions within the group, the Stones decided to start 1985 off on a positive note. Although the band members had been busy pursuing solo projects, the public's overwhelming interest in the Stones and the chance to make music together again would motivate them to set old dissensions aside.

Sessions for *Dirty Work* initially took place in Paris under the auspices of producer of the moment, Steve Lillywhite, who was renowned for his work with the likes of U2.

Mick: "It's very nice to be back with the familiar faces, back to all the jokes you have, and the grooves and tunes you can say, 'Let's do that one!' There's a certain tension at the beginning of any recording session, even if it's the Stones. How's it going to work out? Until you get something under your belt you're a little nervous."

317

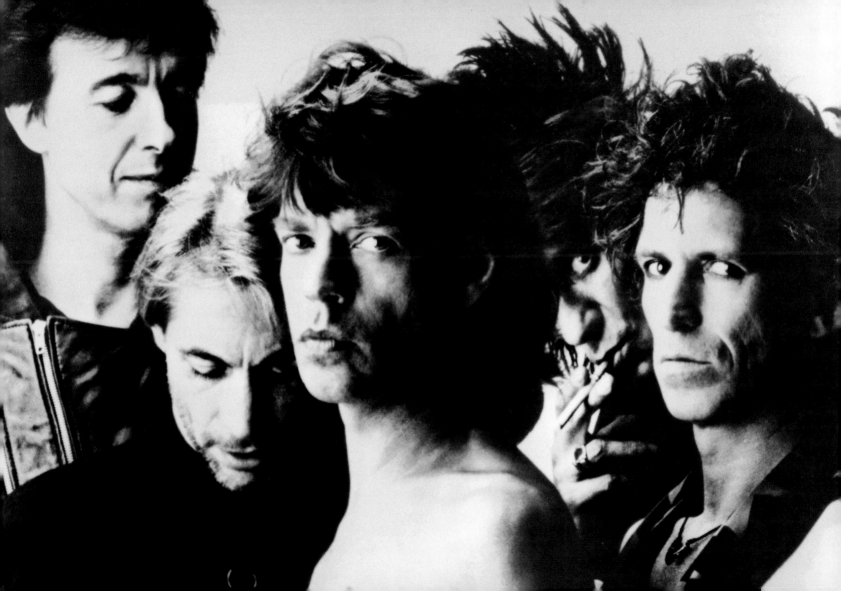

Looking to the Future

Mick caught in a reflective mood during the summer of 1985. The 1980s were a major transitional time for rock music, particularly for those bands that had survived the '60s. With new groups such as U2, Simple Minds, and INXS turning to the Stones for inspiration, Mick was left to ponder the future direction of the band.

Mick: "I went to see this band, INXS, from Australia. They were an OK band, very much like a version of the Rolling Stones, but not as good. The singer is good and he looks great, but he doesn't really move. He can't be expending much energy. He can't really be tired when he comes offstage. And he's, like, twenty-three. He must be able to sit there and be recovered in three minutes. But who cares, really?"

A Parent's Pride

While Mick keeps his eyes fixed on his wife, Jerry looks every bit the proud mum at the christening of son James. The couple's second child, and Mick's first son, was brought into the world in New York City at Lenox Hill Hospital on August 28, 1985. Although Mick had had a few squeamish moments in the delivery room while Jerry was in the throes of a twelve-hour labor, welcoming a son into the Jagger dynasty sent him into raptures of delight.

Mick: "I love my daughters, but there's nothing like having a first son."

Proud Grandparents

A rare glimpse of Eva and Joe Jagger as they arrive for the christening of new grandson James. While Mick's parents had always kept a respectable distance from their son's exploits, they obviously relished the opportunity to celebrate their newborn grandson.

320

A Pair of Nannies

Courtesy of their nannies, Mick's daughter, Elizabeth (left), and baby son, James, make their way into the family home in Kensington, London, in 1985. The demands of the twin worlds of rock and fashion left little time to attend to all the niggling details of child rearing. Consequently, Mick and Jerry employed two full-time nannies to attend to the tots' every need.

Jerry Hall: "My mother said it was simple to keep a man: you must be a maid in the living room, a cook in the kitchen, and a whore in the bedroom. I said I'd hire the other two and take care of the bedroom bit."

321

Jazzing It Up

Mick and Keith turn up to lend some support to Charlie at the London jazz club Ronnie Scott's on November 19, 1985. During the two-year break in the Stones' touring and recording schedule, Charlie found time to indulge his passion for jazz, with a residency at Ronnie Scott's in Soho. The rest of the band members had undertaken their own solo ventures with varying degrees of success, but Charlie had happily stepped outside the parameters of rock into the less glamorous field of jazz. The weeklong residency saw Charlie playing with the 29-piece Charlie Watts Orchestra.

Charlie: "Jazz is a beautiful circle. It's going around lots of times banging away. I love the sound of Clifford Brown. I just love the sound of Ornette Coleman, Sonny Rollins, Coleman Hawkins. I just love the sound of those people."

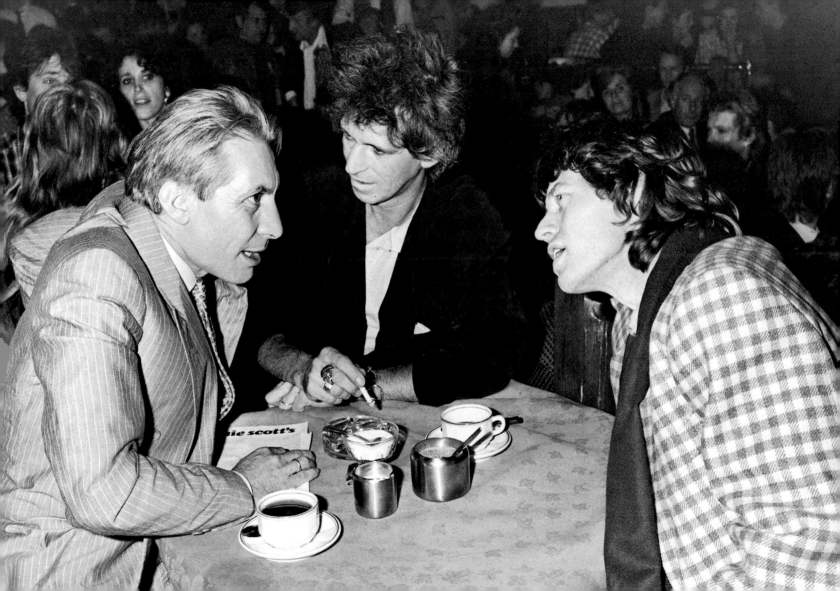

Just Another Night

Mick at yet another party, another nightclub, in 1985. Even at 42, Mick couldn't escape the media's constant scrutiny. If anything, more speculation than ever was brought to bear on Mick's aberrant behavior, which seemed so at odds with middle age and its presumed conventions.

Jay McInerney (*Esquire*): "Jagger shifts in his chair and tugs at his ears, his nose, and his crotch. He is a study in raving body language, exercising either a genuine sensuality or the licence of a star to scratch himself whenever or wherever he itches. Or both."

323

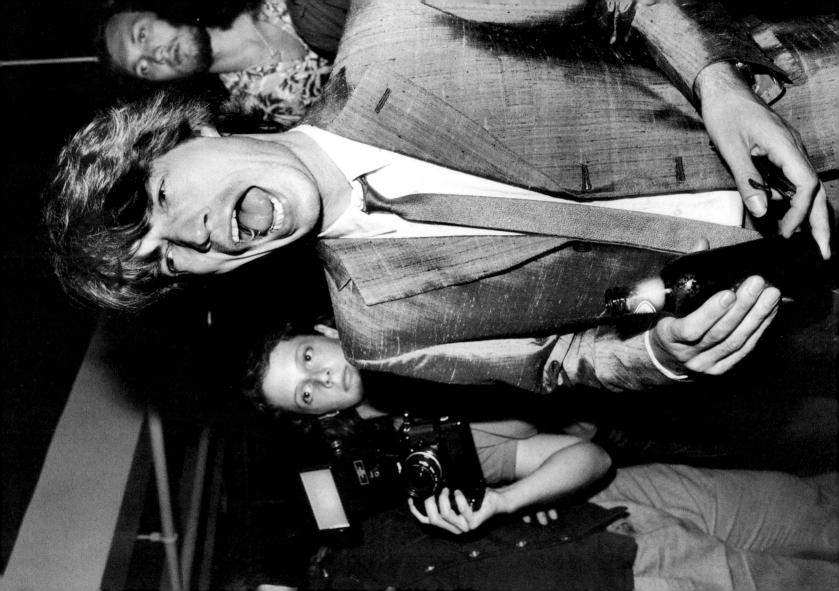

In Memory of a Friend

Mick and Keith play in tribute to Ian Stewart at London's 100 Club on February 23, 1986. If ever there was a long-standing stalwart of the Rolling Stones, it was Ian Stewart. A founding member of the band, he had been ousted at the behest of Andrew Loog Oldham for not looking the part of a Stone. "Stu," as he was known, nonetheless bit the bullet, stayed with the group behind the scenes, and went on to supply solid support in so many ways—be it lugging gear, acting as security backstage, or playing keyboards at a recording session or onstage.

Stewart died of a massive heart attack at the early age of 47, in December 1985. All five Stones were present at his funeral in Leatherhead, Surrey, to pay homage. Mick, who was normally somewhat stoic not given to displays of emotion, openly wept as Stewart's coffin was lowered into the ground; with Stu's death, the Stones lost their most loyal supporter and confidant.

Keith: "Why'd you have to leave us like that, you sod! At least he went out on an upswing. He was excited about the new album and was delighted about the Charlie Watts big band… No one has a bad word to say about him. You know, I've had other friends pass on, and you'd go, 'Gee, it's a shame.' But Stu was different. I could think of a hundred other fuckers who should have gone instead of him."

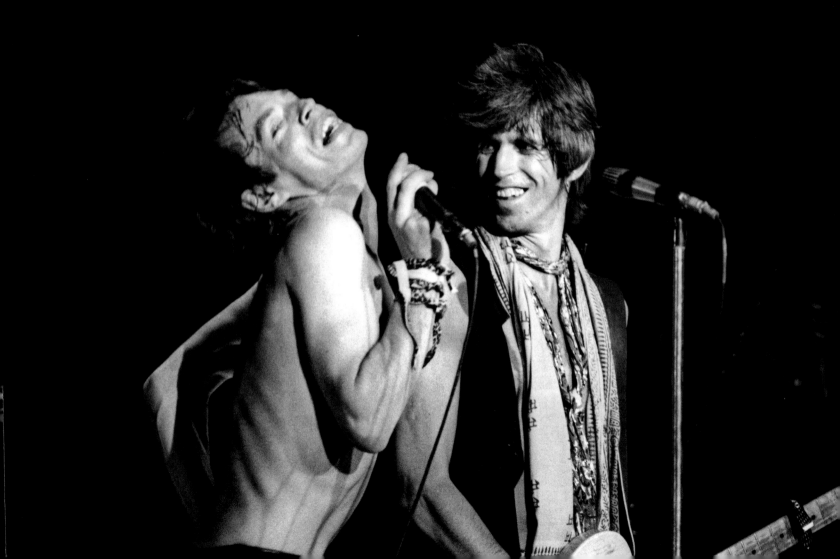

A Pocket of Stones

Four Stones make their way out of the dark recesses of Oxford Street's 100 Club, following their tribute for loyal aide Stu on February 23, 1986. The evening was graced by the extended family of the Stones and their supporters, as well as the presence of fellow travellers Pete Townshend, Jeff Beck, and Eric Clapton, all there to pay tribute to a much loved man.

Bill: "It made a nice jam. We hadn't played together for four years. We like to do small gigs once in a while for nostalgia. Playing at the 100 Club for Stu was like playing our first-ever gig."

325

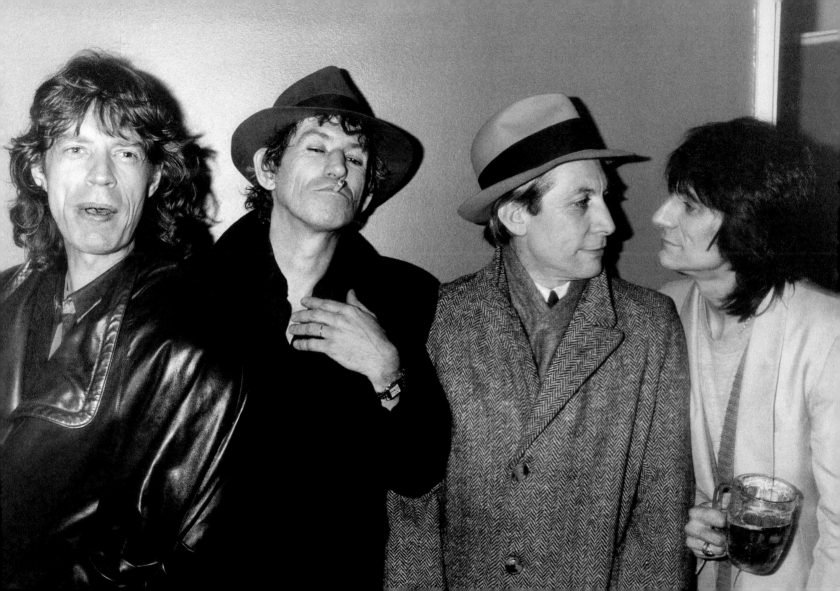

Grammy

Charlie, wife Shirley, and daughter Seraphina prepare to take the lift up to Kensington's Roof Gardens on February 27, 1986. The swanky nightclub played host to the Grammy Lifetime Achievement Award ceremony, where the Rolling Stones were honored that evening—repudiating rumormongers' allegations of an impending split. So that American audiences could watch the ceremony live on television, the Stones waited until 3:00 a.m. to receive the award, which was presented by Eric Clapton.

Raise a Glass

Mick and Eric Clapton at a party for Bob Geldof on June 10, 1986. In 1985, the culture of rock music had witnessed a significant change. Events such as Live Aid brought an altruistic component to the otherwise self-centered genre. Although Mick had been heavily criticized in certain circles for his admiration of conservative prime minister Margaret Thatcher, he was quick to sign up for Live Aid, regardless of the fact that the Stones as a collective had turned the fund-raiser down.

Bob Geldof's monumental and momentous efforts to relieve famine in Ethiopia had been fully embraced by rock's aristocracy, and the concerts in London and Philadelphia raised millions of pounds, pledged through the various telethons that ran alongside the events. In honor of his enterprise, Geldof was awarded an honorary Knighthood of the British Empire (or KBE). After receiving his medal from the queen at Buckingham Palace, Geldof threw a bash for his rock-star pals at the nearby Hard Rock Cafe in London's Piccadilly. The star-studded guest list included the likes of Phil Collins, Simon Le Bon, Sting, and of course, Mick, who with Eric Clapton, were happy to raise a glass to their friend Sir Bob.

327

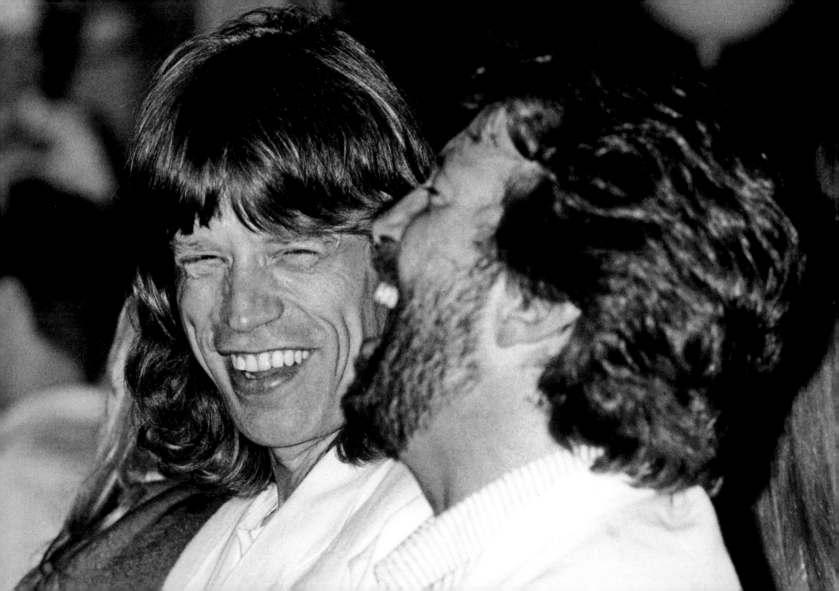

Rock-and-Roll Superstars

Taking the stage on June 23, 1986 (from left to right): Paul McCartney, Mick, Mark Knopfler, David Bowie, Mark King (of Level 42), and Bryan Adams. With the trend toward goodwill fostered by Live Aid still going strong, organizers coordinated the 1986 event at Wembley Arena to raise funds for the Prince's Trust, a charity established by the Prince of Wales. Mick and David Bowie staged a repeat performance of their Live Aid number "Dancing in the Streets." Paul McCartney made a live appearance—his second since John Lennon's death. In the VIP box, disco-mad Princess Diana jiggled her way through the concert with a bag of popcorn in one hand, and even Prince Charles defied royal protocol and took his jacket off to wobble along to a few numbers.

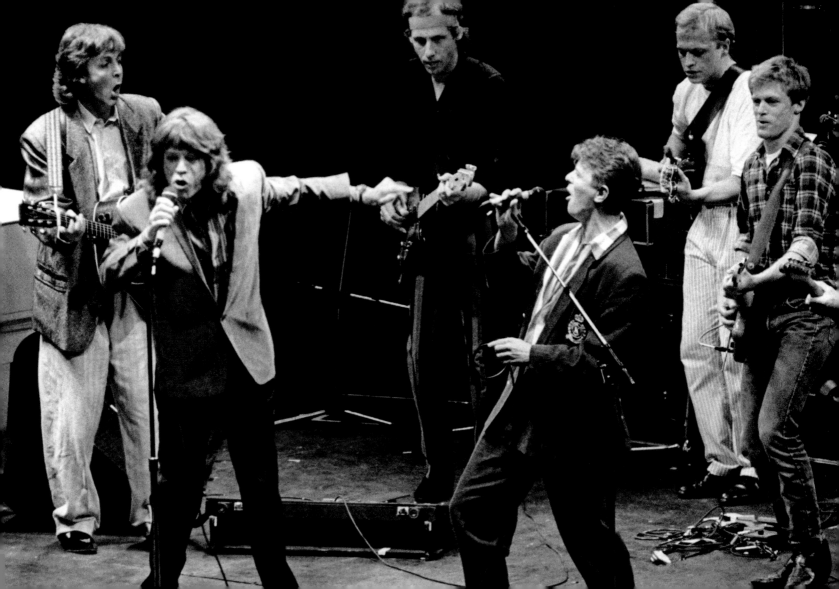

"Hail! Hail! Rock 'n' Roll"

Keith and Eric Clapton trade guitars during a tribute to Chuck Berry, summer 1987. The Stones' recent break from touring and recording had allowed Keith to pursue a few independent projects close to his heart. He had envisioned working on a film exploring the life and times of seminal blues artist Robert Johnson, but this idea never came to fruition, and in its stead arose *Hail! Hail! Rock 'n' Roll*, a film documenting the life of rock-and-roller Chuck Berry. Keith would act as musical director. As Berry neared his sixtieth birthday, a concert was organized in his honor, and the preparations and performances were to be part of the film. Eric Clapton, Robert Cray, Julian Lennon, Linda Ronstadt, and many other stars were slated for the show, and as musical director Keith would lead the arrangements.

Berry's influence on the Stones—and on Keith in particular—had been enormous. The innovative guitar strokes Berry was known for had a direct influence on Keith's own technique, and the band's early sound owed a huge debt to the legendary musician. Nevertheless, Keith found working with Berry challenging: there were even a few tense moments as Berry remonstrated with Keith regarding the arrangements for his classic songs. But ultimately, the resulting concert and film were memorable tributes to the man whose music had helped shape music history.

329

Big Night Out

Ron, wife Jo, and children Jamie, Jesse, Tyrone, and Leah enjoy the
limelight at London's 51/51 restaurant-cum-gallery on February 19, 1988.
Ron's reputation as a painter received a boost in 1987 when he consented
to an exhibition of his portraits of legendary musicians. He would diversify
on the music theme with a highly acclaimed series of paintings entitled
Endangered Species, which highlighted his interest in the conservation and
protection of wildlife. The work was well received by critics and fans alike,
and was exhibited around the world.

Meet the Family

Keith, Patti Hansen, and their two daughters, Theodora and Alexandra, take a stroll out to the Big Apple Circus in Damrosch Park, New York in November 1988. The enormous tented circus made its annual winter home at New York's Lincoln Center, and its focus on classical circus elements was evidently a hit with the Richards family. Despite his reputation as a wild man of rock, Keith adored family life and loved spending time with his wife and children.

Keith: "I'm a family man. I have little two-year-old and three-year-old girls that beat me up."

"But I like it!"

Mick and soul legend Tina Turner get down and party at the Rock and Roll Hall of Fame concert on January 18, 1989. The Rock and Roll Hall of Fame was the first institution to offer a permanent tribute to the rock genre, and naturally the Rolling Stones were among the first acts to be inducted. Rock musicians become eligible twenty-five years after their first record, and the award must be rubber-stamped by a broad sweep of 150 journalists, producers, record company executives, and musicians.

Prior commitments kept Charlie and Bill away, but Mick, Keith, and Ron attended the induction ceremony, and a jam session inevitably ensued. Ron stood in for Bill on bass, while Mick sang with Tina Turner on "Honky Tonk Women." In a blast from the past, former Stone Mick Taylor made an unscheduled appearance at the ceremony. The task of handing out the prestigious award was left to another 1960s enfant terrible: Pete Townshend of the Who.

Pete Townshend: "Guys, whatever you do, don't grow old gracefully. It wouldn't suit you."

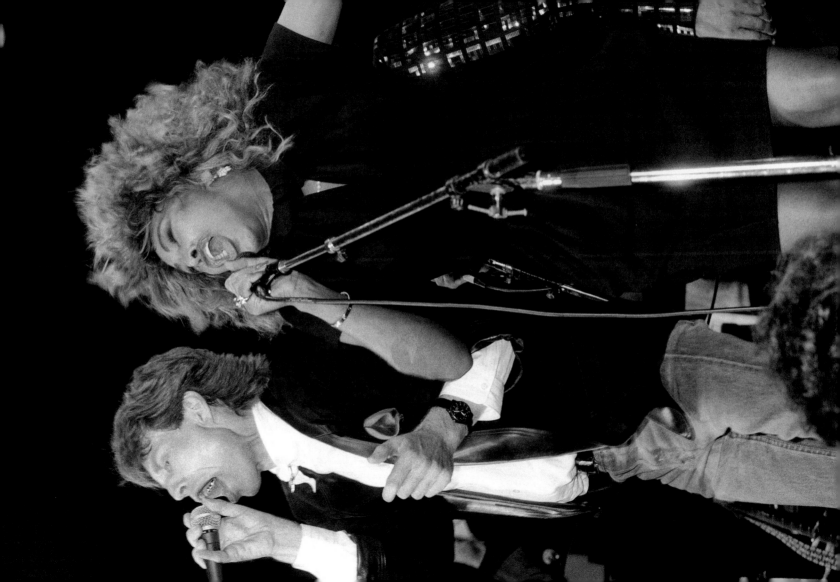

Wedding Bells

A photo from the wedding of Bill Wyman and Mandy Smith on June 5, 1989. When it was first alleged that Bill had secretly been romancing wild-child Mandy Smith since she was 13 years old, all proverbial hell let loose. Bill and Mandy had managed to keep their affair under wraps, but after Mandy had innocently blabbed about the relationship to a couple of undercover journalists in Spain, their cover was blown.

Naturally, the press leapt on the story with unbridled gusto, and with Bill under the microscope over his involvement with Mandy, the couple retreated into separate lives and as much anonymity as possible. Despite calls for charges to be levied against Wyman, the director of public prosecution decided against pursuing a case.

For the next few years, Wyman and his teenage girlfriend were under constant scrutiny, and although they were still seeing each other secretly, they were never together in public. Eventually, however, with Smith on the verge of a physical and nervous breakdown, the couple decided to marry.

Mandy Smith: "My mum said, 'He's a Rolling Stone. He's got a choice of any woman he wants in the world, and he's picked you.'"

333

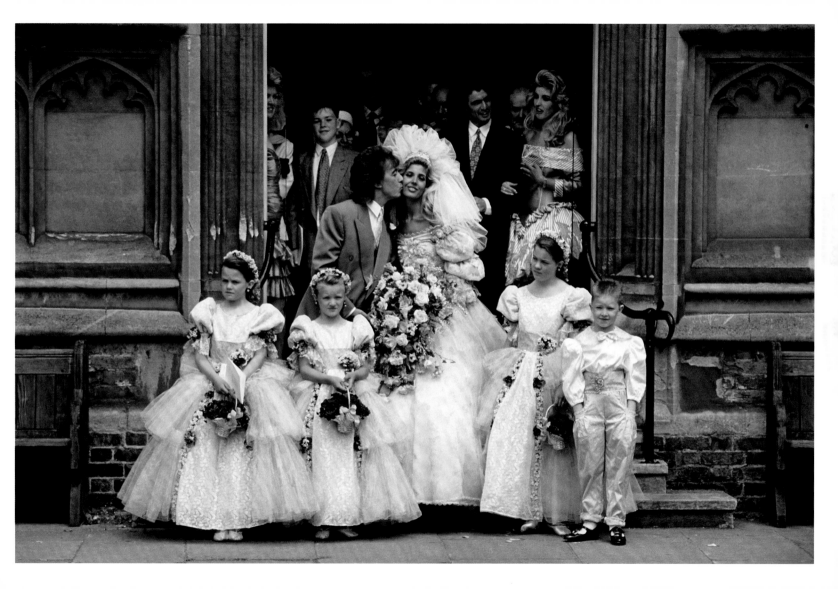

We Are Gathered Here Today

Mandy and Bill with the extended Stones family at their wedding reception in London's Mayfair on June 5, 1989. More than four hundred guests attended the lavish event at the Grosvenor House Hotel on Park Lane. All of the Stones and their respective partners attended the bash, as did numerous members of the rock community, including Elton John, Tina Turner, and Eric Clapton. Mick and Jerry presented the couple with a rare Picasso etching, valued at £200,000, while veteran comedian Spike Milligan gave Bill a walker with a tag attached to it that read: "To help Bill get through the honeymoon!"

334

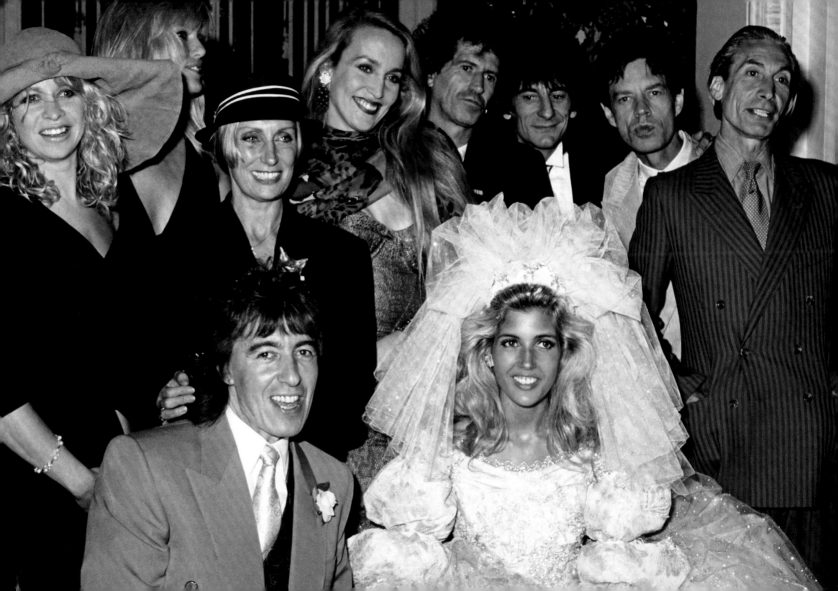

Oh, Happy Day!

A wedding portrait of a smitten Bill Wyman with new bride Mandy. No less than two days were devoted to the festivities celebrating the union of the couple. The ceremony was a quiet affair, held at a registry office close to Bill's country estate, on June 2. The formal blessing took place at the Church of St. John on June 5, followed by the sumptuous reception.

Mandy Wyman: "They called it the wedding of the year and certainly the paparazzi and the press were out in force, flashbulbs popping like a November-fifth fireworks display as we entered the hotel."

335

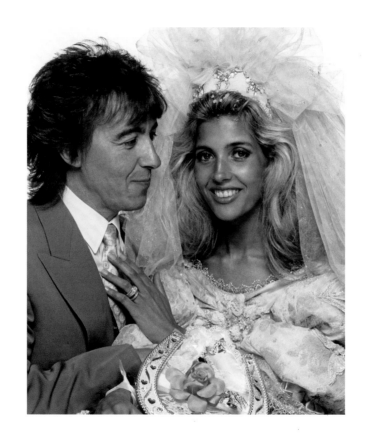

The Couples

Patti and Keith, Jerry and Mick, pose for Terry O'Neill, the official photographer at Bill and Mandy's wedding. Although privately there had been some mutterings as to the inappropriateness of the Wyman-Smith relationship, the Stones nevertheless turned up for the wedding and celebrated at the reception.

For Jerry, it was a poignant, if sad moment: she was surrounded by happily married Stones, but her man had as yet failed to deliver on nuptials. And she was quickly tiring of the interminable questions as to the potential for upcoming wedding bells.

Q: "When will you and Mick get married?"
Jerry Hall: "Golly, I'm trying! Y'all quit rubbing it in!"

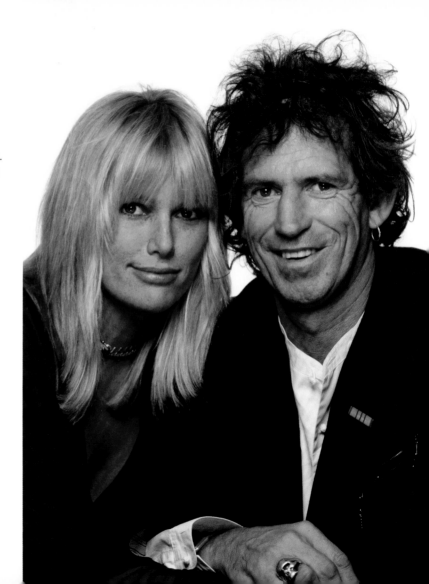

336

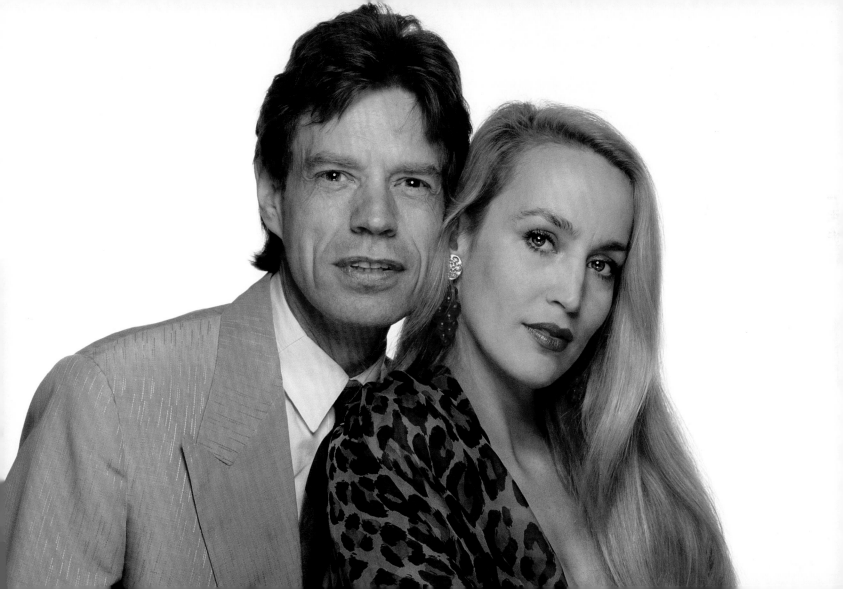

More Couples Portraits

Ron and Jo and Shirley, Charlie, and Seraphina Watts are all smiles at Bill's June 5 wedding celebration. Bill and Mandy's wedding was a family affair for the Wattses, and a rare public outing for 21-year-old Seraphina. Being the offspring of a Rolling Stone—even if it was the relatively steadfast Charlie—carried with it a lot of baggage. Things had been awkward for her at Millfield, an exclusive public school in Somerset, where she had been expelled for smoking cannabis. While this was not in itself an unusual offense for a teenager, because of her family name, it received a good deal of press. She later married and moved with her husband to idyllic Bermuda. Eventually the couple separated, however, and Seraphina returned home, declaring Bermuda to be "somewhat boring."

337

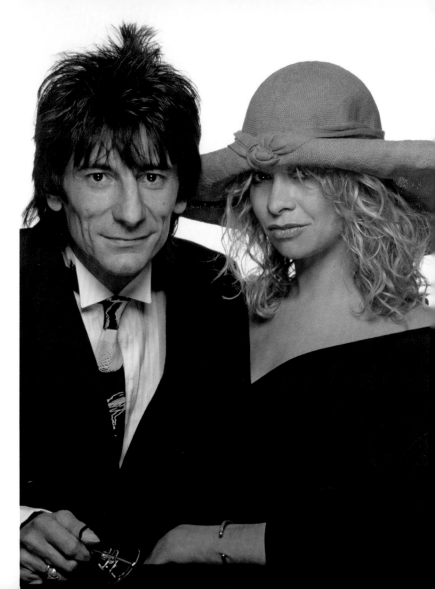

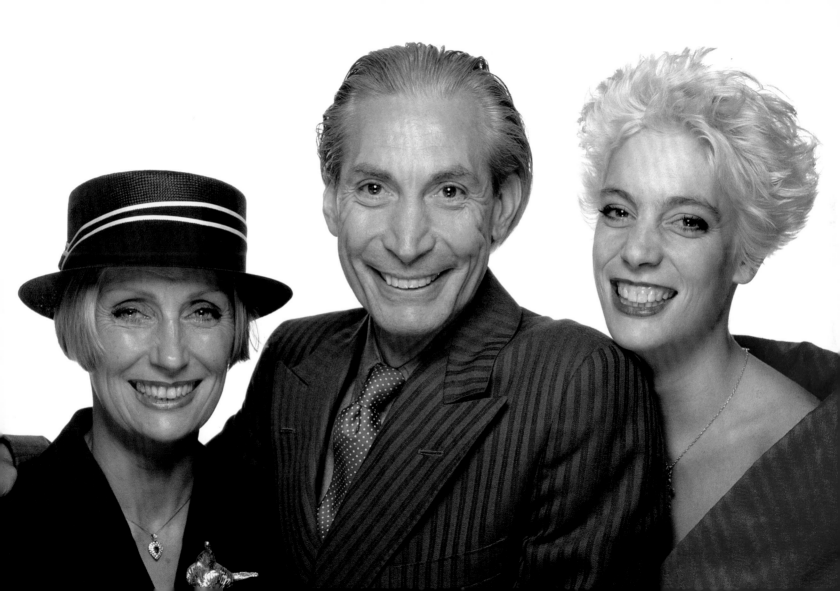

Urban Jungle Ecstasy

Taking a bow, the Stones complete a sell-out show on the *Urban Jungle* leg of their world tour. By the time the *Steel Wheels* tour reached Europe, it had been renamed *Urban Jungle*. And with Europe in the midst of an *Acid House* epidemic, audiences were filled with neophyte revelers, drawn by the Stones' legendary penchant for partying. In tribute to this new mood of excess, the Stones' set list mined such psychedelic classics as *Paint It Black* and *2000 Light Years from Home*. Fans around the world turned out in droves, easily selling out 100,000-seat stadiums, and once again proving that the Stones' advancing years had zero negative impact on their popularity.

338

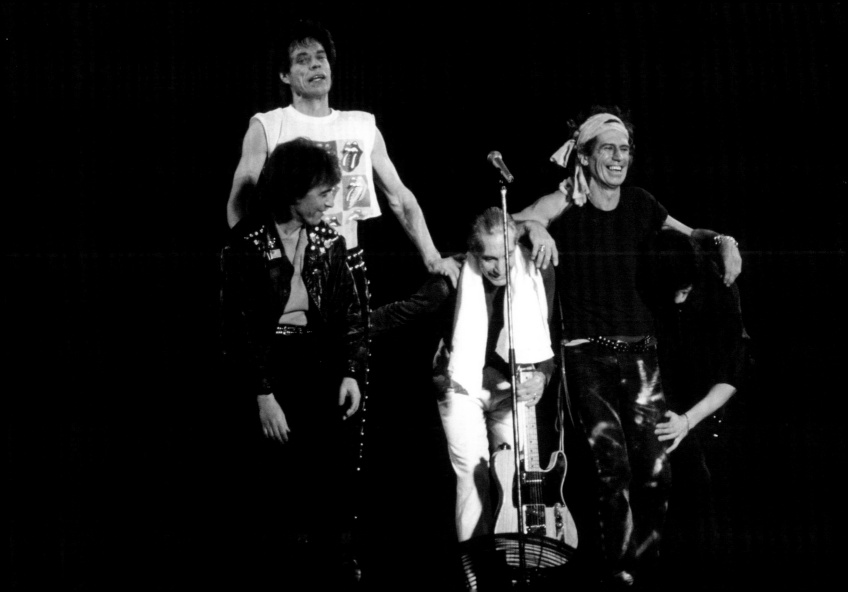

Last Time for Bill

The *Urban Jungle* tour arrives at London's Wembley Stadium on July 4, 1990. The massive size of the venues meant that the band could indulge in the most extravagant and outlandish sets ever employed on a rock tour.

This tour went on to roll around Europe before heading back to Wembley for the two final dates in late August 1990—the last times Bill Wyman would play with the band. However, it would be another two years before he would make his decision to quit the band public with a formal announcement.

Bill: "I didn't want to stay in the Stones and be stuck in a position having to play music I didn't like anymore and that restricted me from doing all the other things I'm interested in."

339

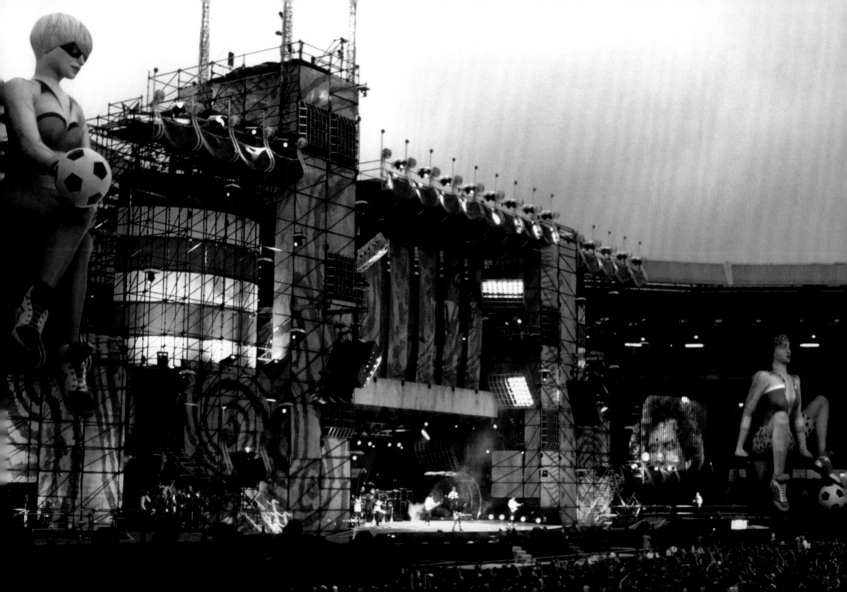

Under the Awnings

Mick and Keith share a smile at Wembley on July 4, 1990. The 1980s had been a difficult period in Mick and Keith's relationship, but a heated exchange in 1989 had served to clear the air, and within months the Glimmer Twins were writing together again. The new decade would see the pair involved again in one of the most fruitful collaborations in the history of rock and roll.

Mick: "Keith might just be sitting there playing something, just doodling, and you say, 'That's really good.' Collaboration has a lot to do with picking up on things. But just one piece—however great it is—is not enough for a song. Songs need three pieces. Sometimes they even need four pieces. And sometimes I feel like a broken record when I say to Keith, 'Yeah, that's great, but we need another piece and then we need another piece.'"

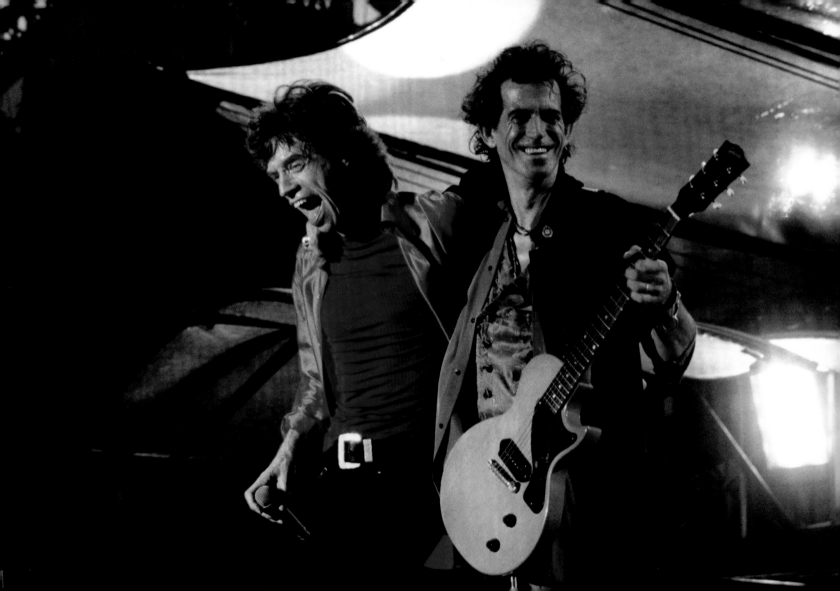

Under Cover of Night

Mick, patently the worse for wear, tries in vain to escape the flashbulbs after a night out in London in 1992. Mick's eventual marriage to Jerry Hall—in Bali on November 21, 1990—had hardly obstructed his roving eye. He had reportedly been out on numerous occasions with other women. Mick certainly notched up a few notable conquests during this period, but his most public liaison was with supermodel Carla Bruni. The Italian's devastating beauty overwhelmed Mick, and the publicity that followed their association would help launch her singing career.

Not surprisingly, the risqué reports of Mick's affair made their way back to an enraged Jerry, and from that point on, her marriage was fodder for the press. In 1992, one reporter intercepted a handwritten letter allegedly from Jerry to Mick. The highly personal contents were splashed across the tabloids, offering insight into the desperate state of the couple's union.

Jerry's letter to Mick: "I want you to have your freedom and I won't be mad if you fuck other girls. Oh my darling Mick, the thought of losing you breaks my heart in two. I'm truly sorry I was jealous. I tried to push you and was unsympathetic. I'll be good to you. I respect, admire, trust, need, and love you through my being."

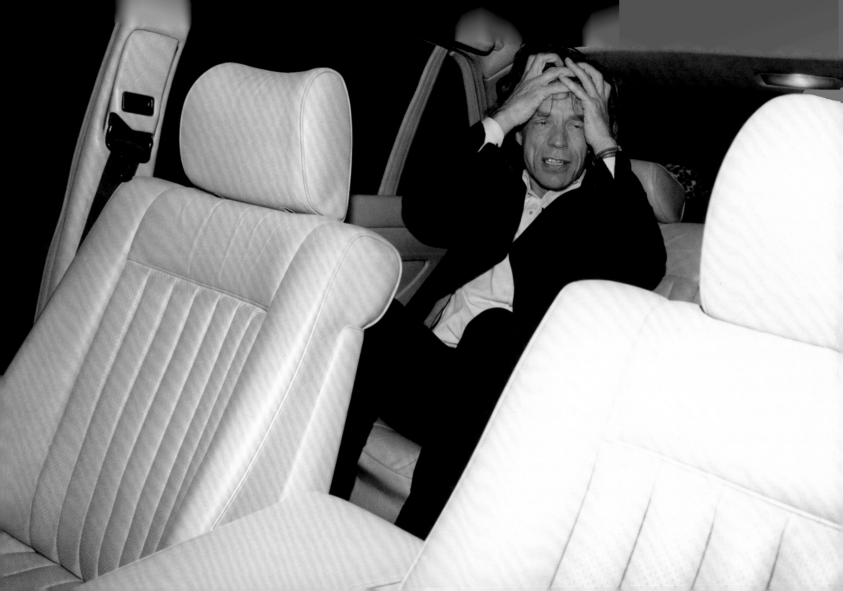

The Voodoo Lounge

A snapshot of the Stones' fantastic stage set prior to their concert at Rodriguez Stadium in Mexico City on January 14, 1995. Following the release of the *Steel Wheels* album to lukewarm reception and the departure of Bill from their ranks, the Stones had taken some time off to regroup and recharge their creative batteries.

Their next album, *Voodoo Lounge*, was not released until 1994. The Stones turned to Don Was to coproduce the album; Don had built a reputation based on his own work with Was (Not Was) and his production work for the B-52's and Bob Dylan. Darryl Jones took over Bill's role as bass guitarist for the album, which was recorded in Ireland and Los Angeles, and once sessions ended, intense rehearsals for the world tour (which opened in July 1994) began. Despite Bill's absence, the *Voodoo Lounge* tour ended up taking in over $320 million. It remains the highest grossing rock tour ever.

Checking Sound

Mick leads the soundcheck prior to a performance on the *Voodoo Lounge* tour at Rodriguez Stadium in Mexico City on January 15, 1995. Given the size of the arenas they were playing, perfect sound transmission was a number one priority for the group.

343

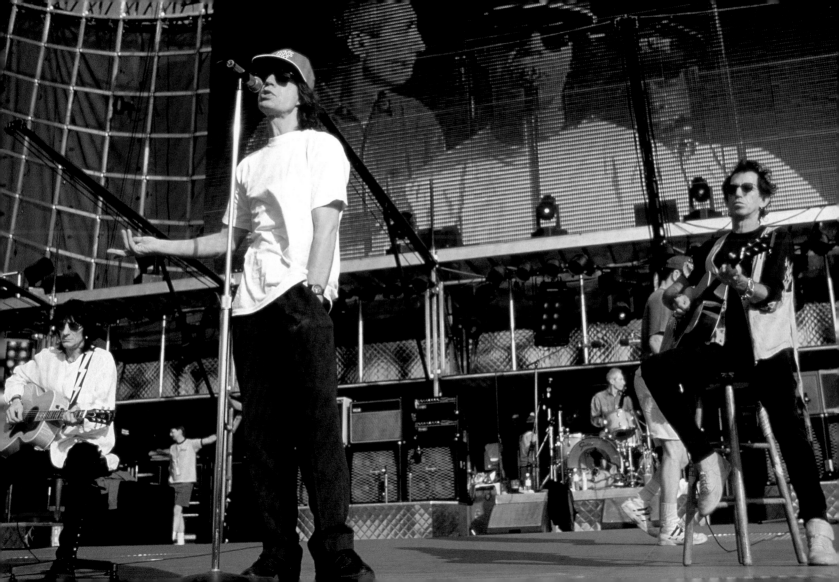

Voodoo Chile

Mick dances through the lights on the U.S. leg of the *Voodoo Lounge* tour, summer 1994. More than three hundred personnel were employed on the massive tour, ensuring a supersmooth run. Between the scores of roadies, every angle was covered—from the stage being swept prior to the Stones' arrival to the incredible set being put into and moved out of place. The unique mise-en-scène for this tour gave the impression of a futuristic city, with flashing lights and snatches of film projected on the gigantic screens behind the stage. But the highlight of the set was the appearance of a 95-foot steel snake, which towered over the Stones as they played.

Stephen Howard (*Voodoo Lounge* production manager): "The Rolling Stones are the original innovators and creators of the stadium rock spectacle. Their shows have always been massive, they've always been different in that you could always expect to see something that you have never seen before. They tend to do things that no one else has ever done. They don't copy people, others tend to copy them."

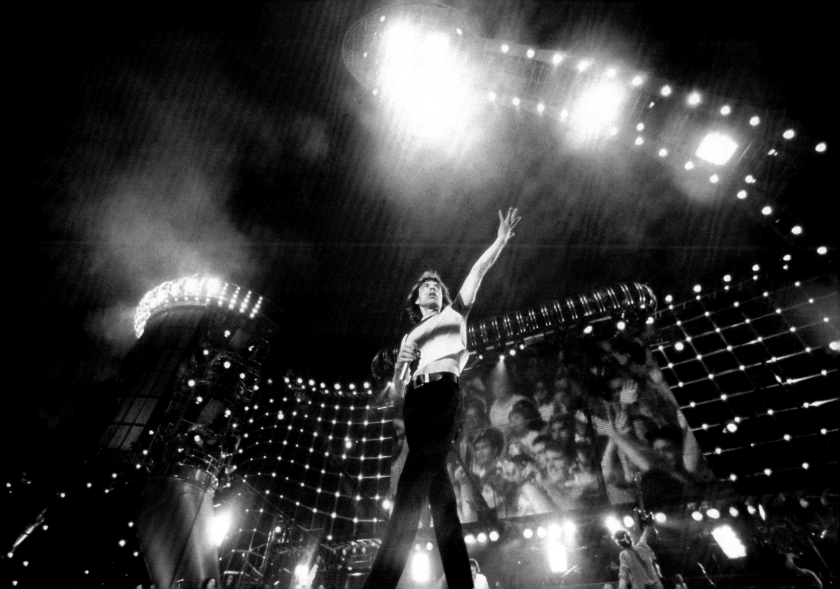

Classic Richards

Keith on the U.S. leg of the *Voodoo Lounge* tour during the summer of 1994. Mick chose to ward off the effects of his advancing age by hiring an Olympic trainer to put him through punishing exercise sessions. For Keith the gig itself was the workout, and he normally turned in a performance that would put rockers half his age to shame. But on the road, once a gig was over he'd retire to his hotel room—dubbed the "baboon cage" by the crew—and the dusk-till-dawn lifestyle would take over.

Keith: "Quite honestly, on the road it's pretty much the same as ever. After a show, we get back to the hotel, and within a half hour there's a knock on the door, people drop by for a drink, discuss the show, have a few more drinks, play more sounds, and before you know it, the sun's up."

345

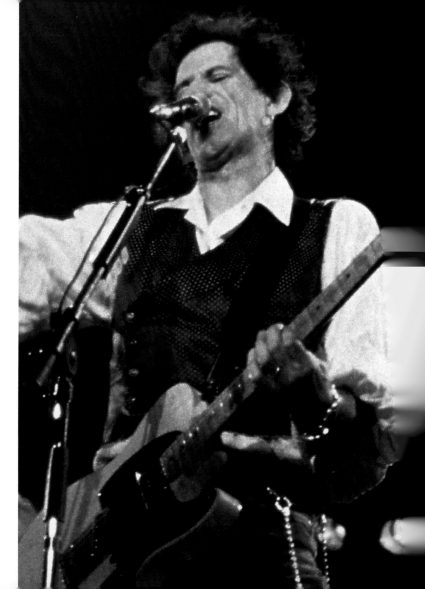

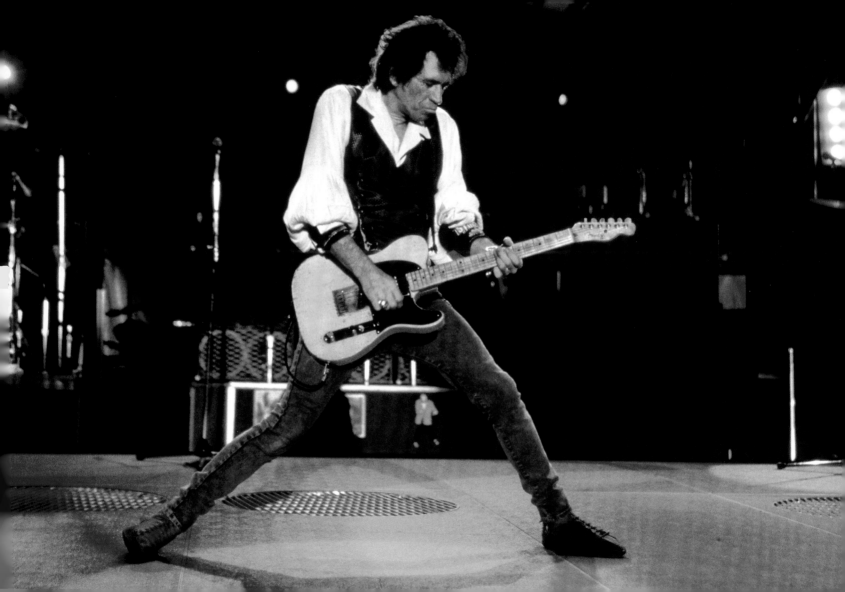

Stones Minus One

While Mick paces the stage, new recruit Darryl Jones (background) anchors the sound on the *Voodoo Lounge* world tour, 1994. The Stones' *Voodoo Lounge* world tour had one major component missing from its ranks: Bill Wyman. The veteran bass player had always maintained that he would leave the band in their thirtieth year, and true to his word, he made the formal announcement in 1992. Understandably, the loss of such an integral member led to some head scratching as to who could replace their enigmatic colleague. Darryl Jones, who had more than proved himself with Miles Davis, proved the best bet, and he provided ample bass lines both for the tour and on the album.

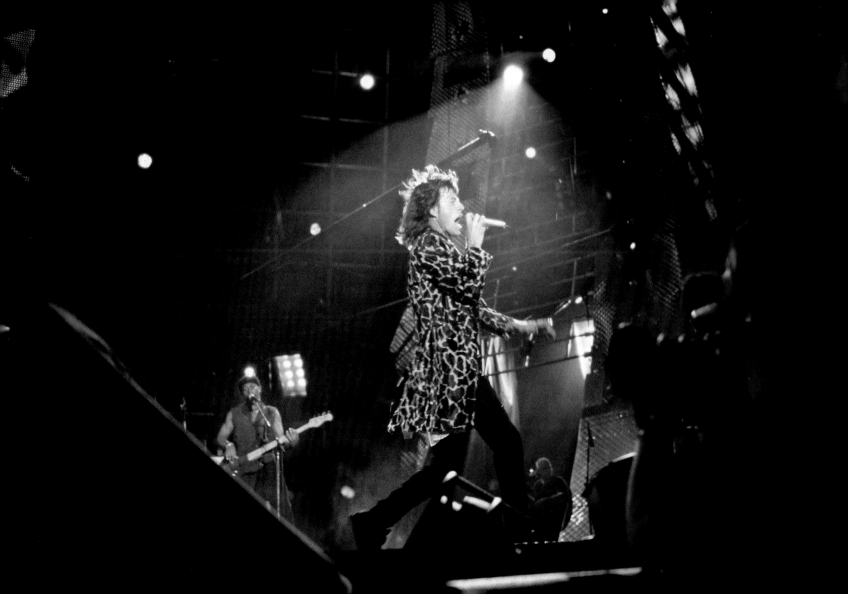

Honky Tonk

Mick rides the crest of American adulation on the *Voodoo Lounge* tour, summer 1994. The indoor-outdoor tour rolled around the world over a span of two years, leaving legions of fans and critics in awe of the magnitude of the special effects. A mass of pyrotechnics and video displays, the extravaganza left little to the imagination. During "Honky Tonk Women," a variety of sultry lasses paraded across the gigantic video screens in a montage of suggestive poses, and there were a few gasps when none other than the British queen appeared among them, cut into the sensual action — but rest assured, she was wearing a head scarf.

Charlie: "Something happens around us, and it happens when we play. It's either magic or catastrophe whichever way you look it at."

347

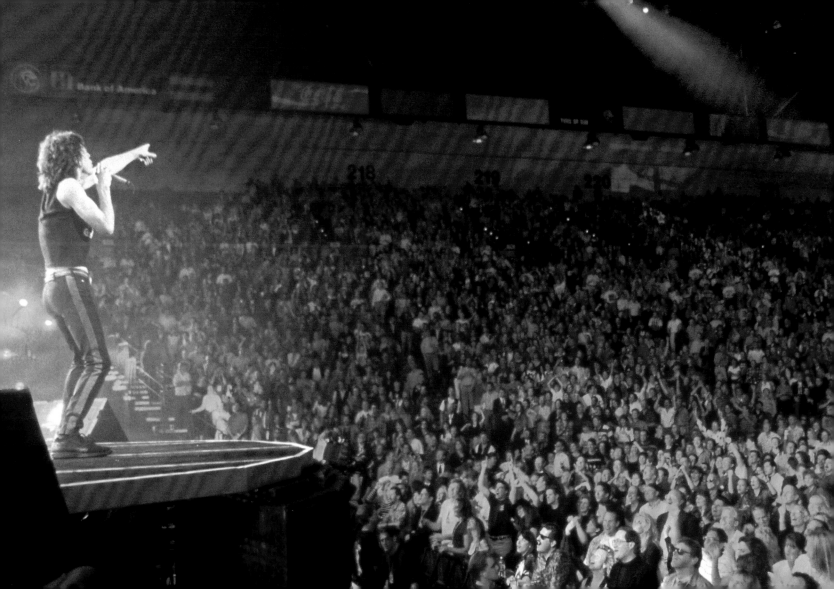

The Fab Four

Keith proffers his customary greeting as the Stones meet the press in Stockholm on the eve of the European leg of the *Voodoo Lounge* tour, June 2, 1995. Given the Stones' enduring and pervasive popularity, press conferences were an ideal opportunity to meet a region's countless media requests simultaneously. For the most part the Stockholm press conference was a typically repetitive affair, with the standard banal questions: "Is this your last tour?" But when a German journalist asked the band members their thoughts on Volkswagens, an uneasy silence fell; it was a sticky question considering that the car company was sponsoring the tour. After a few awkward moments, Mick asserted himself: "I drive a Mercedes myself."

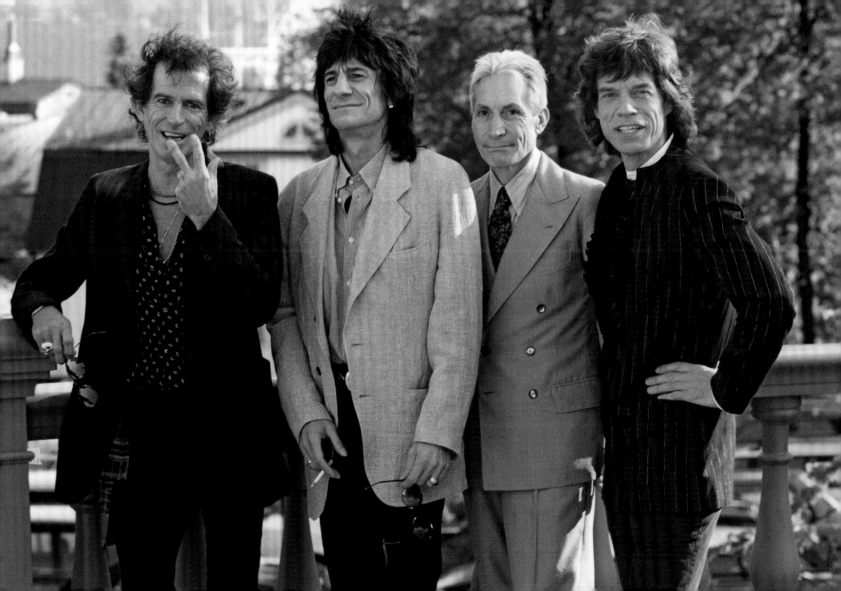

London Calling

View from the front as 70,000 ecstatic Stones' fans congregate at London's Wembley Stadium to welcome the group onstage on July 12, 1995.
Yet again, London was finding itself in the grip of Stones-mania. The group's arrival onstage to the strains of "Not Fade Away" sent a powerful message to the press, which had once again dug out the "Stones' Final Tour" headlines. Beyond the Stones' desire to prove the media wrong, the expectant, albeit partisan, crowd provided further impetus for the band to put on a great show, and they went all out for more than two hours.

Mick: "When you have an audience that has seen everything, like a London audience or a Paris audience, they tend to be much more blasé, so you have to work a lot harder."

349

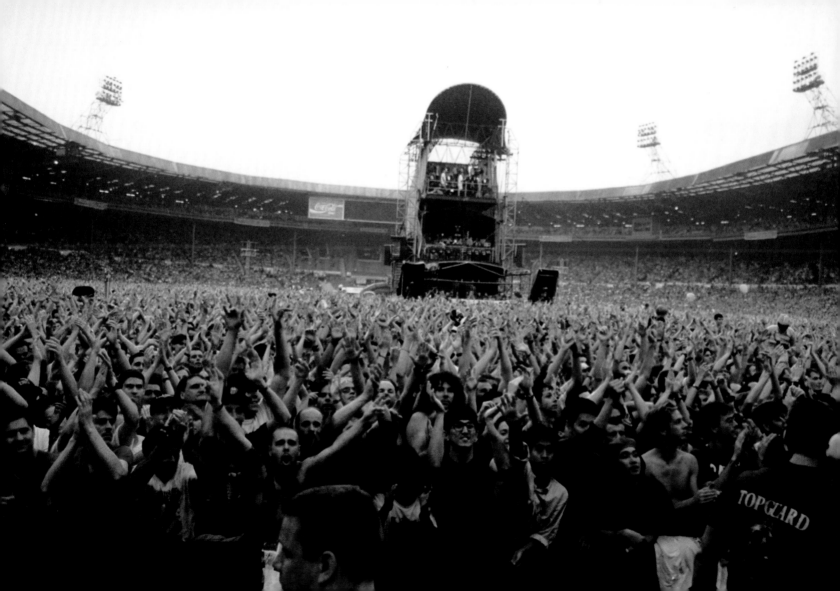

Raising the Spirits

Voodoo Lounge fervor takes over Wembley Stadium on July 12, 1995. In London, demand for tickets was at a peak, and there were no seats or standing room available. Given the immensity of the *Voodoo Lounge* arenas, Mick was concerned about the audiences' experience. Prior to a gig, he would often sit in the furthermost regions of the stadium to check that the sound was as good as it could be. More than anyone in the group, Mick was adamant that the Stones remain as current as possible, but he was equally mindful of the demands of the audience members, many of whom he knew came just to hear the old numbers.

Mick: "I'm trying to see it from the punters' point of view. I'm trying to get away from being a performer. I'm just trying to hear it, listen to the sound, and check out what it looks like."

350

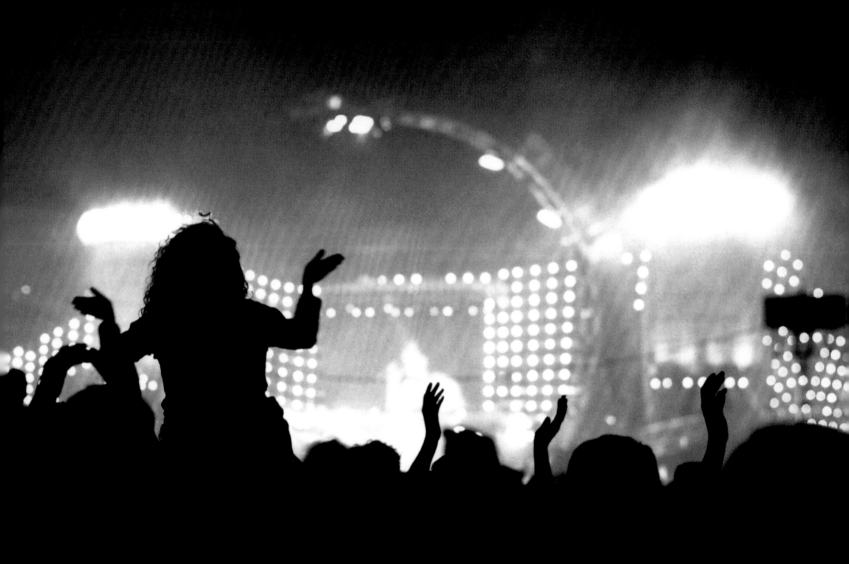

Bridges to Babylon

On the *Bridges to Babylon* tour, the evening of September 25, 1997, in Chicago, culminates in fireworks. Still buzzing from the *Voodoo Lounge* tour—their most successful tour ever—the Stones quickly recorded follow-up album *Bridges to Babylon* in April-May 1997 and recommenced touring. Working with Don Was had clearly been a recipe for success, and the band again turned to him for production on several tracks; Mick and Keith (credited as the Glimmer Twins) also assumed some of the responsibilities.

Don Was: "These guys are masters at what they do. It's really like, what Muddy Waters is to blues, these guys are to rock and roll. They are so good. I can go through man by man. Jagger, the way his vocals leap off the tape. That's something that's just so supernatural."

351

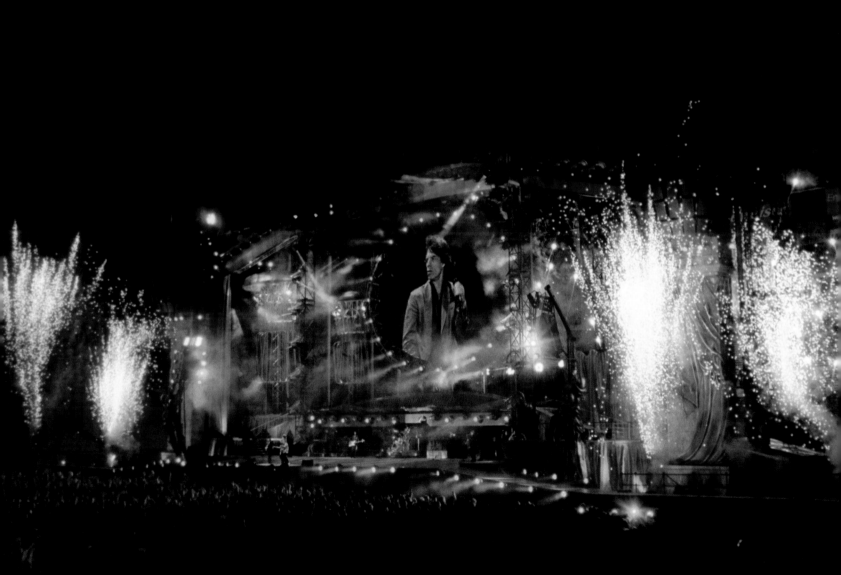

Still Going Strong

Rhythm twins Keith and Ron share a smile during the *Bridges to Babylon* tour. With recording and touring consuming much of their time in the nineties, the Stones gradually retreated from the solo projects they had begun in the '80s. Individually, none had come close to the level of success they had achieved collectively.

However, on *Bridges to Babylon*, Keith—for the first time—was afforded a trio of numbers. Belying his years and his physical appearance, he had maintained a loose alliance with yet another band, the X-pensive Winos, and between Stones' commitments he toured the States with them playing at smaller venues, to generally positive reception.

352

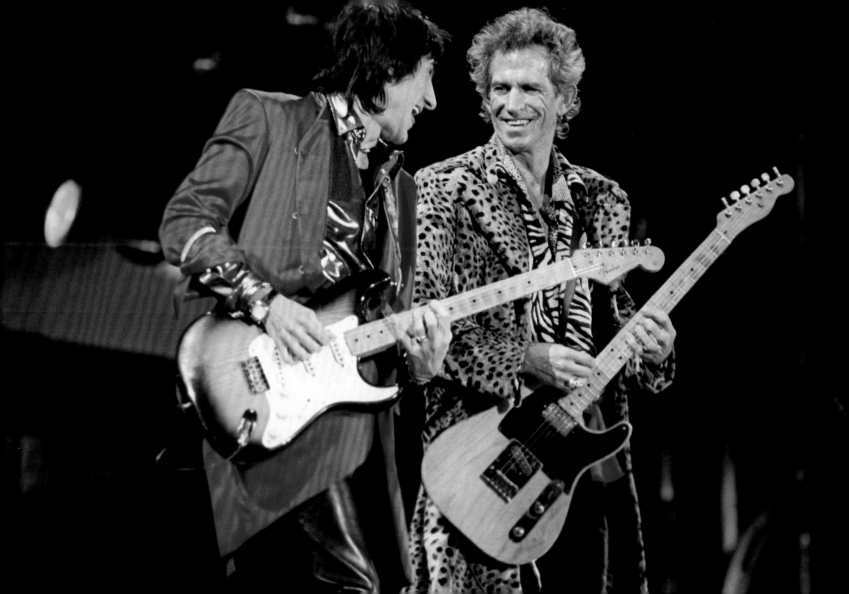

Fashion Victims

Mick, designer Vivienne Westwood, Jerry Hall, and Elizabeth Jagger at a tribute to Vivienne Westwood at London's Victoria and Albert Museum, November 17, 1998. Young Elizabeth Scarlett was well placed to follow in the footsteps of her famous mother. Inheriting Jerry's glamour, height, and overt celebrity, Elizabeth was snatched up at the age of 14 by designers looking to promote their fashion lines.

Vivienne Westwood was among the designers who wisely seized the chance to use the Jagger name in promoting her work. Canonized for her punk creations, Westwood had made her way to the very top of British design, and would later be awarded the title of dame for her services to the industry. When it came to models, Westwood always used the cream of the crop, and a Jagger strutting down the catwalk in her designs ensured considerable interest—not least from Elizabeth's adoring mother and father.

353

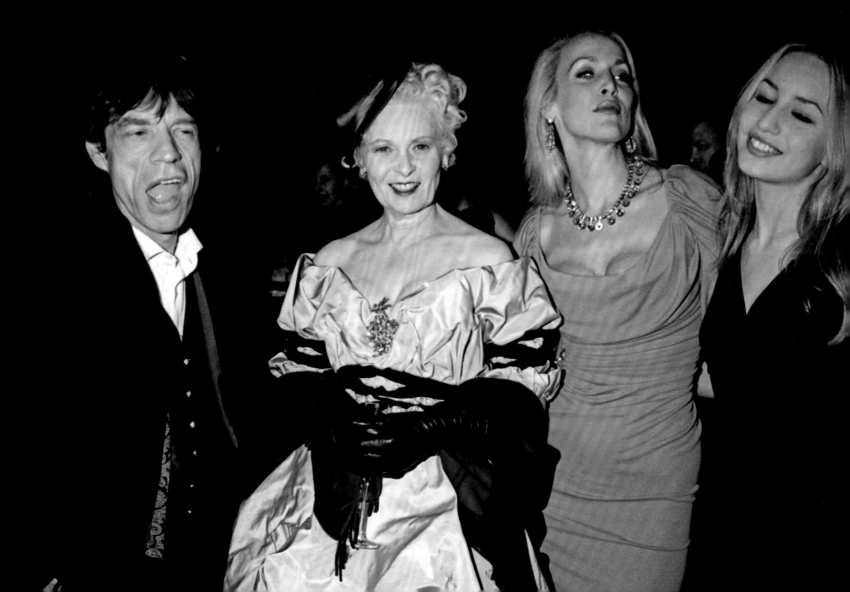

Jagger and Jagger

Proud father Mick with daughter Jade at the launch of her new jewelry line in 1999. Mick's relationship with Jade, his daughter with former wife Bianca, had had its ups and downs over the years, but despite the struggles, there was no doubt that Mick was determined for his daughter to succeed.

Following Mick and Bianca's acrimonious divorce in 1979, Jade had retreated with her mother to the United States. She attended primary school in New York before returning home to be educated in the English public school system—fulfilling the wishes of both her parents. Jade was duly indentured to the exclusive St. Mary's School in Wiltshire. In a classic act of teenage rebellion, she absconded from school to be with her wealthy boyfriend, Josh Astor. Reports suggested that Mick wasn't exactly impressed with her chosen beau, and he was dismayed when Jade was asked to leave the academy as a result of her behavior.

Following her dismissal, Jade flirted with art and fashion before securing a place with a top modeling agency, but her desire to embark on a serious art career ultimately took over and she headed off to Italy. While studying Renaissance art there with her partner, Piers Jackson, Jade found that her artwork garnered considerable interest, although some critics cited the family name, rather than any intrinsic talent, as being the crucial factor in her success. Jade went on to have two children, and managed to straddle the art and fashion worlds over the years. And on occasion she still found the energy to attend a celebrity bash or two.

Jade Jagger: "I'm not that much of a party girl, but when you're seen at parties, then that's the perception. I'm good at throwing a party, but I'm also good at getting up early and taking my kids to school."

354

Gathering No Moss

Kate Moss and Jade Jagger collide at Jade's launch party for her new jewelry line. Jade was more than an occasional presence on the London social scene during its renaissance in the mid-1990s. Proving to be something of a dilettante, she had redirected her fashion and art pursuits and diversified into jewelry. Her talents were quickly seized upon by Asprey and, later, the royal jeweler Garrard, where she was signed on as creative director.

The principal protagonist of the wild-child contingent, model Kate Moss was an occasional customer of Jade's creations, at one point even dishing out £10,000 for one of her rings. The pair would share a tempestuous relationship over the years, especially when Jade's then boyfriend Dan Macmillan, heir to the publishing empire, was reported to be sharing his favors with Moss.

Backstage Pass

Keith and Ron meet and greet Tom Cruise backstage in Las Vegas on the *No Security* tour, April 16, 1999. The enduring celebrity of the Stones ensured that Hollywood's A-list would be hankering to meet the group after their shows. Actor Tom Cruise, renowned for his anti-drug stance as a supporter of the Scientology movement, was nonetheless more than happy to embrace the seasoned roisterers after the concert.

356

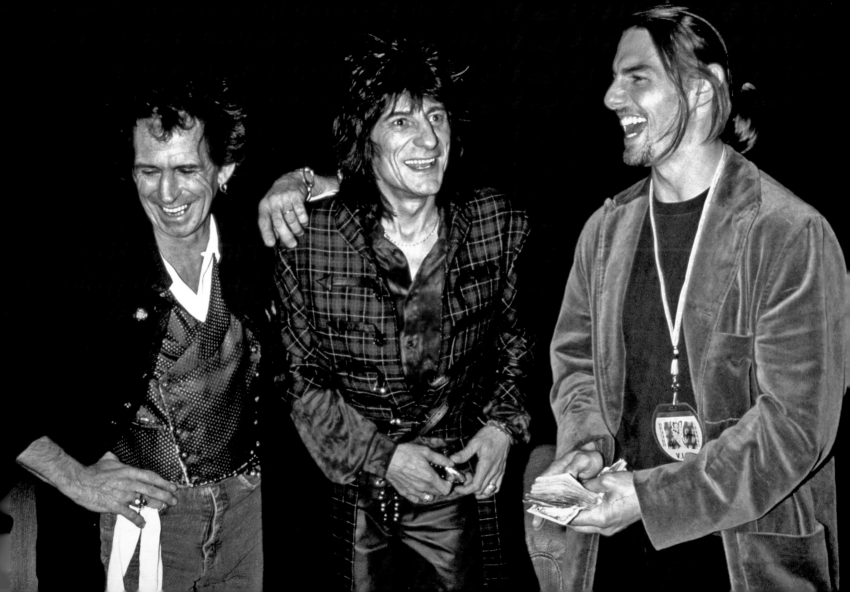

Bridging the Gap

Straddling his set list, Keith gets up close and personal at London's Shepherd's Bush Empire on June 8, 1999. Tickets for what was becoming the customary "club" date on the Stones' tour went on sale the morning of the show. Costing just £10 a piece, the 1,200 tickets were snapped up by fans who had queued up overnight in hopes of catching the most intimate show on the *Bridges to Babylon* tour.

The guest list for this event was bulging with London's A-list celebrities. Among the revelers were Steven Tyler (Aerosmith), Dave Stewart (Eurythmics), Jimmy Page, Elizabeth Hurley, Bob Geldof, and Anita Pallenberg. Also nestling in the guest balcony was the entire contingent of Stones family members, who bopped and jiggled all through the ninety-minute set. Mick was in top form, and his dedication was heavy on irony, and gutsy considering that Jerry Hall was in the audience.

Mick: "It's really great to be back in London doing this gig with all our friends. Friends we haven't seen for a long time, people we've only seen yesterday, people we've seen this morning, wives, ex-wives… and that's just Charlie!"

357

Mouthing Off

The *Bridges to Babylon* tour comes to Wembley Stadium on June 11, 1999. As people began to talk about the approach of the new millennium, the Stones entertained British audiences in a fin-de-siècle atmosphere. The two concerts at Wembley were met with the traditional outpouring of adoration from fans, but some journalists, faced with rewriting the familiar scenario yet again, were less appreciative.

The *Observer*: "The only person who really seemed to be enjoying the evening was Keith Richards. He has gone into a hideous new happy bunny mode, and kept clambering down into the audience and gabbling incoherent speeches on the theme of 'I love you all' and 'Whoo!,' as ingratiating as a puppy. Even Jagger, at one point, thanked us all for coming, and so he bloody well should after his whinge about paying taxes last year. But basically he seemed to be doing the show in much the same spirit as I imagine he does his workouts or his tax returns, as a necessary chore."

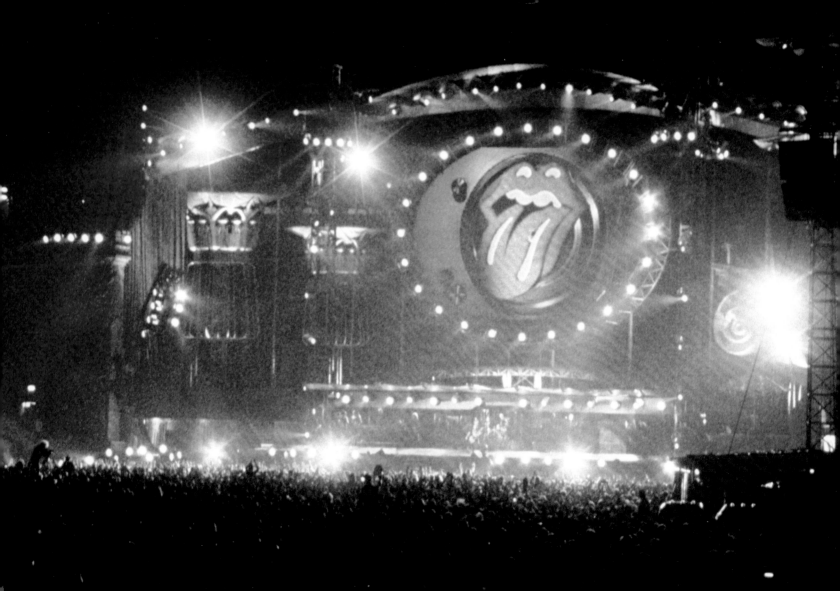

"You've come a long way."

Keith plays to the home crowd at Wembley on June 11, 1999. Approaching sixty though he was, Keith was evidently in no mood to put up his feet and apply for a bus pass. After nearly forty eventful years, Keith was welded to the Stones' lifestyle, and there seemed to be no indication, even in his heart of hearts, that the frequent touring had become a formality.

Keith: "It's still getting better... Every time we get back together there's this extra juice that makes people feel good about playing. That's the important thing: You can't take this gig on and think, 'I'm just going to grind it out,' because you'll grind yourself out. You've got to be looking forward to something, and morale right now is very good. Sometimes I wonder, 'Am I working for the audience, or am I working for myself?'"

359

Rolling Zeppelin

The Rolling Stones arrive at Van Cortlandt Park in the Bronx, New York, to launch the *Forty Licks* tour on May 7, 2002. The Stones traditionally employed some sort of attention-grabbing stunt to launch each new tour. Arguably, their trip down Fifth Avenue in New York on a flatbed truck in 1975 had been their most famous exploit, but some of the more recent promotional tricks were just as idiosyncratic. For the *Steel Wheels* tour in 1989 they'd arrived at Grand Central Station on a train; for the *Voodoo Lounge* jaunt in 1994 they'd launched proceedings from a yacht on the Hudson River; and for the *Bridges to Babylon* inauguration in 1997 they'd driven into Manhattan in a Cadillac, Mick at the wheel. But none of the prior stunts could rival the formal announcement of the *Forty Licks* tour when the Rolling Stones dropped in on New York from a gigantic yellow blimp emblazoned with their enduring logo—just in time for a press conference.

Mick: "Either we stay at home and become pillars of the community or we go out and tour. We couldn't really find any communities that still needed pillars."

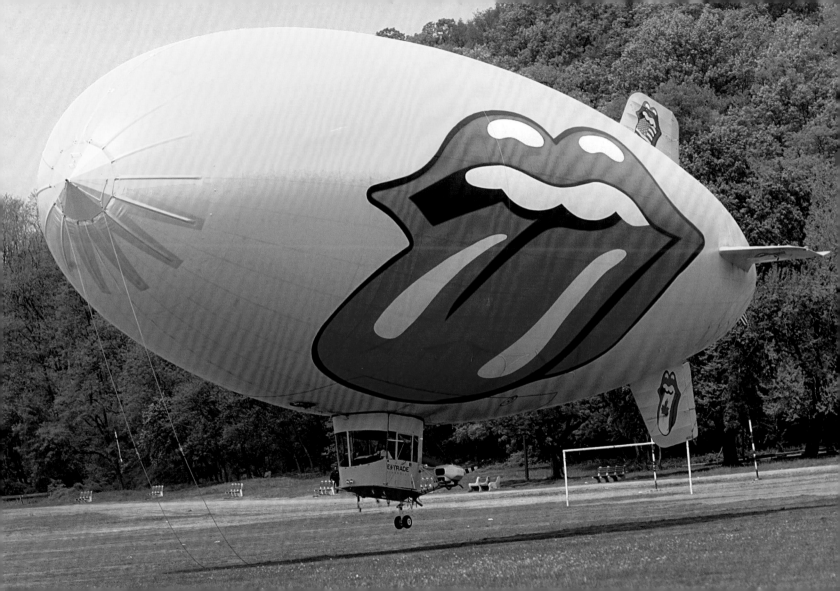

Wembley Fever

The Rolling Stones get back to basics at London's Wembley Arena on
September 15, 2003. After the histrionics of the *Bridges to Babylon* tour,
the band elected to scale things back for the *Forty Licks* tour. Wembley's
ten-thousand-seat arena could hardly be called intimate, but in comparison
with the enormous stadiums the Stones had been playing, it was relatively
modest. The former Olympic swimming pool, where the Stones had played
many times since their first *New Musical Express* poll-winner concerts in the
sixties, was one among a host of smaller-sized arenas booked for the tour.

For the first time in years, the band employed the sublime skills
of saxophonist Bobby Keyes. They followed a set list that included many
numbers they'd never played live before, and they carried the two-hour set
with consummate ease. The shows were a tremendous success—showing
that the Stones could easily upstage their imitators and defy their critics.
With a combined age of well over two hundred years, the Rolling Stones
displayed boundless energy and continued to be a revelation.

361

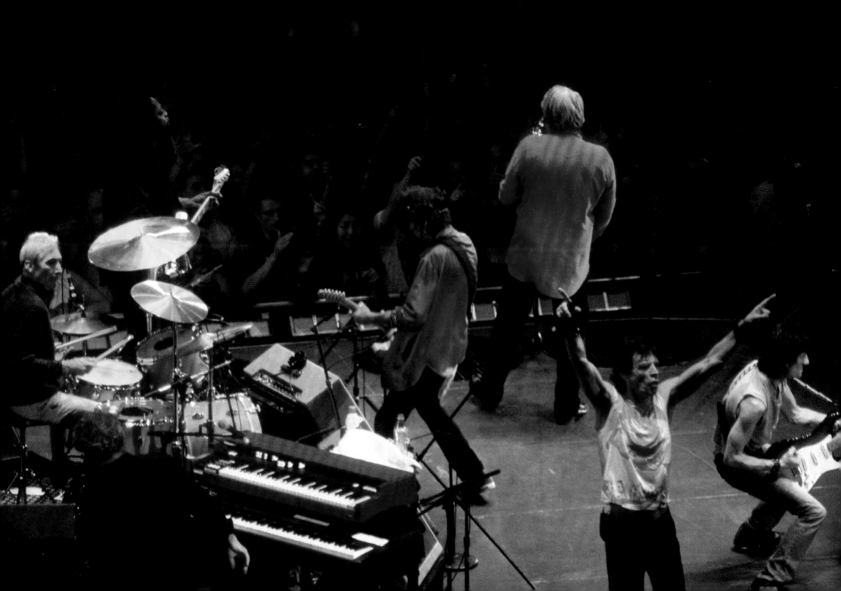

Sir Mick Jagger

The Jaggers come together at Buckingham Palace for Mick's investiture into knighthood on December 12, 2003. From left to right are Mick's 92-year-old father, Joe Jagger; Mick; daughter Karis Jagger; and daughter Elizabeth Jagger.

Rock and roll was still relatively new in the eyes of Britain's royal family, and it had taken some time to reach the status of a bone fide art form worthy of royal acknowledgment. Paul McCartney and Elton John had recently been knighted, and in 2002 the announcement came that none other than the original "wild man of rock" would join the esteemed list. It took a full 18 months for Mick to find time in his schedule to officially receive the award.

The queen had been incapacitated with a minor knee operation, so Prince Charles undertook the actual knighting. While that put something of a damper on the celebration, the prince was perhaps better placed to bestow the honor upon Mick, as the queen's dislike for rock music was well known.

Outside, as a gentle drizzle fell, Mick happily posed with members of his family for the assembled media. A few of the slier photographers, however, couldn't help but focus in on the shoes Mick had selected for the formal affair: a pair of Adidas sneakers. Fellow Stone Keith was less impressed than most with Mick's new award and title.

Keith: "I don't want to step out onstage with someone wearing a fucking coronet and sporting the old ermine.... I thought it was ludicrous to take one of those gongs from the establishment when they did their very best to throw us in jail."

Time-Out for Age 45 and Over

The Stones provide the half-time entertainment at the fortieth Super Bowl at Detroit's Ford Field on February 5, 2006. The Super Bowl is not just any football game—it's broadcast to a worldwide audience, reaching an estimated one billion viewers. After the furor over Janet Jackson's bare breast in 2004, however, the Stones found themselves at the mercy of concerned broadcasters. The lyrics "You make a dead man come" in "Start Me Up" and "Am I just one of your cocks?" in "Rough Justice" were strongly objected to by broadcasters, who took it upon themselves to censor the lines, fading out Mick's microphone during the offending passages. The Stones retaliated through their spokesperson: "The censorship was absolutely ridiculous and completely unnecessary."

Further controversy arose over policies governing the distribution of tickets for the 15-minute show: the two thousand available spaces were limited to people under the age of 45. Condemnation over the alleged age discrimination was swift, but organizers were quick to point out that the ticket holders' regime required a considerable amount of youthful agility. The chosen few would have to endure five Super Bowl rehearsals, some lasting as long as seven hours, in addition to the show itself.

Help the Aged: "It's ironic that the organizers of a Rolling Stones' gig should be so blatantly ageist when the band themselves are all well over 45. The group has shown through its own long-standing success that age is absolutely no barrier to having a good time."

363

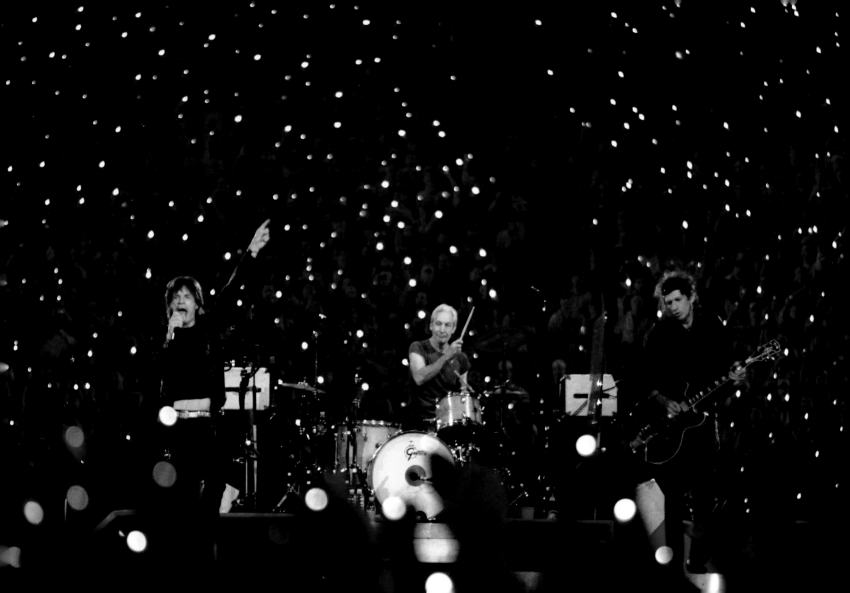

The Biggest Bang

Rio de Janeiro's Copacabana Beach prepares for the Stones' free outdoor concert on February 19, 2006. After forty-odd years together, the Stones proved in Rio that they could still upstage themselves, with their largest-ever gig to an estimated 1.3 million spectators.

Fans from all over the world had queued up for days to secure a place near the front of the stage. The authorities were taking no chances, and over ten-thousand uniformed personnel, including six hundred firefighters and scores of lifeguards, were deployed in case revelers got too carried away with the celebrations. Indeed, in an attempt to reverse Rio's image as a hot spot for crime, the city itself raised ten percent of the show's $5.4 million cost. While fans gathered up and down the two-mile-long beach on both land and water, the entire district reveled in the festive atmosphere, and parties popped up along the coastline wherever it afforded enthusiasts a vantage point of the Stones in action.

Flavio Tanure (Rio's secretary of health): "This is the biggest live show that has ever occurred in the world."

364

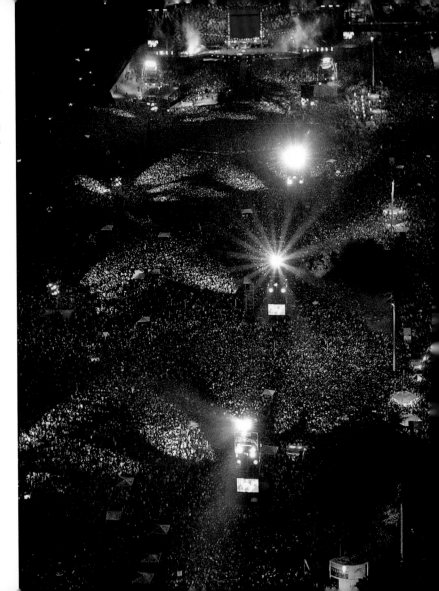

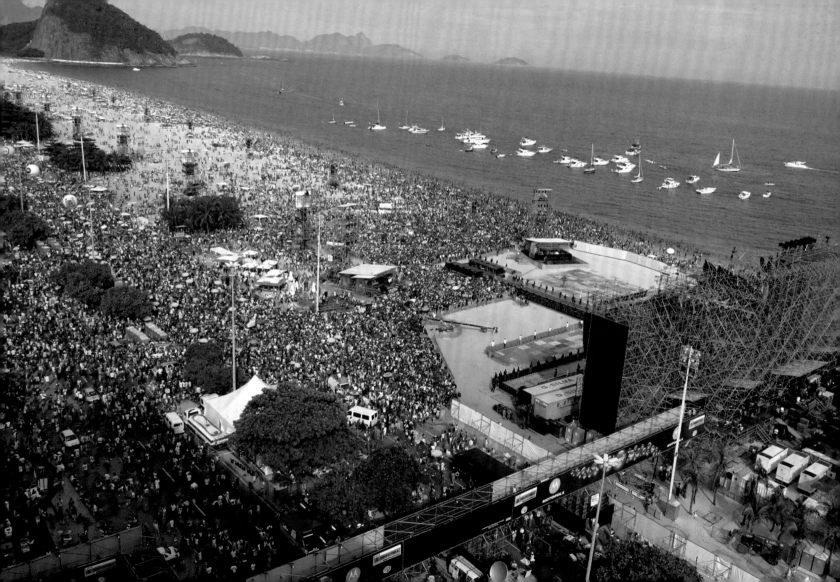

Shanghai Surprise

Ron, Mick, and Keith spread the gospel at Shanghai's Grand Stage Arena on April 8, 2006. In spite of an edict from China's Ministry of Culture forbidding five of the Stones' more suggestive numbers ("Brown Sugar," "Beast of Burden," "Let's Spend the Night Together," "Honky Tonk Women," and "Rough Justice") being played, the Stones' first appearance in China was a tumultuous success. Such was the demand, that the 8,000 tickets were reportedly changing hands for $600 prior to the concert.

In recent years, China's stranglehold on Western music has relaxed somewhat, and Whitney Houston, Elton John, and Deep Purple have all made appearances there. But the Stones' gig was the most radical and certainly the biggest rock act to perform in the country. Naturally, in the wake of this historic concert, the Stones once again dominated the news media.

The enduring appeal of the Stones continues to roll. In a career that has spanned more than forty years, they've been to hell and back so many times their critics have lost count. Defiance is the key element in the Stones endurance, and evidently their stamina is derived from that and their passion for playing live. Outside of rock and roll, they may well enjoy the good life, but always in the back of their minds is the next tour, the next album. And for that, they will keep on rolling until they drop.

Mick: "There is something to be said for working to keep yourself going. I'm not a workaholic, but when you are in this business you have to work hard. It's not a gentle plod."

365

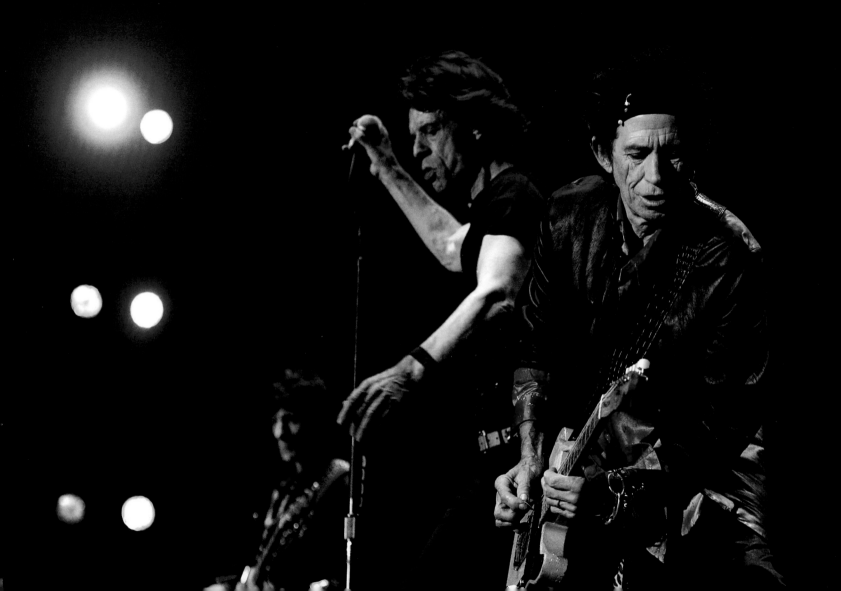

Bibliography

Books

Anderson, Christopher. *Jagger Unauthorised*. New York: Simon and Schuster, 1993.

Appleford, Steve. *The Rolling Stones: It's Only Rock 'n' Roll*. Carlton Books, 1997.

Bockris, Victor. *Keith Richards: The Biography*. London: Hutchinson, 1992.

Booth, Stanley. *The True Adventures of the Rolling Stones*. London: William Heinemann Ltd., 1985.

Catterall, Ali and Simon Wells. *Your Face Here: British Cult Movies Since the 1960's*. London: Fourth Estate, 2000.

Dalton, David. *The Rolling Stones: The First Twenty Years*. London: Thames and Hudson, 1981.

Dalton, David and M. Farren. *Rolling Stones: In Their Own Words*. London: Omnibus Press, 1980.

Faithfull, Marianne (with David Dalton). *Faithfull: An Autobiography*. London: Michael Joseph Ltd, 1994.

Goddard, Peter and Phillip Kamin. *The Rolling Stones Live*. London: Sidgwick and Jackson, 1982.

Hall, Jerry and Christopher Hemphill: *Tell Tales*. London: Elm Tree Books, 1985.

Hoffman, Dezo. *The Rolling Stones*. London: Vermilion, 1984.

Kamin, Phillip and James Karnbach. *The Rolling Stones: The Last Tour*. Sidgwick and Jackson, 1983.

Martin, Linda. *The Rolling Stones in Concert*. New York: Crescent Books, 1982.

Norman, Philip. *Symphony for the Devil*. London: Linden Press/Simon and Schuster,1984.

Rawlings, Terry. *Who Killed Christopher Robin?: The Life and Death of Brian Jones*. London: Boxtree, 1994.

Reed, Jeremy. *Brian Jones: The Last Decadent*. Los Angeles: Creation Books, 1999.

Sandford, Christopher. *Mick Jagger*. Victor Gollancz, 1993.

Schfold, Carey. *Jagger*. Methuen, 1983.

Scudoto, Anthony. *Mick Jagger: A Biography*. W. H. Allen, 1974.

Smith, Mandy (with Andy Coulson and Ingrid Miller). *It's all Over Now*. London: Blake Publishing, 1993.

Wyman, Bill (with Ray Coleman). *Stone Alone: The Story of a Rock and Roll Band*. New York: Viking, 1990.

Newspaper and Magazine Archives

Daily Mirror, Guardian, London Times, Melody Maker, Mojo, New Musical Express, Rolling Stone, Rolling Stones Monthly.

Web Sites

www.timeisonourside.com

www.toru.com

www.ukrockfestivals.com (thanks, Dave for permission to quote eyewitness reports from your Knebworth site)

Audio and Visual Sources

BBC News Archive

ITN News Archive

London Weekend Show: Punk, LWT, 1976

Donald Cammell: The Ultimate Performance by Kevin Macdonald and Chris Rodley, BBC, 1998

Gimme Shelter by David and Albert Maysles, 20th Century Fox, 1970

The Rolling Stones European Premiere, DoRo Productions, 1995

The Beatles' Interviews by David Wigg, 1977

Photo Credits

Acknowledgments

My eternal gratitude must go to Andrea Danese, senior editor at Abrams in New York, and Jennifer Jeffrey, photo researcher for Getty Images in London. Their adroit professionalism has ensured the smoothest passage in the history of publishing! I am indebted to them for their patience, understanding, and total commitment to this project. Thanks!

The extensive picture collections brought together by Getty Images provide the basis for this book. General deep-file research in these vast archives has been wonderfully supplemented by images from other collections represented by Getty Images, including Time & Life Pictures, Terry O'Neill, Christopher Simon Sykes, and Graham Wiltshire.

There is no way this book could have come together without the combined efforts of everyone at Abrams and Getty Images. Thanks are more than due to Michael Jacobs, Eric Himmel, and Brady McNamara at Abrams, as well as to Charles Merullo, Liz Ihre, Tea Aganovic, Paul Prowse, Zoltan Mayersberg, and Laurie Noble and his scanning team at Getty Images. Thanks are also due to Carrie Hornbeck for her prodigious copyediting skills, and to Kayhan Tehranchi for his fantastic design, which so perfectly captures the spirit and energy of the Stones.

Hats off to Mr. Paolo Hewitt, Mr. Mark Lewisohn, Sir Mark Baxter, and Mr. Adam Smith for inspiration and support.

My undying thanks, as always, to Kensington and Chelsea libraries, especially the staff of the Central Reference Department, who continue to excel with their professionalism and commitment.

On a personal note I would like to thank my family, friends, and colleagues for their continued support and kindness.

Simon Wells

To my brother, Robert: we've come a long way, kid! –SW

Editor
Andrea Danese
Designer
Kayhan Tehranchi
Photo Research
Jennifer Jeffrey, Getty Images
Production Manager
Anet Sirna-Bruder

Library of Congress Cataloging-in-Publication Data
Wells, Simon, 1961-
The Rolling Stones : 365 days / by Getty Images and Simon Wells.
p. cm.
ISBN 0-8109-3088-9 (hardcover)
1. Rolling Stones--Pictorial works. I. Getty Images, Inc. II. Title.
ML421.R64W46 2006
782.42166092'2--dc22
[B]
2006014840

Printed and bound in China

10 9 8 7 6 5 4 3 2 1

HNA
harry n. abrams, inc.
a subsidiary of La Martinière Groupe

115 West 18th Street
New York, NY 10011
www.hnabooks.com